American Portrait Miniatures

IN THE MANNEY COLLECTION

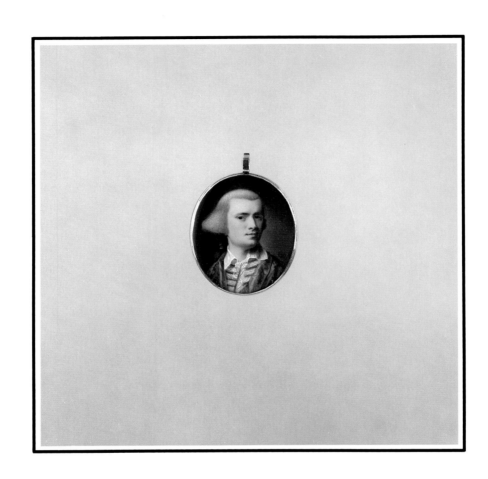

AMERICAN PORTRAIT MINIATURES

IN THE MANNEY COLLECTION

DALE T. JOHNSON

The Metropolitan Museum of Art, New York

Distributed by Harry N. Abrams, Inc., New York

This book is published on the occasion of the exhibition
Tokens of Affection: The Portrait Miniature in America
held at The Metropolitan Museum of Art, New York,
November 20, 1990–February 10, 1991.
The exhibition has been made possible by Richard and Gloria Manney.
It was co-organized by The Metropolitan Museum of Art and
the National Museum of American Art, Smithsonian Institution.

Published by The Metropolitan Museum of Art, New York

John P. O'Neill, *Editor in Chief*
Barbara Burn, *Executive Editor*
Ruth L. Kozodoy, *Editor*
Klaus Gemming, *Designer*
Helga B. Lose, *Production*

Photography by Geoffrey Clements
with these exceptions: photographs on pages 18 and 19 by Katherine Eirk;
photographs for cat. nos. 154 and 155, page 168,
courtesy of Butterfield's, San Francisco

Composition by Dix Type Inc., Syracuse, New York
Color separations by Professional Graphics, Inc., Rockford, Illinois
Printed by Mercantile Printing Company, Worcester, Massachusetts
Bound by Riverside Book Bindery, Inc., Rochester, New York

Jacket: Charles Willson Peale, *Mrs. Joseph Donaldson* and
Joseph Donaldson (cat. nos. 148, 149)
Frontispiece: John Singleton Copley, *Self-portrait* (cat. no. 41)

Contents

Foreword

IN collecting a large number of outstanding American portrait miniatures and placing them before the public, Richard and Gloria Manney have shown vision as well as generosity. We are grateful to the Manneys for sponsoring two projects devoted to the unjustly neglected art form of the miniature. *American Portrait Miniatures in the Manney Collection* is both a comprehensive catalogue and a unique compendium of historical, technical, and biographical material. The Manneys' generosity extends also to include the sponsorship of *Tokens of Affection: The Portrait Miniature in America,* the Metropolitan Museum's first loan exhibition of masterworks of this genre since the landmark exhibition curated by Harry Wehle in 1927.

The Manneys have amassed a highly representative collection of American portrait miniatures, most of them made between 1760 and 1860; together these works provide an excellent overview of miniature painting as it developed from the colonial period through the time of the early republic and on into the post-Jacksonian years. Their history runs parallel to the exploration of full-size portrait painting, constituting a microcosm of portraiture in this country. Many of America's foremost painters were also miniaturists, among them John Singleton Copley, Charles Willson Peale, Thomas Sully, Samuel F. B. Morse, George Catlin, Henry Inman, and Emanuel Gottlieb Leutze. Outstanding artists who worked almost entirely in miniature include John Ramage, Edward Greene Malbone, Benjamin Trott, Anna Claypoole Peale, Sarah Goodridge, and Anson Dickinson.

While miniatures have been treasured as family heirlooms over the years, they have been little studied, even by scholars. Because of their delicacy and small scale, miniatures were often left unsigned. Attributions are therefore a challenge: they must be made largely on the basis of variations in style and technique, often requiring a level of connoisseurship beyond that of the casual collector. The Manneys have assiduously sought signed or documented examples that serve as valuable benchmarks by which unsigned examples may be identified. They have carefully chosen each object for its aesthetic quality, authenticity, state of preservation, and art-historical importance. Remarkably, almost every miniaturist of note who worked in America is represented in the Manneys' collection by at least one example. The Manneys have also sought out unusual pieces by lesser-known or unidentified miniaturists.

Miniatures are only one facet of Richard and Gloria Manney's extensive collecting and active connoisseurship. First known to the Metropolitan Museum for their fine collection of furniture by John Henry Belter and other artists of the rococo revival, they generously funded the Rococo Revival and Greek Revival parlors in the American Wing. Their inspired collecting in a wide range of other areas of American art has also benefited the Museum, as

evidenced by an extraordinary plateau by the New York silversmith John W. Forbes on view in the Federal Gallery, and a unique late-nineteenth-century punch bowl of copper, silver, and horn in The Henry R. Luce Center for the Study of American Art. One hundred ten miniature landscapes which comprised an exhibition at the Museum in 1982, *Tokens of a Friendship: Miniature Watercolors by William T. Richards,* remain here on loan.

The Museum is grateful to Dale T. Johnson, Research Consultant in the Department of American Paintings and Sculpture and author of this catalogue, for her scholarship and dedication. Our thanks also go to Carol Aiken for her essay on the technical aspects of miniatures; to Ruth Kozodoy, who edited the book; and to John K. Howat, Lawrence A. Fleischman Chairman of the Departments of American Art, who gave the project his full support.

Philippe de Montebello
Director

A Note from the Collector

INITIALLY, my interest in collecting miniatures developed from the romantic imaginings of my early years. I began acquiring these tiny paintings at the age of four, when poor health kept me in the hospital much of the time. My grandparents gave me a few miniatures to play with. They were portraits by Continental miniaturists; delicately painted and brightly colored, they were framed in elaborate cases. I found these diminutive, ornamental objects completely delightful. They reminded me of characters in fairy tales. Fascinated by precise detail, by images of ladies with ornate hairdos, and by fancy trimmings and jewelry, I became a young collector of portrait miniatures.

To this day, I am drawn to whatever I find beautiful and unusual. The maker of an object is of interest to me primarily as part of the work's documentation. I would much prefer to own an extraordinary piece by an unknown artist than one of modest character by a master. I am particularly fond of my one hundred or so eye miniatures—tiny portraits of a single eye—mounted in brooches, lockets, bracelets, necklaces, rings, and watch fobs.

With much of the art we have acquired, Richard and I have been inspired by our passion for the unique. We have collected widely, choosing objects both in and out of vogue in a variety of areas including furniture, paintings, sculpture, silver, glass, porcelain, and books. For us, collecting is fun as well as exciting. We never know when or where we will find a treasure.

We have given many pieces of Belter furniture to the Henry Francis du Pont Winterthur Museum, and a number of the objects we own are on loan to museums because we strongly believe that artworks of exceptional beauty or craftsmanship should be available to the public for study and enjoyment. After putting a great deal of time and effort into building a collection, we want the fruits of that labor to be accessible to many people.

When we were assembling our collection of miniatures, we came to understand the importance of acquiring pieces that represent each phase of the artist's work, making it possible to study his work as a whole. For instance, the style of the brilliant miniaturist Edward Greene Malbone changed dramatically after the beginning of his career, so we looked very hard to find an early miniature by him. Every phase of painting by James Peale is represented in our collection—from early miniatures, remarkably close in style to those by his brother Charles Willson Peale, to late examples that are often mistaken for the work of his daughter Anna Claypoole Peale.

In the course of building the collection we also discovered that miniature portraits can be valuable historical documents. When the names of the sitter and the artist are known, other facts about their lives can usually be uncovered. Even when a miniature appears to be undocumented, it may present "clues" from which further information can be extracted. In

a number of instances, identifying the subject of a portrait has led to the work's reasonably certain attribution to a known artist.

For Richard and me, collecting miniatures has accompanied important occasions in our lives. When we were married we spent our honeymoon in Williamsburg, where we went antiquing and I bought two exquisite Continental miniatures with mother-of-pearl cases. One of my favorite pieces, *Mrs. Otis* by Henry Inman, was a gift from my husband one Mother's Day: a portrait of a mother, for a mother. I had seen it in a sale catalogue and had hinted rather broadly that I would love to own it. In the catalogue illustration, the miniature appeared to be framed in an open gold case. When Richard gave me what looked like a gold locket I was sorely disappointed, thinking he had forgotten about the one gift I wanted. Imagine my pleasure when I opened the lid and found inside the exceptional little portrait of Mrs. Otis! (The portrait is number 111 in this catalogue, shown with its engine-turned lid in colorplate 8 and on page 31.)

Although many art and antique dealers have played a part in the formation of our collection, two have been most helpful: E. Grosvenor Paine in the early years, and later on, Edward Sheppard, who with his astute eye has assisted us in the search for examples that are of exceptional quality, especially interesting, or valuable because they are representative. We have eagerly and aggressively purchased these tiny objects by seeking them out in antique shops, shows, and auctions. Applying high standards, we have carefully weeded out works that presented problems of origin, condition, or quality. The present size of the collection is well over three hundred pieces. Assembling these precious miniatures has been an engrossing project; placing them before the public is a great joy.

We are especially grateful to Edward Sheppard, who enthusiastically shares our enjoyment of miniatures; to Barbara DeSilva, our curator, for bringing organization to our collections; to Carol Aiken, the able conservator who worked with the miniatures and wrote a lucid essay on technique; and to Dale Johnson for her tireless effort, skillful research, and dedication to the project that this catalogue represents.

Gloria Manney

Acknowledgments

T<small>HIS</small> catalogue and the exhibition it accompanies are the happy result of the initiative, farsightedness, and public spirit of Gloria and Richard Manney. The project could not have been brought to completion without the efforts of many other individuals as well. I am greatly indebted to a number of Museum colleagues for the assistance they so generously contributed. John K. Howat, Lawrence A. Fleischman Chairman of the Departments of American Art, gave enthusiastic support throughout. Lewis I. Sharp, former Curator and Administrator of The American Wing, laid the foundation for the project with vision and skill, and Peter Kenny, Assistant Curator and Assistant for Administration, provided the encouragement, advice, and direction that helped bring it to fruition.

Particular thanks go to Robin Bolton-Smith of the National Museum of American Art, a leading scholar in the field of American miniatures and co-organizer of the exhibition. She generously shared ideas, observations, and information from her files, the compilation of decades of research. Scholars who are specialists on particular miniaturists or areas of miniature production have given me the benefit of their expertise, and staff members of many museums provided invaluable access to their collections for study and have lent their delicate objects for the exhibition. I am grateful to Linda Bantel, Pennsylvania Academy of Fine Arts; Georgia B. Barnhill, American Antiquarian Society; Judith Barter, Mead Art Museum; Russell Bastedo, Stamford Historical Society; W. Batson, Museum of Early Southern Decorative Arts; Annette Blaugrund, The New-York Historical Society; Jerry M. Bloomer, R. W. Norton Art Gallery; Elizabeth Broun, National Museum of American Art; David Cassidy, Historical Society of Pennsylvania; William V. Elder, The Baltimore Museum of Art; Linda Eppich, Rhode Island Historical Society; Reba Fishman, The New-York Historical Society; Robin Frank and Paula Friedman, Yale University Art Gallery; Nancy Frisella, Pennsylvania Academy of Fine Arts; Zehava Goldberg, Museum of the City of New York; Nina Gray, The New-York Historical Society; Tammis Groft, Albany Institute of History and Art; Erica E. Hirshler, Museum of Fine Arts, Boston; Holley Hotchner, The New-York Historical Society; Elizabeth Jarvis, Historical Society of Pennsylvania; Phillip Johnston, The Carnegie Museum of Art; Elizabeth Kornhauser, Wadsworth Atheneum; Merrill Lavine, The Maryland Historical Society; Angela Mack, Gibbes Art Gallery; Libby McLintock, Wadsworth Atheneum; Ellen Miles, National Portrait Gallery; Christopher Monkhouse, Museum of Art, Rhode Island School of Design; M. B. Munford, The Baltimore Museum of Art; Milo Naeve, The Art Institute of Chicago; Paula B. Richter, Essex Institute; Deborah Rebuck, The Dietrich American Foundation; Daniel Rosenfeld, Museum of Art, Rhode Island School of Design; Paul Schweizer, Munson-Williams-Proctor Institute; Martha Severens, Portland Art Museum; Darrell Sewell, Philadelphia Museum of Art; Nancy Rivard Shaw, The Detroit Institute of Arts; Linda Simmons, The Corcoran Gallery of Art; Susan E. Strickler, Worcester Art Museum; Robert Stuart, National Portrait Gallery; and Paul Winfisky, Peabody Museum of Salem.

For the information and aid generously given by these independent scholars, descendants of artists, and private collectors, I wish to express my gratitude: David Anderson; Mrs. Joseph Carson; Clifford Chieffo; Sarah Coffin; Mrs. Julian Crocker; Mona Leithiser Dearborn; Susan

Detweiler; Davida Deutsch; Maymie Eschwey; Charles Fleischmann; Charles Gilday; Anne Sue Hirshorn; Thomas Holberton; Robert L. McNeil, Jr.; Donald Millerbernd; E. Grosvenor Paine; Mrs. Oliver Hazard Perry; Lewis Hoyer Rabbage; Graham Reynolds; Mrs. John Schorsch; Robert Spears; Mr. and Mrs. Herbert Tannenbaum; Ann Verplanck; Mrs. John Wadleigh; William Collins Watterson; Marta Goldsborough Wetmore; and Mrs. Jeanette Whitebook.

I am most grateful to Edward Sheppard, who offered keen observations on individual techniques and advice about attributions as well as providing information on casework and documentation of subjects and provenances.

Thanks to Barbara DeSilva, who organized the Manneys' collection, supplied pertinent catalogue information, and attended to countless details regarding the project.

The conservators who specialize in the highly fragile medium of watercolor on ivory deserve particular recognition. Carol Aiken worked with the Manneys' collection, shared her exceptional knowledge of materials and casework, and contributed to this catalogue a remarkably concise, informative essay on the miniaturist's technique. Katherine Eirk, who superbly treated the Museum's entire collection, provided invaluable records of conservation and generously shared technical analyses, including microscopic photography; she also served as conservator to the exhibition. William Wiebold provided guidance on several issues of conservation and made fine reproduction cases and frames for a number of the Manneys' miniatures. Thanks also go to the Museum's conservators: Margaret Lawson of Paper Conservation and Yale Kneeland, Jeffrey Perhacs, William Gagen and Nancy Reynolds of Objects Conservation.

I am appreciative of the insights and assistance of my colleagues in The American Wing: Doreen Bolger, Mishoe Brennecke, Alice Cooney Frelinghuysen, Donna Hassler, Morrison Heckscher, Kathleen Luhrs, Arline Nichols, Amelia Peck, Carrie Rebora, Stephen Rubin, Frances Gruber Safford, Thayer Tolles, Catherine Hoover Voorsanger, and John Wilmerding. I am grateful to the late Oswaldo Rodriguez Roque, a good friend who deepened my interest in portraiture. For their good-natured attention to numerous administrative tasks I thank Pamela Hubbard and also Elisabeth Agro, Emely Bramson, Catherine M. Hiller, Ellin Rosenzweig, and Seraphine Wu. Volunteers and interns Elizabeth Quackenbush and Jo Nelle Long and also Jane Bobbe, Elizabeth Bunting, Mary Paramore, Rebecca Tennen, and Miriam Stern performed a multitude of clerical and research tasks. Gary Burnett, Edward Di Farnecio, Sean Farrell, and Don E. Templeton, our departmental technicians, were conscientious and exceedingly helpful.

Particular thanks go to Tracie Felker, who researched and organized biographical information on numerous miniaturists thoroughly and with great resourcefulness; Leslie Symington, who doggedly and successfully ferreted out valuable genealogical facts about the subjects of many of the portraits; and Nancy Gillette, who coordinated a multitude of details.

For extraordinary help of all kinds in planning the exhibition I thank Linda M. Sylling, David Harvey, John Buchanan, Gwen Alston, and Willa M. Cox.

I would like to express most sincere gratitude to Ruth Kozodoy, who edited the book with infinite skill and remarkable insight. My profound thanks also go to John O'Neill and Barbara Burn, who gave the project editorial direction from the start; Teresa Egan, who trafficked quantities of material; Penny Jones, who checked the bibliography; Susan Bradford, who compiled the index; and Helga Lose, who ably and energetically oversaw the book's production. Geoffrey Clements skillfully photographed all the miniatures, and Klaus Gemming designed the book with care and a sensitive eye.

I am grateful to my family for their continuing encouragement, support, and patience throughout the project.

Dale T. Johnson

An Introduction
to the History of American Portrait Miniatures

DALE T. JOHNSON

> We heard the turning of a key in a small lock; she has opened a secret drawer of an escritoire, and is probably looking at a certain miniature, done in Malbone's most perfect style, and representing a face worthy of no less delicate pencil.
>
> —NATHANIEL HAWTHORNE, *The House of the Seven Gables*

THE brief history of portrait miniature painting in America spans, approximately, the century between 1750 and 1850. The tradition of miniature painting in this country, like that of full-size portraiture, was adapted from European models, particularly from English painting of the rococo period. However, although American artists were strongly influenced by English art, they preferred a more penetrating realism and eschewed the artificiality that was popular in European portraiture. In the American spirit of pragmatism, painters sought to capture the individual character of each sitter rather than produce idealized images of the sort valued by their more aristocratic cousins.

Portrait miniatures were as highly prized as full-size portraits in oil and frequently took as long to complete. John Singleton Copley (1738–1815) wrote in 1771, "I saw a miniature the other Day of Governor Martin by Miers [Jeremiah Meyer] which cost 30 Guineas and I think it worth the Money. The Gover's says he sat at least 50 times for it."[1] That miniatures were deeply woven into the fabric of life becomes apparent from an examination of English and American portraits of the eighteenth and early nineteenth centuries, in which the sitter is often depicted wearing or holding a cherished miniature. Miniatures have often figured significantly in artistic works of the highest order—by Shakespeare (*Hamlet*), Balzac (*Splendeurs et misères des courtisanes*), Dickens (*Nicholas Nickleby*), and Verdi (*La forza del destino*), to name a few examples.

In America, the first miniatures were made in colonial times. They were small, soberly painted, finely crafted works; the master practitioner of this art during the Revolutionary period was Charles Willson Peale (1741–1827). There followed a brilliant flowering of miniature painting by such artists as James Peale (1749–1831), Edward Greene Malbone (1777–1807), Benjamin Trott (1770–1843), and Joseph Wood (1778–1830), who produced elegant, luminous, pale-toned portraits. That supreme moment of the art was cut short when a new and radical approach to miniature painting was introduced. Small, oval portraits were replaced by larger, rectangular, densely painted works imitating oil paintings. Since

rectangular miniatures were kept in folding cases or hung on the wall, the miniature lost its fundamental purpose as a personal memento to be worn or carried. With the inevitable next step in the quest for representing reality "in little"—the invention, in 1839, of the daguerre-otype, and soon thereafter of the wet-plate photographic process—the age of the miniature came to a close.

The portrait miniature evolved ultimately from two sources. One is the illuminated manu-script of the Middle Ages. (Surprisingly, the word "miniature" refers to the red lead pig-ment, minium, used in the decoration of illuminated manuscripts; it had nothing to do with size until the eighteenth century, when it assumed its current meaning.) Small-scale portrait painting was originally called "limning," a term derived from the word "illumination." In-deed, the miniaturist's method—precise, exquisite brushwork with water-based paints—is derived from the illuminator's. Medieval manuscripts, which were generally of the fine parchment called vellum, occasionally contained "portraits," but these were likely to be images of historical, religious, or mythological personages.

The other antecedent of portrait miniatures is the portrait medal, which began in classical antiquity and was revived by artists of the Renaissance. These circular medals, true portraits (usually in profile) that conveyed both the subject's appearance and his personality, were the first small portable likenesses. During the second decade of the sixteenth century, elements of the portrait medal and of the illuminated manuscript were joined in the small, detached watercolor portrait, which became the fountainhead of a new artistic tradition.

Although a self-contained miniature portrait painted in enamel was made by Jean Fouquet (ca. 1420–ca. 1481) about 1460 (Musée du Louvre, Paris), it had no immediate followers. The tradition more properly began about 1520, when the French court painter Jean Clouet (1486–1540), decorating a manuscript titled *La Guerre gallique*, included seven portraits of prominent French commanders. These head-and-shoulder likenesses, which show the face in three-quarter view against a blue background, are circular paintings about two inches in diameter. Clouet also painted two independent miniatures; one, *Charles de Cossé*, is in the collection of the Metropolitan Museum.

During the same decade, coincidentally, self-contained miniature portraits were being painted in England by Luke Hornebolte of Ghent (ca. 1490/95–1544). The full-blown miniature tradition evolved from paintings created by Hornebolte and his successors in England during the reign of Henry VIII. Although ideas cross-fertilized between England and France, it was England where the art took its earliest and strongest hold, and England was the center of its subsequent development. As the king's painter in the early Tudor period, Hornebolte portrayed his subjects in a three-quarter pose against a brilliant blue background, applying transparent and opaque watercolors to a small disk of vellum which was then pasted to a cut piece of a playing card. He brought fine brushwork and delicate color harmonies to the making of a tiny, circular, encased, precious object.

Hornebolte's contemporary Hans Holbein (1497–1543), also painting in England, pro-duced miniatures which in their acute realism equal his full-size portraits. A goldsmith and limner of a later generation, Nicholas Hilliard (1547–1619), modeling his work on Hol-bein's, became the outstanding English painter of his day. He created the first miniatures

that were oval rather than circular, setting a precedent for subsequent English and, later, American works. Miniatures by Hornebolte, Holbein, and Hilliard, painted for the privileged members of the English court, were frequently mounted on gold or ivory boxes, perhaps embellished with precious stones. Some prized pieces were mounted in gold lockets, brooches, and bracelets that reflected their own jewellike quality. These exquisite objects were intended as personal mementos to be worn and cherished by loved ones, and this tradition continued into the nineteenth century.

During the seventeenth century, the technique and materials used in miniature painting remained virtually unchanged. In the early eighteenth century, miniatures enameled on copper became the fashion. The demand had increased for miniature copies of full-size portraits. Enamel painting, like mezzotint engraving (in which a number of miniaturists were skilled), was a painstaking process but one suitable for making copies.

At first there were no English miniaturists working in the medium of enamel, and foreign enamelists immigrated to England to meet the need. Soon, a number of practitioners were producing finely detailed characterizations in enamel. The best enamelist in England was Christian Frederick Zincke (1683/84–1767), the son of a Dresden goldsmith, whose work dominated miniature portraiture until the mid-1750s. However, the majority of works of this type exhibited a decorative, mannered sameness. The late baroque fashion of elaborate dress and style had supplanted the earlier passion for realism. Miniatures had become larger, frequently reaching a height of three and one-half inches. (These works were the precursors of the Continental "fancy pieces" of the nineteenth century which today are regarded as a species of souvenir.) Eventually the decorative style fell out of favor, and once again the demand grew for miniatures that were painted from life rather than copied.

The single most innovative advance in the art of portrait miniature painting was made by a Venetian miniaturist, Rosalba Carriera (1675–1758), who applied a watercolor technique to the decoration of ivory snuffboxes. The English artist Bernard Lens III (1682–1740) was the first in his country to paint a miniature in watercolor on ivory, *The Reverend Dr. Harris* of 1707 (Yale Center for British Art, New Haven). In technique it is so close to examples by Carriera that it probably was modeled after one of her works. Apparently Lens never traveled abroad; the likelihood is that a miniature by Carriera was brought to England. Lens's adoption of the ivory support had an importance that cannot be overstated. It revolutionized the art of miniature painting.

Ivory holds a great aesthetic advantage over vellum, for its luminosity dramatically enhances skin tones and enables the painter to render the sheen of hair and fabrics. This is the case, however, only when the medium is transparent watercolor. Sixteenth- and seventeenth-century miniatures on vellum had traditionally been made using transparent watercolor for the face and opaque "body color" for the eyes, hair, clothing, and background. Employing the same method but substituting ivory for vellum, Lens was able to impart a glowing warmth to the faces in his portraits. His miniatures were widely admired for their remarkable freshness, and the ivory support was rapidly taken up by other artists. After 1720, few miniatures were painted on vellum. By mid-century the enamel medium too was losing ground to watercolor on ivory. However, it would be almost forty years after the introduction of the ivory support before the artistic possibilities of the ivory approached full realization.

Technically, the use of ivory posed problems. Paint does not easily adhere to the slippery, nonporous ivory surface. The antipathy between watercolor and ivory made miniature painting one of the most formidable techniques ever devised. The task was further complicated by the portrait's minute size, which required work of the most controlled precision. The tiniest error was usually irreversible; an attempt to rework or make a correction could lift the paint right off the ivory. Therefore, paint had to be applied cautiously, using a meticulous technique of hatch, stipple, and wash. The American miniaturist Thomas Seir Cummings (1804–1894) later explained: "In the first named [hatch], the colour is laid on in lines, crossing each other in various directions, leaving spaces equal to the width of the line between each and finally producing an evenly-lined surface. The second [stipple] is similarly commenced, and . . . is finished by dots placed in the interstices of the lines, until the whole has the appearance of having been stippled from the commencement. The third is an even wash of colour, without partaking of either the line or dot, and when properly managed, should present a uniform flat tint."[2] Every artist had his own way of combining these techniques.

As patronage extended beyond the court to include politicians and merchants of the upper middle class, the miniature contracted once again to a modest size, usually measuring, by 1750, no more than one and one-half inches. The diminutive format was also desirable because it was easier to work the treacherous new medium on a smaller scale. Previously, miniatures had been worn as pendants and brooches; now the delicate little portraits could easily be mounted on bracelets as well. The modesty of these works was manifest not only in their scale but also in their subdued coloration and sparingly applied paint. It was this type of small, restrained, unidealized miniature likeness that found its way to the New World.

Traditionally, Americans looked to their British cousins for the latest vogues in art and fashion. A few miniatures had been produced in this country by artists practicing in the rococo style, including some in oil on copper made in 1734 by John Smibert (1688–1751) of Boston. The earliest known American miniature on ivory, *Woman of the Gibbes or Shoolbred Family*, was painted about 1740 by Mary Roberts (d. 1761) of Charleston (Carolina Art Association, Charleston). Shortly thereafter, ivory became the standard support for American miniatures as well as English ones. Important early examples that survive are *Mrs. Jacob Motte* (ca. 1755; private collection) by Jeremiah Theüs (ca. 1719–1774); *Mrs. Thomas Hopkinson* (before 1764; Historical Society of Pennsylvania, Philadelphia) by Matthew Pratt (1734–1805); and the only known miniature by Benjamin West (1738–1820), a self-portrait done about 1758, when West was eighteen (Yale University Art Gallery, New Haven).

Painters continued to emerge in America, and many of them took up the art of the miniature. John Singleton Copley, the Boston painter who became the leading American portraitist of his generation, was strongly influenced by British portraiture, but in his work he pursued the almost scientific quest for factuality that came to characterize American painting. Copley's portraits, both full-size and in miniature, combine powerful realism, vivid color, strong value contrasts, and a sure touch; they are entirely contrary in mood to the flickering, atmospheric, conspicuously brushstroked paintings in the English baroque or rococo style. Copley began painting miniatures in Boston about 1758, first in oil on copper and later in watercolor on ivory.

The political climate in America prompted Copley's move to London in 1774. West had already departed, in 1760. Charles Willson Peale now became the leading portrait painter in America. Peale's works, unlike Copley's, have a slightly provincial flavor. His charming miniatures on ivory are delicate and subtle in coloration, but effectively convey the individual characters of their subjects. In 1786 Charles turned his miniature business over to his brother James, who soon was one of the country's finest miniaturists, surpassing Charles in that field.

A Boston artist, Joseph Dunkerley (active 1784–88), produced wiry little likenesses during the 1780s that somewhat resemble Copley's miniatures, although they are much more provincial. The Philadelphia-born artist Henry Benbridge (1743–1812) studied in Rome under Anton Raphael Mengs (1728–1779) and Pompeo Batoni (1708–1787) and also in London, acquiring a colorful, linear, crisply realistic portrait style remarkably close to Copley's. He settled in Charleston in 1772 and fell heir to the position of portraitist for that fashionable seaport when Theüs died in 1774. Benbridge married the miniaturist Hetty Sage, who was a student of Charles Willson Peale.

The inventor Robert Fulton (1765–1815) arrived in Philadelphia in 1782 and probably took instruction from James Peale, for within three years he had opened a miniature business and was turning out fine portraits in a style similar to Peale's. The miniatures he painted after his trip to England, however, were mannered "fancy pieces."

John Ramage (ca. 1748–1802), an emigrant from Ireland by way of London, began working in Boston but by 1777 was in New York, where he maintained the lead in miniature painting until 1794. Extremely fine in technique and richly colored, his miniatures give the effect of enamels. William Verstille (1757–1803), a Connecticut artist, painted in New York between 1784 and 1790, where he modeled his miniatures on those of Ramage. He later developed his own style, doing his best work in Salem, Massachusetts, around the turn of the century.

These colonial miniaturists were at work in America during the second half of the eighteenth century, producing, in general, provincial versions of the English prototype. At the same time, the leading English miniaturists, especially Jeremiah Meyer (1735–1789), Richard Cosway (1742–1781), John Smart (1742/43–1811), Richard Crosse (1742–1810), and Samuel Cotes (1734–1818), were developing the art to the high state which is known as its "golden age." As the technique of the English painters became more assured, they learned how to use more of the translucent surface to advantage, allowing the pale ivory to glow through the paint or to appear free of paint as a highlight in the skin, hair, fabric, and background sky. The ability to control the effects of watercolor on ivory gave artists the confidence to undertake painting on larger ivories. The small size and conservative mode of the 1750s were abandoned; by the 1780s, the usual height of a miniature had once again increased to about three inches. The new fashion for high hairdos and plumed hats also encouraged the use of a larger format.

The first artist in England to make extensive use of the ivory's possibilities was Jeremiah Meyer. Instead of employing the conventional techniques of stipple and hatch, he applied to the ivory a delicate network of gracefully curving lines of varied length; each stroke was in precisely the proper hue and direction to enhance the modeling of the face. Meyer used pale, transparent washes combined with light lines of color to define the hair, clothing, and

Enlarged details illustrating the techniques
of individual miniaturists, all taken from miniatures
owned by The Metropolitan Museum of Art

Charles Willson Peale: broad vertical
and diagonal hatch
(*General Henry Knox*, Gift of Mr. J.
William Middendorf II,
1968 68.222.5)

Robert Field: fine curved brushstroke
(*Robert Stuart*, Fletcher Fund, 1939 39.141)

Charles Fraser: broad stipple and hatch
(*Francis Kinloch Huger*, Harris Brisbane
Dick Fund, 1938 38.165.33)

Anson Dickinson: delicate crosshatch
combined with transparent washes of
color (*Edward Livingston*, Fletcher
Fund, 1938 38.41)

Sarah Goodridge: delicate stipple and hatch (*Young Woman*,
Gift of Mr. J. William Middendorf II, 1968 68.222.25)

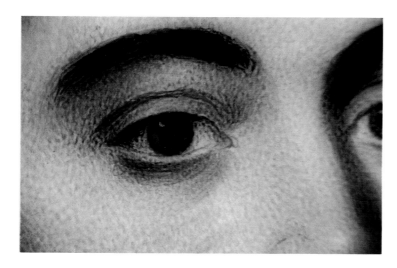

Thomas Seir Cummings: tight precise
stipple (*Gentleman of the Pruyn Family*,
Rogers Fund, 1969 69.221)

background. A few opaque touches created darker accents. When explored by Meyer and his late-eighteenth-century followers in England and America, these new, sensitive, expressive methods yielded remarkable developments in the art of miniature painting.

Meyer's immediate followers in England worked in a technique similar to his, but they were unable to achieve the same degree of controlled freedom or to reproduce the subtle calligraphic modeling on which it depended. However, their accomplishments were significant. Richard Crosse used transparent washes but resorted to controlled stippling in painting the face. Richard Cosway fully exploited the possibilities of transparent watercolor and the luminosity of the ivory surface; his pale palette was perfectly suited to rendering the gauzy fabrics and powdered wigs of his aristocratic clientele. John Smart, working in a tight stipple, produced subtle modulations of form and achieved a remarkably smooth effect without sacrificing transparency.

On the Continent the taste was very different, favoring the application of gouache in thick opaque layers, brilliant color, and meticulous decoration. The two leading exponents of the art in France at this time were Jean-Baptiste-Jacques Augustin (1759–1832) and Jean-Baptiste Isabey (1767–1855).

Toward the end of the eighteenth century, scores of miniaturists from Great Britain, France, and Italy came to America to paint the citizens of the young republic. British artists brought with them the enlarged, more luminous miniature, while those from the Continent imported their precise, decorative style. Some of these expatriates made the United States their permanent residence; others worked here only for a while before returning home, but not without leaving a lasting impression.

Artists from the British Isles included the brothers Archibald (1765–1835) and Alexander Robertson (1772–1841), who came in the early 1790s from Aberdeen, Scotland. They founded the Columbian Academy in New York, where students were introduced to the enlarged ivory, techniques to enhance its translucency, and a style that employed freer brushwork.

Walter Robertson (ca. 1750–1802), an Irishman not related to the Robertson brothers, came to America with Gilbert Stuart (1755–1828) in 1793. He painted elegant miniatures of prominent New Yorkers and Philadelphians in which superb, seemingly smooth modeling was actually effected by a technique of delicate hatching. Robertson's innovative work proved instructive to American disciples.

The most accomplished foreign-born miniaturist working in this country was Robert Field (ca. 1769–1819). Traveling in the Atlantic states between Maryland and Massachusetts during the years 1800–1808, Field worked in the best English tradition of Jeremiah Meyer, employing delicate serpentine strokes of color to model the flesh and making optimum use of the ivory's luminosity.

Edward Miles (1752–1828), who trained under Sir Joshua Reynolds (1723–1792) and at the Royal Academy, left England in 1807 to settle in Philadelphia, where he founded the Society of Artists (later the Columbian Society of Artists) and became especially well known as a teacher of drawing. His miniatures, painted in the style of Cosway, are softly modeled with a fine stipple of pale color.

Toward the close of the eighteenth century, many accomplished Continental miniatur-

ists immigrated to America, such as Pierre Henri (ca. 1760–1822), who announced to a New York public in 1788 that he was "lately arrived from France." Jean Pierre Elouis (1755–1840), a refugee from the French Revolution, worked in the middle Atlantic states between 1791 and 1799, and Philippe Abraham Peticolas (1760–1841), who came to Philadelphia from France in 1791, traveled from New York to Richmond, Virginia, painting miniature likenesses. David Boudon (1748–ca. 1816), an engraver from Geneva, journeyed to the United States about 1794, toured the South and Midwest, and settled in Chillicothe, Ohio.

In the new century, more artists who had been trained on the Continent arrived to try their luck. The French painter Louis Antoine Collas (1775–ca. 1829) worked in New York, Charleston, and New Orleans between 1816 and 1829, producing exquisite miniatures, some with elaborate backgrounds. Miniaturists arrived from Italy during this period. Gennarino Persico (ca. 1800–ca. 1859) came to Philadelphia from Naples in 1818, later opening a drawing academy in Richmond. Anthony Meucci (active 1818–37) and his wife, Nina Meucci (active 1818–27), both miniaturists, arrived in New Orleans in 1818 and practiced their art in most of the port cities of the East Coast. Other important miniaturists who visited this country include the French artists Joseph-Pierre Picot de Limoëlan de Clorivière (1768–1826), Jean François de Vallée (active 1785–1826), and Nicolas Vincent Boudet (active 1793–1820). Many immigrant artists found it necessary to work as itinerants in order to earn a living, and they had an impact on the work of native-born miniaturists wherever they went. A number of artists opened schools for young ladies and offered instruction in the precise, decorative style of miniature painting they had brought from the Continent.

British critics scorned the techniques of French and Italian miniaturists. The circular format and the use of gouache, employed in broad impasto and with touches of opaque color for decoration, were considered archaic when compared with English practices. "The English preferred to treat the ivory as a light shining behind transparent hatches and washes, and cultivated the linear rhythms which are equally apparent in the contemporary watercolour drawings of this elegant age."[3] While English artists fully exploited the luminous quality of the ivory support, Continental painters continued to hide its natural properties under several coats of opaque paint.

American portraiture of the nineteenth century was as profoundly altered by the work of Gilbert Stuart (who was not known as a miniaturist) as portraiture of the eighteenth century had been by Copley's. Stuart left Newport when the pending revolution reduced the demand for portraits. He spent years in London and Dublin, returning to the United States in 1792 to become his country's most successful and influential portraitist. Stuart learned a great deal from his exposure to the fluid, airy, decorative manner of the foremost English painters. However, he shared the American appetite for factuality. Stuart's likenesses, which are brilliantly painted yet not idealized, seem to offer the definitive statement on their subjects' characters. The miniaturists of Stuart's time, especially those working near him in Philadelphia or Boston, strove to capture on ivory dashing, glowing likenesses of the kind that Stuart had achieved on canvas.

A host of outstanding painters flourished during the extraordinary era of American miniature painting that followed. The Philadelphian James Peale, whose miniatures had previously been small, densely colored, and linear, by 1794 was painting larger ivories with

a softer, more delicate brushwork. By 1800 his style had changed again, becoming graceful and elegant and allowing the ivory to glow through broad washes of pale color, yet retaining the charm and frank realism that characterized Peale's early work.

Edward Greene Malbone reached maturity just at the time of the flowering of American miniature painting in which he was a major force. Although he died at the age of twenty-nine and was active for fewer than twelve years, Malbone is regarded as the finest American miniature painter. Precociously talented, Malbone was in London in 1801, absorbing the lessons to be learned from portraits by Sir Thomas Lawrence (1769–1830) and miniatures by Samuel Shelley (1750/56–1808) and Richard Cosway. He returned to America with a lightened palette, a technique of delicate cross-hatching, a freer, more assured brushstroke, and an appreciation of the use of pale, transparent washes. During the next six years he produced hundreds of elegant, graceful portraits, which, despite their beauteous mode, are keen revelations of character.

Charles Fraser (1782–1860), a lawyer, author, and poet, turned to miniature painting in 1818 and produced sure likenesses of Charleston's prominent citizens. His work, although strongly influenced by Malbone's, makes use of a prominent stipple that is distinctive.

The irascible Benjamin Trott of Philadelphia was a miniature painter of renown. By applying extremely thin washes and even leaving areas of the ivory surface bare, he used the luminous support more advantageously than any other American miniaturist had done, particularly in the rendering of sky in the background. His elegantly posed portraits, executed with dashing brushstrokes of clear color, are strongly indebted to Gilbert Stuart.

Two members of the second generation of the Peale dynasty of painters joined James Peale in dominating the miniature painting profession in Philadelphia and Baltimore. Raphaelle Peale (1774–1825), the son of Charles Willson, whose style was heavily influenced by his uncle James, employed a light palette with exceedingly pale skin tones. Anna Claypoole Peale (1791–1878), James's daughter, produced charming, lively miniatures whose wiry brushwork is distinctive. Her niece, Mary Jane Simes (1807–1872) of Baltimore, took the miniature profession into the third Peale generation.

Another major figure in American miniature painting was Anson Dickinson (1779–1852) of Connecticut, who modeled his early work on Malbone's. His record book, begun in 1803 and recording the commissions of about fifteen hundred miniatures, is an important document. Joseph Wood was coached by Malbone, who was his friend and adviser, and Wood's best works are strongly influenced by his mentor's. Wood's miniatures often yield an even more powerful sense of the subject's individuality than Malbone's.

In England, the "golden age" of miniature painting was beginning to be eclipsed by a new style. Andrew Robertson (1777–1845), younger brother of the two Scottish-American painters, became a leading miniature painter in London. About 1805 Andrew painted an eight-by-seven-inch copy of Van Dyck's portrait *Cornelius van der Geest*. It was so elaborately composed and brilliantly colored that fellow artists were astonished to learn it had been done in watercolor on ivory. Robertson detested the delicate, lightened palettes of leading English artists like Cosway and Smart, maintaining that "Modern paintings, placed besides Rubens, etc. are like drawings, from their blueness and cold tone," and "Most miniatures are too much like china. Ivory must be brought down very much to give it the softness of flesh." The works of Cosway he called "pretty things but not pictures. No nature, colouring, or force."[4] Much in the way that watercolor painters of this period were imitating the color

and depth of oil painting, Robertson attempted to give his miniatures the appearance of oils. He used rich, dense colors, quantities of gum, and even varnish on his large ivory rectangles. Robertson was appointed miniaturist to the duke of Sussex in 1805, and his works drew such fervent acclaim that the direction of the art was changed forever.

The introduction of a rectangular format not only radically altered the aesthetics of the miniature but also negated its original purpose, which was to be worn on the person of the owner. Although oval miniatures had grown quite large by the end of the eighteenth century, they continued to be worn as lockets. The new rectangular miniature functioned as a portable object for a while, but as the demand for small "oil paintings" grew, the appeal of the affectionate memento diminished. Additional impetus for the larger painting came from miniaturists' desire to exhibit their pieces and their fear that miniatures would be overshadowed by portraits in the large.

During the 1820s this new style of English miniature painting was assimilated by Americans. The elegant, understated portraiture of the early republican era represented by Malbone and his close followers no longer seemed appropriate. The new-style miniatures, meticulously realistic and highly finished, were housed in leather cases or small wooden frames that intensified their resemblance to oil paintings. The sitters, wearing their finest clothes, were sometimes portrayed in highly detailed interiors documenting their possessions. These substantial portraits ideally suited the democratic purposes of the Jacksonian era's burgeoning middle class.

Miniature painting in styles both traditional and innovative continued to thrive in the nation's eastern states, particularly in the major port cities of Philadelphia, Baltimore, New York, and Boston. Competition became so keen, however, that by the 1830s miniaturists were also traveling throughout the South and Midwest, and even to California.

An important role was played by the painter Thomas Sully (1783–1872), who returned in 1812 from a year's study in London, bringing to Philadelphia a fluid portraiture style modeled after that of Sir Thomas Lawrence. During his long life Sully produced over twenty-five hundred portraits and miniatures: stylish, rather flattering likenesses that became the new model for portraiture in this country as practiced by Samuel F. B. Morse (1791–1872), Henry Inman (1801–1846), Thomas Seir Cummings, and Charles Cromwell Ingham (1796–1863).

New York's academies of art and newly affluent clientele made that city a natural center for miniaturists, who flocked there to study and practice the art. Some started out as miniaturists and later became prominent portraitists in oil. Samuel F. B. Morse, who painted miniatures early in his career, led the founding of the National Academy of Design in 1826 and served as its president until 1845. Henry Inman arrived from Utica and began a seven-year apprenticeship under John Wesley Jarvis (1780–1840); later the two formed an enormously successful partnership, completing up to six full-size portraits and miniatures a week. Subsequently, Inman took Thomas Seir Cummings on as his pupil and eventually as partner. Inman was a founder of the National Academy of Design and, in 1827, its first vice president. Cummings was an officer of the National Academy of Design from 1827 to 1865 and kept annals which constitute an important history of that institution. Nathaniel Rogers (1788–1844) had arrived in New York in 1811 and had been taken on as an apprentice by Joseph Wood. By the following year, when Wood went to Philadelphia, Rogers had become a New York miniaturist second in demand only to Inman. Anne Hall (1792–1863), who

studied under Alexander Robertson and began exhibiting unique miniature compositions of children and flowers, was the first woman elected to the National Academy of Design.

Boston attracted a large number of miniaturists. Henry Williams (1787–1830), who was in partnership with William M. S. Doyle (1769–1828), published an important treatise, *Elements of Drawing*, in 1814. Alvan Clark (1804–1887) started out as an engraver, painted some highly individualized miniatures, and later became the leading manufacturer of telescopes. Sarah Goodridge (1788–1853) received some instruction from Gilbert Stuart in the 1820s and went on to paint realistic works that combine strong individualization with sensitive detail. Gilbert Stuart's daughter Jane Stuart (1812–1888) made countless copies of her father's famous portraits of Washington, some of them miniatures. Richard Morrell Staigg (1817–1881) admired the miniatures of Malbone, who had died three decades earlier. His own work began as an imitation of Malbone's, but soon he became exceedingly successful making large, richly painted, intensely colored miniatures in a style of his own. Moses B. Russell (1810–1884), who was active as a miniaturist in Boston for five decades (from 1833 to 1884), frequently collaborated with his wife, Clarissa Peters Russell (1809–1854), who was also a miniaturist. When they worked separately, he produced forceful portraits, generally of male clients, while Clarissa specialized in charming, somewhat naive likenesses of women and children.

During the 1840s, John Carlin (1813–1891), George Freeman (1789–1868), and George Lethbridge Saunders (1807–1863), painting in Philadelphia and New York, helped fill the demand for miniatures that closely imitated oil portraits in the style developed by Andrew Robertson. They worked in an enlarged format made possible in 1840 by the invention of a device that could cut sheets of ivory from the circumference of a tusk rather than cutting simple planar slices.

Miniaturists were striving to replicate the oil portrait ever more closely. Not only had miniatures become larger and more strongly colored; in addition they sometimes portrayed full-length figures and groups of figures and showed interior settings in elaborate detail. They acquired a high finish and a sharp focus, taking on the qualities of their impending rival, the photograph. The desire to duplicate reality with exactness ultimately resulted in a miniature art that was dry and insipid.

After the invention of the daguerreotype in 1839, many miniaturists abandoned their art. Miniatures could not compete with the new kind of portrait produced by light on polished silver. To Americans—pragmatic, inventive, inquisitive, and entranced by factuality—the daguerreotype held enormous appeal.

Frequently, color was added to daguerreotypes by hand. Colored daguerreotypes and the superrealistic painted miniatures were almost indistinguishable, and technically they nearly converged. A daguerreotype was even mounted exactly like a miniature, in a hinged case with a stamped metal mat and a protective glass.

Some ex-miniaturists found employment coloring photographs. Others continued to paint miniatures while also copying photographs and offered their clientele a choice of mediums. John Alexander McDougall (1810/11–1894) remained active in New York and Newark about 1840 to 1880, producing reasonable likenesses on ivory and celluloid and

painting over photographs. In Philadelphia, John Henry Brown (1818–1891) achieved remarkable success making miniatures that were precise copies of daguerreotypes. Others who adapted their skills to the new process were George H. Hite (ca. 1810–1880), John Wood Dodge (1807–1893), and Edward S. Dodge (1816–1857), who continued to paint on ivory but also copied photographs and became photographers.

No sooner had the new process been brought to this country than the miniaturist Augustus Fuller (1812–1873), together with his brother George (1822–1884), bought a camera and began to make daguerreotype portraits. George wrote to their father on April 11, 1840: "You have heard much (through the newspapers) of the daguerreotype, or drawing produced by rays of light upon a plate chemically prepared. Augustus and I went to see the specimens, and were much pleased. . . . Now this can be applied to taking miniatures or portraits. . . . The plate (metallic) costs about $1.50, and it is easily prepared; but two minutes' time is required to leave a complete impression of a man's countenance, perfect as nature can make it. . . . This is a new invention, and consequently a great novelty of which every one has heard, and has a curiosity to see. It is just what the people of this country like, namely, something new. I think anyone would give $7.00 for their perfect likeness."[5]

Nor was the photograph's popularity confined to America. At the Royal Academy in London, the exhibition entries for 1830 had included three hundred miniatures. By 1863 the number had dropped to thirty-three. After the 1850s the single-image daguerreotype itself all but disappeared; it was replaced by the photograph made by a wet-plate process, which allowed multiple prints to be made from a negative.

In *The House of the Seven Gables*, Nathaniel Hawthorne has the daguerreotypist Holgrave say: "While we give it credit only for depicting the merest surface, [the daguerreotype] actually brings out the secret character with a truth that no painter would ever venture upon, even could he detect it."[6] Rembrandt Peale (1778–1860), although he expressed admiration for the photograph's "relative merit" as a memorial, held the opposing view. "The task of the portrait painter," he wrote, "is quite another thing—an effort of skill, taste, mind, and judgement . . . to render permanent the transient expression of character . . . and to mark every part of the countenance with a harmony and *unity* of sentiment."[7] But there was no holding back the tide. "The miniature in the presence of the photograph," wrote Harry Wehle, a leading scholar of American miniatures, "was like a bird before a snake: it was fascinated—even to the fatal point of imitation—and then it was swallowed."[8]

At the turn of the twentieth century there was a renewal of interest in miniature painting. The revival was part of the arts and crafts movement, a reaction against industrialization on the part of artists and artisans who championed a return to the handcrafting of objects. The movement's emphasis on sheer aesthetics, however, often depersonalized the subject and worked against the creation of a true portrait, thus removing the miniature even further from its original purpose as an intimate keepsake. Sitters were often studio models, and miniatures bear titles such as *The Black Fan*, *Violet and Amber*, and *The Green Coat*, in the spirit of paintings by James McNeill Whistler (1834–1903). Even a subject who is identified by name is often portrayed in an elaborate interior space that includes the decorative oriental motifs of the aesthetic movement. Other miniatures depict nudes, still lifes, and landscapes.

As ivory became increasingly difficult to procure, ivorine or celluloid was substituted. Miniatures were often as large as seven inches high.

Some prominent miniaturists of the revival period were William J. Whittemore (1860–1955), Lucia Fairchild Fuller (1872–1924), Lucy M. Stanton (1875–1931), Rosa Hooper (1876–1963), and Margaret Foote Hawley (1880–1963). The American Society of Miniature Painters, established in 1899, remained in existence until 1965, and a few artists are still making miniatures. While many revival miniatures show considerable technical proficiency and even aesthetic distinction, they lack the skillful buildup of forms, the delicate, precise brushwork, and the clarity of purpose that characterize eighteenth- and nineteenth-century works. Revival miniatures never achieved widespread popularity; nor did they supplant the ubiquitous photographic image.

Portrait miniatures have undergone damage from the growth of photography even greater than their own demise. Because the small portrait image that is entirely commonplace and familiar to us now is the photograph, it is impossible for us to contemplate miniatures from a viewpoint not informed by photography. But a photograph is speedily taken and is made by a machine, however sensitively wielded, while a miniature is painstakingly crafted, every tiny stroke conceived by a human mind and applied by a human hand. For all their small size, miniature paintings are works of art, and they were valued as such by their owners (unlike most photographs) in addition to being cherished for their personal significance. These representatives of a personalized art now gone are the bearers of an exquisite artistic tradition.

NOTES

1. Massachusetts Historical Society, *Letters & Papers of John Singleton Copley and Henry Pelham*, Collections, vol. 71 (Cambridge, Mass., 1914), p. 128.

2. William Dunlap, *History of the Rise and Progress of the Arts of Design in the United States*, vol. 2 (New York: George P. Scott and Co., 1834), pp. 10–11.

3. Graham Reynolds, *English Portrait Miniatures*, rev. ed. (Cambridge: Cambridge University Press, 1988), p. 142.

4. John Murdoch et al., *The English Miniature* (New Haven and London: Yale University Press, 1981), p. 199.

5. Quoted in Van Deren Coke, *The Painter and the Photograph: From Delacroix to Warhol* (Albuquerque: University of New Mexico Press, 1964), p. 21.

6. Nathaniel Hawthorne, *The House of the Seven Gables*, first published in 1851 (New York/Toronto: Bantam Books, 1981), p. 68.

7. Rembrandt Peale, "Portraiture," in *The Crayon* 4 (1857), p. 44; reprint, New York: AMS Press, 1970.

8. Harry B. Wehle, *American Miniatures, 1730–1850* (Garden City, N.Y.: Doubleday, Page & Company, 1927), p. 69.

Materials and Techniques
of the American Portrait Miniaturist

CAROL AIKEN

U NTIL the middle of the nineteenth century, personal images of friends and loved ones were recorded in diminutive paintings called portrait miniatures. The intimate size and decorative appearance which made the miniature an ideal memento and keepsake also distinguished it from other forms of painting.

Over the centuries, specialized painting techniques evolved for making the small portraits. The development of miniature painting from the first known examples, painted in the 1500s during the reign of Henry VIII, is well documented.[1] Early miniatures were painted in opaque colors applied to vellum. A decisive change took place in the early 1700s, when the English artist Bernard Lens introduced the use of ivory to replace vellum. As a result of his efforts and those of his two sons, by about 1720 ivory had become the standard support for miniature painting in England. The transition from vellum to ivory forced artists to adjust their colors and methods of application; opaque paints eventually gave way to transparent watercolors, which took full advantage of the ivory's translucency.

The new technique spread to the Continent and to the American colonies, where miniature painting was in its infancy. As eighteenth-century artists gained technical confidence and skill in the use of the ivory support, the miniature portrait underwent changes in size, shape, and style of framing. Gradually British and American miniatures became clearly distinguishable both from Continental examples and from each other.

American miniatures flourished principally from the mid-eighteenth century through the mid-nineteenth century, when they were superseded by the photograph. The attraction of the miniature, however, has never waned. The charm of a small portrait, the beauty and complexity of its case, and the personal mementos displayed within the housing all contribute to its special, distinctly emotional appeal. For the connoisseur of miniatures an added satisfaction comes from recognizing the idiosyncrasies that characterize a particular artist's style. A fuller understanding of these works is achieved as well through knowledge of the materials and techniques used by American miniaturists.

Artists' Materials

The portrait miniature was painted on an ivory support that required thorough preparation before it could be used; otherwise colors were apt to crack and peel. The ivory sheet was

prepared by degreasing, bleaching, and smoothing. Bleaching and the extraction of natural oils could be carried out simultaneously by placing the ivory, folded in paper, between two heated irons. Alternatively, the ivory was placed in quicklime, which was activated by the addition of water. Some artists advocated applying vinegar or garlic to the ivory surface to remove the oil and placing the ivory in the sun to bleach it. When free of grease and acceptably white, the ivory was rubbed with an abrasive material such as sharkskin or pumice. Then the sheet was attached to a piece of paper with animal glue, gum arabic, or sealing wax. The paper backing would eventually act as a mount for the ivory, permitting it to be secured to a board during the process of painting.

Although some American miniaturists continued to mix their own colors, by the second half of the eighteenth century the majority of artists' colors were bought in prepared form. The laborious process of pigment preparation had been taken over by artists' colormen, who manufactured or imported a wide range of products.

In "A Treatise on Miniature Painting," which Archibald Robertson wrote in New York in 1800 to instruct his brother Andrew, the artist described his palette. "The colors I use are all Reeves' except white, which I prepare myself. . . . Carmine Lake, lake Vermillion-light Red-Prussian Blue-Indigo-Gamboge-King's Yellow-umber, Yellow Ochre-Indian Ink—no ultramarine, it is only for oil. With the above I do all the work I ever have occasion for—it ought to be an universal rule that the fewer colors you use the better—the greater the simplicity the better."[2] The practice of limiting the palette to a small number of colors was also followed by many of Robertson's contemporaries. In 1819 Charles Fraser of Charleston recorded in his account book: "These colours are sufficient for any effect on miniatures on Ivory: . . . vermillion, Carmine, Bt. Siena, Indian Yellow, Indigo, Royal smalt, verditter, Indian Red, Ivory Black, French white, dry and Well levigated."[3]

Robertson probably objected to ultramarine because it had a gritty quality not suitable for painting a miniature. All the pigments used by miniaturists were carefully chosen, since some had unacceptable working properties, were not durable, or were chemically unstable. The fading of pigments presented a particular problem. Artists avoided nondurable colors, known as "fugitive" colors, which could completely disappear upon exposure to light. The loss of a color with fugitive properties would eventually skew the balance among the remaining colors. "It is difficult to get genuine Indian Red, it is all artificial, . . . [made] of purple brown and vermillion or lake; the latter particularly flies and leaves nothing but the brown which is dreadful."[4]

By the sixteenth century it had been recognized that white lead darkens when used as a watercolor, and miniaturists were warned to avoid this unstable color. As the eighteenth-century miniaturist's palette became increasingly transparent, some artists abandoned the use of whites, even for highlights. They allowed the ivory support to show through the colors and contribute light tones to the painting. Alternative white pigments such as zinc oxide and barium sulfate, which were introduced in the late eighteenth and early nineteenth centuries, could be used when a white color was desired.

To impart the qualities of a paint, a binder was added to the pigment as a vehicle. Gum arabic, a transparent resin from Africa and the Levant, was considered the best binder. It was dissolved in water and combined with a small amount of pigment. The mixture was then placed in a container, ready for use by rewetting with a brush. To prevent the paint

from cracking and chipping as it dried, sugar or sugar candy was sometimes added to the gum water. Only enough gum water was used to hold the pigment; a pigment mixed with just a little binder dried with a mellow finish, permitting the artist to correct and finish his work. Too much binder imparted a hard, glossy appearance to the paint surface, making the artist's subsequent corrections conspicuous and increasing the likelihood that the color would peel.

Miniaturists painted with small brushes called pencils. The miniaturist's pencil did not, as was popularly believed, consist of a single hair; it was a small, full-bodied brush with a sharp point, made of sable or camel's hair. Sable was preferred: "Though more expensive . . . [sable brushes] are more springy, and the hairs do not separate as in the common camel's-hair brushes."[5]

Working Techniques

Several sittings were normally required to complete a miniature. Initially the right pose had to be found: "I button, unbutton, pull up, pull down, put one arm back, the other forward, and vice versa, till I am satisfied . . . this sometimes takes one hour. I make the sitter sometimes sit, sometimes stand, to try the effect."[6]

The actual painting method described in the correspondence between the Robertson brothers was probably followed with little variation by other artists as well. At the first sitting, using a single neutral color, the artist outlined the picture and painted in the facial shadows and the dark shadows in the background. "In short I make a kind of picture with it, before I take another color."[7] This preliminary definition of the shadows was referred to as "dead-coloring." The dead-coloring was completed in the presence of the sitter, who by the end of the first session was likely to be very tired. The aspiring artist was cautioned that "no person ought to be detained more than an hour at one sitting. When the sitter becomes fatigued, the muscles relax, and the features become dull and languid."[8]

Before the second session the miniaturist might apply "body color," or opaque paint, to the background, clothing, and draperies. In these areas it was undesirable or unnecessary to expose the luminosity of the ivory. These portions of the miniature could be completed before the colors were added to the face. "Having the picture flat, I . . . float on the dark and light cloud, and sky, and all in the course of a minute or two, . . . you must not take longer, else the color dries on you, and in the same manner, you can manage very rich drapery, with various tints."[9]

The miniaturist applied color to the area of the face while the subject was sitting before him. Thereafter he worked further, without the subject, to remove any perceived "rough and uncouth hardness" and to bring the miniature to the desired state of completion.[10]

A number of brushwork techniques were employed by the miniaturist. Small dots of pigment were placed on the ivory with the point of a brush, a process known as stippling; or paint was applied by hatching, the use of long, parallel brushstrokes. A continuous wet color, or wash, was put on with a pigment-loaded brush. These techniques were used alone or in combination. "Sometimes [I paint] with the brush almost dry, at other times moist, so as to leave a blot at the end of the touch, and at other times a fair, floated on blot, just as I see necessary, for I use all the modes, as I see occasion."[11]

The judicious removal of paint was another technique useful to the miniaturist. "Heighten the lights by making very fine touches on the centre of them with the point of a needle; this is called by some persons a trick, and not painting; but you have a right to use every means in your power to produce effect."[12] Some other "tricks" made use of the ivory's almost transparent quality. Colors painted on the reverse surface of the ivory could bring a faint glow of color to the cheeks or create richer shadows in the hair. Sometimes a small square of foil was placed behind the face in the portrait, to reflect light back through the ivory and infuse the skin with a subtle brightness.

A sharp, hard accent could be applied on the painted surface with gum water, provided that the miniature had been painted with a minimum of gum in the pigment. This technique was particularly useful for delineating the folds and details of a garment which had previously been laid down as a flat, opaque area of body color. In time this technique lost its value, however, since the practice arose of using gum liberally throughout the miniature, making it impossible to define details in gum. The emphasis in miniature painting gradually shifted toward achieving a finer finish and greater transparency, and to that end the entire painting was finished with gum, giving it a soft sheen which approached the effect of varnish on an oil painting.

A miniature that had been completed to the satisfaction of the artist was still not ready for exhibition. "Let the sitter receive your thanks and her release, but do not shew the picture until it is in the frame or the case, as glass acts like varnish on the painting, and greatly improves its appearance."[13]

Housing and Presentation

One of the most attractive features of the miniature can be its mounting. Over the years, three types of mountings predominated: lockets and other metal casings enabling the miniature to be used for personal adornment; frames of papier-mâché or wood designed for hanging on the wall; and hinged leather cases which could be carried in a pocket or placed on a table.

Eighteenth-century metal lockets were made of 15- or 18-karat gold, or from lesser metals resembling gold. One of these was pinchbeck, an inexpensive light-golden-colored alloy of copper and zinc developed by Christopher Pinchbeck (1670–1732) of London. Other copper alloys used for cases were plated with gold.

The locket was designed primarily to be worn or carried on the person of the owner. It was customarily fitted with a loop or ring so that it could be suspended by a

Opposite page
Metal cases: (a) gold engine-turned case with hinged lid, cat. no. 111; (b) reverse of gilded copper case containing ivory medallion on which initials are drawn in chopped hair and hair pigment, cat. no. 230; (c) reverse of gilded copper case showing sheaf-of-wheat hair design with seed pearls on ground of white opalescent glass over foil, cat. no. 76; (d) reverse of gold case with triple bezel framing blue Bristol glass, braided hair, and blue glass medallion with gold monogram, cat. no. 123; (e) reverse of gilded copper case with compartment containing plaited hair and gold monogram, cat. no. 171

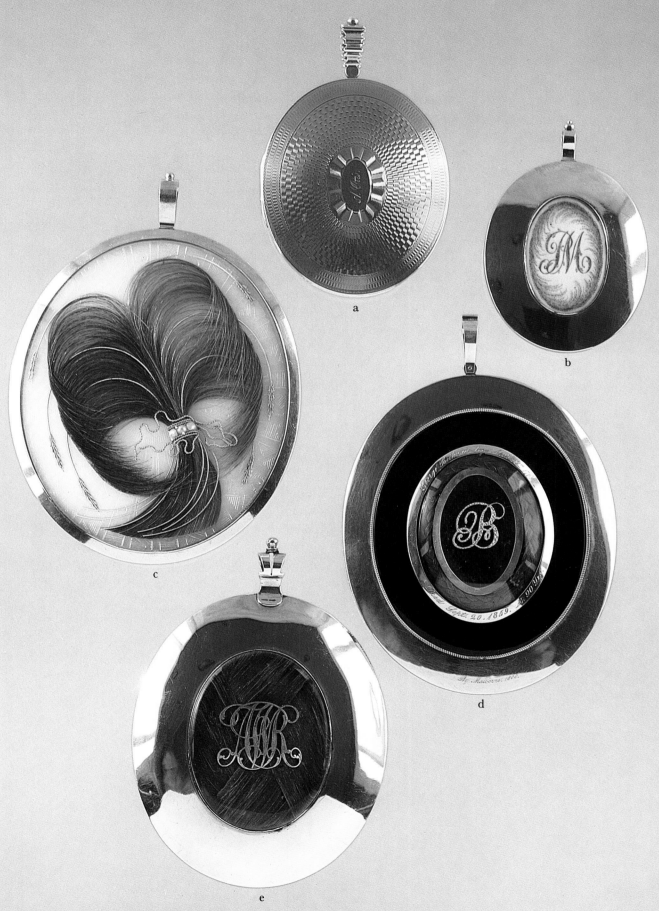

fine chain or ribbon. Many of the small miniatures painted in the late eighteenth century were set in a locket with a concave bottom and a clasp on the side, known as a slide frame, which could be stitched to a ribbon or band to be worn as a bracelet. Martha Washington ordered such bracelet mounts from the miniaturist Charles Willson Peale on December 26, 1780: "Sir, I send my miniature pictures to you. . . . I would have them for Braceletts to were round the wrists."[14]

Miniatures were also set in brooches. It was not unusual for a locket to be fitted with both a hanger and a brooch pin, so it could be worn either way. Locket and brooch cases could be plain or elaborately ornamented. Many late-eighteenth-century cases were decorated with delicate flat chasing known as brightwork. Others were encircled with paste, garnets, or pearls, and some were set with precious stones.

The back of a case was often an assemblage of various elements. Some lockets were backed with colored glass placed over a patterned silver foil, giving the appearance of enamel. Often there was a small, glass-covered opening in the back of the case for displaying a lock of the sitter's hair, which was frequently braided or woven. Sometimes the hair was decorated with an engraved metal monogram or an initial in seed pearls. Small monochromatic "hair paintings" which incorporate finely chopped hair are also found in the backs of lockets. Usually allegorical in nature or associated with the memory of a lost loved one, these pictures seem to have developed from a related tradition of mourning jewelry; gradually the mourning picture became an auxiliary to the portrait miniature.

As lockets and brooches continued to be made through the nineteenth century, their decoration evolved. The flat surfaces of the early cases, which had been chased by means of simple punches and gravers, were replaced by heavily ornamented cast bezels and hangers. The backs of the cases were decorated by the process of engine turning, or machine engraving, in which a geometric pattern of wavy or straight lines is cut on the surface of a metal object.

By the late eighteenth century the miniature was being made in a new, larger size in both oval and rectangular formats. This was a major departure from the traditional practice of fashioning the portrait miniature as a piece of jewelry. In a letter of 1803, Andrew Robertson noted that in London "in the exhibition this year, oval miniatures have disappeared, as they are not so much worn. Most of them are square."[15]

The miniatures on exhibition were probably displayed in frames of black lacquered papier-mâché, with the ivory set in a central metal bezel. A decorative brass ring centered at the top of such a frame served for hanging. The hanger became known as an "acorn ring" because the acorn-and-leaf pattern was the most popular hanger motif. The term can be confusing, however, since hanger designs in fact ranged from floral patterns to cornucopias to anchors.

Papier-mâché frames remained available well into the nineteenth century. At the same time a variety of wooden frames were also in use, with two major types predominating. The first, similar in style to the papier-mâché frame, had a veneered surface and gilt attachments. The second type was made of much thicker wood, which was finished in its natural color or stained black. The additional depth permitted a turned oval depression in the center in which the miniature, in its bezel, was mounted. Small frames of gessoed and gilded wood

were also employed for miniatures. During the 1780s oval frames with a hammered (or "pressed") brass front began to appear; they were still being used well after the turn of the nineteenth century.

The earliest leather cases used for miniatures were probably small folding pocket cases made of red leather, or less often, of a rough green leather called shagreen. In some instances an exterior leather case contained and protected a metal-cased miniature, but typically the oval leather case housed the miniature directly. The miniature was protected by a closely fitted convex glass. All leather cases had hinged covers which were secured with small hooked clasps. The earliest cases were plain; the later ones were decorated with tooling and gilding.

In 1839, after photography created a new use for the leather case, casemaking suddenly became a rapidly expanding industry. Millions of small cases in varying sizes were produced in the period 1840–50 and well into the 1860s. With industrialization in full swing, many new processes were created and applied to the manufacturing of the rectangular miniature cases, which by then were known as daguerreotype cases although they were used to house both ivories and photographs. Many of the later cases were covered with embossed papers carrying richly decorative motifs.

Initially two components, a mat and a glass, were needed to protect and enhance the miniature housed in a rectangular leather case. Mats were made of metal which was gilded or otherwise given the appearance of gold. Early mats were of ormolu (gilded bronze). The later sheet-brass mats, also used for photographs, were variously known as "common," "fire-gilt," "engraved," or "stamped," depending on the style of finishing, which was achieved by acid etching or stamping. As the portrait miniature became increasingly overshadowed by the photograph, it began to imitate the photograph ever more closely in its presentation. A third framing component was borrowed from the mounting of photographs; a flexible metal edging known as the "protector" or "preserver," it was used to bind the glass, the mat, and the miniature into a compact unit. The exact date of its introduction is not known, but it was almost ubiquitous in the framing of photographs by 1850.

One element common to all the methods of miniature presentation was the convex cover glass or crystal which protected the painted surface from damage. All miniature cover glasses were slightly domed so that the glass would not touch the surface of the painting; the only exceptions were the flat glasses that were raised above the painted surface by a metal mat. Glasses were purchased from abroad or made by anyone who had the skills necessary to form and grind a convex glass. Charles Willson Peale appears regularly to have made his own cover glasses, as is indicated by his diary entries; for example, October 19, 1775: "bought one Doz: Watch Glasses to form them into Ovals for miniature pictures"; October 20, 1775: "spent in making Glasses for miniture pictures out of watch Glasses."[16]

Before a miniature was placed in a case or frame, it was necessary to trim the paper backing to which the ivory had been attached. If the miniature was to be set in a metal locket or a frame bezel, the excess paper was usually trimmed all the way to the edge of the ivory. The paper directly attached to the back of the ivory was left on to prevent a dark or uneven surface behind the ivory from showing through. Artists were frequently insistent that this backing be retained, writing their instructions directly on the paper, as, "Cut the card / &

Ivory togeather / Whin set."[17] A larger, rectangular miniature, mounted under a metal mat, often retained its complete backing paper. Usually present on the margins of these papers are strokes of colors tried by the artist during the painting of the miniature.

In the final preparation for framing, the miniature was usually bound directly to its cover glass with a thin strip of goldbeater's skin, a natural product made from animal intestine. The goldbeater's skin sealed the package, excluding dust and dirt, and also helped insure that the ivory would remain flat and in place under the cover glass.

The Conservation of Miniatures

Miniatures are subject to a variety of physical problems, some brought on by the passage of years, others by damage or improper care. The treatment of ailing miniatures is not new. In 1797 Joseph Barrell of Boston wrote to a jeweler in London, "The family peice, which you executed some years since . . . [has] some parts cleaving from the ivory; for this reason I have sent it that you may rectify it."[18]

Many of the problems encountered with miniatures can be ameliorated by professional conservators. Just as artists developed techniques that were specific to the painting of a portrait miniature, conservation specialists have developed particular techniques for treating the variety of ills, briefly described below, that beset miniatures.

If exposed to too much light, miniatures painted in watercolor soon fade, and some fugitive colors may be lost altogether. As it fades, a miniature usually loses the reddish and yellowish tones that gave it warmth and depth, and as a result it may look bleached or thin. The extent of light damage varies with the type of light to which the miniature has been exposed and the conditions of exposure. This type of damage is cumulative and cannot be reversed.

Flaking paints result from "inherent vice"—that is, improper manufacture of the miniature—or from poor environmental control. If the vehicles binding the pigments were faulty, or if the ivory support was not initially prepared with sufficient care to insure good adhesion, the paint will flake. Flaking paint can be reattached, or consolidated, by means of synthetic resins. When paint is completely lost from the surface of a miniature, new colors can often be filled in, or "inpainted," by a conservator; losses on faces, however, are generally considered irreparable and are not reconstructed.

Ivory is a hygroscopic material; its dimensions change in the presence of moisture, and it must therefore be protected from abrupt changes in humidity. If not protected, the ivory may respond with movement that results in warping, cockling (uneven distortion), or splitting. Physical changes in the ivory can be exacerbated by the presence of the mounting card. Paper, like ivory, is sensitive to changes in humidity, but the two materials do not expand and contract at the same rate, and damage to the miniature may result. Cracks, splits, and warping of the ivory can be corrected to some extent by the conservator, who normally begins the treatment of these problems by removing any backings that are present. Warping can sometimes be reduced by further treatment; the miniature is then remounted on a card. Split and cracked miniatures are almost always remounted in the course of being repaired.

When the miniature is kept in conditions of high humidity, the gum binders used as a pigment vehicle are vulnerable to the growth of mold. The threadlike hyphae of mold obscure the design of the miniature and cause damage by disrupting the paint layer. Mold

may also create strongly colored stains on the painted surface. The ornaments of hair which are frequently displayed in locket cases will support the growth of mold and may be contaminated by its presence. A conservator can remove mold, sometimes by working under a microscope. However, the stains caused by mold are often permanent.

Substances that were initially used to bleach and degrease the ivory support are sometimes still present in the ivory. Under certain conditions these materials can effloresce or crystallize out of the ivory, becoming visible on the painted surface of the miniature or on the inner surface of the cover glass. Examined under magnification, these spots may appear as angular crystals or as tiny, fluffy white areas which sometimes closely resemble light-colored mold. The crystals are usually disfiguring but can often be removed by a conservator.

The lenses of locket miniatures are easily scratched and abraded if the cases are not handled and stored carefully. Heavy abrasion diminishes the clarity of the glass, rendering details of the miniature less visible. Deep scratches on the cover glass may cast shadows on the surface of the painting that are disfiguring or distracting, especially when the shadow falls across the subject's face.

The cover glass of the miniature may be susceptible to various forms of deterioration, usually due to inherent imbalances in the original glass mixture as a result of manufacture at a time of experimentation in the glassmaking industry. A deteriorated glass may have a cloudy or opaque haze which can be mistaken for mold growth or salt efflorescence. This condition, known as "crizzling," is the result of a fine network of cracks and fissures that develop in the glass. Tiny flakes of glass, like minute fish scales, may also be present on the surface of the glass, making it feel dry and rough to the touch. A different form of deterioration, known as "weeping glass," produces tiny droplets of moisture on the surface of the glass. If the droplets become large enough to fall to the painted surface of the miniature, they may cause spotting and staining. Glass in this condition feels greasy or slippery to the touch.

Cover glasses that exhibit signs of deterioration or that are deeply scratched or chipped generally need to be replaced. Glasses with less severe abrasion or shallow scratches can often be repolished, then returned to the miniature. A flat glass that sits directly on the surface of a miniature should be raised with spacers or mats or should be replaced with a convex glass.

Metal miniature cases and metal frame attachments eventually darken as the surface corrodes and discolors. Misguided attempts to clean or brighten the metal with improper materials can seriously damage its surface. The abrasive action of harsh polishes cuts through the gilding, exposing the base metal. (A case which has lost its original gilded surface is often pinkish rather than rich yellow in color; remnants of its original color can usually be seen on protected interior surfaces.) When deposits of metal polish remain on miniature cases and frames, they obscure the finer decorative details of the case. A nonabrasive solution should be used for cleaning; thereafter, a conservator may coat the surface of the case with a corrosion-resistant polish, or in some instances, a lacquer.

A miniature should always be removed before its metal case or the metal furniture of its frame is cleaned; cleaning solutions pose a serious threat to the painted surface of the miniature. A cleaning solution can easily penetrate a closed case and will rapidly dissolve the water-soluble paints, destroying the miniature.

It is generally recommended that only a specialist remove a miniature from its frame, since without the frame the miniature is extremely vulnerable. An unprotected miniature must be touched with the hands as little as possible and never on the painted surface, which is easily marked by fingerprints. It should be held by the fingertips on the outside edge in line with the grain of the ivory, which is normally from the top of the miniature to the bottom. Pressure exerted across the grain may cause bending, paint loss, or even cracking. A miniature should not be held flat in the palm of the hand, where it may begin to curl in response to the warmth and moisture of the hand. One should never speak over an unprotected miniature: tiny droplets of moisture expelled with the breath may spot the painted surface. If this occurs, however, do not touch the surface, because brushing the moisture away can smear the paint and result in additional damage.

Many treatments exist for restoring a case or frame in bad repair. This is often a more desirable course of action than replacing an antique case, which may then be lost or destroyed over the course of time. However, sometimes a miniature is acquired without any housing. Whenever it is necessary to reframe a miniature, the new housing should be carefully chosen. Reproduction frames and cases are available, as are contemporary frames.

Reframing must be carefully done. Under no circumstances should pressure-sensitive tape, such as Scotch or masking tape, be used to secure a miniature in its frame, nor should a miniature be glued to a backing board. These procedures are almost guaranteed to result in either the staining of the ivory or its distortion through warping and cockling. A miniature should never be cut down to fit into a frame or forced into a frame too small to permit some movement of the ivory. Stable materials such as acid-free ragboard should be used in framing. Any original material recovered from a previous frame or case should be saved and recorded, if pertinent to the history of the miniature. Inscriptions, labels, and other information can often be attached to the new housing.

It is best to entrust the treatment of any problems to a specialist who has had experience working with portrait miniatures. A knowledgeable conservator seeks not only to correct existing problems but also, whenever possible, to protect the miniature from further deterioration. Work carried out by a professional conservator is fully documented with photographs, written treatment reports, and often, recommendations for display, storage, and handling.

Care of Miniatures

When miniatures are displayed at home, achieving ideal conditions is seldom possible. Miniatures in frames should be placed on interior walls and never over fireplaces, radiators, or heating ducts. Miniatures must be protected from high levels of light and from exposure to direct sunlight. Ideally they should be displayed in cases protected by opaque covers which can be lifted. Miniatures not on display should be stored in total darkness whenever possible. Otherwise, low levels of illumination should be maintained and an attempt made to limit the duration of exposure.

The custodian of a portrait miniature should be able to recognize signs in the miniature of a potentially damaging condition and should consult a professional if the need arises.

NOTES

The notes refer in shortened form to works listed in the bibliography below.

1. Among the most thorough treatments of the history of portrait miniatures are Robin Bolton-Smith, "Fraser's Place in the Evolution of Miniature Portraits," in Severens and Wyrick; John Murdoch et al., *The English Miniature* (New Haven and London: Yale University Press, 1981); and Graham Reynolds, *English Portrait Miniatures*, rev. ed. (Cambridge: Cambridge University Press, 1988).

2. Robertson, p. 22.

3. Severens and Wyrick, p. 146.

4. From Andrew Robertson, "A Treatise on Art," in Robertson, p. 163.

5. Whittock, pp. 5–6.

6. Andrew Robertson, in Robertson, p. 160.

7. Archibald Robertson, in Robertson, p. 22.

8. Whittock, p. 41.

9. Archibald Robertson, in Robertson, p. 30.

10. Ibid., p. 24.

11. Ibid., p. 23.

12. Whittock, p. 56.

13. Ibid., p. 57.

14. Miller, pp. 357–58.

15. In Robertson, p. 99.

16. Miller, p. 150.

17. Dunbar, p. 105.

18. Martha Fales, "Federal Bostonians and Their London Jeweler, Stephen Twycross," *Antiques*, March 1987, p. 646.

SELECTED BIBLIOGRAPHY

Day, Charles William. *The Art of Miniature Painting.* London: Winsor and Newton [1878].

Dunbar, Philip H. "Portrait Miniatures on Ivory, 1750–1850, From the Collection of the Connecticut Historical Society." *Connecticut Historical Society Bulletin* 29 (October 1964), pp. 97–121.

Foskett, Daphne. *Miniatures, Dictionary and Guide.* Woodbridge, Suffolk (England): Antique Collectors' Club, 1987.

Harley, Rosamund. "Artists' Brushes—Historical Evidence from the Sixteenth to the Nineteenth Century." In *Conservation and Restoration of Pictorial Art*, edited by Norman Bromelle and Perry Smith, pp. 61–66. London: Butterworths, 1976.

———. *Artists' Pigments c. 1600–1835.* 2nd ed. London: Butterworth Scientific, 1988.

McKechnie, Sue. *British Silhouette Artists and Their Work, 1760–1860.* London: Sotheby Parke-Bernet, 1978.

Miller, Lillian B., ed. *The Selected Papers of Charles Willson Peale and His Family*, vol 1. New Haven and London: Yale University Press, 1983.

Murrell, V. J. "Notes on the Techniques of Portrait Miniatures." In *English and Continental Portrait Miniatures: The Latter-Schlesinger Collection*, edited by Pamela Pierrepont Bardo. New Orleans: New Orleans Museum of Art, 1978.

Rinhart, Floyd and Marion. *American Miniature Case Art.* South Brunswick, N.J., and New York: A. S. Barnes and Company; London: Thomas Yoseloff, 1969.

Robertson, Emily, ed. *Letters and Papers of Andrew Robertson, A. M.* London: Eyre and Spottiswoode, 1895.

Severens, Martha R., and Wyrick, Charles L., Jr., eds. *Charles Fraser of Charleston.* Charleston, S.C.: Carolina Art Association, 1983.

Whittock, N. *The Miniature Painter's Manual.* London: Sherwood, Gilbert, and Piper, 1844.

Colorplates

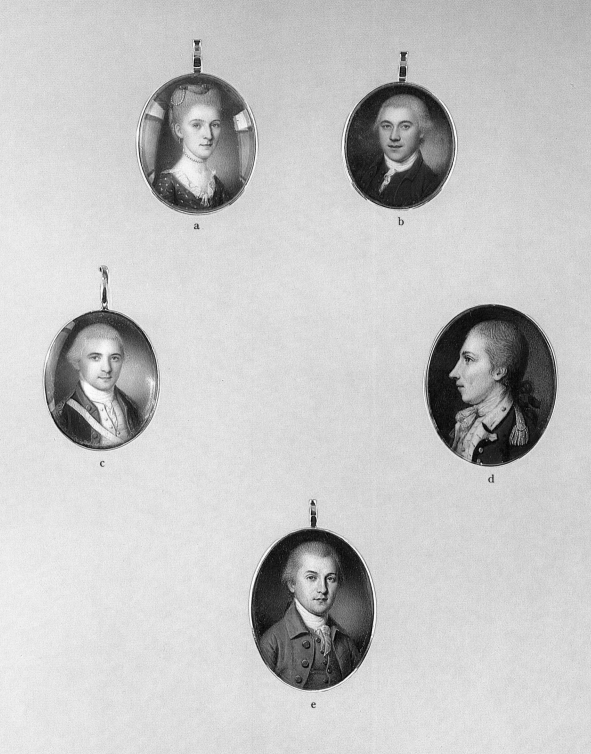

PLATE 1. Charles Willson Peale: (a) *Mrs. Joseph Donaldson*, cat. no. 148; (b) *Joseph Donaldson*, cat. no. 149; (c) *Ennion Williams*, cat. no. 150; (d) *General Richard Montgomery*, cat. no. 153. (e) James Peale, *Gentleman thought to be John Sager*, cat. no. 156

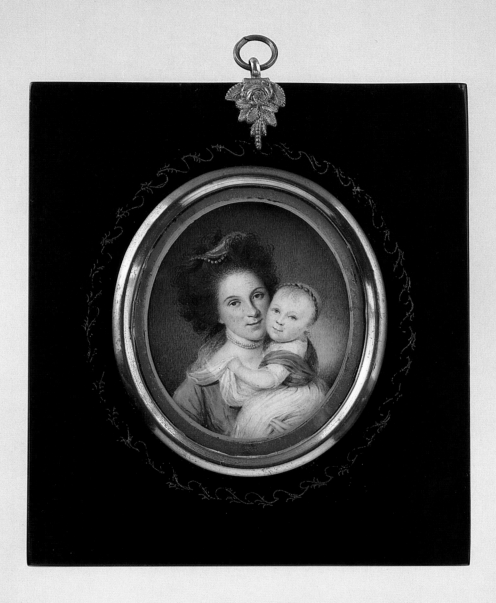

PLATE 2. Charles Willson Peale, *Rachel Brewer Peale and Baby Eleanor*, cat. no. 147

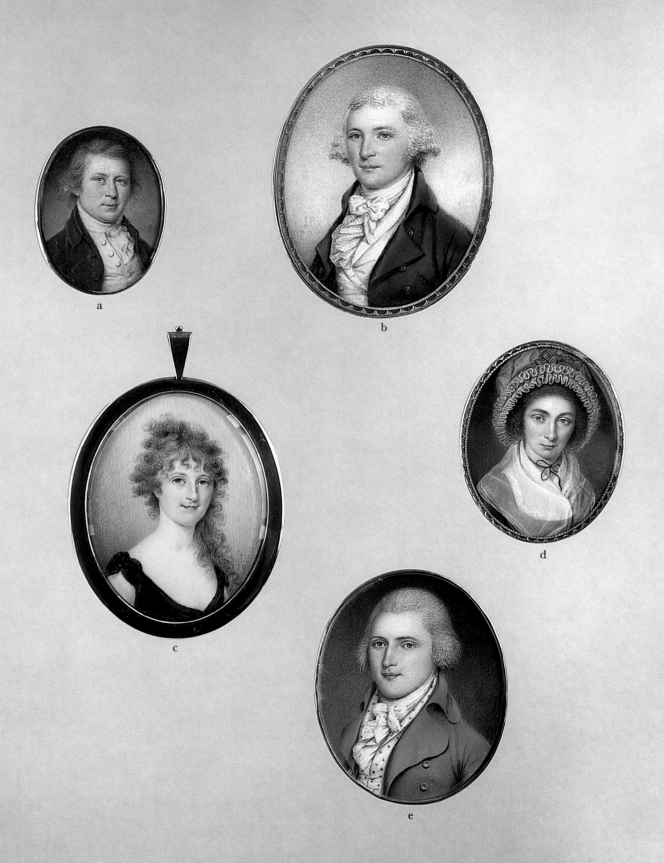

PLATE 3. James Peale: (a) *Self-portrait*, cat. no. 157; (b) *William Jonas Keen*, cat. no. 162; (c) *Lady with the Initials T B*, cat. no. 168; (d) *Mrs. John McAllister*, cat. no. 159 (e) *Gentleman in a Green Coat*, cat. no. 160

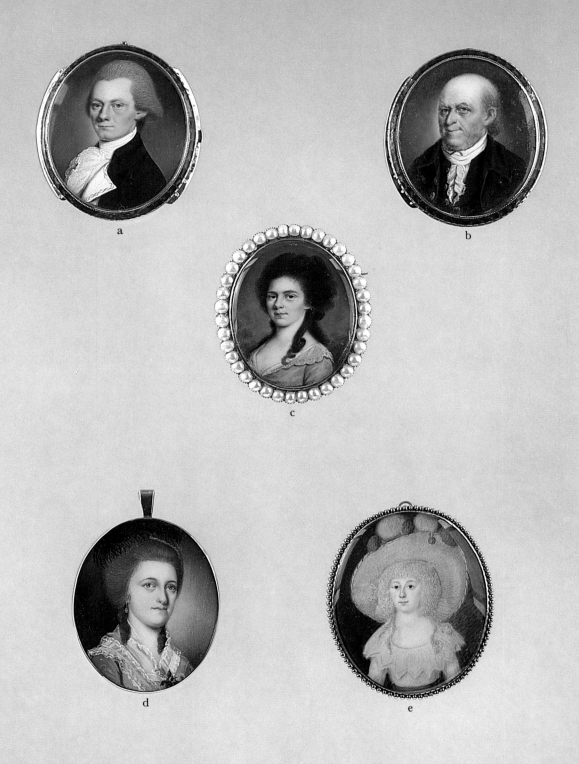

PLATE 4. John Ramage: (a) *William Few*, cat. no. 184; (b) *Thomas Witter*, cat. no. 186; (c) *Catherine Few*, cat. no. 185. (d) Robert Fulton, *Lady*, cat. no. 82. (e) Joseph Dunkerley, *Eliza Champlin*, cat. no. 72

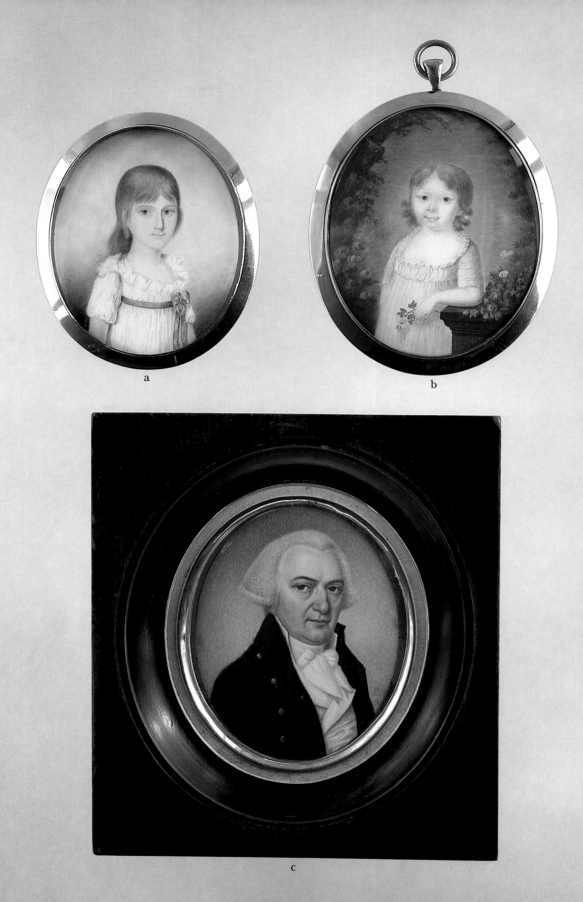

PLATE 5. (a) Lawrence Sully, *Miss Annis*, cat. no. 232. (b) Philippe Abraham Peticolas, *Little Girl*, cat. no. 180. (c) Pierre Henri, *Gouverneur Morris*, cat. no. 102

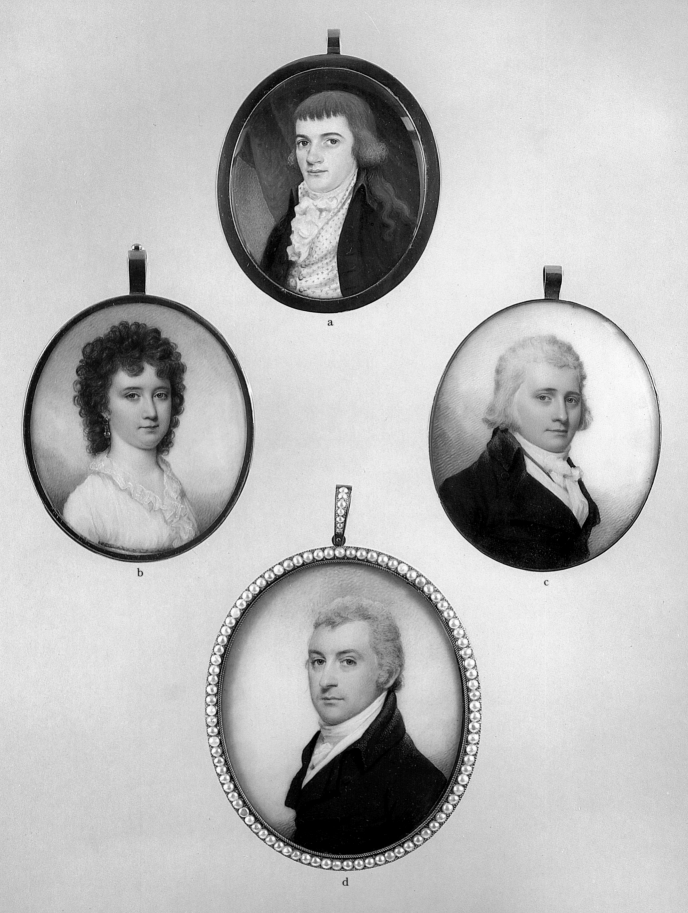

PLATE 6. Edward Greene Malbone: (a) *Nathaniel Pearce*, cat. no. 122; (b) *Anna Maria Hampton*, cat. no. 125; (c) *Samuel Denman*, cat. no. 124; (d) *George Bethune*, cat. no. 123

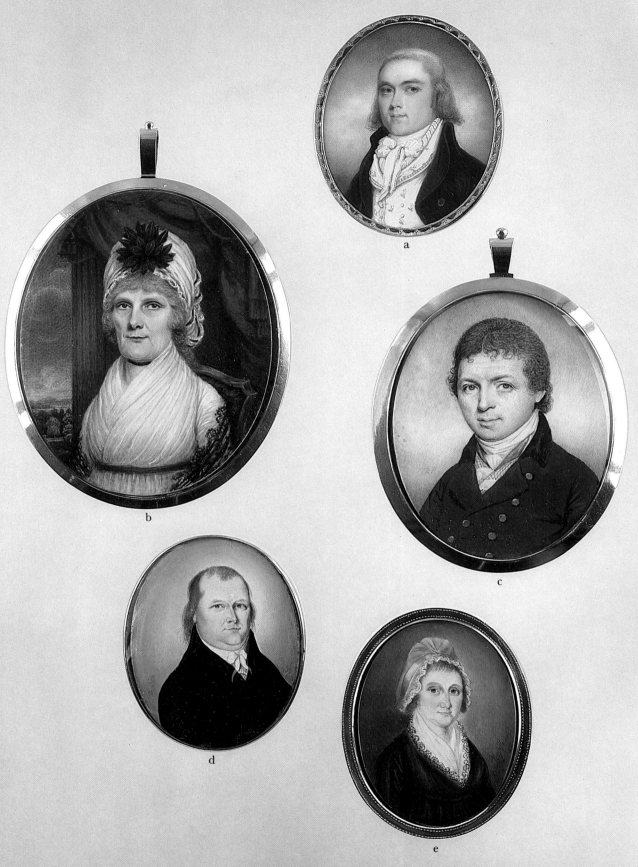

PLATE 7. (a) Archibald Robertson, *William Loughton Smith*, cat. no. 188. (b) Robert Field, *Lady with a Red Drape*, cat. no. 76. (c) Raphaelle Peale, *Gentleman with the Initials J G L*, cat. no. 174. William Verstille: (d) *Elderly Gentleman*, cat. no. 258; (e) *Mrs. Joseph White*, cat. no. 260

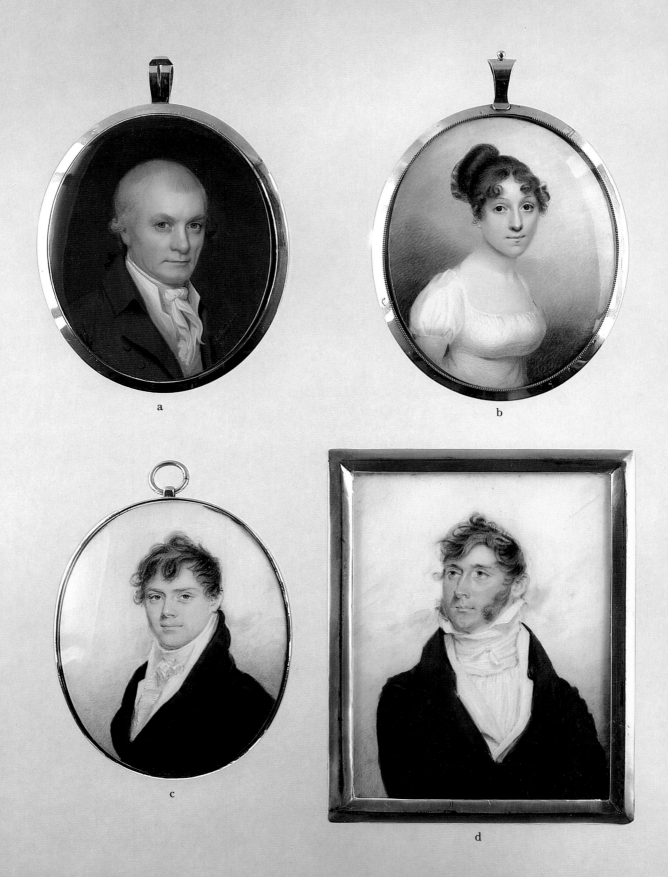

PLATE 8. Joseph Wood: (a) *James Stuart*, cat. no. 275; (b) *M. Muir*, cat. no. 276. Benjamin
Trott: (c) *Alexander Henry Durdin*, cat. no. 243; (d) *Benjamin Chew Wilcocks*, cat. no. 244

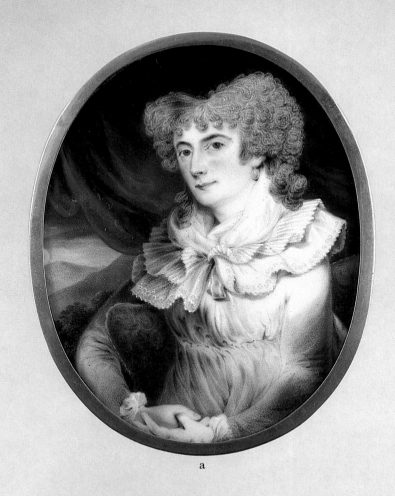

PLATE 9. William Birch: (a) *Lady with a Red Drape*, cat. no. 13; (b) *Principa Falls*, cat. no. 15;
(c) *The Stump*, cat. no. 16

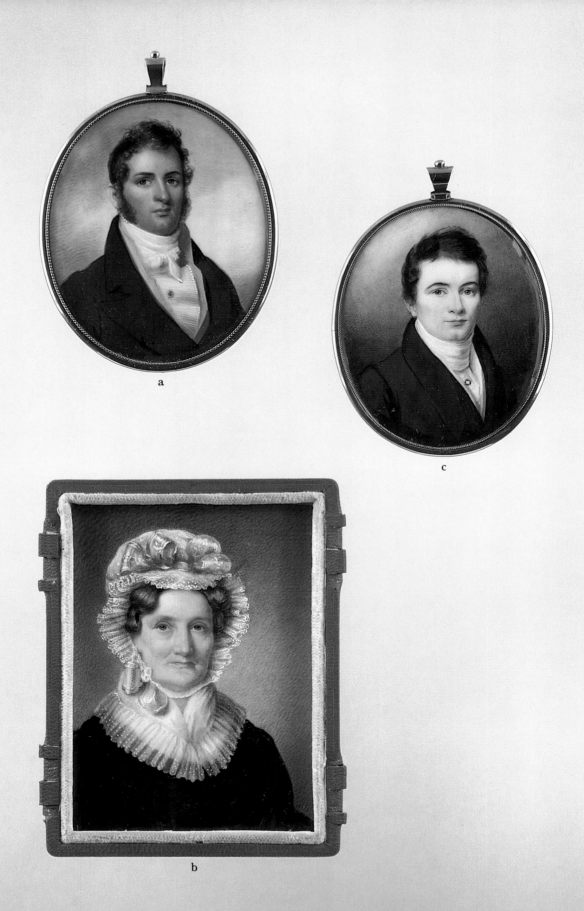

PLATE 10. Anson Dickinson: (a) *Gentleman with a Pleated Stock*, cat. no. 50; (b) *Mrs. George Burroughs*, cat. no. 51. (c) Daniel Dickinson, *Charles Leland*, cat. no. 54

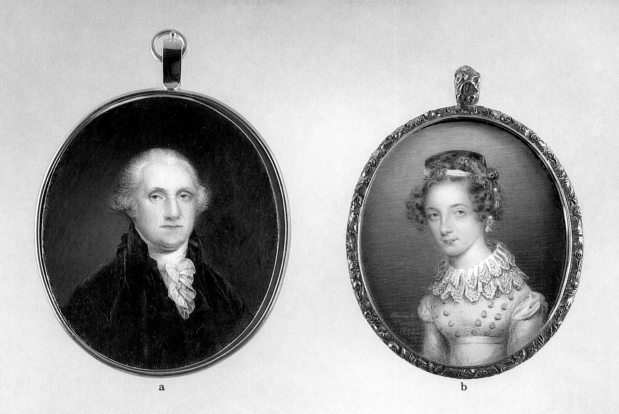

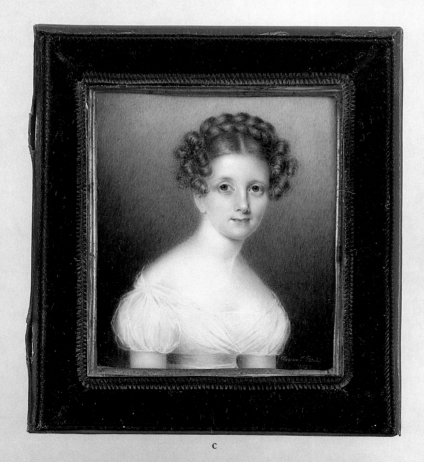

PLATE 11. Anna Claypoole Peale: (a) *George Washington*, cat. no. 146; (b) *Lady with Red Hair*, cat. no. 142; (c) *Mrs. John A. Brown*, cat. no. 143

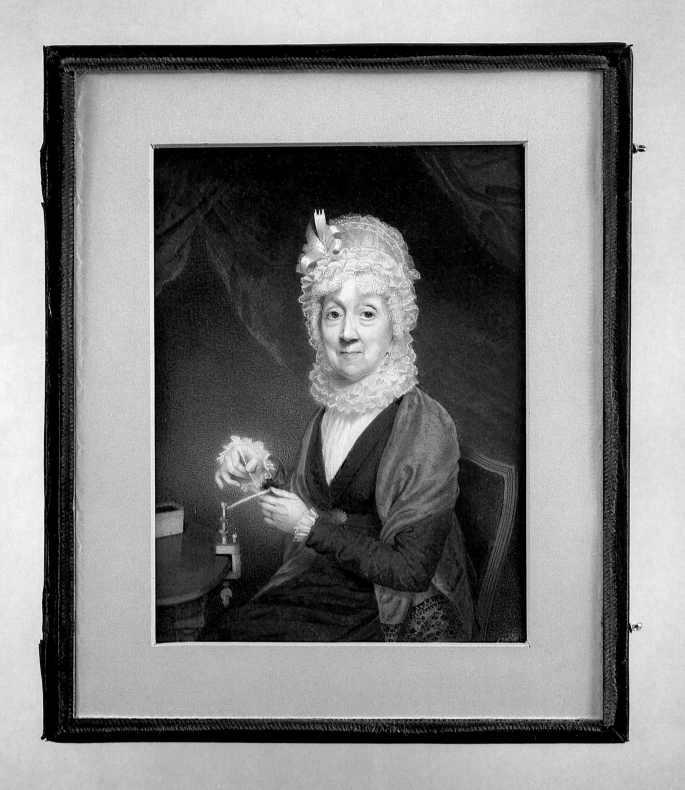

PLATE 12. Attributed to Charles Fraser, *Lady Making Lace*, cat. no. 79

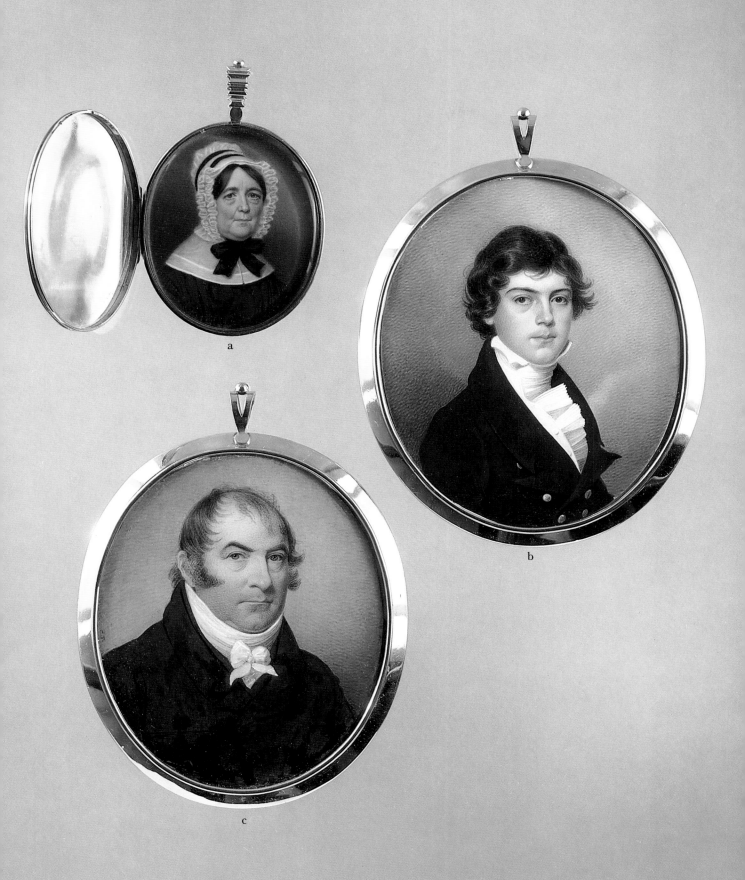

PLATE 13. (a) Henry Inman, *Mrs. A. Otis*, cat. no. 111. Charles Fraser: (b) *O'Brien Smith McPherson*, cat. no. 78; (c) *Colonel James Elliott McPherson*, cat. no. 77

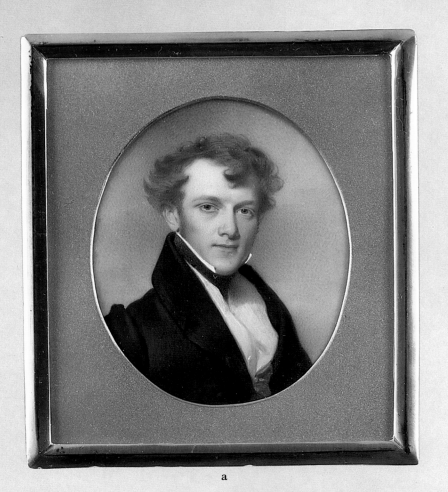

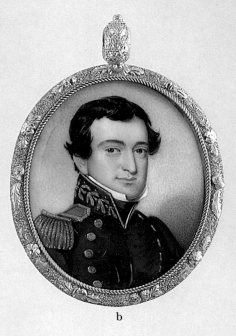

PLATE 14. (a) Henry Inman, *John Inman*, cat. no. 110. (b) George Catlin, *Midshipman Joseph Stallings*, cat. no. 32. Attributed to George Catlin: (c) *United States Military Academy at West Point, Looking North*, cat. no. 35; (d) *United States Military Academy at West Point, Looking South*, cat. no. 34

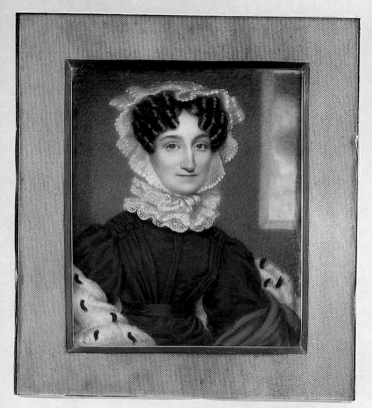

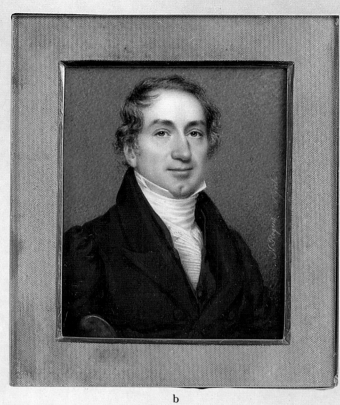

a

b

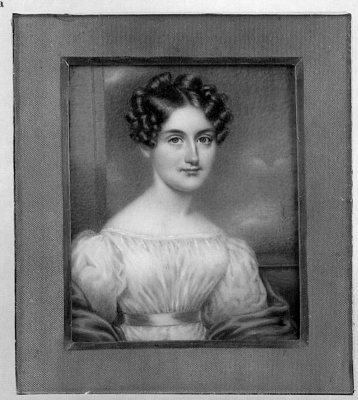

c

PLATE 15. Nathaniel Rogers: (a) *Lady Wearing a Bonnet*, cat. no. 194; (b) *Gentleman*, cat. no. 193; (c) *Young Lady*, cat. no. 195

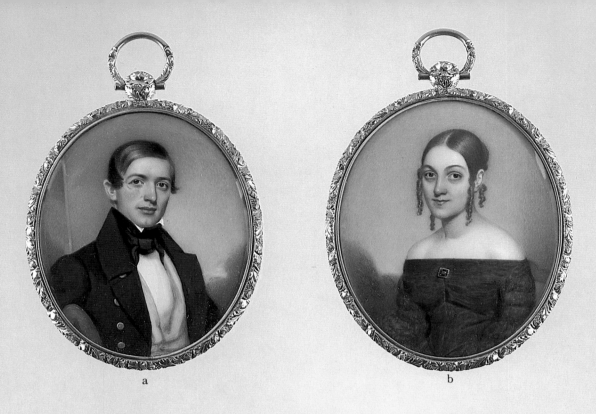

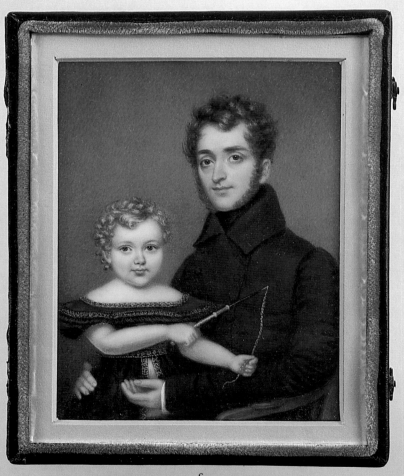

PLATE 16. Thomas Seir Cummings: (a) *Mr. McKinley*, cat. no. 43; (b) *Mrs. McKinley*, cat. no. 44.
(c) Nathaniel Rogers, *Ferdinand Sands and Eldest Son Joseph Sands*, cat. no. 204

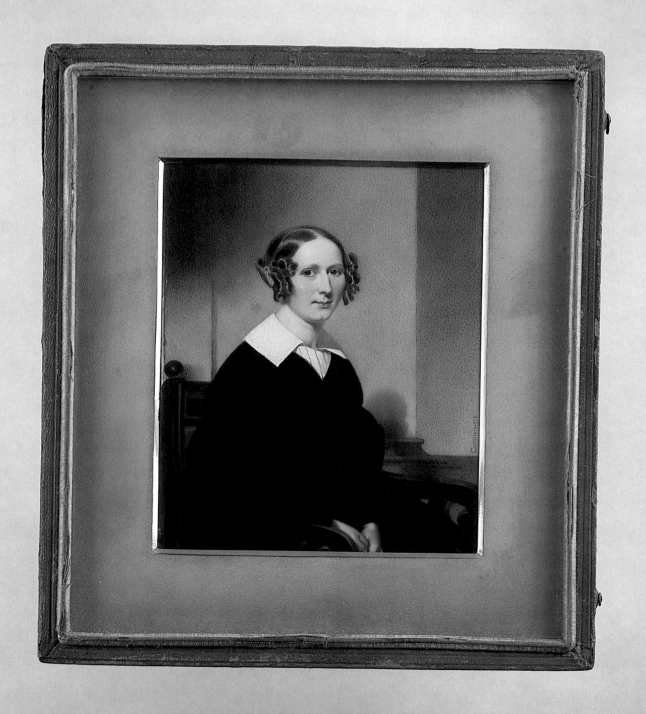

PLATE 17. Thomas Seir Cummings, *Catherine Navarre Macomb Cammann*, cat. no. 42

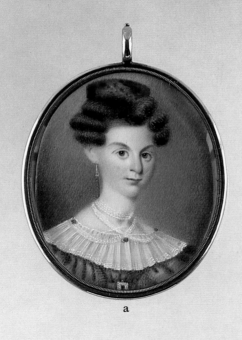

a

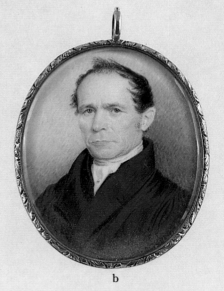

b

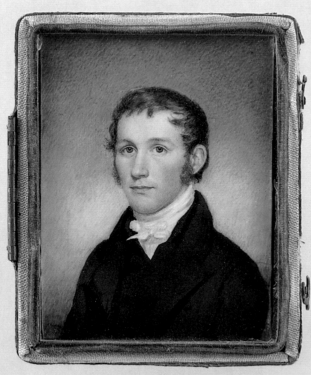

c

PLATE 18. (a) William Lewis, *Louisa W. Dixon*, cat. no. 116. (b) Eliza Goodridge, *Gentleman*, cat. no. 86. (c) Sarah Goodridge, *Gentleman*, cat. no. 88

PLATE 19. Sarah Goodridge, *Beauty Revealed*, cat. no. 89

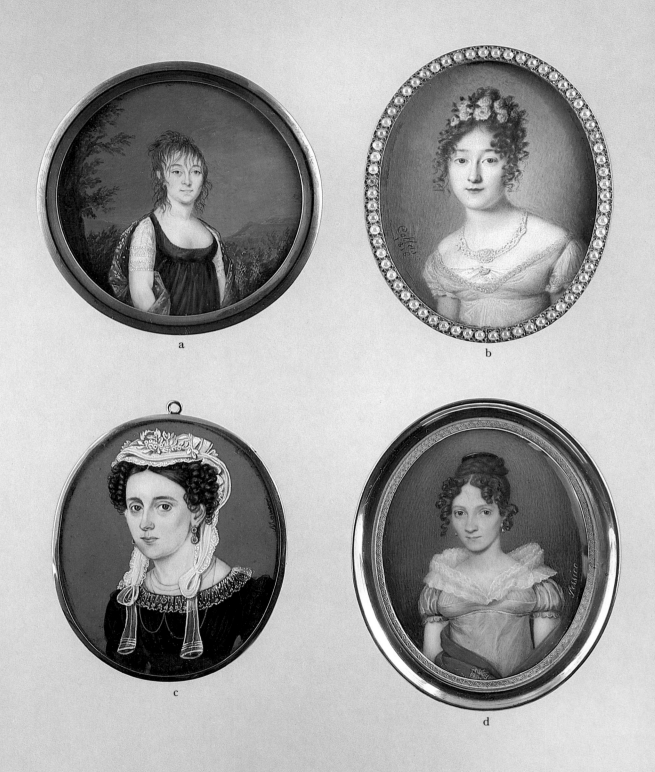

PLATE 20. (a) David Boudon, *Lady*, cat. no. 19. (b) Louis Antoine Collas, *Lady*, cat. no. 40.
(c) Anthony Meucci, *Lady*, cat. no. 133. (d) Gennarino Persico, *Eliza Taylor Hall*, cat. no. 179

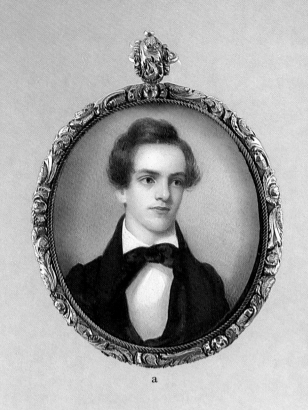

a

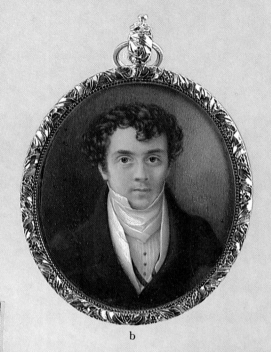

b

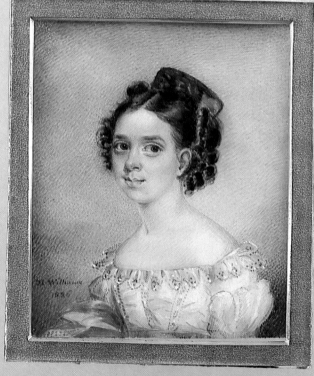

c

PLATE 21. (a) James Passmore Smith, *Gentleman with the Initials E W*, cat. no. 222. (b) George Harvey, *Self-portrait*, cat. no. 98. (c) Henry Williams, *Lady of the Weaks Family*, cat. no. 274

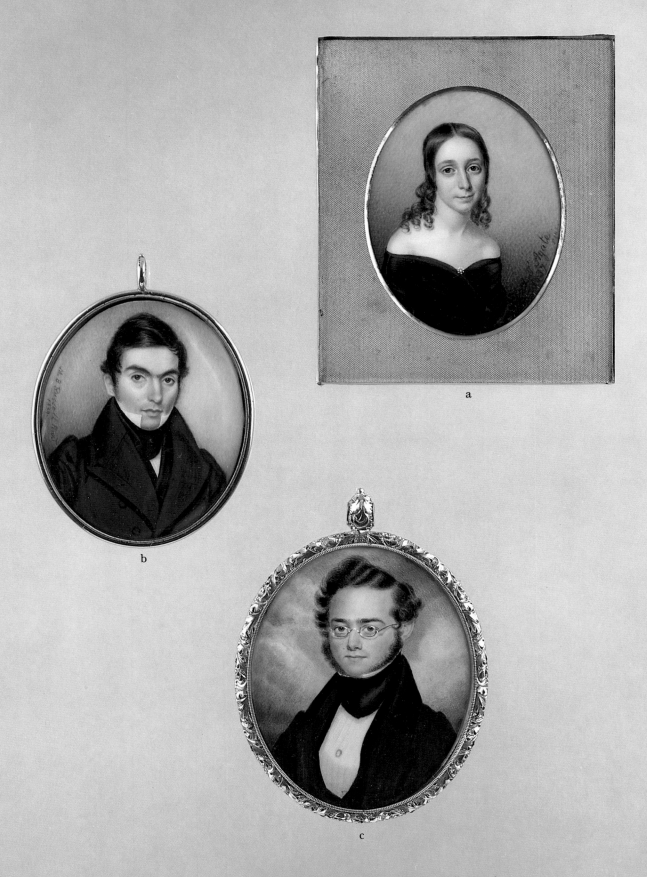

PLATE 22. (a) Alfred Agate, *Miss Bruce*, cat. no. 1. (b) Moses B. Russell, *Gentleman*, cat. no. 205.
(c) William A. Watkins, *L. P. Church*, cat. no. 265

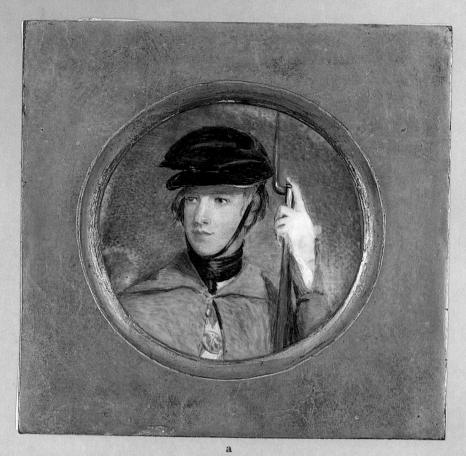

a

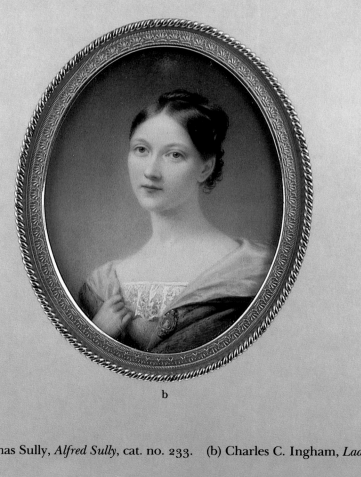

b

PLATE 23. (a) Thomas Sully, *Alfred Sully*, cat. no. 233. (b) Charles C. Ingham, *Lady*, cat. no. 107

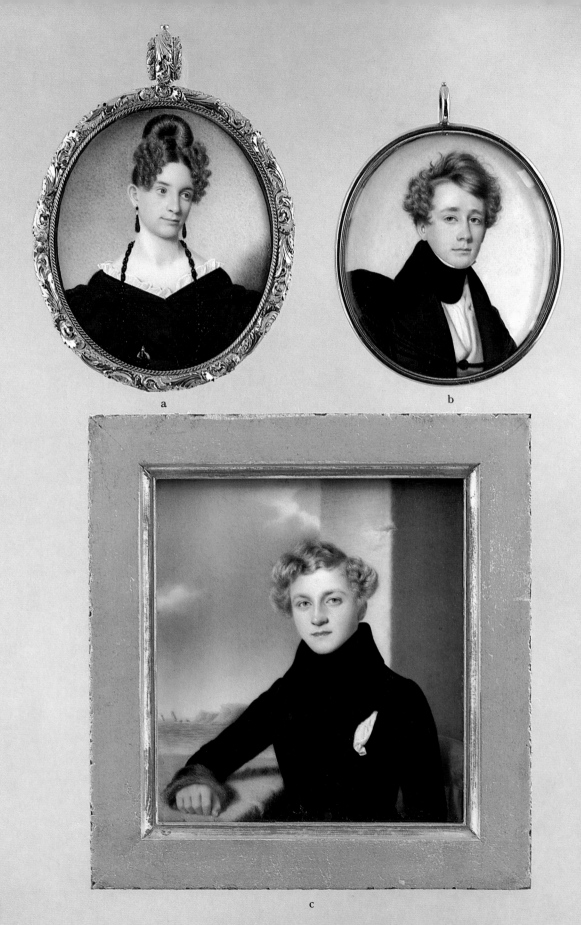

PLATE 24. John Wood Dodge: (a) *Lady of the Wiltsie Family*, cat. no. 66; (b) *Gentleman Wearing a Black Cape*, cat. no. 65; (c) *Edward S. Dodge*, cat. no. 62

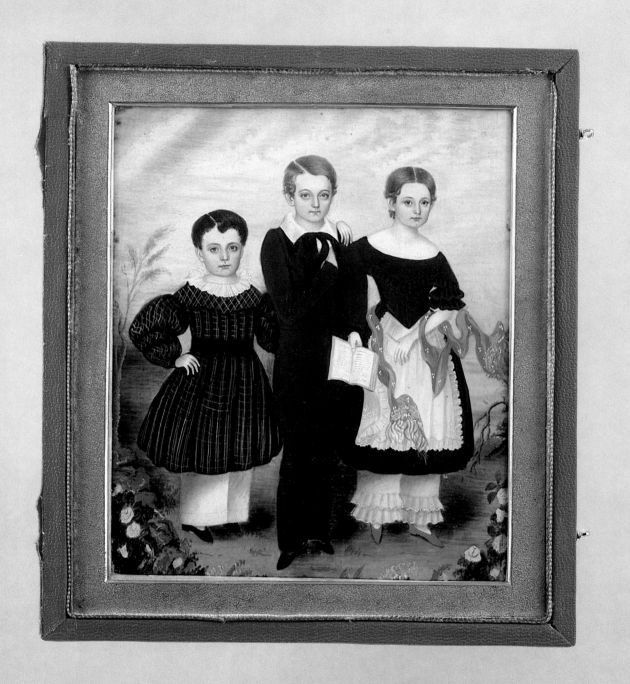

PLATE 25. Mrs. Moses B. Russell, *The Starbird Children*, cat. no. 212

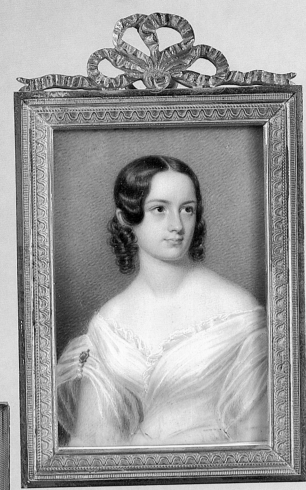

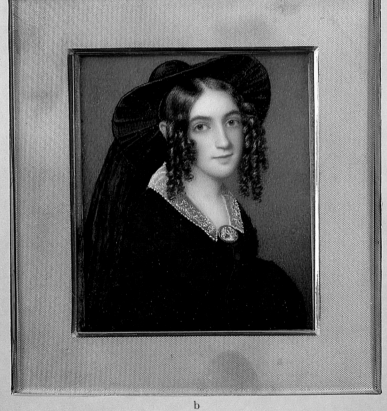

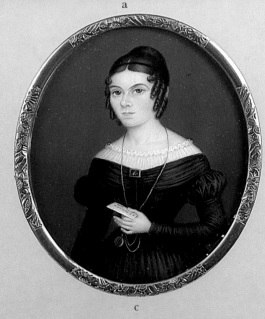

PLATE 26. (a) George Augustus Baker, Jr., *Mary Crosby*, cat. no. 7. (b) James A. Whitehorne, *Mary Kellogg*, cat. no. 271. (c) Attributed to Leopold Paul Unger, *Lady with a Letter*, cat. no. 250

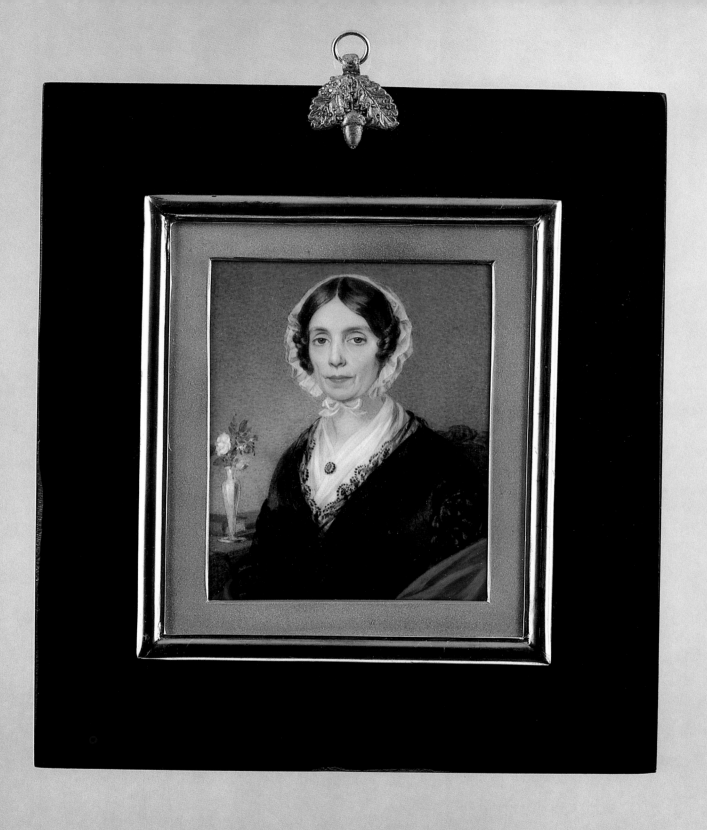

PLATE 27. George Lethbridge Saunders, *Mrs. Israel Thorndike*, cat. no. 216

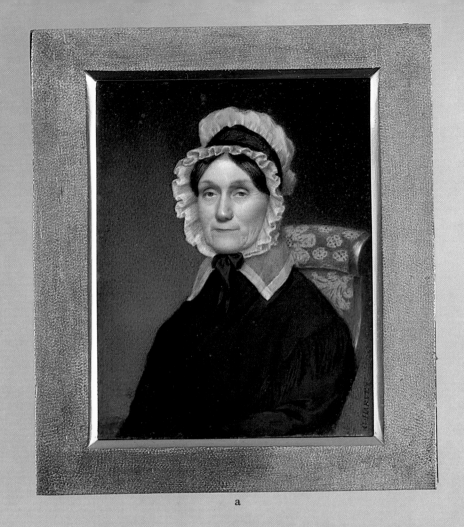

a

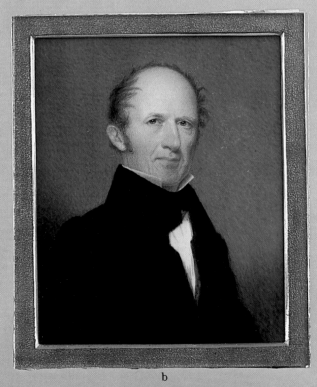

b

PLATE 28. (a) George Harvey, *Sarah May Holland*, cat. no. 97. (b) Alvan Clark, *John Pickering*, cat. no. 38

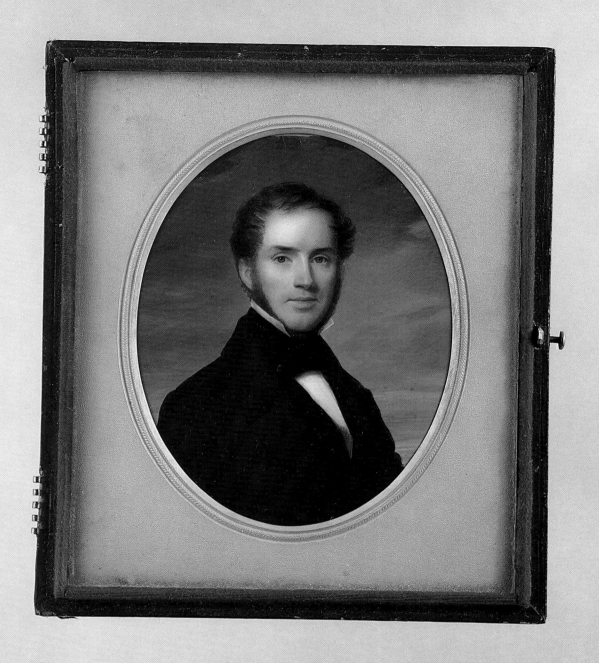

PLATE 29. Henry I. Brown, *Benjamin Daniel Greene*, cat. no. 22

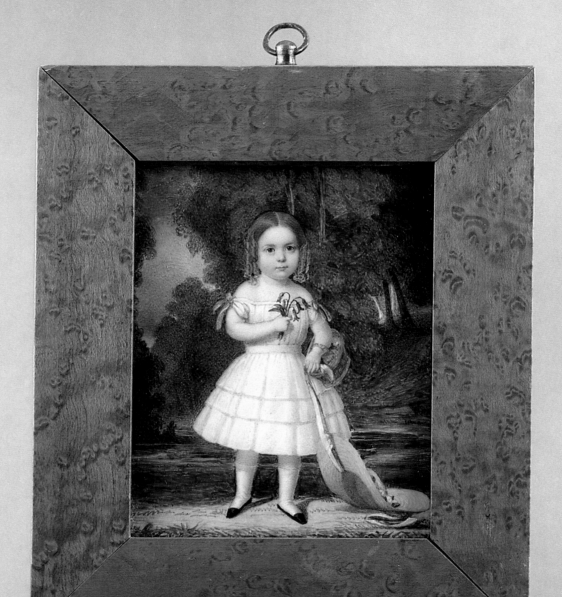

PLATE 30. John Carlin, *Florine Turner*, cat. no. 26

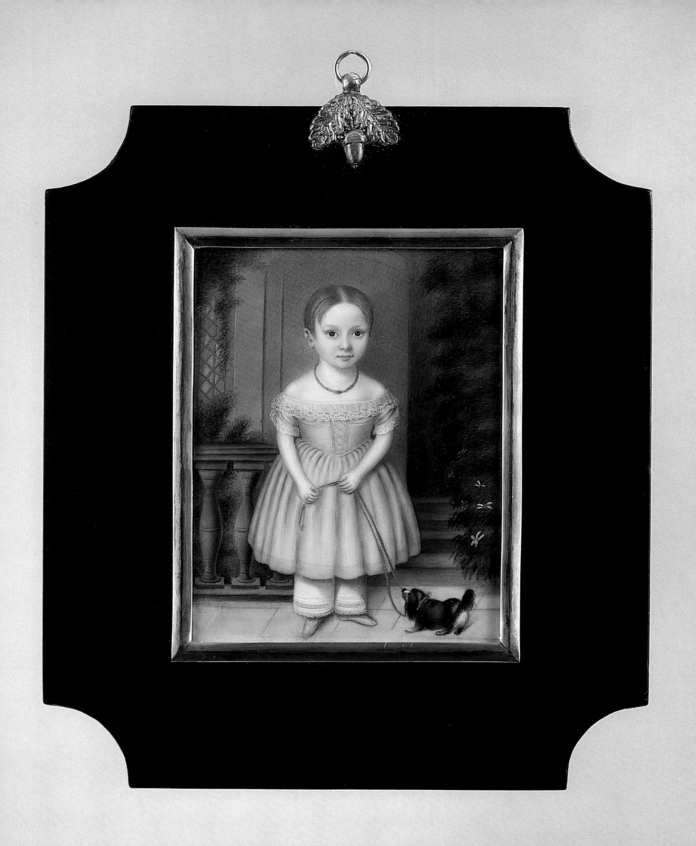

PLATE 31. Aramenta Dianthe Vail, *Rebecca Fanshaw*, cat. no. 251

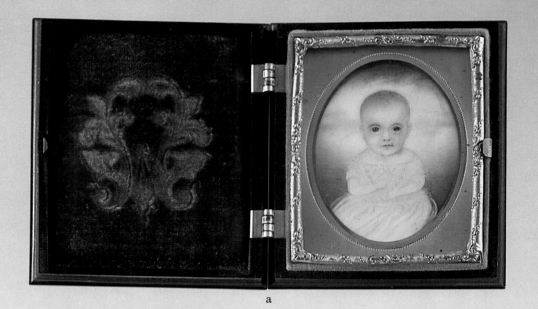

a

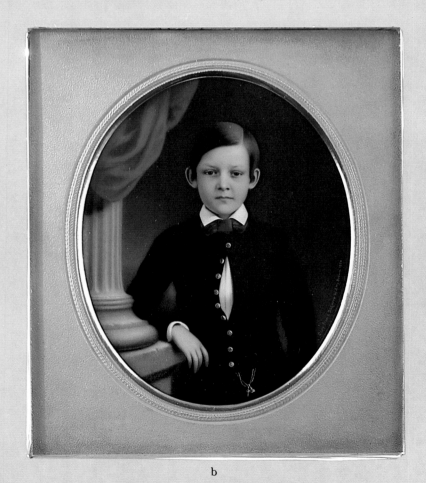

b

PLATE 32. (a) Mrs. Moses B. Russell, *Baby*, cat. no. 213. (b) John Henry Brown, *Boy*, cat. no. 24

The Catalogue

Notes to the Catalogue

Arrangement and Attribution

Biographies of the artists are arranged alphabetically. For each artist, works are catalogued in approximately chronological order.

Miniatures are frequently unsigned. Unsigned works are assigned to artists largely on the basis of style. When a miniature's authorship is regarded as less than certain, the work is identified as attributed and is catalogued after the artist's other works.

Miniatures by unidentified artists follow the catalogue entries for known artists.

Names

Additional spellings of artists' names are given parenthetically. Occasionally, an alternate spelling is based on confusion with the name of another artist.

Cross-references

The appearance of an artist's name in small capitals in a text passage indicates that the artist is listed alphabetically in the catalogue.

Dates

A miniature's date is given in the catalogue entry when the date is supported by an inscription or other documentation. No attempt has been made to assign dates to miniatures that lack documentation. The chronological ordering of undated miniatures is generally based on the evidence provided by dress and painting technique.

Dimensions

The dimensions of the visible painted surface are given in inches and in centimeters, with height preceding width. Miniatures are illustrated at approximately true size, except where noted.

Casework

Most miniatures retain their original cases; these are described in the catalogue. Lids are generally not shown. Cases that are not original are identified as modern and are not described.

Inscriptions and Labels

Inscriptions are printed with slashes to indicate line divisions. Inscriptions engraved on cases or placed inside them were sometimes added by descendants at a later date, and, as research has revealed, are not always completely accurate. Thus, discrepancies between inscriptions and the cataloguing information regarding the dates and the identification of the sitter sometimes occur.

A label attached to the outside of a case is usually a relatively recent addition made by a descendant, a collector, or an art dealer.

Bibliographic References

The bibliography is in two sections: a general bibliography and a bibliography for individual miniaturists, alphabetized by the artists' names. For works that are cited only by the author's last name and the date, full references appear in the general bibliography that begins on page 249. When, additionally, the reader is referred to the bibliography for a given artist, the reference appears in the bibliography for individual miniaturists that begins on page 253.

Collections

Known owners are listed chronologically. When an art dealer is named, "with" precedes the name.

MMA is the abbreviation used for references to The Metropolitan Museum of Art.

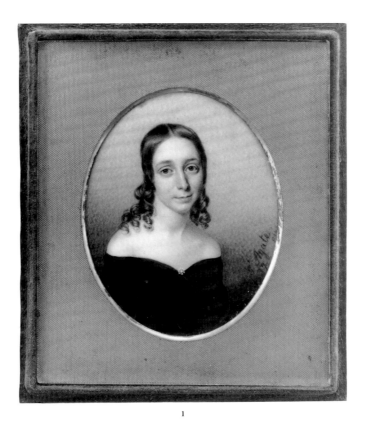

1

Alfred T. Agate

(1812–1846)

A painter, miniaturist, and illustrator, Alfred T. Agate was born in Sparta, New York, the younger brother of the painter Frederick Styles Agate (1807–1844). Sometime around 1830 he went to New York City and there met THOMAS SEIR CUMMINGS, who taught him the art of miniature painting. Agate exhibited miniatures at the National Academy of Design between 1831 and 1839 and was elected an associate of the Academy. In 1838 he agreed to serve as portraitist and botanical artist with the Scientific Corps of the United States Exploring Expedition, which was under the command of Charles Wilkes. In four years the corps circled the globe, making stops at the islands of the South Pacific, in the Antarctic, and along the American northwest coast. On his return in 1842, Agate settled in Washington, D.C., where he prepared drawings for the engravings that appeared in Wilkes's report, *Narrative of the United States Exploring Expedition* (Philadelphia: C. Sherman, 1844).

1. *Miss Bruce of Marlborough, Massachusetts*

1837
Watercolor on ivory, 2⅝ x 2 in. (6.7 x 5 cm)
Signed and dated at right edge: *A T Agate / 1837 pinx*
Casework: hinged maroon leather with ormolu mat
Label: identifying the artist, subject, and town
EX COLL.: purchased from Edward Sheppard, New York

Colorplate 22a

Ezekiel Bruce and his wife, Betsey Smith, were living in Marlborough in 1837. They had four daughters, whose ages in that year ranged from fourteen to twenty-six: Abigail Smith, Sally Morse, Mary Ann, and Elmira. It is not known which of the young ladies this miniature portrays.

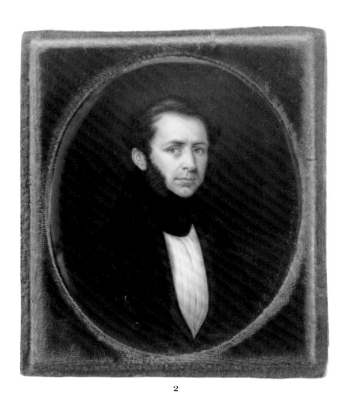

2

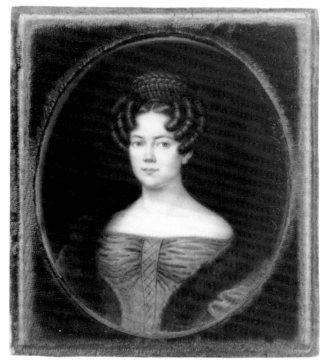

3

JEAN CHRISTOPHE ALEXANDRE

Jean Christophe Alexandre is known to have worked in Florence, Italy, between 1834 and 1839. In the May 1839 exhibition of the Apollo Association in New York he exhibited *The Fornarina of Raphael*, most likely a copy of the well-known painting, and listed Florence as his address. The only known miniatures by Alexandre are the two shown here. Their high quality makes it particularly surprising that other works by this artist have not survived.

2. *Thomas Dillard*

1834
Watercolor on ivory, 3⅛ x 2⁹⁄₁₆ in. (7.9 x 6.5 cm)
Signed and dated at right edge: *J. C. Alexandre
 Florence. 1834.*
Casework: hinged brown leather with velvet lining
Label: on back of case, identifying the sitter and
 the owner
Ex COLLS.: the sitter's son, Henry Kuhl Dillard; his
 son, Henry Kuhl Dillard, Jr.; purchased from
 Edward Sheppard, New York

Thomas Dillard was born in Virginia in 1801.

He entered the naval service as a surgeon's mate in 1824 and was commissioned as a surgeon in 1829. Dillard served at sea and also practiced medicine in Philadelphia. He married Matilda Kuhl about 1830. The couple were in Italy in 1834; after their return to the United States in 1835, they lived in Philadelphia. Dillard retired from the service in 1863 and died in 1870.

Catalogue nos. 2 and 3 are companion pieces.

3. *Matilda Kuhl Dillard*

1834
Watercolor on ivory, 3⅛ x 2⁹⁄₁₆ in. (7.9 x 6.5 cm)
Signed and dated at right edge: *J. C. Alexandre.
 Florence 1834*
Casework: as for cat. no. 2
Label: on back of case, identifying the sitter and
 the owner
Ex COLLS.: as for cat. no. 2

Matilda Kuhl was born in Philadelphia in 1807. She married Thomas Dillard, bore him four children, and died in Philadelphia in 1898.

DANIEL F. AMES

During the years 1837–41 Daniel Ames exhibited miniatures in New York City at the National Academy of Design and the American Academy, giving his address as New York. In 1858, when he again exhibited one painting at the National Academy of Design, he was living in Canarsie, Long Island.

4. *Lady with Flowers*

Watercolor on ivory, 3¹⁄₁₆ x 2⅜ in. (7.8 x 6 cm)
Signed along right edge of chair back: *D F Ames*
Casework: modern (not shown)
Ex colls.: with E. Grosvenor Paine, New Orleans; sale, Sotheby Parke-Bernet, New York, Jan. 29, 1986, lot 218; purchased from Edward Sheppard, New York

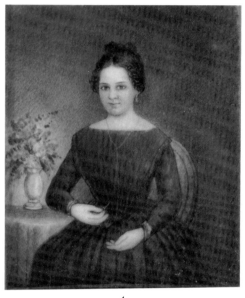

4

WILLIAM G. ARMSTRONG

(1823–1890)

Born in Montgomery County, Pennsylvania, William Armstrong moved at an early age to Philadelphia, where he studied under the engraver James Barton Longacre (1794–1869). He made portrait engravings for Longacre's

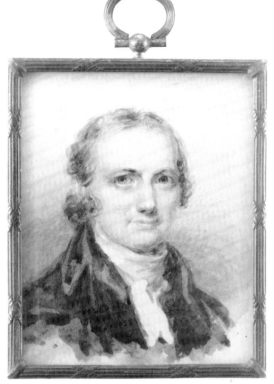

5

and James Herring's *National Portrait Gallery of Distinguished Americans* (Philadelphia: 1834–39) and engravings for *Illustrated Poems* (1849) by Lydia H. Sigourney and for *Godey's Lady Book* (1849). Most of Armstrong's professional career was devoted to engraving bank notes. In 1855 a writer for *The Crayon* praised his "exquisitely engraved vignettes, portraits, and other ornaments, and engine turnings of the most elaborate character" (vol. 1, February 21, p. 117). Armstrong painted miniatures and watercolor sketches after portraits that he engraved, but none of the paintings have been located. Likewise, if he made an engraving of William Ellery, whose portrait miniature is catalogue no. 5, it is unknown today.

5. *William Ellery*

Watercolor on paper, 3⅛ x 2⅜ in. (7.9 x 6 cm)
Signed on the backing card: *W. G. Armstrong fecit.* On the backing paper, a watercolor painting of a woman holding scales of justice, in front of a mill
Casework: modern
Label: on back of case, identifying the subject
Ex coll.: sale, Sotheby Parke-Bernet, New York, July 14, 1981, lot 264

William Ellery (1727–1820) was a lawyer, jurist, and congressman from Newport, Rhode Island, who served as a delegate to the Continental Congress and was a signer of the Declaration of Independence and the Articles of Confederation. From 1789 until his death he was the Collector of Newport.

Clearly this watercolor sketch was not painted from life, since its subject and its artist did not live at the same time. The miniature was probably a copy after a full-size portrait. During the first half of the nineteenth century there was a considerable market for miniature copies of portraits of eminent persons.

EZRA ATHERTON

(active 1838–42)

Ezra Atherton, a little-known artist, was a wood engraver and a portrait and miniature painter. About 1829 he was taken on as an apprentice in the Boston firm of Carter, Andrews & Co., a printing and binding company, where he worked as a wood engraver until the firm's failure in 1833. Between 1830 and 1834 he copied

proofs for Thomas Nuttall's *A Manual of the Ornithology of the United States and Canada.* Atherton exhibited miniatures at the Boston Athenaeum in 1838 and 1839, and in 1841 he showed an oil painting at the Boston Mechanics' Association.

6. *Gentleman*

1840
Watercolor on ivory, 2⅜ x 1¹⁵⁄₁₆ in. (6 x 4.9 cm)
Inscribed on backing paper: *Painted by E Atherton / Boston / July 1st 1840*
Casework: gilded copper with chased bezel and hanger; reverse engine turned
EX COLL.: purchased from Edward Sheppard, New York

GEORGE AUGUSTUS BAKER, JR.

(1821–1880)

George Augustus Baker, Jr., was born in New York City, the son and namesake of a miniature painter from Strasbourg, France, who instructed him in the art. By 1837 Baker had become established as a miniature painter, turning out over 140 works in that first year alone. He continued to work in the medium, meanwhile studying at the National Academy of Design, until 1844. Then he spent two years in Europe, and after his return to New York he embarked upon a career as a painter of full-size portraits. Baker's talents were in such demand that he often took orders two years in advance. Henry Tuckerman wrote in 1867 (p. 489) that Baker was "originally devoted to miniature-painting, much of the delicacy and fidelity of his pencil is owing to the high finish and exactitude acquired in that kind of limning." Baker was elected an academician of the National Academy of Design and, despite crippling neuralgia, exhibited there annually until his death from Bright's disease. His portrait of the painter John F. Kensett is owned by the Metropolitan Museum.

Surprisingly few of the many miniatures Baker executed have been discovered. Identification is difficult because he did not sign them. For that reason the miniature of Mary

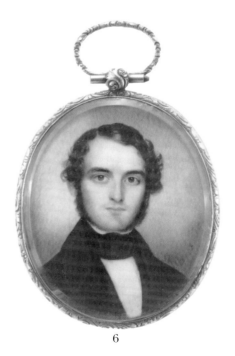

6

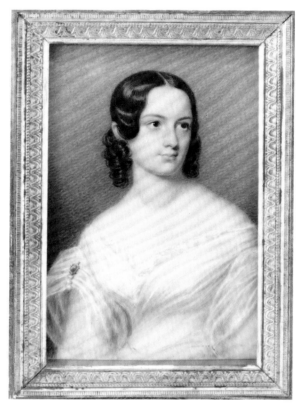

7

Crosby (cat. no. 7), with its inscription on a backing paper naming the artist, is a valuable indicator of Baker's style. In pose and attitude this pensive young woman exhibits "a grace of expression, and a beautiful refinement" (Tuckerman, p. 489) typical of his work. Her pale skin tones, delicately hatched, are set off by a more broadly hatched gray background.

7. *Mary Crosby*

1840
Watercolor on ivory, 3⅜ x 2³⁄₁₆ in. (8.5 x 5.5 cm)
Casework: modern
Inscribed on a backing paper: *My miniature / taken when I was / seventeen (October 1840) by George Baker / to be given to my / namesake niece / Mary C. Brown / Signed (Mary Crosby)*
Ex colls.: the subject's niece, Mary Crosby Renwick Brown; descended through her family; with the Chatelaine Shop; purchased from Edward Sheppard, New York

Colorplate 26a

Mary Crosby (1822–1913) was the daughter of William Bedlow and Harriet Ashton Clarkson Crosby of New York. Her great-grandfather was William Floyd, a congressman and a signer of the Declaration of Independence. Miss Crosby was injured in 1837, when she fell from a carriage in Switzerland, and remained an invalid thereafter. She never married.

Attributed to George Augustus Baker, Jr.

8. *Major William Boerum*

Watercolor on ivory, 2⅝ x 2¹¹⁄₁₆ in. (6.6 x 6.8 cm)
Casework: modern
Ex coll.: sale, C. G. Sloan & Co., Inc., Washington, D.C., Feb. 19, 1978, lot 1597

William Boerum was born in Brooklyn in 1796 to Martin and Jane Fox Boerum. He entered the United States Navy as a midshipman in 1811 and was commissioned a lieutenant in

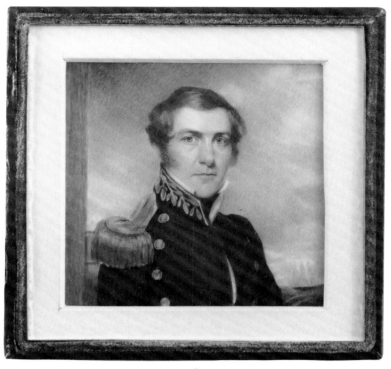

8

1817 and a commander in 1837. He married Emily Browne in 1818. Boerum was lost at sea in the Mozambique Channel in 1842 while commanding the ship *Concord*.

When this miniature was purchased, it had been variously attributed to George Augustus Baker, Jr., and to Sarah Goodridge. The technique is not that of Goodridge. Positive attribution to Baker is difficult, since few of his miniatures are documented; however, the work is somewhat similar to a miniature of Andrew Jackson painted by Baker (location unknown; see Bolton, 1923, ill. facing p. 42). The miniature of Jackson is copied after a portrait by John Vanderlyn, and the miniature of Boerum may have been copied after a full-size portrait as well.

THOMAS E. BARRATT

(born ca. 1814)

Born in England, Thomas E. Barratt settled in Philadelphia after 1833, and between 1837 and 1849 he exhibited frequently at the Artists'

Fund Society and the Pennsylvania Academy of the Fine Arts. He was still living in Philadelphia in 1854. His work was often mistaken for that of Rembrandt Peale, as noted by Wehle (*American Miniatures*, 1927, p. 45): "Many Philadelphia miniatures which exhibit rather prosaic likenesses painted in heavy browns and blacks have been attributed to him [Peale], but they are probably in reality by Thomas E. Barratt."

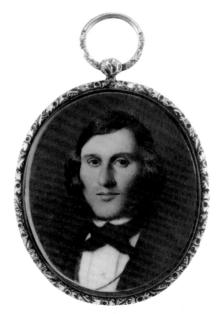

9

9. *Gentleman said to be Edward Oldham*

Watercolor on ivory, 2⅛ x 1¾ in. (5.4 x 4.4 cm)
Casework: gilded copper with chased bezel and
 hanger; the reverse engine turned, with chased
 bezel framing a compartment for hair
Ex COLL.: sale, Sotheby Parke-Bernet, New York,
 Nov. 15, 1980, lot 227

When this miniature was purchased, its subject
was described as Edward Oldham, a member
of George Washington's staff. A Captain Ed-
ward Oldham joined Infantry IV of the Mary-
land Regiment in 1777, but since this miniature
appears to have been painted around 1840, he
cannot be its subject. However, a marriage be-
tween Edward S. Oldham and Amelia C. Wa-
meling was recorded in Baltimore on January
11, 1849, and the census for that period lists an
Edward Oldham living in Baltimore. Perhaps a
descendant of Captain Oldham, he is probably
the subject of the miniature.

CHARLES F. BERGER

A portrait, miniature, and landscape painter,
Charles Berger was active in Philadelphia from
1841 into the 1890s. He exhibited a landscape,
Scene in Germany, at the Pennsylvania Academy
of the Fine Arts in 1853. Berger painted por-
traits of such notable figures as James Knox
Polk and Henry Clay. Most of his miniatures
were executed in the 1840s. They usually carry
an inscription on the backing paper.

10. *Gentleman*

1843
Watercolor on ivory, 1¹⁵⁄₁₆ x 1⁹⁄₁₆ in. (5 x 4 cm)
Inscribed on backing paper: *Charles F. Berger /
 Portrait & Miniature Painter / 192 Chesnut St Phila
 / Nov. 1843.*
Casework: gilded copper with chased bezel and
 hanger; the reverse, engine turned with chased
 bezel framing compartment containing braided
 hair, engraved initials *E W S*
Ex COLLS.: with Ronald Bourgeault, Salem,
 Massachusetts, until 1974; with E. Grosvenor
 Paine, New Orleans; sale, Sotheby Parke-
 Bernet, New York, Jan. 29, 1986, lot 183

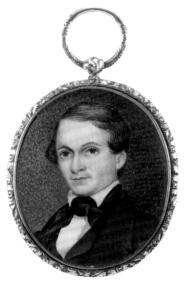

10

THOMAS BIRCH

(1779–1851)

Thomas Birch, an engraver and a painter of
miniatures, landscapes, and marine scenes, was
the son of WILLIAM RUSSELL BIRCH. Born in
Warwickshire, England, he came to Philadel-
phia at the age of fifteen with his father, who
began an engraving business. Thomas assisted
in the business by making views of the city until
in 1802 he struck out on his own as a portrait-
ist, specializing in miniature profiles in water-
color on cardboard and Bristol board. A few
oil portraits by him are known, all of sea cap-
tains. By 1813 Birch had abandoned portrai-
ture and listed himself in the city directory as a
marine and landscape painter. He made nu-
merous copies after European paintings in his
father's collection by artists such as Jacob Ruis-
dael and Jan van Goyen; probably on that
foundation he developed a style in the Dutch
marine tradition. Birch's accuracy in painting
the naval battles of the War of 1812 earned
him a name as the first American ship portrait-
ist. His entire career was pursued in Philadel-
phia, where he exhibited regularly at the
Pennsylvania Academy of the Fine Arts, the
Society of Artists, and the Artists' Fund Society.

In the early nineteenth century, profile
miniatures, usually executed on paper, were
extremely popular. Patrons found these like-

nesses inexpensive compared with the highly finished, elegant miniatures on ivory; at the same time they were more colorful and realistic than cut-paper silhouettes. Birch's profile portraits display in their format and style an artistic innocence and charm associated with the folk art tradition. However, his technique, linear and precise, reveals his training as an engraver.

11. *Lady*

Watercolor on paper, 3⅝ x 2⅝ in. (9.2 x 6.7 cm); shown reduced

Casework: carved gilt wood, eglomise (glass with gold design painted on the reverse side) mat with black background

Framemaker's engraved label on reverse: *David Brendann / 181 Baltimore Street / Pictures framed artistically / moderate prices.*

Catalogue nos. 11 and 12 are companion pieces.

12. *Gentleman*

Watercolor on paper, 3⅝ x 2⁹⁄₁₆ in. (9.2 x 6.6 cm); shown reduced

Casework: as for cat. no. 11

Framemaker's label: as for cat. no. 11; second label: *Garrett*

WILLIAM RUSSELL BIRCH

(1755–1834)

An enamelist, painter, and engraver, William Birch was born in Warwickshire, England. As apprentice to Thomas Jeffrey, a London goldsmith and jeweler, Birch learned the rudiments of enamel work; he studied further under Henry Spicer (1743–1804). During the years 1775–94 he exhibited enamel miniatures at the Royal Academy and the Society of Artists. Sir Joshua Reynolds took notice of Birch and hired him to make small enamel copies of his oil paintings, which he feared would discolor in time. Birch also made engravings after paintings by Reynolds and by Benjamin West, Thomas Gainsborough, and others, which he published in London in 1789 as *Délices de la Grande Bretagne.*

In 1794 Birch took his family to Philadelphia, arriving with a letter of introduction from West to the statesman and banker William Bingham. Bingham engaged Birch "to instruct his two Daughters in Drawing at his own House . . . I then built me a furnace" (from the

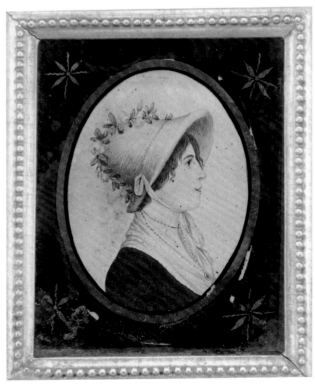

11

12

artist's autobiography; see bibliography for William Birch). Birch reestablished himself as an enamelist and went on to earn wide acclaim for his work in that medium, which was new to Americans. He made miniature portraits, landscapes, and copies after old master paintings, incorporating them into brooches, pendants, and snuffboxes. Birch's most popular miniature was of George Washington, painted after the Vaughan portrait by Gilbert Stuart; he made approximately sixty of these. With his son THOMAS BIRCH he established an engraving firm which published twenty-eight *Views of Philadelphia* (1798–1800). Sometime around 1812 he moved to his home, Springland, at nearby Neshaminy, and for the remainder of his career he created enamel paintings.

Birch's unpublished autobiography, "The Life of William Russell Birch, Enamel Painter, Written by Himself," also includes an essay about the art of enamel painting and a partial list of his enamels (Historical Society of Pennsylvania, Philadelphia). His enamels are unique in this country; jewel-like in finish and brilliant in color, they display excellent draftsmanship and careful stippling.

13

13. *Lady with a Red Drape*
(probably Mrs. William Bingham)

1795
Enameled copper, 4⁵⁄₁₆ x 3⁵⁄₁₆ in. (11 x 8.5 cm)
Signed and dated at lower left: *W B / 1795*
Casework: gilded copper bezel, probably designed
 to be mounted in the lid of a box
Ex COLLS.: sale, Sotheby Parke-Bernet, New York,
 Jan. 26, 1977, lot 232; with E. Grosvenor Paine,
 New Orleans; sale, Sotheby Parke-Bernet, Jan.
 29, 1986, lot 161

Colorplate 9a

This miniature was purchased as *Portrait Miniature of a Lady*, but experts on William Birch have suggested that the subject is Mrs. William Bingham, the former Anne Willing (1764–1801). The miniature resembles a portrait of her painted by Gilbert Stuart (coll. George H. Fisher, Esq., Philadelphia). When Birch was employed by William Bingham, as he later wrote in his autobiography, "I painted a full size picture in enamel of Mr. Bingham and a smaller one from it for [his daughter] Miss

Bingham, whoe afterwards marryed Sir Francis Baring." It is very likely that he also made a miniature of Mrs. Bingham at that time; his list of enamels is missing for 1784–1813. This miniature may also be one of the two works, each entitled *Portrait of a Lady in Enamel*, that he exhibited at the Columbianum Exhibition in Philadelphia in 1795. The subject's elegant pose and costume and the elaborate background reveal the strong influence of Sir Joshua Reynolds.

Anne Willing was the daughter of Thomas and Anne McCall Willing of Philadelphia. Considered a lady of exceeding charm and great beauty, she was admired by George Washington and John Jay. In 1780 she married William Bingham (1751–1804), Philadelphia banker, speaker of the Pennsylvania House of Representatives, and a United States senator.

14

14. *Samuel Chase*

Enameled copper, 1⁷⁄₁₆ x 1¼ in. (3.7 x 3.2 cm)
Casework: gold set with half pearls, mounted to be
usable as a locket, bracelet ornament, or brooch
Ex colls.: with Clapp & Graham, New York;
Erskine Hewitt, New York; his nephew's wife,
Mrs. Norvin H. Green, Tuxedo Park, New
York; sale, Parke-Bernet, New York, Nov. 30,
1950, lot 233; Harry Fromke, New York; sale,
Christie's, New York, Oct. 18, 1986, lot 383
Exhibited: New-York Historical Society, 1935;
Lyon Galleries, New York, 1941

Samuel Chase (1741–1811) was a signer of the
Declaration of Independence for Maryland
and in 1796 became an associate justice of the
United States Supreme Court. Distantly related
to Birch, he persuaded him to immigrate to
America.

15. *Principa Falls*

Enameled copper, 2¹⁄₁₆ x 1⁷⁄₈ in. (5.3 x 4.8 cm)
Inscribed on the back in enamel: *Principa Falls /
Maryland / US / NA / A bridge over these / stones was*

15

*destroyed by the British / in 1812 / painted by W.
Birch from / nature.*
Casework: carved gilt wood (not shown)
Ex coll.: purchased from Edward Sheppard, New
York, July 24, 1983

Colorplate 9b

16. *The Stump* (after Ruisdael)

1815
Enameled copper, 3 x 2½ in. (7.6 x 6.4 cm)
Inscribed on the back in enamel: *Painted by Wm
Birch / at Springland Pennsylva / N. Amer'a. in
1815. / From an Original Picture / by Ruysdeal. in
his own possession.*
Casework: modern (not shown)
Ex colls.: with Arthur J. Sussel, Philadelphia; sale,
Parke-Bernet, New York, Mar. 19, 1959, lot
538; Dr. and Mrs. Milton Wohl; sale, Sotheby
Parke-Bernet, New York, June 10, 1985, lot 87
Exhibited: Philadelphia Maritime Museum, 1966,
Thomas Birch

Colorplate 9c

16

An entry in the artist's list of enamels reads:
"The Stump From the Düsseldorff Gallery by
Ruysdell/ A well known picture mentioned in
several of the travels through Europe as one of
the choicest pictures of the master. The inimi-
table perfection of the stump of a Birch tree,
the beautiful effect of light in the distance, pe-

culiar to his pencil and the clear air of the picture, renders it one of the finest landscapes in the World." Birch's account book (Historical Society of Pennsylvania, Philadelphia) contains the entry: "1824 Henry Cary, 2 enamels, the Ruysdell 'Stump.'"

William Birch acquired a valuable collection of European paintings, including works, listed in his autobiography, by Jan van Goyen, Pieter Brueghel, Thomas Gainsborough, and Salvator Rosa. He mentioned owning two paintings by Jacob Ruisdael which had come from the Düsseldorf Gallery, *A Landscape* and *The Stump*, about which he wrote: "I am indebted to the researches of Napoleon for these pictures, he being expected to seize upon that celebrated collection. It was taken down and dispersed. In the confusion of the times, several of them were sent to this country, these fortunately fell into my hands." Birch made at least three enamel copies after *The Stump*.

17

17. *Daniel Webster*

Enameled copper, 1 1/16 x 13/16 in. (2.7 x 2 cm)
Inscribed on the back: *Webster; 11*
Casework: gold, mounted as a brooch

There are at least two versions of this miniature and perhaps as many as the eleven suggested by the inscription. One is in the Metropolitan Museum. These enamels of Daniel Webster (1782–1852), the statesman, lawyer, and orator, are after the engraving made by James B. Longacre in 1833 for the *National Portrait Gallery of Distinguished Americans* (New York, vol. 1, 1834).

18

Attributed to William Russell Birch

18. *Cornelius Vanderbilt*

Enameled copper, 15/16 x 3/4 in. (2.4 x 1.8 cm)
Casework: modern

Cornelius Vanderbilt (1794–1877), the New York magnate and financier, erected Grand Central Terminal and built major railroad and shipping lines in New York State and across the country.

DAVID BOUDON

(1748–ca. 1816)

A miniaturist working in silverpoint and watercolor, David Boudon (or Bourdon, Boudet) was also a teacher of painting, music, and dancing. He was born in Geneva, Switzerland, where at the age of twelve he was apprenticed to a copperplate engraver, Jean-Daniel Dupré. His earliest known work is a metalpoint portrait executed in Geneva in 1780. Boudon immigrated to America about 1794, and there found that an abundance of competition forced him to travel continually in search of work. During the next several years he worked, in the following order, in Charleston, Savannah, New York City, the eastern shore of Maryland, Philadelphia, Alexandria, Raleigh, Fayetteville, Pittsburgh, Baltimore, and Washington, D.C. He

also gave lessons in drawing and painting to supplement his income. By 1813 Boudon had left the eastern seaboard and had begun to work his way west through Maryland, Virginia, and West Virginia, finally settling in Chillicothe, Ohio. The last recorded mention of him is a joint advertisement for his drawing school and a piano concert given on November 28, 1816.

More than three-fifths of Boudon's extant American miniatures are profiles made in silverpoint on vellum, paper, or ivory, an unusual medium for a miniaturist. Even his watercolors employ a meticulous linear technique that recalls his early training as an engraver. Approximately sixty of Boudon's works are recorded. Often they carry an unusually complete inscription on the backing paper that includes the artist's name and birthplace and the miniature's date and place of execution.

19. *Lady*

Watercolor on ivory, 2½ x 2½ in. (6.3 x 6.3 cm)
Signed on tree along left edge: *Boudon*
Casework: modern
Ex colls.: Lucy Wharton Drexel, Penrynn, Pennsylvania; her granddaughter, Mrs. Andrew Van Pelt, Radnor, Pennsylvania; sale, Christie's, London, Nov. 7, 1988, lot 71

Colorplate 20a

The composition of this painting, with its sub-

19

ject portrayed frontally in three-quarter length against an elaborate landscape, is a rare one for Boudon. The mountains in the background suggest that the miniature was painted in Virginia or West Virginia when Boudon was traveling west to Ohio.

HUGH BRIDPORT

(1794–ca. 1869)

Hugh Bridport was a portrait and landscape painter, an engraver, a lithographer, and an architect but was best known as a painter of miniatures. Born in London, he studied with the miniature painter Charles Wilkin (1756–1814) and at the Royal Academy, where he exhibited three miniatures in 1813. In 1816 he came to America and settled in Philadelphia, joining his brother George Bridport (active 1807–17), an ornamental painter and interior decorator. For a short while the two brothers ran a drawing academy. In 1818 Bridport and the architect John Haviland (1792–1853) opened an architectural drawing school and published a book, *The Builder's Assistant*, for which Bridport supplied the engravings. Bridport was a founding member of the Franklin Institute, where he taught drawing from 1826 to 1833. In the early 1820s he painted miniatures in various parts of Massachusetts and in Newark, New Jersey, and Troy, New York, but he spent most of his time in Philadelphia, where he exhibited at annual shows of the Pennsylvania Academy and at the Artists' Fund Society. He was unable to find enough work; THOMAS SULLY recorded helping him in 1839, and in the years 1838–44 he sought commissions in Virginia, South Carolina, and Louisiana. He seems to have abandoned miniature painting after 1848, listing himself in the city directories as "gentleman."

Bridport's early brushwork was loose, with the paint applied in broad washes; later the execution became crisp, tight, and highly finished. Backgrounds often show clouds and sky. The miniatures are usually signed along an edge and frequently inscribed on the backing paper.

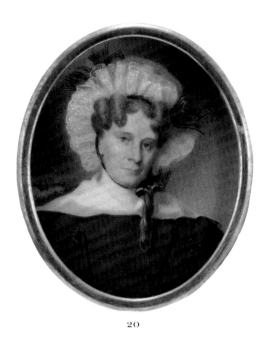

20

Street in 1869, when he exhibited a portrait of THOMAS SULLY at the Pennsylvania Academy of the Fine Arts.

21. *Gentleman*

1838
Watercolor on ivory, 2⁷⁄₁₆ x 2 in. (6.2 x 5 cm)
Signed and dated at left edge: *Broadbent 1838.*
 Inscribed on backing paper: *Broadbent Pinx 1838*
Casework: gilded copper with cast bezel and
 hanger; on the reverse, cast bezel framing a
 compartment containing a silhouette of a
 woman
EX COLLS.: with E. Grosvenor Paine, New Orleans;
 sale, Sotheby Parke-Bernet, New York, Jan. 29,
 1986, lot 198

20. *Lady*

Watercolor on ivory, 2¹³⁄₁₆ x 2³⁄₁₆ in. (7.2 x 5.5 cm)
Signed along right edge: *Bridport*
Inscribed on backing paper: *Painted by / H. Bridport
/ Philia.*
Casework: gilded copper
EX COLLS.: sale, Sotheby Parke-Bernet, New York,
 June 15, 1978, lot 141; with E. Grosvenor Paine,
 New Orleans; sale, Sotheby Parke-Bernet, New
 York, Jan. 29, 1986, lot 118

SAMUEL BROADBENT, JR.

(ca. 1812–ca. 1874)

Samuel Broadbent, Jr., was born in Wethers-
field, Connecticut, the son and namesake of an
itinerant surgeon and painter of portraits and
miniatures. Although much of the elder Broad-
bent's life has been documented, little is known
about Broadbent Jr. He was probably in-
structed by his father. He married about 1830
and later moved to Philadelphia, where he
made his living painting portraits and taking
daguerreotypes. He listed himself in the city
directories as a photographer between 1852
and 1874 and was living at 115 North 12th

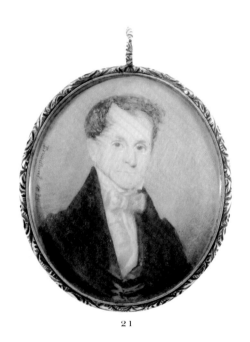

21

HENRY I. BROWN

(active 1840–51)

Little is known of Henry I. Brown except that
he was painting portrait miniatures in Boston
between 1840 and 1851. He is probably the
artist of that name who exhibited *The Reverend
Mr. Todd* at the Philadelphia Artists society in
1839, a miniature of George Washington at the
Boston Art Association in 1843, and several

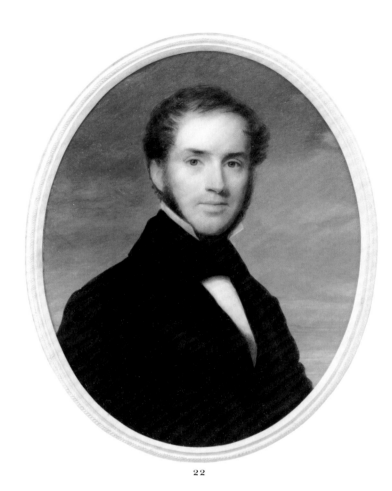

22

portraits at the Pennsylvania Academy of the Fine Arts in 1844. Brown's use of opaque, thickly applied paint suggests that he also painted portraits in oil.

22. *Benjamin Daniel Greene*

1848
Watercolor on ivory, 4¼ x 3¼ in. (10.8 x 8.3 cm)
Inscribed on backing paper: *B. D. Greene Painted by H.* [illegible] / *184*[8]. Inscribed on paper inside back lid: *H. Brown / 1848*
Casework: hinged brown leather with ormolu mat (partially shown)
Framemaker's label inside back lid: *S. J. H. Smith / Maker / 182 Washington St. / Upstairs / Over Frost's Hardware Store / Boston*
EX COLLS.: with E. Grosvenor Paine, New Orleans; sale, Sotheby Parke-Bernet, New York, Jan. 29, 1986, lot 155

Colorplate 29

Benjamin Daniel Greene (1793–1862) was born in British Guiana, the son of Gardiner Greene and Elizabeth Hubbard Greene of Boston. He was graduated from Harvard College in 1812 and received an M.D. in Edinburgh, Scotland, in 1821. In 1826 he married Margaret Morton Quincy, the daughter of Josiah Quincy (1772–1864), president of Harvard University and mayor of Boston. Greene served as the first president of the Boston Society of Natural History.

JOHN HENRY BROWN

(1818–1891)

John Henry Brown was born in Lancaster, Pennsylvania. Apprenticed to the painter Ar-

thur Armstrong (1798–1851), he taught himself how to paint miniatures on his days off. Brown first established himself as a portraitist and sign painter, but by 1844 he was painting miniatures exclusively. The following year he settled permanently in Philadelphia. He was a frequent exhibitor at the Pennsylvania Academy of the Fine Arts in the years 1844–64 and received a medal for the miniatures he showed at the Centennial Exhibition in 1876. Tuckerman praised him as "one of the best miniature painters in the country and constantly employed" (1867, p. 479). His eminent sitters included Abraham Lincoln, James Buchanan, and Stonewall Jackson.

Brown imitated photography so closely that his miniatures became virtually indistinguishable from hand-colored photographs. As early as 1846 he was copying daguerreotypes, and in painting Lincoln's portrait in 1860 he relied partly on ambrotypes. He is one of the few miniaturists who continued to work throughout the century; unlike most of his contemporaries, who were driven out of business by photography, Brown achieved considerable success through its exact replication.

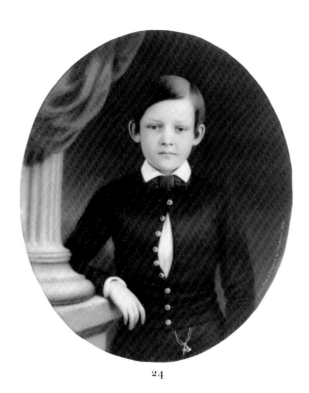

24

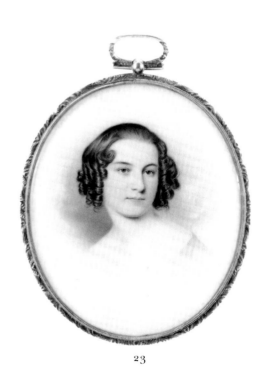

23

23. *Mrs. Gerard Roth*

Watercolor on ivory, 2¹¹⁄₁₆ x 2³⁄₁₆ in. (6.8 x 5.6 cm)
Casework: gilded copper with chased bezel and hanger; reverse engine turned, with chased bezel framing a compartment containing tightly plaited hair
Ex coll.: sale, Sotheby Parke-Bernet, New York, Nov. 19, 1976, lot 519

This miniature was said at the time of its purchase to be a portrait of Mrs. Gerard Roth. Although many Roths were living in Philadelphia and Lancaster during the period when this work was painted, none with the first name Gerard is known.

24. *Boy*

1854
Watercolor on ivory, 3⁹⁄₁₆ x 2⁷⁄₈ in. (9.1 x 7.3 cm)
Signed and dated at right edge: *Copy from a Daguerre by J. Hy. Brown 1854*. Inscribed on backing paper: *J. Henry Brown / Phila 1854*
Casework: hinged red leather with ormolu mat (not shown)
Ex coll.: purchased from Edward Sheppard, New York

Colorplate 32b

EBENEZER F. BRUNDAGE

(active 1843–67)

Ebenezer Brundage lived in New York between 1843 and 1867, listing himself in city directories variously as a portrait painter, artist, and coffee seller. His name appears in exhibition records only once, in 1847, when he exhibited *Bust of Silas Wright* in the sculpture category at the American Institute of the City of New York.

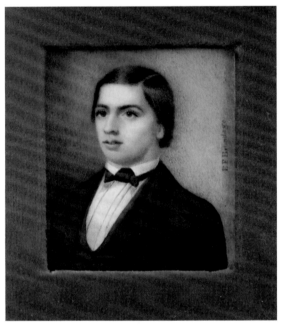

25

25. *Gentleman*

Watercolor on ivory, 2⅜ x 1¹⁵⁄₁₆ in. (6 x 5 cm)
Signed along right edge: *E F Brundage*
Casework: modern (partially shown)
Ex colls.: with E. Grosvenor Paine, New Orleans; sale, Sotheby Parke-Bernet, New York, Jan. 29, 1986, lot 218; purchased from Edward Sheppard, New York

JOHN CARLIN

(1813–1891)

John Carlin, a miniaturist, genre and landscape painter, writer and poet, was born a deaf mute in Philadelphia. At nineteen he opened an ornamental sign business. By 1834 he was studying portrait painting with John Neagle (1796–1865) during the day and by night taking lessons in drawing from John Rubens Smith (1775–1849). In 1838 Carlin went to France; there he studied with the academic master Paul Delaroche (1797–1856) and devoted two days a week to painting miniatures. He returned to the United States in the spring of 1841, establishing himself in New York as a miniaturist.

Carlin's ability to produce a faithful likeness at a reasonable price and with remarkable speed ensured him continuous employment. Close to two thousand miniatures are listed in the record book he kept from 1835 to 1856 (New-York Historical Society); according to family correspondence, he painted over three thousand altogether. Between 1841 and 1856 he worked in Pennsylvania, New York State, Connecticut, Massachusetts, and Washington, D.C., and Baltimore, but during most of that time he was in New York City painting miniature portraits of socially prominent people. Among his close friends were Philip Hone, Thurlow Weed, Horace Greeley, and William Cullen Bryant. Carlin exhibited in New York at the National Academy of Design annually during the years 1847–86 and occasionally at the American Art Union, the Maryland Historical Society, and the Pennsylvania Academy of the Fine Arts. A contemporary critic writing for the *New York Times* praised his works: "His flesh tints are remarkably pure, and his finish all that can be desired, while the strong individuality of each face assures us of the faithfulness of the likeness" (quoted in *Biographies of Deaf Persons*, Foreword by the Reverend T. B. Berry [Albany, n.d.], p. 117).

Several of Carlin's poems and stories were published, including an illustrated children's book, *The Scratchside Family* (New York: W. L. Stone & J. T. Barron, 1868), and "The Mute's Lament" (in *Deaf Mutes' Journal* [April 30, 1891]). He married a deaf mute, Mary Allen

Wayland; their five children had normal hearing and speech.

Carlin painted single subjects and family groups of up to five people, all detailed in an equally meticulous fashion by means of a delicate stipple. Hands and feet tend to be overly small. He employed a palette of brilliant color. Carlin was particularly skillful in rendering the tiniest of portraits. The smallest works, often less than one and one-half inches high, are usually signed discreetly along an edge, while more elaborate full-length or group portraits are prominently signed and dated at the bottom.

26. *Florine Turner*

1845
Watercolor on ivory, 4 x 3¹⁄₁₆ in. (10.1 x 7.8 cm)
Signed and dated lower left: *J Carlin 1845*.
 Inscribed on backing paper: *The portrait of Mis Florine Turner / painted by John Carlin / a Deaf Mute / New York / June 1845.*
Casework: modern (not shown)
Ex COLLS.: with Ruth Troiani, Farmington, Connecticut; purchased from Edward Sheppard, New York

Colorplate 30

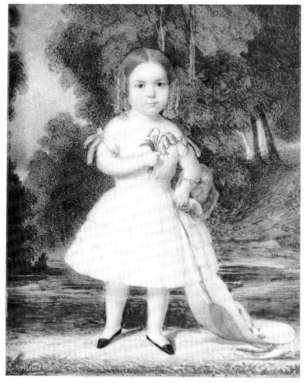

26

Florine Turner was the daughter of David Booth Turner of Newton, Connecticut. In 1872 she married Richard Starr Dana, a China trade merchant from New York. She died in 1909. The miniature is listed in Carlin's record book: "May 1845 / 725 of Miss Turner 25 00."

27. *Mrs. Nicholas Fish* (Elizabeth Stuyvesant)

1848
Watercolor on ivory, 3⅞ x 3⅛ in. (9.8 x 8 cm)
Signed and dated lower left: *J. Carlin / 1848*
Casework: ormolu mat, modern frame (partially shown)
Ex COLLS.: descendants of the subject; sale, C. G. Sloan, Washington, D.C., Feb. 19, 1978, lot 1600

Elizabeth Stuyvesant was the descendant and heiress of the Dutch governor of New Amsterdam, Peter Stuyvesant. In 1803 she married Nicholas Fish, a distinguished officer in the Revolutionary War. Their son was the statesman Hamilton Fish. This miniature is noted in Carlin's record book: "May 1848 / 1093 of Mrs Fish 40.00."

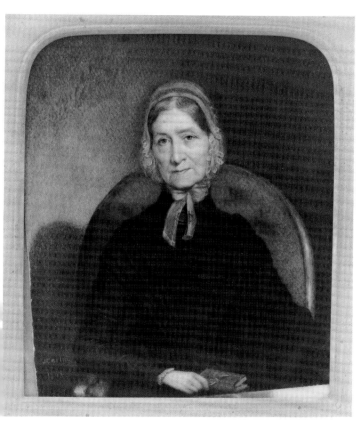

27

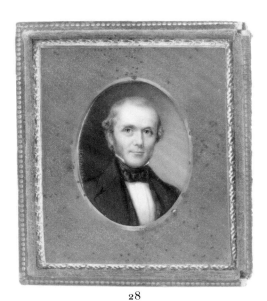

28

28. *Gentleman*

1854
Watercolor on ivory, 1⁹⁄₁₆ x 1³⁄₁₆ in. (4 x 3 cm)
Signed and dated on left edge: *J. Carlin. 1854*
Casework: hinged brown leather with gold-colored
 mat and protector
Ex COLL.: sale, Sotheby Parke-Bernet, New York,
 Feb. 17, 1982, lot 553

29. *Gentleman*

Watercolor on ivory, 1⁵⁄₁₆ x 1 in. (3.4 x 2.6 cm)
Casework: gilded copper with chased bezel; slide
 clasp (for mounting on a bracelet) and original
 brooch conversion
Ex COLL.: purchased from Edward Sheppard, New
 York

Catalogue nos. 29 and 30 are companion pieces.

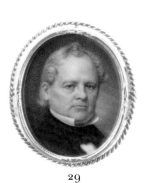

29

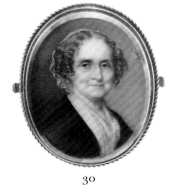

30

30. *Lady*

Watercolor on ivory, 1⁵⁄₈ x 1¼ in. (4.1 x 3.2 cm)
Signed on left edge: *J Carlin*
Casework: as for cat. no. 29 but without chasing on
 bezel
Ex COLL.: as for cat. no. 29

31. *Lady in a Bonnet*

Watercolor on ivory, 1¹⁵⁄₁₆ x 1½ in. (4.9 x 3.8 cm)
Casework: modern

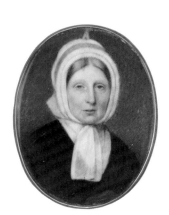

31

GEORGE CATLIN

(1796–1872)

Although he is better known for his paintings
of Indians, George Catlin spent the early part
of his career as a miniaturist. Born in Wilkes-
Barre and raised in the Wyoming Valley in
Pennsylvania, he developed a fascination with
Indians based on his mother's stories of her
own capture and escape. Catlin's father was a
lawyer who schooled his son at home in the
classics, sciences, and arts.

At twenty-one Catlin entered Reeves and
Gould Law School in Litchfield, Connecticut,
the home of his cousins, who taught drawing at
Miss Pierce's Academy. Their example piqued
his artistic interest, as did miniatures by ANSON
DICKINSON and portraits by Ralph Earl (1751–
1801). After passing the bar exams in 1818,

Catlin returned to his native Luzerne County in Pennsylvania to practice law, but his penchant for art soon began to interfere with his career: with "penknife, pen and ink and pencil sketches of judges, jurors, and culprits . . . he converted his law library into paint pots and brushes" (Thomas Donaldson, *The George Catlin Indian Gallery in the U.S. National Museum* [Washington, D.C., 1886], p. 706). By 1823 Catlin had moved to Philadelphia to establish himself as a miniature painter. He exhibited miniatures at the Pennsylvania Academy of the Fine Arts from 1821 to 1824, was made an academician, and began painting portraits in oil. In Philadelphia he saw a delegation of Indians from the West arrayed in their native costume; they inspired his vow that he would devote himself to documenting on canvas every tribe in America.

Between 1824 and 1829 Catlin spent time in Hartford, Albany, Buffalo, New York City, and Washington, D.C. In 1826 he was elected an academician of the National Academy of Design in New York, and twelve of his works were exhibited at the American Academy there in 1828. Soon thereafter Catlin married Clara B. Gregory and moved with her to Richmond, Virginia. There he made a painting in oil of the delegates to the Virginia Constitutional Assembly which was a composite of over one hundred miniature portraits. His miniature of Dolley Madison (Morris Museum, Morristown, New Jersey) was painted in appreciation of her care for his ailing wife. In 1830 Catlin set out alone to pursue his lifelong ambition of making and exhibiting portraits of Indians. He spent eight years painting in the American West; then he took his collections abroad, where he spent the next thirty years. He returned to America in 1870.

Catlin's miniatures are strong, self-assured images, painterly in execution and more skillfully done than his works in oil. As portraits they are highly individualized, with the distinctiveness of the features emphasized. The hair, rendered in broad brushstrokes, has a chiseled appearance. Catlin possessed a fine color sense and used the translucency of the ivory to optimum effect.

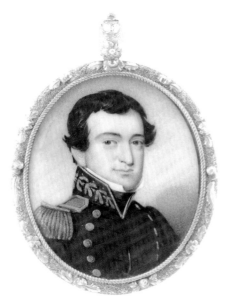

32

32. *Midshipman Joseph Stallings*

ca. 1820
Watercolor on ivory, 2³⁄₁₆ x 1¹³⁄₁₆ in. (5.6 x 4.5 cm)
Signed at lower right: *Catlin*
Casework: gilded copper with tricolored metal chased bezel and hanger; on the reverse, similar bezel framing compartment containing lock of hair; fitted red leather case (not shown); fragment of Washington, D.C., newspaper used as backing paper.
REFERENCES: Hirschl & Adler Galleries, *Faces and Places: Changing Images of 19th Century America* (New York, 1972), no. 10; George Catlin, *Letters and Notes on the North American Indians*, edited by Michael McDonald Mooney (New York: Clarkson N. Potter, 1975), p. 12
EX COLL.: purchased from Hirschl & Adler Galleries, New York, Jan. 1973

Colorplate 14b

Joseph Stallings became a midshipman in 1820 and a lieutenant in 1829. He died in 1841. This may be the miniature that Catlin exhibited in 1821 at the Pennsylvania Academy of the Fine Arts, no. 122, as *Miniature Portrait of an Officer.* The hard, slightly primitive delineation of the features and somewhat incorrect drawing support the assignment of an early date.

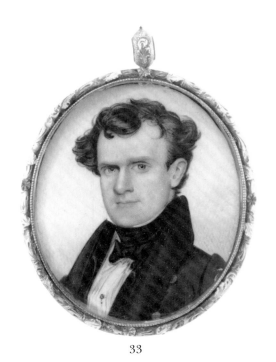

33

33. *Gentleman*

Watercolor on ivory, 2⁹⁄₁₆ x 2⅛ in. (6.5 x 5.4 cm)
Casework: gilded copper with chased bezel and
 hanger; on the reverse, similar bezel framing
 compartment containing piece of fabric with
 backing paper inscribed in ink: *144*
Ex colls.: sale, Christie's, New York, Jan. 21,
 1984, lot 89; purchased from Edward
 Sheppard, New York

Attributed to George Catlin

34. *United States Military Academy at West Point, Looking South*

Watercolor on ivory, ⅞ x 1½ in. (2.3 x 3.8 cm)
Casework: modern
Related works: This miniature and the one that
 follows are replicas of a pair of oil paintings in

the West Point Museum that were painted by
Catlin about 1828. Catlin also made two
watercolor sketches (coll. Gerold Wunderlich,
New York) after the paintings at West Point,
each signed and dated: *Geo. Catlin, 1828*. John
Hill made aquatint engravings of the two scenes
for Catlin, also in 1828; they are Catlin's earliest
known published prints. See Richard J. Koke, *A
Checklist of the American Engravings of John Hill
(1770–1850)* (New York: New-York Historical
Society, 1961), p. 57.

Colorplate 14d

This view looking south across the West Point
parade ground and toward the Academy build-
ings was taken from near the Wood Monu-
ment, which appears in the right foreground.

Catlin's younger brother, Julius, was admit-
ted to the Academy at West Point in 1820 and
graduated in 1824. George frequently visited
his brother there. Probably all his paintings of
the site were made in 1828, the year that Julius
drowned in an accident.

Catalogue nos. 34 and 35 are companion pieces.

Attributed to George Catlin

35. *United States Military Academy at West Point, Looking North*

Watercolor on ivory, ⅞ x 1½ in. (2.3 x 3.8 cm)
Casework: modern

Colorplate 14c

This view looks north across the West Point
parade ground toward the northern gate of the
Highlands of the Hudson, showing Crow's
Nest, Butter Hill, Breakneck Mountain, and
Polopels Island. See Koke (cited for cat. no. 34),
p. 58.

34

35

Daniel Nikolaus Chodowiecki
(1726–1801)

This European artist is included here because his portraits are of an American subject. An engraver and a miniaturist in enamel and ivory, Daniel Chodowiecki was born in Danzig, Poland. He learned how to make miniatures in enamel on copper from his uncle. In 1743 he went to Berlin to study under Chrétien Bernhard Rode (1725–1797), a history painter and engraver; he may also have worked for a time in Paris in the atelier of the enamel miniaturist Jacques Thouron (1740–1789). Chodowiecki developed into a very successful engraver and one of the best-known German miniaturists. In 1764 he was made a member of the Academy of Berlin; he later became a professor there and eventually, in 1797, its director. He supplied hundreds of portraits and historic illustrations for editions of works by Goethe, Sterne, and Shakespeare. He worked for fifteen years on engravings for Johann Kaspar Lavater's influential *Essai sur la physiognomie* (The Hague, 1781–1803). An excellent draftsman, he used a fine, regular stipple technique in his miniatures.

The identity of the artist with initials D C has until now been unknown. He is here identified as Daniel Chodowiecki on the basis of two factors: Chodowiecki is the only known enamel miniaturist whose initials are D C, and his documented signature and handwriting match that of the inscriptions on the two miniatures described below.

36. *Benjamin Franklin*

1785
Enameled copper, 3⅛ x 2½ in. (8 x 6.4 cm)
Signed and dated on the back in enamel: *D C. pxt avril 1785 / le Docteur Franklin / + + + + + +* [refers to number of firings] */ D'après Mr Weyller*
Casework: ormolu mount with bow and laurel leaves; on the reverse, a hinged lid covers the inscription; maker's marks of Gabriel-Sébastien Beau
Related works: The artist with initials D C executed a number of enamel miniatures of Franklin (see Sellers, 1962, pp. 174–76, where they are described as the work of an

36

unidentified artist). One is at the Royal Ontario Museum; see Hickl-Szabo, 1981, p. 29. The miniature shown here is a replica of an enamel miniature by Jean-Baptiste Weyler (1747–1791) of Paris, painted ca. 1782 (coll. Charles Clore, London). It is also related to two miniatures at the Louvre, an ivory and an enamel, both by Jacques Thouron, which appear to be copied after the engraving of Benjamin Franklin published in Lavater's *Essai* (see above), pt. 2, 1783, p. 280. Neither Thouron nor Weyler is known as an engraver, while Chodowiecki is known to have made engravings for the Lavater book. Since the engraving carries the same image as the miniature signed *D C*, it was probably Chodowiecki who engraved the unsigned portrait of Franklin in the *Essai* as well as executing the enamels (see Sellers, pl. 36).
Ex colls.: J. P. Morgan; sale, Sotheby and Co., London, May 16, 1957, lot 37; sale, Sotheby Parke-Bernet, New York, Nov. 19, 1980, lot 252

Benjamin Franklin left France in April 1785, the year this miniature was painted. His departure created a new demand for portraits of him.

37

37. *Benjamin Franklin*

1785
Enameled copper, 3¼ x 2¹¹⁄₁₆ in. (8.2 x 6.8 cm)
Signed and dated at center right: *D C / 1785;*
 inscribed on the back: *Mr. Benjamin / Franklin /*
 D C pxt / 1785 / D'après Mr Duplessis./
 + + + + + +
Casework: as for cat. no. 36
Ex colls.: as for cat. no. 36

In 1778 JOSEPH-SIFFRED DUPLESSIS painted the first of his many portraits of Franklin. Made for Le Ray de Chaumont, Franklin's host while he was at Pasay, France, it was exhibited at the Paris Salon the following year and is referred to as the "fur collar" version (MMA). Chodowiecki in his inscription calls this miniature "after Mr. Duplessis," but although in pose and dress it resembles the painting by Duplessis, the miniature is much more closely related to a pastel of Franklin by Jean Baptiste Greuze (1725–1805) commissioned in 1777 by Elie de Beaumont (coll. J. Lawrence, Jr., Boston). Sellers cited the two miniatures published here, describing this one as after Greuze, but was unable to puzzle out the identity of D C (1962, pp. 174–76).

ALVAN CLARK

(1804–1887)

Alvan Clark, an engraver, portraitist, and miniature painter, was born in Ashfield, Massachusetts, the son of a farmer. Having taught himself the rudiments of drawing and engraving, he began to travel about New England executing small portraits in watercolor and india ink. In 1827 he secured a job engraving rolls for a calico painter in Lowell. For the next nine years he worked at that trade in Providence, New York City, and Fall River, Massachusetts, meanwhile supplementing his income by taking likenesses. In 1836 Clark moved to Boston, where he opened a studio as a painter of portraits and miniatures. Between 1829 and 1850 he exhibited at the Gallery of Paintings in Providence, the Boston Athenaeum, and the National Academy of Design and the Apollo Association in New York. In 1844 Clark turned from painting to the manufacture of telescopes: operating in Cambridge, Massachusetts, and assisted by his two sons, he became the leading American manufacturer of telescopes. He produced the first achromatic lenses made in this country.

Although Clark abandoned miniature painting, it was not for lack of skill. He painted women in delicate flesh tones, often wearing brightly colored garments, while his paintings of men are generally subdued and nearly monochromatic. Usually three-quarter length, the portraits present highly individualized characterizations.

38. *John Pickering*

Watercolor on ivory, 3¼ x 2⁹⁄₁₆ inches (8.3 x 6.5 cm)
Casework: hinged brown leather with ormolu mat (partially shown)
Framemaker's label inside frame back: *Made at / Smith's / No 2 Milk St. / Opposite Old South / Boston*
RELATED WORKS: There are three known replicas of this miniature: at the Museum of Fine Arts, Boston, at the Museum of Art, Carnegie Institute, Pittsburgh, and in the possession of the subject's descendants.

Colorplate 28b

John Pickering (1777–1846) was born in

Salem, Massachusetts. After graduating from Harvard College in 1796 he studied languages and law abroad. When he returned to this country he practiced law in Boston and was the city solicitor from 1829 until 1845. However, he devoted himself primarily to linguistics, acquiring fluency in Chinese and in European and Semitic languages, and becoming the leading authority on the languages of the North American Indian. His works and publications made him one of the most highly regarded Bostonians of his day.

39

38

39. *Mary Elizabeth Snow*

1839
Watercolor on ivory, 3⅝ x 2¾ in. (9.3 x 7 cm)
Casework: ormolu mat, modern frame (partially shown)
Inscribed on backing paper: *My Mother / Mary Elizabeth Snow / Boston, Mass 1839.* On separate paper: *Mr. Nathaniel Snow / No 44 Milk Street / Boston*
Ex COLLS.: Nathaniel Snow, Boston; purchased from Edward Sheppard, New York

The Nathaniel Snow whose name appears here may be the one listed as a merchant in the Boston directories between 1846 and 1862. Mary Elizabeth Snow may be the person listed as Elizabeth Snow, widow of Horatio G. Snow, in the 1840 Boston directory.

LOUIS ANTOINE COLLAS

(1775–ca. 1829)

The French portrait and miniature painter Louis Antoine Collas was born in Bordeaux. He studied in Paris with François André Vincent (1746–1816) and occasionally exhibited portraits and miniatures at the Salon during the years 1798–1812. From 1803 to 1811 Collas lived in St. Petersburg, where he painted portraits of members of the czar's court. By 1816 he was in New York, listed in the city directory as Lewis Collers. He exhibited miniatures there in that year and in 1820, at the American Academy of the Fine Arts. In 1816

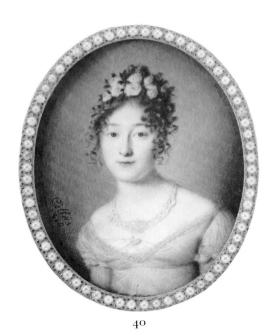

40

Collas was also in Charleston, executing miniatures of very high quality in which the subjects were often placed against elaborate landscape backgrounds. He was back in New York in 1820, then worked in New Orleans from 1822 to 1829. He is probably the Collars whose pair of miniatures was exhibited about 1825 at Peale's Baltimore Museum. Collas is often confused with his son, Louis Augustin Collas, a painter of miniatures who exhibited at the Paris Salon in 1831 and 1833.

Collas's technique is characterized by the use of a rather dry pigment applied in carefully delineated, meticulous strokes. He often employed an opaque gray background enlivened by brightly colored, decorative details in the French tradition. He is unsurpassed in his ability to render an elaborate background without detracting from the subject.

40. *Lady*

1816
Watercolor on ivory, 2¾ x 2³⁄₁₆ in. (7 x 5.5 cm)
Signed and dated at lower left edge: *Collas / 1816*
Casework: modern
EX COLL.: purchased from Edward Sheppard, New York

Colorplate 20b

JOHN SINGLETON COPLEY

(1738–1815)

America's foremost painter of the eighteenth century, Copley was born in Boston, the son of Anglo-Irish immigrants. His father died while Copley was still a boy, and in 1748 his mother married Peter Pelham (1697–1751), an engraver and painter. Although Pelham died only three years later, he had by then exposed his stepson to a studio busy with artistic activity. At thirteen Copley took up engraving, copying portraits by Joseph Badger (1708–1765), John Smibert (1688–1751), Robert Feke (ca. 1705–ca. 1750), and John Greenwood (1727–1792), and by the age of sixteen he had established himself in Boston as a professional painter. The painter Joseph Blackburn arrived in town in 1755; within three years Copley had fully assimilated his masterly costume-painting technique and elegant rococo style.

In 1766 Copley submitted a portrait of his half-brother Henry Pelham, *Boy with a Squirrel* (Museum of Fine Arts, Boston), to the Society of Artists in London. Benjamin West and Sir Joshua Reynolds praised the work and advised Copley to come to Europe, but he declined, for he was enjoying remarkable success in Boston. He had developed his own penetrating style of portraiture utilizing strong side lighting and clear modeling, and notable for its directness. This approach enabled him brilliantly to capture on canvas the characters of the pre-Revolutionary Bostonians who were his subjects. He followed the portrait of Pelham with a similarly composed portrayal of the silversmith Paul Revere, painted 1768–70 (Museum of Fine Arts, Boston). During this time Copley was also mastering the painstaking mediums of pastel on paper and watercolor on ivory. His two most successful works in these mediums, both striking self-portraits, were executed in 1769 (see below).

Copley married Susanna Farnham Clarke, the daughter of a prominent Boston merchant, in that year. By 1774 troubled political conditions in Boston prompted his departure for Europe; he toured the Continent and then settled with his wife and children in England. There he took up history painting and adopted a new

style which was less linear than his American style, more tonal and dramatically brushed. He remained in England until his death.

Copley was one of the first practitioners of miniature painting in America; he taught himself the art by carefully copying examples in the English tradition. In relation to his total output his miniatures were few, all executed in the years 1755–70 and all in the Boston area. His early works, some thirty in number, are painted in oil on copper and measure three to six inches in height. Then, yielding to the vogue at that time in London to adopt the use of ivory as a support, Copley produced about fifteen tiny watercolors on ivory, approximately one inch high, during the 1760s. All of these small works, like Copley's paintings in the large, combine intense realism, strong contrasts in value, and vivid color.

41. *Self-portrait*

1769
Watercolor on ivory, 1⁵⁄₁₆ x 1¹⁄₁₆ in. (3.3 x 2.7 cm)
Signed and dated lower right: *I S C* [monogram] *1769*
Casework: gold with burnished bezel, probably made by Paul Revere. (Revere noted in his record book that between January 8, 1763, and September 3, 1767, he made nine gold or silver cases and glass lenses for Copley's miniatures. Since Copley was working on Revere's portrait until 1770, it seems likely that Revere continued to make his cases.)
RELATED WORKS: *Self-portrait*, pastel on paper, 23¾ x 17½ in. (Henry Francis du Pont Winterthur Museum, Winterthur, Delaware); unsigned replica painted in England, watercolor on ivory, 1⁵⁄₈ x 1¼ in. (4.1 x 3.2 cm), mounted in silver and paste case (Museum of Fine Arts, Boston; Gift of Copley Amory)
REFERENCES: Frank W. Bayley, *The Life and Works of John Singleton Copley* (Boston: The Taylor Press, 1915), p. 84; Bolton, 1921, p. 29, no. 8, ill. facing p. 7; Wehle, 1927, p. 25, pl. IX; Frank W. Bayley, *Five Colonial Artists* (Boston: privately printed, 1929), ill. p. 165; Frederic Fairchild Sherman, "John Singleton Copley as a Portrait Miniaturist," *Art in America* 18 (June 1930), p. 211, ill. p. 209; Sherman, 1932, pl. LIV; Barbara N. Parker and Anne B. Wheeler, *John Singleton Copley: American Portraits* (Boston: Museum of Fine Arts, 1938), pp. 243–44, pl. 129; Jules David Prown, *John Singleton Copley in America 1738–1774* (Cambridge, Mass.: Harvard University Press, 1966), vol. 1, pp. 68, 212, pl. 250; Barbara N. Parker, "New England

Miniatures," *Antiques* 74 (September 1958), p. 239, ill. p. 237
EXHIBITED: National Gallery of Art, Washington, D.C., *Early American Paintings and Miniatures*, no. 45, exh. cat. p. 20; MMA, 1927, *Miniatures Painted in America 1720–1850*, exh. cat. p. 23, ill. p. 82; Museum of Fine Arts, Boston, 1938, *John Singleton Copley*, no. 92, exh. cat. pp. 10, 30, cover ill.; Museum of Fine Arts, Boston, 1957, *New England Miniatures 1750 to 1850*, no. 44, exh. cat. pp. vi, 9–11, ill. n.p., figs. 1, 12; Yale University Art Gallery, 1976, *American Art: 1750–1800, Towards Independence*, no. 16, exh. cat. pp. 79, 80, 278, ill.; National Portrait Gallery, Washington, D.C., 1987, *American Colonial Portraits 1700–1776*, exh. cat. no. 76, ill. pp. 215, 239; Hirschl & Adler Galleries, New York, 1979, *Recent Acquisitions of American Art, 1769–1938*, exh. cat. no. 1, ill.
EX COLLS.: John Singleton Copley; his daughter, Mrs. Gardiner Greene, Boston; her grandson, the Rev. John Singleton Copley Greene, Sr., Boston; his daughter, Mary Amory Copley Greene, Boston; her nephew, Henry Copley Greene, Cambridge; his daughter, Katrine Rosalind Copley Greene, New York; her sister, Mrs. Gordon Sweet (on loan to the Museum of Fine Arts, Boston, 1971–72, and to Yale University Art Gallery, New Haven, 1972–78); purchased from Hirschl & Adler Galleries, New York, 1979

Colorplate, frontispiece

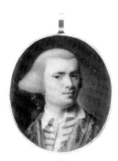

41

In 1769 Copley created his earliest self-portraits that survive, a full-size pastel (in the Winterthur Museum) and its minute replica, this watercolor on ivory. A brilliant painting, it reflects Copley's self-esteem, which was reinforced by his early artistic success, his marriage in that year to the daughter of a wealthy Loyalist merchant, and his acquisition of an elegant home on Beacon Hill. Arresting eye contact intensifies this portrayal of a stylish and hand-

some young gentleman. By means of delicately stippled layers of transparent color, Copley achieves an extraordinary appearance of three-dimensionality. Within a blue overall tonality there are striking details of intense color: a bright blue damask banyan with purple facing, a waistcoat striped in red and yellow, rosy lips and cheeks. The background, a dark monotone, subtly shades from dark olive to a lighter gray-green. The portrait's small size accords with the taste then prevalent in England.

THOMAS SEIR CUMMINGS

(1804–1894)

Thomas Seir Cummings was born in Bath, England, and was brought to New York as a child. In his father's shop of artists' supplies, customers who noticed the boy's talent persuaded his father to send him to a drawing school run by John Rubens Smith (1775–1849). In 1821 Cummings became a student of HENRY INMAN, who taught him to paint oil portraits and min-

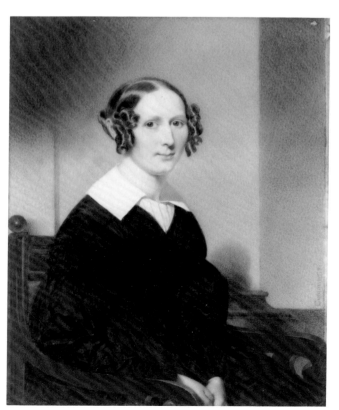

iatures. At the end of three years Inman took him into partnership; some miniatures from that period bear their joint signatures. After 1827 Inman began to devote himself exclusively to oil painting, "leaving Cummings the best-instructed miniature painter then in the United States" (Dunlap, 1834, vol. 2, p. 400). Cummings became the most successful and prolific miniaturist of the second quarter of the nineteenth century.

Cummings had also studied at the troubled American Academy of the Fine Arts, whose antiquated teaching policies inspired him to join SAMUEL F. B. MORSE and others in founding a new school. In 1826 this became the National Academy of Design, where he remained an active member: he exhibited there annually from 1826 to 1852, served as treasurer in the years 1827–65, and was a vice president 1850–59. After 1851 much of Cummings's career was devoted to teaching and writing. He taught miniature painting and drawing at the National Academy's school for over thirty years beginning in 1831, conducted his own successful school of design, and was elected Professor of the Arts of Design at the College of the City of New York. Cummings wrote an important history of the early years of the National Academy, which was published in 1865. His informative essay "Practical Directions for Miniature Painting" appeared in William Dunlap's history of American design (1834, vol. 2, pp. 10–14). It begins with a statement that summarizes his own style: "Works in miniature should possess the same beauty of composition, correctness of drawing, breadth of light and shade, brilliancy, truth of colour, and firmness of touch, as works executed on a larger scale." Many of Cummings's miniatures are handled exactly like full-size portraits.

Like those of his mentor, Henry Inman, Cummings's miniature portraits are technically flawless and often psychologically perceptive. Although Cummings, a precise painter, lacked the painterly freedom of Inman, he achieved lively, charming effects by his use of striking contrast and brilliant color. (For an illustration of Cummings's technique, see p. 19.)

Cummings's sketchbook, which contains 106 preparatory drawings for miniatures, is owned by the New-York Historical Society.

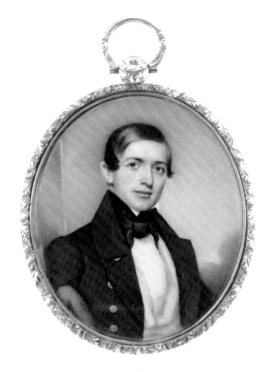

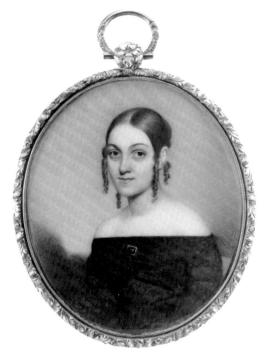

43

44

42. *Catherine Navarre Macomb Cammann*

Watercolor on ivory, 4³⁄₁₆ x 3⁵⁄₁₆ in. (10.5 x 8.5 cm)
Signed at right edge: *Cummings*
Casework: hinged brown leather with ormolu mat
(not shown)
Ex colls.: sale, Sotheby Parke-Bernet, New York,
Jan. 29, 1986, lot 143; purchased from Edward
Sheppard, New York

Colorplate 17

Catherine Navarre Macomb was the daughter
of John Navarre and Christina Livingston Ma-
comb. She married Oswald John Cammann, a
New York banker, in 1829. Portrait miniatures
of their four children, also painted by Cum-
mings, were exhibited at the National Academy
of Design in 1843 as no. 371, listed as belong-
ing to O. Cammann.

43. *Mr. McKinley*

Watercolor on ivory, 2⅝ x 2³⁄₁₆ in. (6.8 x 5.6 cm)
Casework: gilded copper with chased bezel and
hanger; on reverse, chased bezel framing
compartment containing braided hair; fitted
brown leather case (not shown). Backing paper
is cut from a New York newspaper.
Ex colls.: with C. W. Lyon, Inc., New York, 1944;
with E. Grosvenor Paine, New Orleans;
purchased from Edward Sheppard, New York

Colorplate 16a

This miniature and the one that follows came
down from previous owners identified as por-
traits of Mr. and Mrs. McKinley. They were
painted sometime around 1840, a period when
two marriages of McKinleys were recorded in
New York City: Augustus C. McKinley married
Ann Eliza Johnson and Samuel A. McKinley
married Margaret Ann Caldwell, both in 1839.

Catalogue nos. 43 and 44 are companion pieces.

44. *Mrs. McKinley*

Watercolor on ivory, 2¾ x 2¼ in. (7 x 5.8 cm)
Casework: as for cat. no. 43
Ex colls.: as for cat. no. 43

Colorplate 16b

45. *Margaretta*

Watercolor on ivory, 2¼ x 1¹¹⁄₁₆ in. (5.6 x 4.2 cm)
Casework: gold; reverse engine turned, with
compartment containing braided hair and
medallion engraved: *Margaretta*
Ex coll.: sale, Sotheby Parke-Bernet, New York,
Jan. 29, 1976, lot 224

Miniatures were most commonly painted on
the occasion of marriage, when they were often
exchanged, and of death, when they served as
a final remembrance. This miniature of Mar-
garetta was evidently painted after the subject's

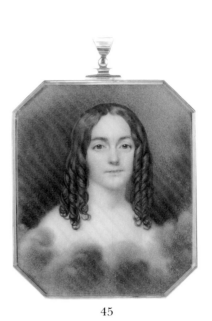

45

46

death, which is symbolized by the clouds surrounding her.

46. *Gentleman*

Watercolor on ivory, 2¼ x 1¹¹⁄₁₆ in. (5.6 x 4.2 cm)
Casework: gold with chased hanger; reverse engine turned, with compartment containing braided hair
Ex coll.: sale, Sotheby Parke-Bernet, New York, Jan. 29, 1976, lot 230

This miniature and the one of Margaretta (cat. no. 45), which were purchased together and have similar frames, probably represent members of the same family.

47. *Gentleman*

Watercolor on ivory, 3³⁄₁₆ x 2⅝ in. (8.2 x 6.7 cm)
Signature incised at right edge: *Cummings pinx*
Casework: gilt wood (not shown)
Ex coll.: purchased from Edward Sheppard, New York, 1983

THOMAS DAWSON

(ca. 1800–after 1850)

Born in Ireland, Thomas Dawson came to the United States about 1825 and settled in Cincinnati. In 1841 he exhibited seven miniatures at the Cincinnati Academy. He remained in Cincinnati with his wife and two children until at least 1850.

48. *Gentleman*

1844
Watercolor on ivory, 2⁹⁄₁₆ x 2¹⁄₁₆ in. (6.6 x 5.2 cm)
Inscribed on backing paper: *Painted by Thomas Dawson / Cinc'ati 1844*
Casework: gilded copper with beaded bezel; on the

47

48

reverse, similar bezel framing compartment
containing braided hair on background of black
fabric
Ex COLLS.: with E. Grosvenor Paine, New Orleans;
sale, Sotheby Parke-Bernet, New York, Jan. 29,
1986, lot 181

ANSON DICKINSON

(1779–1852)

Anson Dickinson was born in Milton, Connect-
icut, the son of a carpenter. First apprenticed
to a silversmith in nearby Litchfield, Dickinson
also tried his hand at enameling and sign or-
namentation. By 1802 he had established him-
self in New Haven as a miniature painter.
Dickinson began keeping a record book in
1803, and over the next forty-eight years doc-
umented about fifteen hundred miniatures.
He moved to New York in 1804; there EDWARD
GREENE MALBONE painted his miniature (Stam-
ford Historical Society), which subsequently be-
came a model for Dickinson's own early work.
Dickinson was often on the road in search
of commissions. Between 1810 and 1846 he
worked in Albany, New York City, Charleston,
Boston, Philadelphia, Baltimore, Washington,
D.C., New Haven, Litchfield, Buffalo, and
parts of Canada, in that order, and also made

repeat visits. He exhibited at the Pennsylvania
Academy of the Fine Arts, the National Acad-
emy of Design and the American Academy of
the Fine Arts in New York, and the Boston
Athenaeum.

Among Dickinson's sitters were Edward
Livingston, Stephen Van Rensselaer, William
Wirt, and Sam Houston. In 1823 Gilbert Stuart
(1755–1828) paid Dickinson the compliment of
asking him to take his likeness (New-York His-
torical Society).

Dickinson's best works, painted early in
his career but after 1804, are so similar to
Malbone's in their delicate modeling technique
and use of soft colors that works by the two
artists are often confused. Later on, Dickinson's
brushwork became increasingly broad and
loose, and his coloring tended toward a suf-
fused pinkish hue. His early works are oval in
format; after 1820 they are usually rectangular.
Dickinson frequently included his trade card in
the case behind the ivory or had its contents
printed on the silk lining of the leather case.
The design of the card was his own, and he
changed it as his address changed, a fact that
has proved helpful in dating his miniatures.
(For an illustration of Dickinson's technique,
see p. 19.)

49. *William Burrows*

ca. 1807–13
Watercolor on ivory, 2⅞ x 2¼ in. (7.3 x 5.7 cm)
Engraved trade card used as backing: *A Dickinson /
Miniature Painter / No. 158 Broad-Way New York.*
Dickinson used trade cards of this design
between 1807 and 1813.
Casework: gilded copper with chased bezel and
hanger
Ex COLLS.: sale, Christie's, New York, Dec. 12,
1980, lot 513; purchased from Edward
Sheppard, New York

William Burrows (1785–1813) was the son of
Lieutenant Colonel W. W. Burrows, first com-
mandant of the United States Marine Corps.
Burrows himself was a naval officer from Phil-
adelphia. He commanded the *Enterprise* in
1813 and was mortally wounded in battle
against the British.

49

51

50

52

50. *Gentleman with a Pleated Stock*

Watercolor on ivory, 2¾ x 2¼ in. (7 x 5.7 cm)
Casework: gilded copper with beaded bezel; on the
 reverse, compartment containing plaited hair
Ex COLL.: sale, Sotheby Parke-Bernet, New York,
 Feb. 18, 1982, lot 566

Colorplate 10a

51. *Mrs. George Burroughs* (Mary Fullerton)

Watercolor on ivory, 3½ x 2⁷⁄₁₆ in. (9 x 6.2 cm)
Casework: modern
Ex COLLS.: Harry Fromke, New York; sale,
 Christie's, New York, Oct. 18, 1986, lot 401

Colorplate 10b

Mary Fullerton (1761–1833) married George
Burroughs, an executive of Union Bank of
Boston, in 1780.

52. *Gentleman*

1838
Watercolor on ivory, 3 x 2½ in. (7.7 x 6.4 cm)
Signature and date incised at lower right: *A
 Dickinson, 1838*
Casework: modern
Ex COLL.: purchased from Edward Sheppard, New
 York, 1983

DANIEL DICKINSON

(1795–ca. 1866)

The younger brother of ANSON DICKINSON,
Daniel was born in Litchfield, Connecticut.
Sometime around 1812 he moved to New
Haven, where he studied drawing with the
brothers Nathaniel (1796–1881) and Simeon
Smith Jocelyn (1746–1823). In 1818 he moved
to Philadelphia and worked there as a portrait
and miniature painter until 1846. Dickinson
exhibited annually at the Pennsylvania Acad-
emy of the Fine Arts and regularly at the Art-
ists' Fund Society. He had plentiful work in
Philadelphia until the rapid development of
photography cut into his practice. In 1847 he
settled in Camden, New Jersey, where he even-
tually turned to horticulture.

Although Daniel's miniatures are often mis-

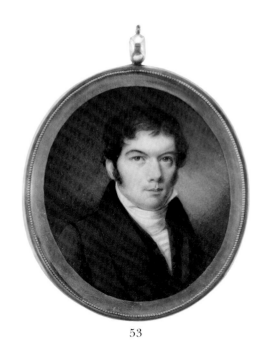

53

taken for the work of his brother, their tech-
niques differ. Daniel worked with a broader
and more painterly brushstroke than Anson;
the effect is a freer, less controlled rendering
of hair and clothing. Faces are strongly mod-
eled, with deep contrasts between illuminated
and shadowed areas.

53. *Mr. Hagner*

Watercolor on ivory, 2⁵⁄₁₆ x 1⅞ in. (5.9 x 4.9 cm)
Casework: gilded copper with beaded bezel and
 fillet under glass; on the reverse, compartment
 containing locks of hair
EXHIBITED: New-York Historical Society, 1934
Ex COLLS.: with Edmund Bury, Philadelphia,
 1932; Erskine Hewitt; sale, Parke-Bernet, New
 York, Oct. 21, 1938, lot 821; purchased from
 E. Grosvenor Paine, New Orleans

54. *Charles Leland*

1822
Watercolor on ivory, 2⁹⁄₁₆ x 2¹⁄₁₆ in. (6.5 x 5.2 cm)
Casework: gilded copper with beaded bezel; on the
 reverse, compartment containing lock of hair
Ex COLLS.: sale, Sotheby Parke-Bernet, New York,
 Dec. 16, 1982, lot 288; purchased from Edward
 Sheppard, New York

Colorplate 10c

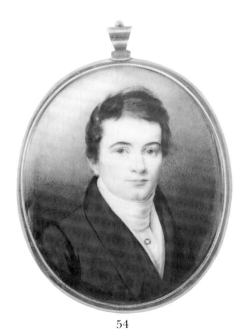

54

Charles Leland was born in 1792 in Philadelphia, where he later was a successful commission merchant. He married Charlotte Godfrey and they had four children, one of whom, Charles Godfrey Leland, became a prominent writer.

55. *Gentleman*

1822
Watercolor on ivory, 2⅝ x 2¹⁄₁₆ in. (6.6 x 5.2 cm)
Inscribed on backing paper: *Painted by / Dickinson at / Earle's Gallery / May 1822*

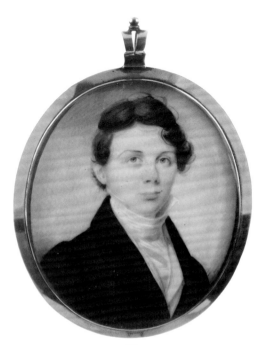

55

Casework: gilded copper with plain bezel; on the reverse, compartment containing lock of hair mounted on black fabric
Ex coll.: purchased from Frank S. Schwarz & Son, Philadelphia, 1984

EDWARD SAMUEL DODGE

(1816–1857)

Edward Dodge, the younger brother of JOHN WOOD DODGE, was born in New York City. He was probably instructed by his brother, whose lead he followed; by 1836 he was exhibiting miniatures at the National Academy of Design. The following year he struck out on his own, moving to Poughkeepsie, where he worked until 1842. In 1844 Dickinson was painting miniatures in Richmond, Virginia, and in the years 1850–54 he lived in Georgia and is known to have worked in Augusta, Athens, and Penfield. During that time he exhibited twice in nearby Charleston at the South Carolina Institute, where he won an award for best miniature and two silver medals. In 1856, his health deteriorating, Dodge moved with his family to his brother's hometown on Cumberland Mountain in Cumberland County, Tennessee. He died of consumption (tuberculosis) at the age of forty-one.

Although Dodge was influenced early on by his brother's virtuoso brushwork and bright palette, his work soon became precise, dry, and almost monochromatic, in imitation of the effects of photography.

56. *William Henry Tallmadge*

1841
Watercolor on ivory, 2⅜ x 1⅞ in. (6 x 4.8 cm)
Inscribed on backing paper: *Painted by / Edw. S. Dodge / Miniature Painter / Pokeepsie / Likeness o / Wm H Tallmadge D.[utchess] C.[ounty] N.Y. / of Pokeepsie / Apl 5th / 41.*
Casework: gilded copper with chased bezel and hanger; reverse machine turned, with chased bezel framing compartment containing lock of hair
Ex colls.: with E. Grosvenor Paine, New Orleans; sale, Sotheby Parke-Bernet, New York, Jan. 29, 1986, lot 136

William Henry Tallmadge was born in Pough-keepsie, New York, in 1813. He graduated from Rutgers College in 1836 and became an iron and steel merchant in his hometown. He married Isabella Montgomery on May 20, 1841; the miniature, painted a month before, was probably made for her.

57

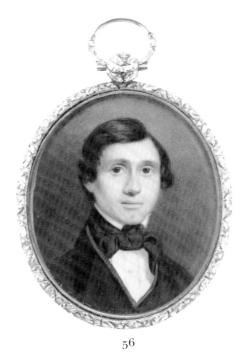

56

57. *John Wood Dodge*

Watercolor on ivory, 3 x 2½ in. (7.6 x 6.3 cm)
Casework: hinged leather with metal mat and
 exterior protector (partially shown)
Stamped on mat, lower right: *E. S. Dodge / Artist*
Ex colls.: the artist's descendants; purchased
 from Frank S. Schwarz & Son, Philadelphia,
 Dec. 1980

JOHN WOOD DODGE was the artist's older brother. This portrait was probably painted during the period 1836–42, when the two brothers were established in New York.

58. *Gentleman*

Watercolor on ivory, 2⅝ x 2³⁄₁₆ in. (6.8 x 5.6 cm)
Casework: modern
Ex colls.: the artist's descendants; sale, Sotheby
 Parke-Bernet, New York, Nov. 19, 1980, lot 243

58

59

59. *Gentleman*

Watercolor on ivory, 3³⁄₁₆ x 2¹¹⁄₁₆ in. (8.2 x 6.9 cm)
Casework: modern
Ex colls.: as for cat. no. 58

JOHN WOOD DODGE

(1807–1893)

John Wood Dodge was born in New York. His father, a goldsmith and watchmaker, apprenticed the boy to a tinsmith at the age of sixteen. While painting designs and trademarks on tin boxes, young Dodge discovered his artistic bent. For two years he practiced drawing at the National Academy of Design. Lacking the means to take classes in painting, he taught himself by copying a miniature he had borrowed from a friend, and within a short time he had established himself as a miniature painter. He first exhibited at the Academy in 1829; by 1832 he had become an associate.

Dodge found constant employment in New York, but in 1841 frail health required him to move south. He settled in Nashville, where he was commissioned to paint miniatures of Andrew Jackson and Henry Clay. In 1848 he acquired land in the Cumberland Mountains of Tennessee and began to cultivate several thousand acres of fruit orchards. In the years between 1838 and 1861 Dodge moved about frequently in Alabama, Tennessee, Kentucky, Louisiana, and Mississippi, turning out the skilled miniature likenesses that were in demand. Beginning in the early 1850s he also took up photography. When the Civil War broke out in 1861, Dodge returned to New York; in 1870 he moved to Chicago. In 1889 he returned to his mountain home in Tennessee, where he died at the age of eighty-six.

From 1828 to 1864 Dodge kept a highly detailed record book in which he documented over eleven hundred miniatures, often noting, in addition to more standard information, the subject's hometown (a copy of the record book is in the Archives of American Art, New York; the original belongs to a descendant). His carefully detailed portraits are direct, sprightly, and highly accomplished. The backgrounds are finely stippled, either of light brown or with striations of high-key pink, green, and blue to resemble sky. Characteristic of Dodge's technique is a thumbprint-shaped shadow which often appears to the right of the subject.

60

60. *James O. Owens*

1832
Watercolor on ivory, 2�5⁄16 x 1⅞ in. (5.9 x 4.8 cm)
Inscribed on backing card in graphite: *By / J. W.
 Dodge / Miniature Painter / No. 82 Franklin St. /
 New Yorke / Nov. 1832 Jas O. Owens*
Casework: gilded copper with chased bezel and
 hanger with multicolored gold appliqués; on the
 reverse, compartment for hair

61. *The Reverend William Lupton Johnson*

1834
Watercolor on ivory, 1⅝ x 1�5⁄16 in. (4.2 x 3.3 cm)
Inscribed on backing card: *Painted by John W. Dodge
 / Miniature Painter / No 485 Pearl St / New York /
 Oct 23, 1834 / Wm L. Johnson*
Casework: gilded copper with chased bezel and
 hanger; on the reverse, chased bezel framing
 compartment containing plaited hair
Ex colls.: sale, Sotheby Parke-Bernet, New York,
 Oct. 13, 1978, lot 439; with E. Grosvenor Paine,
 New Orleans; sale, Sotheby Parke-Bernet, New
 York, Jan. 29, 1986, lot 136

This miniature is recorded in the artist's record
book for 1834: "Sept. Rev. W.L. Johnson /
Jamaica L. Island 40.00." William Lupton
Johnson (1800–1870) was born in Albany,
graduated from Columbia University in 1819,

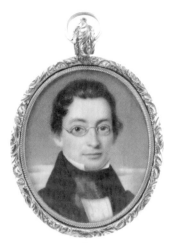

61

and in 1830 became rector of Grace Church in
Jamaica, New York, where he remained until
his death.

62. *Edward S. Dodge*

1835
Watercolor on ivory, 3¾ x 3¼ in. (9.5 x 8.2 cm)
Inscribed on backing paper: *Painted by John W.
 Dodge Likeness / brother Edward S. Dodge / Apl.
 1835. New York.*
Casework: modern
References: *The New York Mirror*, June 13, 1835, p.

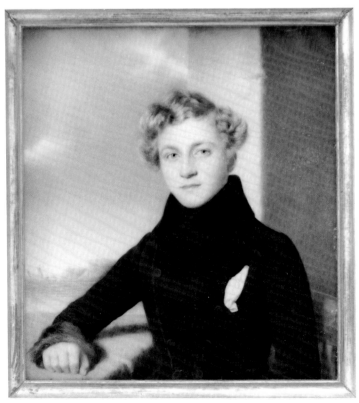

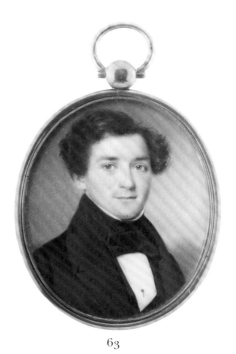

63

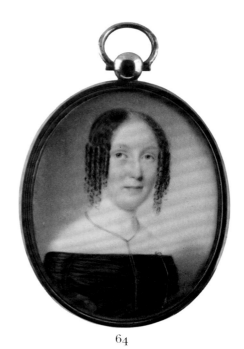

64

395: ". . . a truly fine specimen of Mr. Dodge's skill, and raises him several degrees higher than his former standing in his profession."
EXHIBITED: National Academy of Design, New York, 1835, no. 128
EX COLL.: purchased from Frank S. Schwarz & Son, Philadelphia, Dec. 1980

Colorplate 24c

This miniature is entered in Dodge's record book: "Painted Miniature (Square) of My brother / Edward for the Academy April 1835 J.W.D." It is also listed in his record book of miniatures exhibited at the National Academy of Design: "1835 One Large square miniature of my brother / Edward S. Dodge. With over coat & showing one hand. This picture was pronounced by Mr Ingham, the portrait painter and the City News papers to be the best miniature in the Acady this year." (See EDWARD SAMUEL DODGE.)

63. *Mr. A. L. Clements*

1838
Watercolor on ivory, 2⅜ x 1⅞ in. (6 x 4.8 cm)
Inscribed on backing paper: *Painted by / John W. Dodge / Miniature Painter / 52 White St. / New York / July 31st 1838 / Likeness of / Mr A. L. Clements*
Casework: gilded copper with beaded bezel; reverse engine turned, with chased bezel framing hair compartment and medallion engraved: *A. L. C. to M. L. W. August 1st 1838*

EX COLLS.: Anne Orr, Nashville, to 1944; sale, Sotheby Parke-Bernet, New York, July 17, 1984, lot 65/2

This miniature is recorded in Dodge's record book for 1838: "July 31 Mr. A. L. Clements / oval from Texas American Hotel 60.00." (A. L. Clements was from Matagorda, Texas.) An entry for October 20, 1838, reads: "Repaired Mr. A. L. Clements miniature, soil'd round the edge by perspiration."

Catalogue nos. 63 and 64 are companion pieces.

64. *Mary Louisa Wells Clements*

1838
Watercolor on ivory, 2½ x 2 in. (6.4 x 5 cm)
Inscribed on backing paper: *Painted by / John W. Dodge / Miniature Painter / 52 White Street / New York / Oct. 18th 1838 / Likeness of / Mrs. A. L. Clements*
Casework: gilded copper with beaded bezel; reverse engine turned, with chased bezel framing hair compartment and medallion engraved: *M L C to A L Clements*
EX COLLS.: as for cat. no. 63

This miniature is recorded in Dodge's record book for 1838: "Oct. 20 Ms Mary Clements oval 21st & 9th Avenue 60.00." Mary Louisa Wells was the daughter of James N. Wells of New York. She married A. L. Clements on August 8, 1838.

65. *Gentleman Wearing a Black Cape*

Watercolor on ivory, 2⅝ x 2⅛ in. (6.7 x 5.5 cm)
Inscribed on backing card: *Painted by / J W Dodge / Miniature Painter / No 82 Franklin St / New York Mar / 18*[illegible]. Between the first two lines of the inscription is a three-quarter-length sketch of a woman, in graphite.
Casework: gilded copper with beaded bezel; on the reverse, hair compartment
Ex COLL.: purchased from Edward Sheppard, New York

Colorplate 24b

66. *Lady of the Wiltsie Family*

Watercolor on ivory, 2¹³⁄₁₆ x 2¼ in. (7.1 x 5.6 cm)
Inscribed on backing card: *By / J W Dodge / Miniature / Painter / No. 82 Franklin St. / New York.* On reverse of card: *Wiltsie / Babylon, L.I.*
Casework: gilded copper with chased bezel and hanger; on the reverse, chased bezel framing

compartment containing plaited hair; fitted red leather case (not shown)
Ex COLL.: purchased from Edward Sheppard, New York

Colorplate 24a

The Wiltsie family of Long Island descends from Hendrick Martenson Wiltsee, who emigrated from Copenhagen. The subject of this portrait appears to be in mourning: her eyes averted and her expression sad, she wears a black dress with jet earrings and necklace. A miniature, perhaps of her lost loved one, is attached to her necklace and tucked into her sash.

67. *Lady with Tortoiseshell Comb*

Watercolor on ivory, 2¹³⁄₁₆ x 2¼ in. (7.2 x 5.8 cm)
Casework: gilded copper

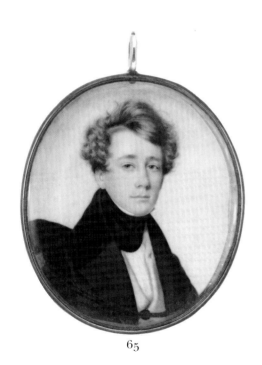

65

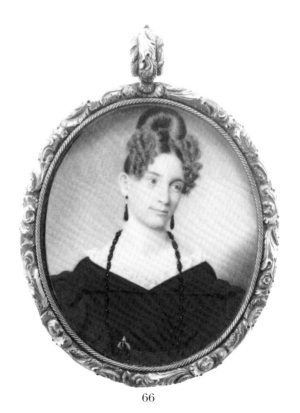

66

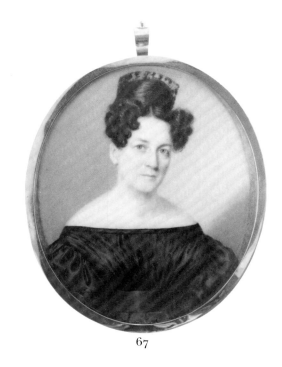

67

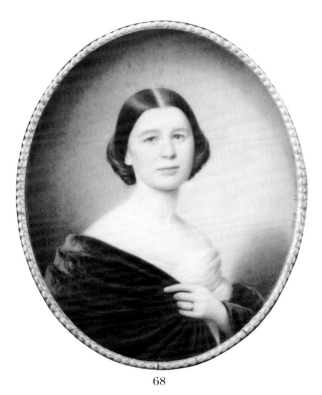

68

Ex colls.: with E. Grosvenor Paine, New Orleans; sale, Sotheby Parke-Bernet, New York, Jan. 29, 1986, lot 109; purchased from Edward Sheppard, New York

68. *Mrs. Annie C. Hyde*

1863
Watercolor on ivory, 3 9/16 x 2 7/8 in. (9.2 x 7.3 cm)
Inscribed on backing paper: *Painted on Ivory / John W. Dodge / Miniature Painter / 362 Broadway / Likeness of Mrs. Anna Hyde / Price $150.00 / Finished June 16th 1863*
Casework: wood and gilt wood (partially shown)
Ex coll.: art market, Sheffield, Massachusetts

This miniature is recorded in the artist's record book for 1863: "June 1. Mrs. Annie Hyde (ivory Case) 150.00 for Saml Robinson." Mrs. Annie C. Hyde is listed in the New York directories from 1855 until 1863 as a widow living at 84 Willoughby. Beginning in 1862 her occupation is listed as teacher. Samuel Robinson, who apparently commissioned this miniature, is listed between 1859 and 1863 at the same address as a teacher of English and the classics.

MRS. DOVE

Nothing is known of Mrs. Dove except that she was working as a miniaturist in Charleston, South Carolina, in 1844. The miniature of C. Louisa Foster, which is somewhat primitive in technique, suggests that Dove was a self-taught artist.

69. *C. Louisa Foster*

Watercolor on ivory, 3 5/16 x 2 11/16 in. (8.5 x 6.8 cm)
Casework: black papier-mâché; ormolu bezel and hanger with grape-and-vine-leaf design
Label on verso: *C. Louisa Foster / Mrs. Edwd Loyd*
Ex coll.: purchased from E. Grosvenor Paine, New Orleans

As is often the case, the label was added at a later date. An Edward Loyd is listed in the 1860 census for Charleston.

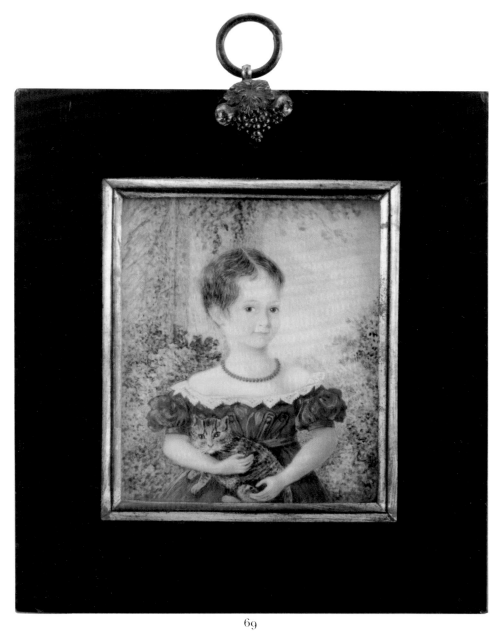

69

WILLIAM M. S. DOYLE

(1769–1828)

A silhouettist, miniature painter, and portraitist in pastel and oil, Doyle started out in 1794 manufacturing wallpaper in Boston. In 1800 he became associated with Daniel Bowen (ca. 1760–1856), who was proprietor of the Columbian Museum and also made wax portraits, silhouettes, and portrait miniatures. By 1803 Doyle had learned enough from Bowen to establish himself as a miniature painter and silhouettist. Bowen and Doyle entered into a partnership in 1806, and when the museum burned the following year they built new premises on Tremont Street. In the same year HENRY WILLIAMS joined the business. Soon thereafter, advertisements run by Williams and Doyle announced, "Miniature and Portrait Painters at the Museum; where profiles are correctly cut." They collaborated at least until 1815. Doyle became proprietor of the museum by 1808 and remained in business there until his death.

In Doyle's miniatures the subject, usually male, is placed left of center, facing right. The paint is applied in broad washes; shadows and folds are emphasized with gum. Doyle's early work was awkward and lacked modeling, but during his association with Williams he learned how to produce a more accurate and accomplished likeness.

70. *Gentleman*

1808
Watercolor on ivory, 2 13/16 x 2 5/16 in. (7.2 x 5.9 cm)
Signed and dated along lower right edge: *Doyle 1808*
Casework: modern
Ex COLL.: purchased from Edward Sheppard, New York

71. *Officer*

1814
Watercolor on ivory, 3 x 2 7/16 in. (7.6 x 6.1 cm)
Signed and dated along lower right edge: *Doyle 1814*
Casework: modern
Ex COLL.: sale, Sotheby Parke-Bernet, New York, Dec. 5, 1979, lot 680

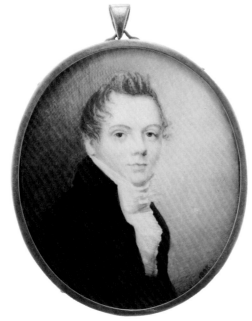

70

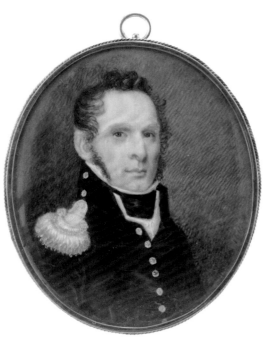

71

JOSEPH DUNKERLEY

(active 1784–88)

Little is known about the life of Joseph Dunkerley, who painted in Boston between 1784 and 1788. An advertisement in the Boston *Independent Chronicle* in December of 1784 announced that Dunkerley "carries on his Profession of Painting in Miniature at his home in the North Square." A second notice, on February 17, 1785, proclaimed his intention to start a drawing school with JOHN HAZLITT "as soon as a sufficient number of scholars apply . . . Miniature Pictures executed in the neatest manner." In Boston Dunkerley rented a house from the silversmith Paul Revere, who made gold miniature cases for JOHN SINGLETON COPLEY and probably for Dunkerley as well; one example is the beaded and deeply incised case that encloses Dunkerley's miniature of Mrs. Paul Revere (Museum of Fine Arts, Boston), painted about 1785. (The miniature was at one time attributed to Copley.) In 1788 or soon thereafter Dunkerley moved to Jamaica.

Dunkerley's miniatures, all no larger than two inches, are occasionally signed with the initials *I D*. Drawing is often inaccurate and somewhat tentative; faces, figures, and clothing are delicately modeled with a wiry, linear brushstroke; lips are thin and lightly defined. The miniatures are frequently confused with works by Copley because of their similar small size, early date, and casework; but Dunkerley's portraits, although charming documents, show nothing of the brilliance of Copley's.

72. *Eliza Champlin*

Watercolor on ivory, 1⅞ x 1½ in. (4.9 x 3.9 cm)
Casework: gold with bullet-shaped beaded edge; on reverse, brightwork border (case is attributed to Paul Revere)
Ex colls.: the granddaughter of the sitter, Mrs. Edward Holbrook, New York; her sister, Margaret Snelling; Erskine Hewitt; sale, Parke-Bernet, New York, 1938, lot 1006; Harry Fromke, New York; sale, Christie's, New York, Oct. 18, 1986, lot 376

Colorplate 4e

Eliza Champlin was the daughter of Christopher and Hanna Hill Champlin of Newport,

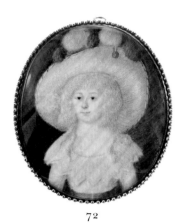

72

Rhode Island. In 1791 she married John Coffin Jones, a prominent Boston merchant.

73. *Gentleman*

Watercolor on ivory, 1¼ x ¹⁵⁄₁₆ in. (3.2 x 2.3 cm)
Casework: gold with burnished bezel

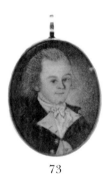

73

JOSEPH-SIFFRED DUPLESSIS

(1725–1802)

A French painter, Duplessis is included here because of his American sitter. He was born in Carpentras, France, and took his first painting lessons from his father, Joseph-Guillaume Duplessis, and a friar, Frère Imbert. In 1745 he went to Italy to study under Pierre Hubert Subleyras (1699–1749); on his return he opened a studio in Paris. Duplessis was appointed por-

traitist to Louis XVI and in that capacity also painted portraits of members of the court and other distinguished subjects. After the Revolution he became director of the galleries at Versailles, a post he held until his death. Although afflicted with poor eyesight, Duplessis was noted for his realistic paintings and for what one critic called "his effect of light on flesh accessories, by a free pencil, much feeling and correct coloring" (quoted in John Clyde Oswald, *Benjamin Franklin in Oil and Bronze* [New York: W. E. Rudge, 1926], p. 12). The few known miniatures by him are all of Benjamin Franklin.

74. *Benjamin Franklin*

1794
Watercolor on vellum, 3⅛ x 2⁷⁄₁₆ in. (8 x 6.2 cm)
Signed and dated: *Duplessis / 1794*
Casework: gold, with laurel and berry border of
green gold; goldsmith's stamps on reverse at
bottom edge
Ex colls.: M. G. de Montauzon, France; sale,
Christie's, London, Nov. 7, 1988, lot 60

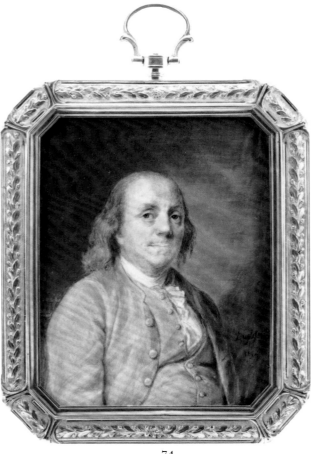

74

Duplessis painted at least two original full-size portraits of Benjamin Franklin (1706–1790) and made many replicas after them. The first large portrait was painted in 1778 for Le Ray de Chaumont, Franklin's host in Pasay, France; it is often referred to as the "fur collar" version (MMA). The second portrait Duplessis executed in pastel in 1783 for Franklin's friend Louis Veillard. Although based on the 1778 portrait, it shows less elaborate dress and is known as the "gray coat" version (New York Public Library). This miniature is a replica of that 1783 portrait.

JEAN PIERRE HENRI ELOUIS

(1755–1840)

Born in Caen, France, Elouis studied under the French painters Robert Lefèvre (1755–1830) and Jean Bernard Restout (1732–1797). He moved to London in 1783 and the following year entered the Royal Academy, winning a silver medal; he exhibited sixteen miniatures there between 1785 and 1787. About the time of the outbreak of the French Revolution, Elouis immigrated to America, where he called himself Henry Elouis and in 1791–92 worked in Alexandria, Annapolis, and Baltimore. Charles Willson Peale, who met him in Annapolis, later referred to "Mr. Loise . . . he paints in a new stile," and wondered "if this gentleman so cried up will do better than Mr. Pine [Robert Edge Pine, 1730–1788] whose reputation was equally cried up" (quoted in Sellers, 1962, p. 82). In 1792 Elouis moved to Philadelphia, where he opened a drawing school for young ladies and worked as a portrait and miniature painter until 1799. During that time "he gave instruction in drawing to Eleanor Custis [granddaughter of Martha Washington] and painted miniatures of Washington and of Mrs. Washington," according to Dunlap (1931, vol. 3, p. 298). His sitters also included General Anthony Wayne, whose portrait was later exhibited at Peale's New York Museum; its present location is unknown.

During the years 1799 to 1804 Elouis trav-

eled with the German scientist Alexander von Humboldt on his expedition to Mexico and South America, serving as draftsman. He returned to France in 1807; there, abandoning miniature painting, he exhibited portraits in oil at the Paris Salon from 1810 to 1819. Elouis was appointed curator of the Caen Museum in 1814 and worked there until his death. His miniatures are characterized by accurate drawing, bright, fresh color, and the use of a short, broad brushstroke.

Attributed to Jean Pierre Henri Elouis

75. *Martha Washington*

1793
Watercolor on ivory, 2½ x 2½ in. (6.4 x 6.4 cm)
Casework: gilded silver with rose-cut diamond
 border, engraved on the back: *Martha
 Washington / 1732–1802 / Henry Elouis, pinxt. /
 Philadelphia. / 1793*
REFERENCES: Bolton, 1921, p. 47; Wehle, *American
 Miniatures*, 1927, p. 34; Charles Henry Hart,
 "Anthony Wayne: Presentation of His Portrait
 to the Historical Society of Pennsylvania," *The
 Pennsylvania Magazine of History and Biography* 35
 (1911), pp. 257–63.
EX COLLS.: Lucy Wharton Drexel, Penrynn,
 Pennsylvania; her granddaughter, Mrs. Andrew
 Van Pelt, Radnor, Pennsylvania; sale, Christie's,
 London, Nov. 7, 1988, lot 45

The inscription on the case of this miniature has not convinced all scholars that it was painted by Elouis. Charles Henry Hart probably took his information from William Dunlap when he asserted that Elouis had painted portraits of George and Martha Washington while in Philadelphia; he attributed two miniatures of Martha Washington to Elouis. However, Harry Wehle, who correctly reattributed one from the Pratt collection to WALTER ROBERTSON, believed the miniature shown here to be of French workmanship but not by Elouis. Perhaps Wehle did not have many examples of Elouis's work to compare with this miniature, which in fact is very similar in pose, color, and technique to signed pieces by the artist.

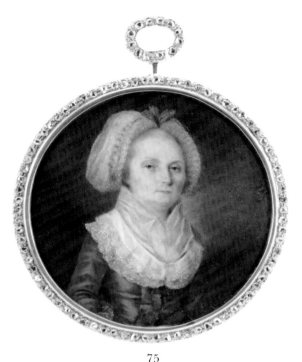

75

ROBERT FIELD

(ca. 1769–1819)

Robert Field was the most accomplished of the foreign-born miniaturists painting in America. Probably born in London, he enrolled in a drawing class at the Royal Academy in 1790, giving his age as twenty-one. From that period his only recorded works are mezzotint engraved portraits. Field arrived in Baltimore in 1794 and there became friendly with Robert Gilmor, an important patron and connoisseur. Through Gilmor he was introduced to the community's prominent citizenry, for whom he painted meticulous watercolor portraits and refined miniatures. But a few months later, after visiting New York, he settled in Philadelphia. Field shared living quarters there with WALTER ROBERTSON and J. J. Barralet (ca. 1747–1815); all three were engaged in the lucrative business of making images of George Washington after Gilbert Stuart.

Field produced excellent portrait engravings but was chiefly known as one of the country's leading miniature painters. From 1800 to 1805 he worked in the area of Washington, D.C., and Maryland; he was in Boston 1805–08. Perhaps because of mounting tension be-

tween the United States and England, Field, who had not been naturalized, moved to Halifax, Nova Scotia, in 1808. He was befriended by the royal governor, Sir John Wentworth, whose influence helped him obtain a steady flow of commissions to paint miniatures and portraits of the well-to-do. In 1816 he moved to Kingston, Jamaica, where he died of yellow fever three years later.

Field portrayed leading members of the new republic in a dignified English neoclassic manner. The skillfully modeled faces show strong characterization. Backgrounds are generally of a brown tonality, but sometimes Field used a blue sky motif and on occasion an elaborate red drape, pulled back to reveal an exterior view. The backgrounds are painted with short, slanted hatchings; the faces are modeled by means of fine curved and serpentine strokes. A characteristic of Field's work is the use of tiny white hatches highlighting the coat collars of male subjects. (For an illustration of Field's brushwork, see p. 18.)

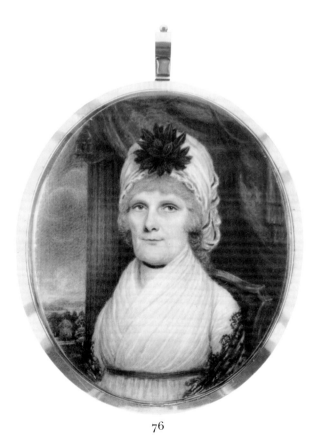

76

76. *Lady with a Red Drape*

Watercolor on ivory, 3⁵⁄₁₆ x 2¹¹⁄₁₆ in. (8.4 x 6.8 cm)
Casework: gilded copper; on the reverse, sheaf-of-wheat hair design with seed pearls on ground of white opalescent glass over machine-turned foil
Ex colls.: with E. Grosvenor Paine, New Orleans; sale, Sotheby Parke-Bernet, New York, Jan. 29, 1986, lot 162

Colorplate 7b and page 31, c

CHARLES FRASER

(1782–1860)

Charles Fraser was a lawyer, author, orator, and poet, but he is best remembered as the miniaturist who depicted Charleston's leading citizens. At an early age Fraser took some drawing lessons from the engraver and landscape painter Thomas Coram (1757–1811). His early sketches are theatrical drawings of stage sets, comical character studies, copies of travel book illustrations, and views of Charleston. His friends included the painters EDWARD GREENE MALBONE, Washington Allston (1779–1843), and THOMAS SULLY, who was a fellow student.

Fraser never went to Europe; with the exception of a few brief trips north, he rarely even left the city. He studied law at the College of Charleston, was admitted to the bar in 1807, and practiced law until 1818. Thereafter he devoted himself primarily to miniature painting, enjoying an active and distinguished career as Charleston's foremost miniaturist. His work satisfied the city's brisk market for sensitive, truthful likenesses. Between 1818 and 1846 Fraser documented 633 works in a record book (Carolina Art Association, Charleston; published in Severens and Wyrick, 1983, pp. 115–46; see bibliography for Fraser). In 1857 he was honored with a retrospective exhibition of his work, comprising miniatures, landscapes, still lifes, and sketches.

Fraser's earliest miniatures show the strong influence of his friend Malbone, who was painting in Charleston between 1801 and 1807. In these works Fraser copied Malbone's light palette and delicate cross-hatching. By the time

he reached the peak of his career he had developed his own style and was producing distinctive works, finely detailed and compelling in their characterizations, such as *Judge Thomas Waties*, 1820 (National Museum of American Art, Washington, D.C.), his *Self-portrait*, 1823, and *H. F. Plowden Weston*, 1824 (both, Carolina Art Association, Charleston), and *Francis Kinloch Huger*, 1825 (MMA). In these miniatures Fraser skillfully utilized a separate pattern of brushstrokes to define each element of the composition. Contours and shadowing of the flesh are executed with a unique mosaiclike pattern of stippling. A dark, curved stroke on the eyelid defines the crease above the eye. Backgrounds are often horizontally hatched, and fabric is rendered by either an applied wash or, for more textured cloth, a mottling technique. (For an illustration of Fraser's brushwork, see p. 18.)

The quality of Fraser's later work gradually declined, and he increasingly employed darker colors, a broadened brushstroke, and a conspicuous, mostly unvarying stipple. His early miniatures were oval in shape, the later ones rectangular; he generally mounted them in leatherette cases.

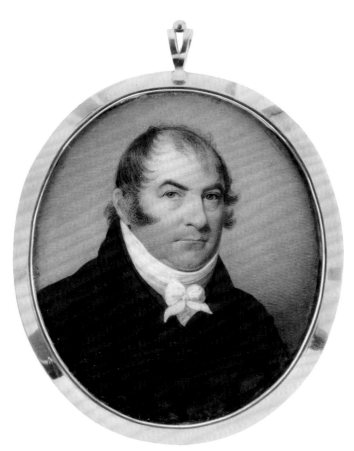

77

77. *Colonel James Elliott McPherson*

1819
Watercolor on ivory, 3 9/16 x 2 15/16 in. (9.1 x 7.5 cm)
Signed on left edge: *C F*; on backing paper: *C Fraser / fecit / 1819 / This paper must not be removed from the picture.*
Casework: modern; engraved on back: *Col. James E. MacPherson / of Charleston S.C. / 1819 / Charles Fraser / pinxit*
References: Bolton, 1921, p. 65; Carolina Art Association, *A Short Sketch of Charles Fraser and a List of Miniatures and Other Works*, exh. cat. Gibbes Art Gallery (Charleston, 1934), p. 31
Exhibited: Fraser Gallery, Charleston, 1857, *Works of Charles Fraser*, no. 214
Ex colls.: G. S. Manigault, Charleston; Lucy Wharton Drexel, Penrynn, Pennsylvania; her granddaughter, Mrs. Andrew Van Pelt, Radnor, Pennsylvania; sale, Christie's, London, Nov. 7, 1988, lot 55

Colorplate 13c

A replica of this miniature is in the collection of the Carolina Art Association, Charleston. In 1819 Fraser made a notation in his account book which refers either to the replica or to this miniature: "Col McPherson 50 [dollars]."

James McPherson (1769–1834) was born in Charleston to Isaac and Elizabeth Miles McPherson. The commanding officer of the South Carolina Militia, he was married to Elizabeth Skirving. He owned two plantations in Prince William's Parish.

78. *O'Brien Smith McPherson*

1823
Watercolor on ivory, 3 13/16 x 3 1/8 in. (9.7 x 7.9 cm)
Inscribed on backing paper: *Painted by Chs Fraser / May 1823 / Charleston / SC*
Casework: modern; engraved on back: *Isaac O'Brien MacPherson / of Charleston S.C. / 1823 / Charles Fraser / pinxit*
References: Alice R. Huger Smith and D. E. Huger Smith, *Charles Fraser* (New York: F. F. Sherman, 1924), p. 41, pl. 7b; Carolina Art Association, 1934 (see reference for cat. no. 77),

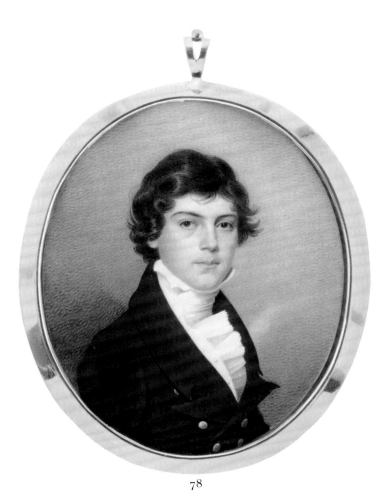

78

p. 31; Alice R. Huger Smith, "Charles Fraser," *Art in America* 23 (December 1934), pp. 23, 29 (as Master O'Brien McPherson); Bolton, 1921, p. 65, no. 205
EXHIBITED: Fraser Gallery, Charleston, 1857, *Works of Charles Fraser*, no. 215; Atlanta Cotton and International Exposition, 1895
EX COLLS.: as for cat. no. 77

Colorplate 13b

O'Brien Smith McPherson (1801–1835) was the son of Colonel James Elliott McPherson. Fraser listed this miniature in his account book for 1823: "Mr. McPherson 50 [dollars]."

The cases for this miniature and for cat. no. 77 are not original. They appear to be of the Centennial period, and the engraved inscriptions are most likely from the same period. Probably at that time the subject's first name was mistakenly recorded as Isaac; the error could have resulted from the existence of several other members of the family named Isaac McPherson.

Attributed to Charles Fraser

79. *Lady Making Lace*

Watercolor on ivory, 5⁵/₁₆ x 3¾ in. (13.5 x 9.5 cm)
Casework: modern (not shown)
EX COLL.: purchased from Alexander Gallery, New York, March 1989

Colorplate 12

This miniature is attributed to Charles Fraser on the basis of its very distinctive technique. The method of modeling in the flesh, including a certain signature hatch in the cheek, the stipple, rendering of contours around the chin, tightness of the bottom lip, shadow of the nose, and characteristic single stroke in forming the crease of the eyelid, are very close to the technique in Fraser's *Francis Kinloch Huger* (MMA), although in *Lady Making Lace* the stipple is somewhat finer. Horizontal strokes in the background of this work are identical to those in the stock in Fraser's *Powell Macrae* (MMA). *Lady Making Lace* is unsigned; there is water damage in the lower right corner, where a signature or initials might have been. The backing paper has been removed, with only remnants visible.

Lady Making Lace is elaborate in its composition, and the pose, dress, furnishings, and background curtain are in the style of Gilbert Stuart. It may have been copied after a full-size portrait. However, the spontaneous, alert expression, specificity of detail, and careful modeling all suggest firsthand observation.

AUGUSTUS FULLER

(1812–1873)

An itinerant painter of portraits and miniatures, Augustus Fuller was deaf and dumb. He was born in Brighton, Massachusetts, and moved at an early age to Deerfield; as the result of a severe childhood illness he lost his hearing. Fuller was educated at the American Asylum in West Brookfield, Connecticut. In April of 1832 he was in Chatham, Connecticut, painting portraits for ten dollars apiece and miniatures for two dollars; by July he and his father,

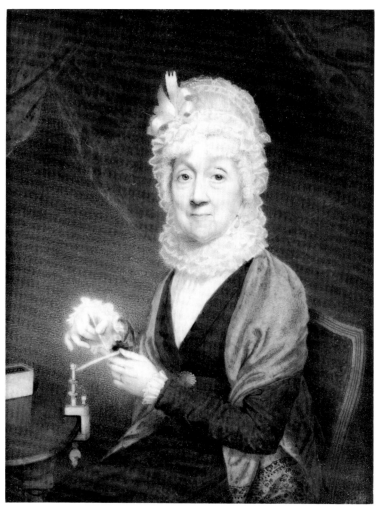

79

Aaron Fuller, were both executing portraits in Clinton, New York. Fuller may have studied briefly with the portraitist Chester Harding (1792–1866) in Springfield, Massachusetts. He worked in Boston between 1840 and 1844 and wrote to his family in Deerfield: "I am daily engaged in miniature painting . . . happily to record many days with glorious profession" (August 19, 1840; Archives of American Art, roll 611, frame 75). In 1845 he was painting in Fitchburg, receiving supplies of ivory from Boston sent by his half-brother George Fuller (1822–1884), also a painter. He worked in New Hampshire and Vermont as well.

Few of Fuller's works have been found; his known oil portraits are from an earlier, more primitive period than his documented miniatures. In these, features are delicately delineated, flesh and fabric are rendered with paint applied in transparent washes, and backgrounds are finely stippled in pale green.

80. *Mr. Pierce*

1843
Watercolor on ivory, 2⅜ x 2⅛ in. (6.7 x 5.4 cm)
Inscribed on backing paper: *Augustus Fuller, artist / 1843*
Casework: gilded copper with cast bezel and

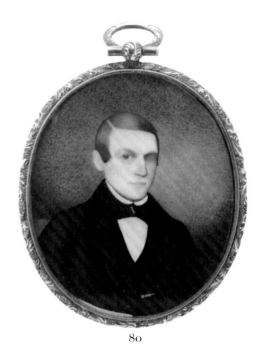

80

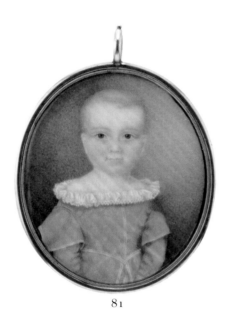

81

hanger; on the reverse, beaded bezel framing
compartment containing a lock of hair
Ex colls.: with E. Grosvenor Paine, New Orleans;
 sale, Sotheby Parke-Bernet, New York, Jan. 29,
 1986, lot 218

When this miniature was purchased, it was
identified only as the portrait of a brother of
Franklin Pierce, the fourteenth president of
the United States. The sitter appears to be
about thirty years old. Franklin Pierce had
three brothers; the only one who would have
been close to that age in 1843 is Henry D.
Pierce (1812–1880). He was born in Hillsbor-
ough, New Hampshire, and married Susan
Tuttle; they had two children. Fuller has por-
trayed Pierce with an eye missing, but the rea-
son for this has not been ascertained.

81. *Boy in Pink*

Watercolor on ivory, 2¼ x 1⅞ in. (5.7 x 4.7 cm)
Casework: gilded copper with beaded bezel; on the
 reverse, beaded bezel framing compartment
 containing hair of two colors
Ex colls.: John B. and Marjorie H. Schorsch, New
 York; sale, Sotheby Parke-Bernet, New York,
 May 1, 1981, lot 212; purchased from Edward
 Sheppard, New York

ROBERT FULTON

(1765–1815)

An artist, engineer, and inventor, Robert Ful-
ton was born in New Britain Township (now
Fulton), Pennsylvania. His family moved to
nearby Lancaster the following year. At the age
of ten he was making his own pencils and dem-
onstrating a genius for drawing. Shortly after-
ward he invented a skyrocket and became an
expert gunsmith. In 1782 Fulton went to Phil-
adelphia, where he worked for a silversmith,
drew landscapes, executed mechanical and ar-
chitectural drawings, and designed carriages.
He met CHARLES WILLSON PEALE and JAMES
PEALE and probably was instructed by them, for
in 1785 he established himself as a miniature
painter, working in a style similar to theirs. Dur-
ing the winter of 1786 he was in Petersburg,
Virginia, where he advertised his portraits,
miniatures, and hairwork and gold miniature
settings.

Later in 1786 Fulton left for England to
study with Benjamin West (1738–1820). Dur-
ing the years 1791–94 he exhibited in London
at the Royal Academy and the Society of Art-
ists. He set himself up in Devonshire as a por-

traitist and there developed a wide circle of patrons. Fulton began experimenting with canal boats, submarines, steamboats, and torpedoes. He returned to America in 1806 after an absence of twenty years, and in 1807 *The Clermont,* Fulton's invention and the first successful commercial steamboat, made the voyage from New York to Albany. Fulton was elected a member of the Pennsylvania Academy of the Fine Arts in 1813; while he continued to be occupied with the construction of steamboats, he painted portraits and miniatures until his death.

Fulton's earliest miniatures are delicate and charming, though often inaccurately drawn with long, somewhat clumsy brushstrokes. His best works, which reflect the influence of James Peale and were painted just before he went to Europe, are small, lively characterizations displaying pursed lips and narrow shoulders, done with meticulous attention to detail. They little resemble the elaborate, artificial "fancy pieces" that Fulton turned out after his return from England.

82. *Lady*

ca. 1785
Watercolor on ivory, 1¹³⁄₁₆ x 1⁷⁄₁₆ in. (4.5 x 3.6 cm)
Casework: gilded metal with burnished bezel
Ex colls.: sale, Sotheby Parke-Bernet, New York, May 31, 1979, lot 388; purchased from Edward Sheppard, New York

Colorplate 4d

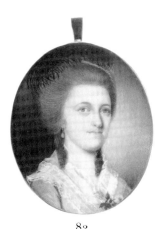

82

ELIZA (ELIZABETH) GOODRIDGE
(1798–1882)

Eliza Goodridge, the younger sister of the well-known miniaturist SARAH GOODRIDGE, is much neglected as an artist in her own right. She was born to Ebenezer and Beulah Childs Goodridge in Templeton, Massachusetts. Her father was a shoemaker; for a time he worked in Boston in the organ-building business with his son-in-law, Thomas Appleton. Eliza went to Boston after 1820 and there was probably taught the art of miniature painting by her sister. She returned to Templeton and at the age of fifty-one married a widower, Colonel Ephraim Stone. Sometime after his death in 1860 she moved to the home of her niece in Reading.

The largest collection of Eliza Goodridge's miniatures is at the American Antiquarian Society in Worcester, Massachusetts. Her work is little known and although it is often mistaken for Sarah's, it is usually regarded as of inferior quality. However, many of Eliza's documented works reveal an exceptionally fine hand. While in pose and technique they resemble portraits by her sister, careful study reveals certain differences, particularly coloristic ones. Skin tones have a slightly yellow cast compared to the more purely pink tones in Sarah's works; backgrounds, often blue-green like Sarah's, are also tinged with yellow.

Eliza's early works are tentative and her draftsmanship is not yet strong. With male subjects, characteristically, the back of the head is not fully rounded, showing instead a slight slant at the crown. Subjects tend to be shown in modest scale, with particularly small eyes; faces reveal scant modeling. About 1835 Goodridge became preoccupied with the meticulous rendering of background interiors and by dint of careful observation developed into a very competent draftsman. Her portraits are occasionally as individualized as Sarah's, while her keen recording of architectural elements and furnishings in a tiny space is unique.

83. *Gentleman*

ca. 1829
Watercolor on ivory, 3¹⁄₁₆ x 2⅜ in. (7.8 x 6 cm)
Casework: hinged red leather (partially shown)

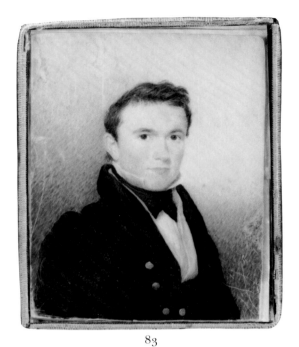

83

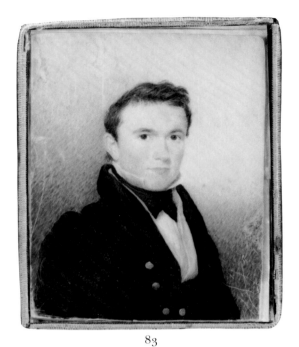

84

Ex coll.: sale, Sotheby Parke-Bernet, New York,
Jan. 29, 1986, lot 141

Catalogue nos. 83 and 84 are companion pieces.

84. *Lady*

1829
Watercolor on ivory, 3⅛ x 2½ in. (8 x 6.5 cm)
Inscribed on backing paper: *E. Goodridge Pinxt /
Sept. 26, 1829*
Casework: as for cat. no. 83
Framemaker's label inside back cover: *Made at
Smith's / No. 2 Milk St. / Opposite Old South; / Boston*
Ex coll.: as for cat. no. 83

85. *Baby*

ca. 1829
Watercolor on ivory, 2⁵⁄₁₆ x 1⅞ in. (5.9 x 4.8 cm)
Inscribed on backing paper (probably at a later
date): *Executed / by / Mis Goodrich / Nov. 1829*
Casework: gilded copper with cast bezel and
hanger; reverse engine turned, with cast bezel
framing compartment containing a lock of hair

86. *Gentleman*

Watercolor on ivory, 2¼ x 1⅞ in. (5.8 x 4.7 cm)
Casework: gilded copper with cast bezel and
hanger; on the reverse, beaded bezel framing
compartment containing plaited hair

Colorplate 18b

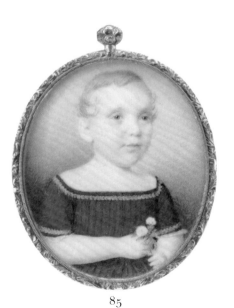

85

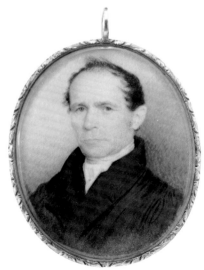

86

SARAH GOODRIDGE

(1788–1853)

America's finest woman miniaturist, Sarah Goodridge was born in Templeton, Massachusetts (for her family background, see ELIZA GOODRIDGE). At seventeen she went to live with her brother William in nearby Milton. Subsequently she took some drawing lessons in Boston and began reading about the techniques of miniature painting.

Goodridge painted in oils until a miniature painter from Hartford taught her how to paint on ivory. By 1820 she had opened a studio in Boston and established herself as a miniaturist. A friend introduced her to Gilbert Stuart (1755–1828), who encouraged her to continue painting. She went to his studio often for help with her works in progress and to make miniature copies of his oil paintings. Stuart's only known miniature, a portrait of General Henry Knox (Worcester Art Museum), was painted for her as an instruction piece. In 1825 Stuart sat for Goodridge, who painted his miniature twice, infusing the images with intellect and energy (Museum of Fine Arts, Boston, and MMA). During the four years that Goodridge received informal instruction from Stuart her work improved dramatically. Her paintings made after 1825 often achieve brilliant characterization and very fine effects of light and shadow.

Goodridge lived her entire life in the Boston area, residing either with her father or with one of her siblings. During summers she returned to Templeton, where she taught school and made portraits for her friends at reasonable prices. In the winters of 1828 and 1841 she visited Washington, D.C.

By producing two miniatures a week Goodridge supported her mother for eleven years; she also nursed her paralytic brother and reared an orphan niece. Because of failing eyesight she painted little during her last ten years. She died of a stroke at a sister's house in Reading, Massachusetts.

Goodridge's best works are direct, realistic, powerfully individualized portraits. Her brushwork is tightly controlled and the compositions tiny in scale; yet in costume, color, and pose, these miniatures are strongly influenced by the work of Gilbert Stuart. The subject is often placed low on the ivory; backgrounds are usually blue-gray, shaded to brown at the bottom; skin tones are light cream and pink. Ladies are frequently painted wearing a hair ornament, jewelry, and a bright red paisley shawl. (For an illustration of Goodridge's brushwork, see p. 19.)

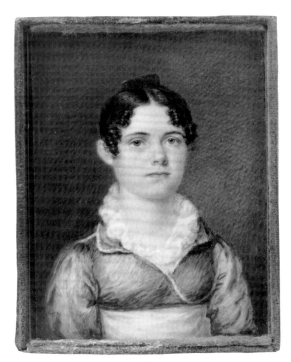

87

88

87. *Lady*

Watercolor on ivory, 3¼ x 2⅜ in. (8.3 x 6.1 cm)
Casework: hinged red leather (partially shown)
Ex COLL.: purchased from Edward Sheppard, New
 York

This miniature may have been damaged by
water; much of the background appears to
have been repainted.

Catalogue nos. 87 and 88 are companion pieces.

88. *Gentleman*

Watercolor on ivory, 3¼ x 2⅜ in. (8.3 x 6.1 cm)
Casework: as for cat. no. 87
Ex COLL.: as for cat. no. 87

Colorplate 18c

89. *Beauty Revealed* (Self-portrait)

1828
Watercolor on ivory, 2⅝ x 3⅛ in. (6.7 x 8 cm)
Casework: modern (not shown)
Ex COLLS.: descended through the family of Daniel
 Webster; sale, Christie's, New York, June 26,
 1981, lot 14A; purchased from Alexander
 Gallery, New York, 1981

Colorplate 19

According to descendants of the statesman
Daniel Webster, this miniature is a self-portrait
by Sarah Goodridge which was presented to
Webster in 1828 (the miniature has been re-
moved from a paper backing inscribed *1828*
whose location is now unknown). Their associ-
ation is well documented in biographies and
letters. Forty-four letters written by Webster to
Goodridge are extant, dating from 1827 to
1851 (Massachusetts Historical Society and Mu-
seum of Fine Arts, Boston). They chronicle the
development of their friendship as he finds a
studio for her, sits for his portrait there, invites
her to his Boston office. The early letters em-
ploy the usual formal address, "Madam"; this
gives way to "Dear Miss G" and finally "My
dear, good friend," an affectionate salutation
for one who generally began letters to his inti-
mates "Dear Sir." Webster sat to have his like-
ness taken by Goodridge at least twelve times
over two decades. The only place that Good-
ridge left home to visit for an extended period
was Washington, D.C., where she spent time
during the winters of 1828–29, 1841–42, and
perhaps 1832. Webster was a senator during
those years and therefore wintered in Wash-
ington; 1828 was the year his first wife died
and in 1841–42 he was separated from his sec-
ond wife. A later self-portrait of Goodridge
painting a miniature (R. W. Norton Museum,
Shreveport, Louisiana) and her easel and

89

paint box were also passed down by members of Webster's family, who referred to her as his fiancée.

Beauty Revealed shows the delicate stipple and hatching typical of Goodridge's technique. A strikingly realistic work, it demonstrates the artist's masterly command of the nuances of light and shadow. Glowing skin tones are achieved by the use of extremely transparent washes of color which do not obscure the luminous ivory surface.

In the United States there is no known precedent for the giving of an artistic expression of affection of this unusual, personal kind. In England and France it was common practice in the nineteenth century to exchange miniatures that portray a single eye. This became a popular way to carry or wear a portrait of a loved one without revealing the sitter's identity. However, "eye paintings" never became the fashion in America.

90

WALTER GOULD

(1829–1893)

A portrait, miniature, and genre painter, Walter Gould was born in Philadelphia. He studied under John Rubens Smith (1775–1840) and THOMAS SULLY. Gould exhibited at the Artists' Fund Society there beginning in 1843 and was elected a member in 1846. For a while he earned his living painting portraits and miniatures in Philadelphia and Fredericksburg, Virginia. Then in 1849 he traveled to Florence, Italy, and except for a few months' study in Paris and sketching trips to Turkey, he remained there until his death. The latter part of Gould's life was devoted to painting full-size portraits and Turkish genre scenes. He was invited to Constantinople in 1851 to paint the sultan's portrait. Exotic subjects were in vogue in this period; one of Gould's scenes of the bazaar at Constantinople was shown at the National Academy of Design in New York in 1866. Few miniatures by Gould have been located. Those that are known show the early influence of Sully.

90. *Edward Ranstead Jones*

1847
Watercolor on ivory, 2¾ x 2⁵⁄₁₆ in. (7 x 5.8 cm)
Inscribed on backing papers: *Edward Ranstead / 1819–1886 / Jones / by Walter Gould / taken 1847; Presented to E.R.J. / by his friend / Walter Gould / Jan. 31, 1849 / Painted in the beginning of 1847; For Philadelphia Museum of Art*
Casework: gilt metal with ormolu mat and protector
Label on case: *From Aunt Soph / Xmas 1894. Miniature of / Uncle Ned Jones*
EX COLLS.: descended in the subject's family; purchased from Edward Sheppard, New York

SARA PETERS GROZELIER

(1821–1907)

Little is known of this miniaturist, the younger sister of Clarissa Peters Russell (MRS. MOSES B. RUSSELL). One of twelve children, she was born in Andover, Massachusetts, to John and Elizabeth Davis Peters. Like her sister, she married an artist, in 1855 wedding Leopold Grozelier (1830–1865), a French-born portrait painter

91

and lithographer. That year she exhibited three miniatures at the Boston Athenaeum. In 1856 she showed a miniature at the Brooklyn Art Association, identifying herself as Madam Grozelier. She was listed in the Boston directory in 1866 (after the death of her husband) and from 1877 to 1883.

91. *Two Girls*

Watercolor on ivory, 4 x 3⅛ in. (10.3 x 8 cm)
Casework: hinged brown leather with ormolu mat (not shown)
Ex coll.: purchased from Edward Sheppard, New York

ANNE HALL

(1792–1863)

Anne Hall, the first woman to become a member of the National Academy of Design, was born in Pomfret, Connecticut, the daughter of Jonathan and Bathsheba Mumford Hall. En-

couraged as a child to pursue her artistic interests, she practiced painting flowers, birds, fish, and insects from nature and copied oil paintings and miniatures sent from Europe by her brother. She received her first few lessons in miniature painting from Samuel King (1748/ 49–1819) during a visit to Newport, Rhode Island. Hall moved to New York and there studied painting in oil with the miniaturist and landscape painter Alexander Robertson (1772–1841). After completing a few oil paintings she turned her attention to miniatures. By 1817 she was exhibiting at the American Academy of the Fine Arts in New York. Hall was elected an artist of the National Academy of Design in 1827 and in 1828 was made an associate member and later a full member. She showed miniatures in many of their annual exhibitions between the years 1828 and 1852. Hall never married. She died in New York in the home of her sister Eliza Hall Ward at the age of seventy-one.

Most of Hall's miniatures depict members of her family. Her early experience making copies after such painters as Guido Reni imbued her with a lasting interest in Madonna and Child compositions, which she often adapted to family groups. Her early works frequently reveal careless draftsmanship. To modern tastes Hall's work often seems sentimental, but contemporaries compared these delicately modeled, richly colored little paintings to portraits by Sir Joshua Reynolds and Sir Thomas Lawrence and to the miniatures of EDWARD GREENE

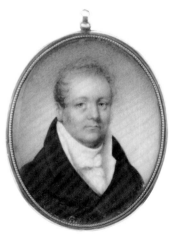

92

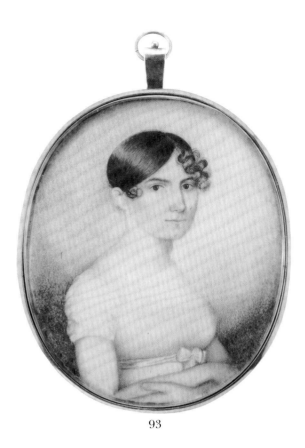

93

MALBONE. Hall excelled in her ability to arrange groups of people and objects in a small format, particularly ones in which "the flowers, and the children combine in an elegant and well-arranged *bouquet*" (Dunlap, 1918, vol. 3, p. 162).

92. *Charles Henry Hall*

Watercolor on ivory, 2 x 1⁹⁄₁₆ in. (5.1 x 4 cm)
Casework: gilded copper with beaded bezel; on the reverse, beaded bezel framing compartment containing plaited hair
Ex COLLS.: sale, Sotheby Parke-Bernet, New York, July 17, 1984, lot 80; purchased from Edward Sheppard, New York

Charles Henry Hall (1781–1852), the artist's brother, was born in New York City. Employed by a shipping firm, he traveled extensively in Europe and from there sent back paintings and miniatures for his sister to copy. He later returned to New York and engaged in the China trade. The owner of a vast quantity of New York real estate, he was instrumental in the planning of streets and railroads.

93. *Eliza Hall*

Watercolor on ivory, 3³⁄₁₆ x 2⅝ in. (8.4 x 6.7 cm)
Casework: modern
Ex COLLS.: the artist's nephew, Henry Hall Ward; sale, Anderson Galleries, New York, May 12, 1915; sale, Sotheby Parke-Bernet, New York, July 17, 1984, lot 80; purchased from Edward Sheppard, New York

Eliza Hall (1789–1872), the artist's sister, was born in Pomfret, Connecticut. In 1818 she married Henry Ward (1784–1838), a merchant from New York City; they lived in New York and had one son, Henry Hall Ward (1820–1872). Although Eliza, too, is said to have been an artist, there are no documented works by her.

94. *Anne Catherine Ward and John Ward*

Watercolor on ivory, 3⅛ x 2⅝ in. (7.9 x 6.8 cm)
Casework: modern (not shown)
Label: modern, on back of case, identifying the subjects
Ex COLLS.: Harry Fromke, New York; sale, Christie's, New York, Oct. 18, 1986, lot 382

Anne Catherine (1835–1840) and John (1837–1838) were the children of William Greene Ward and his wife, Abby Maria Hall, of East

94

95

Greenwich, Rhode Island, and Jamaica, Long Island. Ward was descended from Samuel Ward, the first colonial governor of Rhode Island. Abby Hall was Anne Hall's sister, and the children were the artist's niece and nephew. The apparent ages of the children and their sad expressions, together with the brevity of their lives, suggest that this miniature was a memorial painted after the death of its subjects.

95. *The Magdalen* (after Guido Reni)

Watercolor on ivory, 3¹¹⁄₁₆ x 3¾ in. (9.4 x 9.5 cm)
Casework: hinged red leather with ormolu mat
 (not shown)
EX COLLS.: the artist's nephew, Henry Hall Ward; sale, Anderson Galleries, New York, May 12, 1915, lot 111; sale, Sotheby Parke-Bernet, New York, July 17, 1984, lot 82

Guido Reni painted at least six variations on this subject between 1627 and 1632. Although it does not agree exactly in pose and drapery, this miniature seems closest to the version painted in 1627–28 (Musée des Beaux Arts, Paris). It is not known whether Hall's miniature is copied after the original painting or a print or miniature.

NATHANIEL HANCOCK

(active 1792–1809)

A little-known miniaturist, Nathaniel Hancock painted in New England and Virginia, as the notices he placed in local newspapers attest. Apparently he learned to paint miniatures before coming to America. He may have been related to the prominent family of Hancocks from London who settled in Boston and Salem, Massachusetts. Hancock's first advertisement claimed that "the Likenesses he has taken and finished, since his arrival in Boston will best speak his ability. . . . An European artist, who takes the most correct Likenesses . . . and finish in an elegant style of painting; as miniatures at 2, 3, and 4 guineas; in a gilt frame and glass included, and elegant Devices in Hair on moderate terms" (*Independent Chronicle* [Boston], June 28, 1792).

In 1796 Hancock traveled to Petersburg, Virginia, where he made miniature portraits for about a year; then he moved to Richmond, advertising his art there in late 1797 and early 1798. The following year he was back in Boston, and in 1801 he traveled to Portsmouth and

Exeter, New Hampshire. Dr. William Bentley recorded, "I saw at the public house Mr. Hancock of Boston, who had come to Exeter as a miniature painter" (see the *Diary of William Bentley* [Salem: Essex Institute, 1911], vol. 2, p. 392). In 1805 Hancock moved to Salem, where Bentley saw him again (vol. 3, p. 250); Hancock mentioned having recently seen Gilbert Stuart, who was working on important portrait commissions in Boston. Hancock remained in Salem until 1809. Many of his miniatures are at the Essex Institute there. His self-portrait and a miniature of Jedidiah Morse (father of SAMUEL FINLEY BREESE MORSE), which has on the reverse a painting of the sitter instructing a group of young ladies in geography, are at the Yale University Art Gallery.

Hancock's charming, assured likenesses are the work of an artist with professional training. Faces are deftly modeled using a tiny stipple; features are delineated in a slightly broader stipple, giving them a grainy appearance. A dark line forms the shadow alongside the nose. A distinct stipple and hatch, combined with a sgraffito technique, defines the hair. Backgrounds, diagonally hatched from right to left, are in soft pastel colors when the subjects are children or women. Clothing is also executed with a diagonal hatch. Subjects usually have narrow, sloping shoulders.

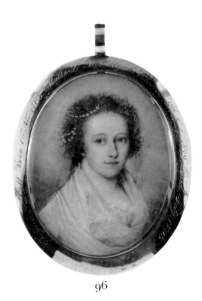

96

96. *Elizabeth Scott Cheever*

ca. 1795
Watercolor on ivory, 1 15/16 x 1 1/2 in. (5 x 3.8 cm)
Casework: gilded copper with plain bezel, engraved around edge: *Elizabeth Scott Brown. 13th Nov. 1768. Married Dr. Abijah Cheever, 5th July 1789. Died July 1795.* On the reverse, plain bezel framing three locks of hair mounted on pink fabric
Ex COLL.: purchased from Alexander Gallery, New York, 1989

Elizabeth Scott was the daughter of Daniel Scott. She married Abijah Cheever in Boston in 1789 and bore him three children before her death in 1795. Cheever, a 1779 graduate of Harvard College, was a surgeon in the navy during the Revolutionary War and afterward became a prominent Boston physician. The surname Brown, given in the inscription, is incorrect.

GEORGE HARVEY

(1800–1878)

Although better known for his atmospheric landscapes, George Harvey was originally an extremely skilled miniaturist. Nothing is known of his formal education. He was born in Tottenham, England, and was painting miniatures before he came to America at the age of twenty. During his first two years in this country he found himself "in the remote wilds of the New World, hunting and trapping, scribbling poetry and prose, drawing and sketching" in Ohio, Michigan, and parts of Canada (the artist's journal, 1820, quoted by Shelley, 1948, p. 11; see bibliography for Harvey). In 1828 he was living in Brooklyn and was elected an associate of the National Academy of Design. In the same year he moved to Boston, where he was immediately successful. Harvey painted many hundreds of miniatures in the years between 1827 and 1845, almost all of them in Boston. In 1844 he exhibited 213 works, including twenty-two portrait and landscape miniatures at the Boston Athenaeum. He remained modest about his accomplishments, writing of himself: "the products of his pencil were over-

estimated . . . and for the purpose of improvement he went to London" (Shelley, p. 11).

Overwork caused Harvey's health to deteriorate, and eventually he was forced to give up miniature painting altogether. He purchased a tract of land along the river at Hastings-on-Hudson, near Washington Irving's home, Sunnyside, which he had helped to design. There he commenced a series of atmospheric watercolor landscapes meant to illustrate seasonal changes in the Hudson River Valley. His aim was to have a group of them engraved and published by subscription. Harvey traveled back and forth between America, Paris, and London, seeking patronage for the project, but ultimately only four scenes were published. Nearly half of the original landscapes are in the collection of the New-York Historical Society. In 1848 Harvey moved back to London but made extended painting trips to Florida and Bermuda until about two years before his death.

Harvey's most successful works are portrait miniatures and atmospheric landscapes. Their technique is similar: in both, detail is carefully rendered by uniform stippling of the surface with a tiny brush, using a dry pigment. The miniatures are frequently rectangular in format, with the subject depicted in half length. Women wear lace bonnets and are often seated at a table with a vase of flowers. The miniatures are usually signed along the right edge.

97. *Sarah May Holland*

Watercolor on ivory, 3⅞ x 2⅞ in. (9.8 x 7.3 cm)
Signed along lower right edge: *G. Harvey.*
 Inscribed in graphite on paper backing: *Willard 16 King St.*
Casework: hinged red leather with ormolu mat (partially shown)
Label: inside case, identifying the subject
Ex COLLS.: the subject; her granddaughter, Louisa Pierce Holland; her nephew (and great-grandson of the subject), William Ellery, 1914; James Kincaid Beal

Colorplate 28a

Sarah May Holland (1772–1849) was born in Boston, the daughter of Samuel May and Abi-

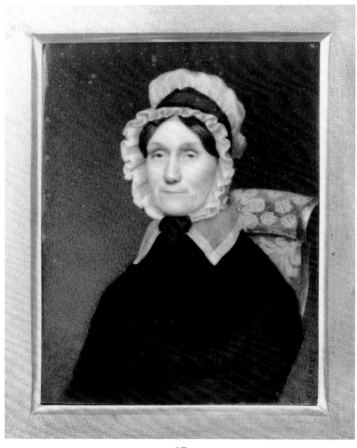

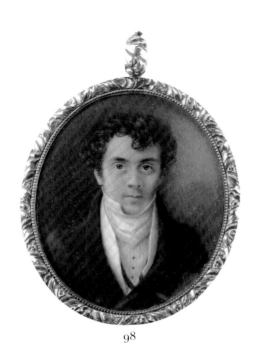

98

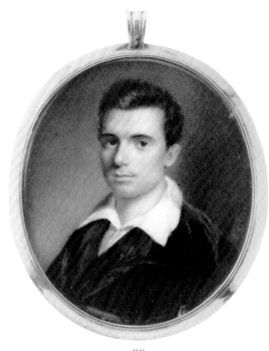

99

gail Williams May. She married Captain John Holland in 1797 and lived her entire life in Boston. This miniature is a copy after an oil painting by Chester Harding (formerly coll. Louisa A. Beal, the subject's granddaughter).

98. *Self-portrait*

1830
Watercolor on ivory, 2⅜ x 1¹⁵⁄₁₆ in. (6 x 5 cm)
Signed and dated along right edge: *Geo. Harvey del: 1830.* Inscribed on backing paper: *1830 G. Harvey aged 30 / taken by himself*
Casework: gilded copper with chased bezel and hanger; on the reverse, compartment containing two locks of hair. Scratched into case interior: *Mar 17, 1831*
EX COLL.: purchased from Edward Sheppard, New York

Colorplate 21b

99. *Gentleman*

Watercolor on ivory, 2⅞ x 2⁵⁄₁₆ in. (7.2 x 6 cm)
Signature incised along right edge: *G Harvey* (appears to have been added at a later date)
Casework: modern
EX COLL.: purchased from Edward Sheppard, New York, 1980

JOHN HAZLITT

(1767–1837)

John Hazlitt was born in Marshfield, England, the son of a Unitarian minister. His younger brother was William Hazlitt (1778–1830), the essayist and critic. The family moved in 1780 to Bandon, Ireland, near Cork, and then in 1783, when Hazlitt was sixteen, to America, living briefly in Philadelphia and afterwards in Boston, Weymouth, and Upper Dorchester. Hazlitt may have painted a few miniatures before he came to America; he was probably self-taught. In 1785 he met JOSEPH DUNKERLEY in Boston and with him attempted to open a drawing school, but not enough pupils were attracted to support the endeavor. Three months later Hazlitt advertised in the *Salem Gazette* his willingness to paint portraits in all sizes. He executed miniatures and pastel portraits in Boston, Weymouth, Salem, and Hingham. In 1787 the Hazlitt family returned to England. There Hazlitt was advised by Sir Joshua Reynolds and copied some of his works. He established himself in London, exhibiting miniatures at the Royal Academy annually between 1788 and 1819. He moved to Stockport, En-

100

from the W. Sill House in Old Saybrook, Connecticut, but no connection between the names Goodwin and Sill has been discovered.

Attributed to John Hazlitt

101. *Gentleman said to be Golding Constable*

Watercolor on ivory, 2⁹⁄₁₆ x 2⅛ in. (6.5 x 5.4 cm)
Casework: gilded copper; on the reverse, hair design with seed pearls on ground of white opalescent glass over machine-turned foil
Label: on back of case, identifying the artist and the subject
Ex coll.: purchased from Alexander Gallery, New York, 1989

101

gland, in 1832 and died there at the age of seventy.

Few of Hazlitt's American miniatures are documented. A miniature representing his brother William, illustrated in Moyne (1970, p. 39; see bibliography for Hazlitt) and attributed to Hazlitt, is much closer in style to the work of Joseph Dunkerley. It was probably painted in 1785, when Dunkerley and the Hazlitt family were in Boston. Hazlitt's works are extremely linear in technique, utilizing long, broad hatches to achieve strongly modeled, emphatically shadowed forms. His subjects are boldly presented in a manner characteristic of English miniature painting.

100. *Samuel Goodwin, Sr.*

Watercolor on ivory, 2¹³⁄₁₆ x 2¼ in. (7 x 5.7 cm)
Signed at lower left: *J H*
Casework: hinged red leather
Ex colls.: sale, Sotheby Parke-Bernet, New York, July 14, 1981, lot 294; purchased from Edward Sheppard, New York

This may be a portrait of Samuel Goodwin, Sr., of Boston, comptroller of the state of Massachusetts, who died in 1821. When the miniature was purchased, it was said to have come

PIERRE HENRI

(ca. 1760–1822)

Pierre Henri (also called Peter Henry) was born in Paris, the son of Pierre and Henriette Henri. Nothing is known of his formal training there. According to the family genealogy, Henri accompanied an uncle on a voyage to North

America, but they were shipwrecked on the island of Hispaniola (now the Dominican Republic) in the West Indies, and he remained there until his uncle's death. In 1788 Henri arrived in New York, where he placed a notice in the *New York Daily Advertiser*: "A Miniature Painter Lately arrived from France . . . he draws Likenesses . . . at the lowest price, and engages the painting to be equal to any in Europe" (May 3, 1788). It seems he met with little success, for seven months later he was in Philadelphia, advertising in the *Pennsylvania Packet* his willingness to paint a miniature likeness for "Four Pounds, which is about the sixth part of the price that I was generally paid before an extraordinary misfortune [probably the shipwreck] I experienced a few months ago" (January 23, 1789).

That year Henri married Elizabeth Osborne, the daughter of Captain Peter Osborne of Philadelphia. Henri's work and travels are well documented by his advertisements in local newspapers. Between 1789 and 1820 he worked in Alexandria, Philadelphia, Charleston, New York, Baltimore, Richmond, and New Orleans, in that order, often making repeat visits. He exhibited a miniature, *Portrait of a Lady of the New Theatre*, at the Columbianum Exhibition in Philadelphia in 1795. In the 1812 New York directory he and John Henri Isaac Browere (1790–1834) are listed jointly as miniature painters. In Charleston Henri claimed that he "takes likenesses in miniature, from the size of a small ring, to that of the largest locket," and that he "draws also miniature likenesses in full length, groupes etc" (*Charleston City Gazette and Advertiser*, February 22, 1791). Indeed, he had painted one allegorical scene that included full-length figures of Napoleon, General Moreau, William Pitt, and George III; it was one inch long and was mounted on a ring. Another miniature depicted his wife wearing his miniature self-portrait, and their three children. (The present location of both miniatures is unknown.) During Henri's last years gout interfered with his work. He died in New York, probably of yellow fever.

Henri tended to give his subjects overly large heads and to place them high on the ivory. Their features are strongly delineated, with large round eyes and a slightly curling

102

mouth. Skin tones are pale, backgrounds of a neutral shade. The hair and background are executed with a short regular hatch which is often decorative in effect. The works are usually initialed and dated.

102. *Gouverneur Morris*

1798
Watercolor on ivory, 2¾ x 2⅛ in. (7 x 5.4 cm)
Signed and dated at right: *P. H. | 98*
Casework: fruitwood with carved, concave oval and ormolu liner (not shown)
Ex colls.: Erskine Hewitt; sale, Parke-Bernet, New York, Oct. 21, 1938, lot 822; Norvin H. Green; sale, Parke-Bernet, New York, Nov. 30, 1950, lot 229; Harry Fromke, New York; sale, Christie's, New York, Oct. 18, 1986, lot 388

Colorplate 5c

Gouverneur Morris (1752–1816), a statesman and diplomat, was born in Morrisania, New York, the son of Lewis Morris and Sarah Gouverneur, a French Huguenot. He graduated from King's College (Columbia University) in 1768. A member of the Continental Congress, he was one of the committee that drafted the Constitution in 1787; subsequently he served as the nation's minister to France and as United States senator from New York. In 1809 he married Ann Carey Randolph of Virginia. This miniature was painted in 1798, after Mor-

ris's return to the United States following his tenure as minister to France.

George Harrison Hite

(ca. 1810–1880)

Born in Urbana, Ohio, George Hite was working as a miniaturist in Virginia by 1832. The following year he executed portraits in Columbus, Ohio, and Sparta, Georgia; in 1835 and 1838 he was in Charleston, South Carolina. He moved to New York City in 1838, established his miniature business there, and exhibited frequently at the National Academy of Design and from 1838 to 1857 at the Apollo Association. In 1844 he also did some work in New Orleans. Hite listed his address as Morrisania, Westchester County, in 1864 and again in 1873, when he exhibited a miniature of Howard Christy at the Louisville Industrial Exposition. At the time he was praised as a renowned watercolor and miniature artist.

Hite's early miniatures are delicately colored and finely stippled or hatched in the face and background; later examples are more deeply colored and broadly hatched and often emulate photographs.

103

103. *Daniel Webster*

1844
Watercolor on ivory, 4 ½ x 3 ½ in. (11.5 x 9 cm)
Signed on left edge: *G. H. Hite 1844*
Casework: gilded gesso on wood with stamped
 metal mat (partially shown)
Inscribed on back of frame: *Miniature Portrait / of
 the Hon. Daniel Webster / Painted by Geo H. Hite /
 New York 1844 / The Property of / F. C. Stainback
 Esq. / Petersburgh Va / Presented to Dabney Browne /
 by F. C. Stainback*
Ex colls.: F. C. Stainback, Petersburg, Virginia;
 Dabney Browne; sale, Sotheby Parke-Bernet,
 New York, Sept. 15, 1979, lot 687

When this miniature was painted, Daniel Web-
ster (1782–1852) was sixty-two; he had served
as secretary of state between 1841 and 1843,
successfully negotiating the Webster-Ashbur-
ton Treaty of 1842, which resolved disputes
with Great Britain about the Canadian border
and suppression of the African slave trade. His
initiation of discussions for the opening of dip-
lomatic relations with China led to the negotia-
tion of a treaty in 1844. Webster returned to
the Senate the following winter. It is not known
whether this miniature is a copy or was painted
from life.

104

The shadow is large and prominent. The art-
ist's initials are subtly rendered to blend with
his brushwork.

SAMUEL V. HOMAN

(active 1841–45)

Apparently a self-taught miniaturist, Samuel
Homan is known only to have been established
in Boston between 1841 and 1845. He used
little modeling in the rendering of face and
figure and employed broad, decorative hatch-
ing for backgrounds and accessory features.

104. *Boy with a Dog*

Watercolor on ivory, 3 ¹¹⁄₁₆ x 2 ¹⁵⁄₁₆ in. (9.4 x 7.5 cm)
Signed at lower left: *S. V. H.*
Casework: hinged leather with velvet liner, ormolu
 mat (not shown)
Label inside back cover: *Made at Smith's / No. 2,
 Milk St. / Opposite Old South / Boston*
Ex coll.: sale, Sotheby Parke-Bernet, July 17,
 1984, lot 96

ROSA HOOPER

(1876–1963)

A founding member of the California Society
of Miniature Painters, Rosa Hooper was born
in San Francisco. She studied at the San Fran-
cisco Art League, where she was instructed
by William Keith (1839–1911), a landscape
painter, and Emil Carlsen (1853–1932), who
specialized in still lifes. Hooper subsequently
studied miniature painting in New York under
Amalia Küssner (1866–1932) and in Europe
with Otto Eckhardt of Dresden and Madame
Gabrielle Debillemont-Chardon (b. 1860) of
Paris. She returned to San Francisco in 1903,
residing chiefly there until 1926; thereafter she

lived in New York (during the years 1926–39), in Coronado, California, in 1946–58, and in San Francisco from 1958 until her death. Hooper received awards for works she exhibited at the Alaska-Yukon-Pacific Exposition of 1909 in Seattle, the Panama-Pacific Exposition of 1915 in San Diego, and the California Society of Miniature Painters, Los Angeles, in 1929.

Attributed to Rosa Hooper

105. *Lady*

Watercolor on ivory, 3³⁄₁₆ x 2½ in. (8.2 x 6.5 cm)
Signed along right edge: *Hooper.*
Casework: gilded copper with stamped border and hanger
Ex coll.: purchased from Edward Sheppard, New York

This miniature does not have the fresh, immediate quality often associated with Hooper's work. However, the pigment is characteristically applied in Hooper's dry, careful manner, with extensive use of gouache. The costume is in the style of approximately 1880, and Hooper did not begin painting miniatures until about 1900. She copied this image from a painting or, more likely, a photograph.

WILLIAM HUDSON, JR.

(1787–ca. 1861)

William Hudson, Jr., was known as a portraitist in oil and pastel, a miniaturist, and a landscape painter. He was painting as early as 1818, probably in Virginia. From 1829 to 1856 he worked in Boston but made his home in nearby Hingham, where he portrayed *The Old Meeting House* in a lithograph (illustrated in Harry T. Peters, *America on Stone* [Garden City, N.Y.: Doubleday, Doran & Co., 1931], p. 73). He exhibited at the Boston Athenaeum in the years 1845–48. Hudson moved to Brooklyn in 1857 and in 1858 showed in New York at the National Academy of Design. It appears that he abandoned miniature painting for landscapes and portraits in oil. He is last listed in the Brooklyn directory in 1861.

Hudson's works are usually signed and dated. The few miniatures he is known to have painted, done early in his career, are competently executed; they show subjects with rosy coloring, often seated in a red chair.

106. *Gentleman*

1821
Watercolor on ivory, 4³⁄₈ x 3⁷⁄₁₆ in. (11.1 x 8.8 cm)
Signed and dated along left edge: *W. Hudson 1821*
Casework: ormolu liner; modern frame (not shown)
Ex coll.: sale, Sotheby Parke-Bernet, New York, July 14, 1981, lot 279

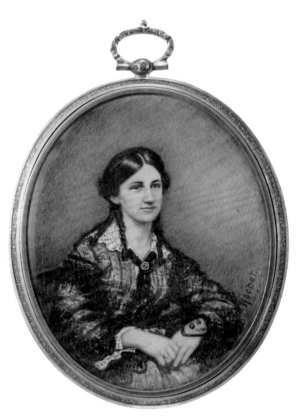

105

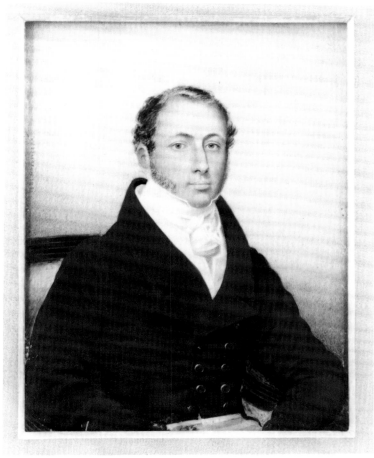

106

CHARLES CROMWELL INGHAM

(1796–1863)

A painter who specialized in portraits of women, Charles Cromwell Ingham was born in Dublin. At thirteen he entered drawing classes at the Dublin Institution; later he spent four years studying with William Cuming (1769–1852), who was then the city's leading painter of ladies' portraits. Ingham was awarded a prize for his oil painting *Death of Cleopatra*, which he took to New York when his family emigrated in 1816. The picture was exhibited that year at the first exhibition of the American Academy of Fine Arts. It was highly praised, and Ingham rapidly achieved success. Over a

period of almost fifty years he continued to set the standard in New York for the portrayal of women. His highly finished, porcelain-smooth portraits and miniatures, in which flesh resembles polished ivory, were both admired and decried by contemporary critics. Ingham was revered by patrons and fellow artists. He was a founder of the National Academy of Design and was its vice president for many years; he was also a founding member of the Sketch Club and the Century Association.

Although Ingham exhibited some two hundred oil paintings between 1816 and 1863, only twice were miniatures included. According to a contemporary, William Dunlap, Ingham began painting miniatures after coming to New York "with a truth of drawing, beauty of

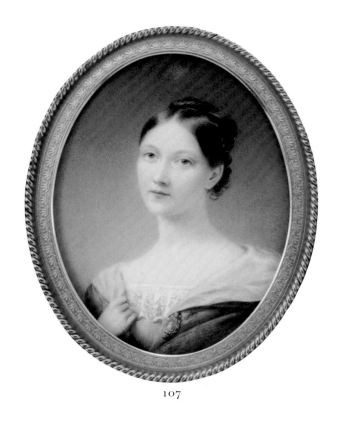

107

colouring, and exquisite finish" on a par with any in the country; however, in 1834 he turned his full attention to oil painting (Dunlap, 1834, vol. 2, p. 273). In both oils and miniature portraits he rendered the details of costume with painstaking care, faithfully recording the velvet, satin, and feathered finery of the elegant belles and matrons of New York.

The smoothness that usually characterizes Ingham's miniatures is achieved by means of extremely fine stippling. His skillful deployment of light and shadow, coupled with the frequently pensive expression of the sitter, imbues these portraits with a romantic mood. His later miniatures (such as those of an uncle and aunt, included here) present a less idealized image. They employ a more broadly stippled technique and show the marked influence of photography.

107. *Lady*
Watercolor on ivory, 3¼ x 2½ in. (8.3 x 6.5 cm)
Casework: ormolu liner; modern frame (not
 shown)

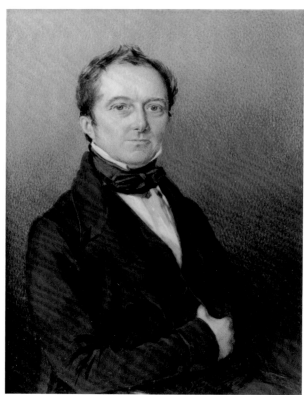

108

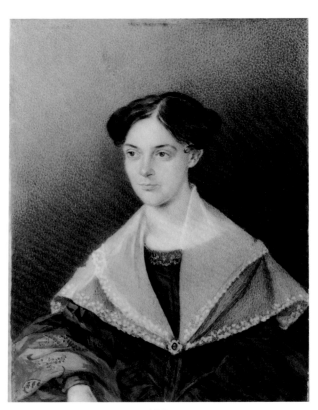

109

Label on frame back: *Painted by / Ingham*
Ex coll.: purchased from Hirschl & Adler
 Galleries, New York, 1979

Colorplate 23b

108. *Uncle Charles*

1844
Watercolor on ivory, 4⅛ x 3⅛ in. (10.5 x 8 cm)
Inscribed on backing paper in graphite: *Uncle
 Charles 1844 / Painted by / Ingham*
Casework: hinged maroon leather with ormolu
 liner (not shown)

Catalogue nos. 108 and 109 are companion pieces.

109. *Aunt Rhoda*

1844
Watercolor on ivory, 4⅛ x 3⅛ in. (10.5 x 8 cm)
Inscribed on backing paper in graphite: *Aunt
 Rhoda 1844 / Painted by / Ingham*
Casework: hinged maroon leather with ormolu
 liner stamped at top: *I GUY* (not shown)

HENRY INMAN

(1801–1846)

Henry Inman, for a time New York's leading
portrait painter, was born in Utica. As a youth
he received instruction from an itinerant draw-
ing master, and he continued the study of
drawing when his family moved to New York
City in 1812. Two years later he began a seven-
year apprenticeship under the distinguished
portraitist John Wesley Jarvis (1780–1840).
Inman made rapid progress and soon became
Jarvis's collaborator. Dunlap recorded that as a
team they were able to complete six portraits a
week, Jarvis painting the heads and Inman fin-
ishing the costume and background (Dunlap,
1918, vol. 3, p. 219). The two made painting
trips to New Orleans, Albany, and Boston,
where Inman began to specialize in miniatures
while Jarvis painted oil portraits.

On his return to New York in 1822, Inman
married Jane Riker O'Brien and opened his
own studio on Vesey Street. In a short time
THOMAS SEIR CUMMINGS became Inman's pupil
in miniature painting, and several miniatures

are jointly signed. In 1824 the two formed a
partnership that lasted through 1827. At that
point they decided to divide the business, with
Inman painting in oils and Cummings doing
miniatures. The agreement seems to have been
maintained, as all of Inman's known miniatures
were painted in the 1820s.

Inman was a founder of the National Acad-
emy of Design in New York, becoming its first
vice president in 1827. During the years 1831–
34 he lived in Philadelphia and was a partner
in the lithographic firm of Childs and Inman;
thereafter he returned to New York, where he
was extremely well patronized and his income
rose proportionately. Despite his success, In-
man felt restricted by the confines of portrai-
ture and increasingly turned to genre painting
and landscapes. In 1844 he traveled to England
with commissions to paint portraits of William
Wordsworth and Thomas Macaulay. His
health was declining rapidly, and he died
shortly after his return to New York.

Inman's miniatures reveal the hand of a
portrait painter in oil, with broad, glistening,
painterly brushwork enlivening the hair and
bringing a soft finish to the skin. Subjects,
placed high on the ivory, are portrayed ele-
gantly and forcefully. Close examination also
reveals the technique of a superb miniaturist;
works are highly finished and meticulously de-
tailed, with elaborately stippled backgrounds
and clear color.

110. *John Inman*

ca. 1825
Watercolor on ivory, 3¼ x 2⅝ in. (8.4 x 6.8 cm)
Casework: modern
Ex colls.: Charles Henry Hart; Mrs. Joseph
 Drexel, Penrynn, Pennsylvania; her grand-
 daughter, Mrs. Andrew Van Pelt, Radnor,
 Pennsylvania; sale, Christie's, London,
 Nov. 7, 1988, lot 59

John Inman (1805–1850) was the painter's
younger brother. In 1823 he went to North
Carolina, where he taught school for two years.
He spent a year traveling in Europe before re-
turning to New York and practicing law there
from 1829 to 1833. Drawn to journalism, he
worked on the staff of several newspapers and
in 1844 became editor in chief of the *Commer-
cial Advertiser.*

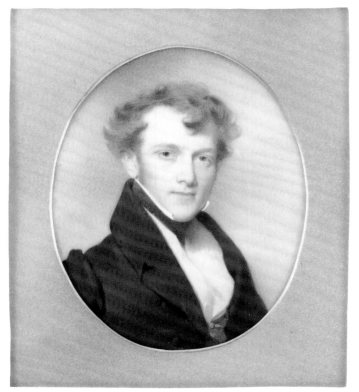

110

111. *Mrs. A. Otis*

Watercolor on ivory, 2³⁄₁₆ x 1¹³⁄₁₆ in. (5.6 x 4.6 cm)
Casework: machine-turned gold with hinged cover;
 on the reverse, engraved central medallion
 inscribed: *Mrs. A. Otis*
Ex colls.: Fannie and Ida Edelson, Philadelphia;
 sale, Sotheby Parke-Bernet, New York, May 10,
 1974, lot 112

Colorplate 13a and page 31, a

The subject of this miniature is probably Anna Huntington Otis (1772–1844), daughter of Levi and Anna Huntington of Norwich, Connecticut. She was married to Joseph Otis, a successful New York merchant. They later retired to Norwich, where he endowed the town library. Anna Otis "was a lady of many estimable qualities, and best known for her sincere and cheerful piety" (*The Huntington Family in America: 1613–1915* [Hartford, Conn.: privately printed, 1915], p. 887).

Henry Inman's first portrait was an oil painting of John made in 1817. John sat for his brother at least three other times for portraits in pencil, watercolor, and oil. This miniature was executed early in Inman's career, about 1825, and reflects the influence of Jarvis's work. It is finely modeled and freely executed, with the subject placed close to the picture plane.

Colorplate 14a

CHARLES WESLEY JARVIS

(1812–1868)

Charles Wesley Jarvis was the son of the well-known portraitist John Wesley Jarvis (1781–1839) and his second wife, Betsy Burtis, who died while Charles was still a baby. Raised by his mother's family in Oyster Bay, Long Island, he did not have a happy childhood; according to family tradition, he "left the wealthy Burtises with half a shirt on his back" (Dickson, 1949, p. 319n; see bibliography for Jarvis). His profligate father neglected him and probably never gave him instruction in painting. HENRY INMAN, who had been John Wesley Jarvis's apprentice, as a return favor took on young Charles as his assistant. Charles worked with Inman in New York and Philadelphia from 1831 to 1834. The following year he returned to New York, where he set up his own portrait studio and exhibited occasionally at the National Academy of Design and the Apollo Association. In 1854 he moved to Newark, New Jersey, but kept a studio in New York until his death. Jarvis seems to have worked only briefly as a miniaturist; he did not exhibit his miniatures and

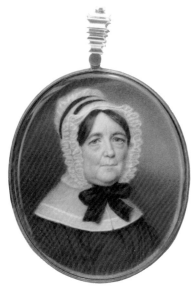

111

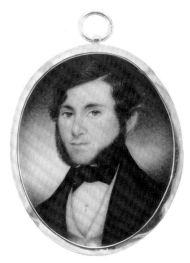

112

listed himself in the city directory as a miniature painter just once, in 1845.

Attributed to Charles Wesley Jarvis

112. *Gentleman*

Watercolor on ivory, 2 1/16 x 1 5/8 in. (5.3 x 4 cm)
Casework: gilded metal
Ex colls.: sale, Sotheby Parke-Bernet, July 17, 1984, lot 90; purchased from Edward Sheppard, New York

There are no well-documented miniatures by this artist, making an evaluation of his style difficult. When this miniature was sold in 1984 it was attributed to Jarvis, but no reason for the attribution was given.

JAMES H. KIMBERLY

(active 1834–46)

The work of James H. Kimberly, a miniaturist who painted in oil on wood and also in watercolor on ivory, is little known. He was an established portrait and miniature painter in New Haven in the years 1834–46 and was in Watertown, New York, in 1838, in Buffalo in 1840, and in New York City during 1841–43. He exhibited there at the National Academy of Design in 1834 and again in 1842, when he showed *Miniatures in Oil*. His works are usually signed and dated on the reverse.

113. *Officer*

Watercolor on ivory, 2 5/8 x 2 1/8 in. (6.8 x 5.5 cm)
Inscribed on backing paper: *J H Kimberly Pinxt / Buffalo City / 1840*
Casework: hinged red leather. On the silk lining of the cover, a transfer engraving of the artist's trade card, reading: *J. H. Kimberly, Portrait and Miniature Painter*
Ex colls.: with E. Grosvenor Paine, New Orleans; sale, Sotheby Parke-Bernet, Jan. 29, 1986, lot 160

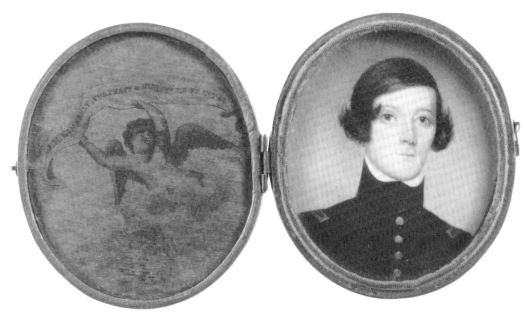

113

JACOB HART LAZARUS

(1822–1891)

A painter of portraits, miniatures, figures, and scenes, Jacob Lazarus was born in New York City. He studied with HENRY INMAN in the early 1840s; the portrait of Inman that Lazarus painted about 1848 (MMA) reflects the training he received. Lazarus regularly contributed oil portraits to the annual exhibitions of the National Academy of Design between 1841 and 1865 and was elected an associate member in 1850. He also exhibited at the Boston Athenaeum and the Pennsylvania Academy of the Fine Arts. After his death, his widow and daughter established a memorial fund to benefit young artists studying in Europe.

There are few documented miniatures by Lazarus. The development of his miniature style probably paralleled that of his oil paintings. His early works show the influence of Inman: broadly painted with a loose brushstroke, they are often idealized. His later works are direct and precise, reflecting the influence of photography.

114. *Charles A. Macy*

Watercolor on ivory, 2⅛ x 1¹¹⁄₁₆ in. (5.4 x 4.4 cm)
Signed at center right: *J H L*. Inscribed on backing paper: *Charles A. Macy*
Casework: gilded metal
REFERENCES: Fielding, 1965, p. 212, the subject incorrectly called Charles A. May; Frederic Fairchild Sherman, "Unrecorded Early American Portrait Miniaturists and Miniatures," *Antiques* 23 (January 1933), p. 13, the subject called Charles A. May
EXHIBITED: Corcoran and Grand Central Art Galleries, New York, 1925–26, *Centennial Exhibition of the National Academy of Design*, no. 532, listed as a portrait of Charles A. May, Esq.; Ehrich Galleries, New York, 1931, *Miniatures by Early American Artists and of American Subjects*, no. 40
EX COLLS.: A. Rosenthal, New York; with Ehrich Galleries, New York

Charles A. Macy (1807–1875) was born in Nantucket, Massachusetts. His family moved to New York City, where in 1831 Macy became a partner in his father's shipping and commission firm. He was later a partner of the private banking firm Howes, Macy & Company. He

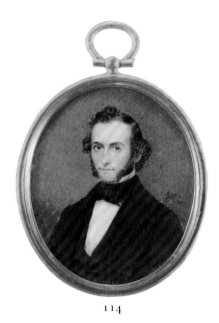

114

married Sarah L. Corlies, with whom he had five children.

EMANUEL GOTTLIEB LEUTZE

(1816–1868)

A painter of historical subjects, landscapes, portraits, and miniatures, Emanuel Leutze was born in Schwäbisch Gmünd, Württemburg. He was nine when his artisan father, a political refugee, brought the family to the United States, settling in Philadelphia. In 1834 Leutze began formal studies with the Philadelphia drawing master John Rubens Smith (1775–1849) and rapidly became proficient. He was commissioned in 1836 to provide likenesses for *The National Portrait Gallery of Distinguished Americans* compiled by James Herring and James Barton Longacre (3 vols.; Philadelphia, 1834–39). Next he worked as an itinerant portraitist in Virginia, Maryland, and Pennsylvania, returning in 1839 to Philadelphia, where he produced portraits and paintings with literary themes which he exhibited at the Artists' Fund Society in Philadelphia and the Apollo Association in New York.

Admirers financed Leutze's study abroad; he arrived in Düsseldorf in 1841 and enrolled in the Royal Art Academy. Leutze's history paintings brought him international recognition, but he became frustrated with the exactitude urged by the academy, left it, and in 1843 embarked on a tour of Germany and Italy. Two years later he returned to Düsseldorf, marrying the daughter of a Prussian officer and remaining for another fourteen years. Leutze became an informal adviser, and his studio a center, for art students from America, a number of whom later became prominent artists. During the period of the revolutions of 1848, Leutze, a liberal, was active politically and in addition organized the independent artists' community.

Leutze returned to the United States in 1859 and took a studio in New York; he worked there on a long series of large historical compositions, many begun in Germany, which included his most famous painting, *Washington Crossing the Delaware* (MMA). He divided his time between New York and Washington, D.C., where in 1862 he completed a mural in the Capitol, *Westward the Course of Empire Takes Its Way*. He died in Washington.

The few known miniatures by Leutze were painted between 1837 and 1855. Two of them, documented self-portraits, are engaging and personal in style; others portray the subject stiffly, lack modeling, and employ broad diagonal hatching in the background.

115. *Gentleman said to be Emanuel G. Leutze*

Watercolor on ivory, 2¾ x 2³⁄₁₆ in. (7 x 5.6 cm)
Traces of signature along right edge: *E L 3[9?]*.
 Inscribed on backing paper: *E G Leutze / No 4
 North 9th St / Philadelphia*
Casework: gilded metal
Ex colls.: Fannie and Ida Edelson, Philadelphia;
 sale, Sotheby Parke-Bernet, New York, May 10,
 1974, lot 121; with E. Grosvenor Paine, New
 Orleans; sale, Sotheby Parke-Bernet, Jan. 29,
 1986, lot 103

When this miniature was sold in 1974, the subject was identified as E. G. L[e]utze, probably because of the inscription. With miniatures, often the artist's inscription giving his name has been misinterpreted as giving the name of the subject, or vice versa. When the

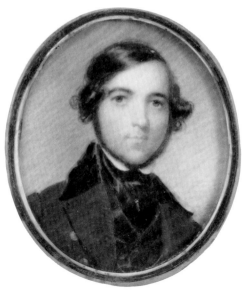

115

work was sold again, in 1986, it was described as a self-portrait by Leutze. However, the subject does not appear to be the person depicted in the documented self-portraits painted between 1842 and 1846 (illustrated in Groseclose, 1975; see bibliography for Leutze).

WILLIAM LEWIS

(1788–after 1838)

William Lewis was born in Salem, Massachusetts. He married Dorothy Skinner in 1812. Lewis worked in Salem as a painter of portraits and miniatures until 1821, then moved to Boston, where he practiced until 1838. During those years he made frequent return visits to his hometown and in the early 1820s also painted in Rhode Island. Lewis exhibited still lifes, portraits, and miniatures at the Boston Athenaeum in 1828 and 1831 and at the Boston Mechanics' Association in 1837. A number of his signed and dated miniatures are owned by the Essex Institute in Salem and the Rhode Island Historical Society in Providence.

Apparently self-taught, Lewis produced

charming miniatures executed in a naive, slightly stilted style. Heads are placed high on the ivory. The subjects appear almost comical: they smile faintly and have large, round eyes, gently hooked noses, and conspicuous, unfinished ears. The faces are softly delineated; the backgrounds, light green or of a neutral shade, are broadly hatched. Costumes and accessories are meticulously depicted in lively colors.

116. *Louisa W. Dixon*

1833
Watercolor on ivory, 2⅜ x 1⅞ in. (6 x 4.7 cm)
Inscribed on backing paper: *Miss Louisa W. Dixon / taken in her 19th year / in the year 1833 / presented by / Mr L. M. Goldsmith / Aug 9th 1833*
Casework: gilded copper with beaded bezel; on the reverse, beaded bezel framing compartment containing a piece of fabric
Ex COLL.: sale, Sotheby Parke-Bernet, New York, July 17, 1984, lot 6

Colorplate 18a

Louisa W. Dixon (b. 1814) was the daughter of Thomas Dixon of Cambridge, Massachusetts.

She married Lazarus M. Goldsmith in 1833. He died in 1840 and she was remarried in 1844 to Francis Parker of New York.

Catalogue nos. 116 and 117 are companion pieces.

117. *Lazarus M. Goldsmith*

1833
Watercolor on ivory, 1¹³⁄₁₆ x 1½ in. (4.6 x 3.8 cm)
Inscribed on backing paper: *Mr L. M. Goldsmith / taken in his 33rd year / in the year - 1833- / presented by Miss / Louisa W. Dixon / Aug 9th 1833*
Casework: as for cat. no. 116
Ex COLL.: as for cat. no. 116

Lazarus M. Goldsmith (1800–1840) owned a dry goods store in Boston.

Attributed to William Lewis

118. *Gentleman*

Watercolor on ivory, 2¹⁄₁₆ x 1¹¹⁄₁₆ in. (5.2 x 4.3 cm)
Casework: gilded copper with beaded bezel; on the reverse, beaded bezel framing compartment containing a piece of fabric

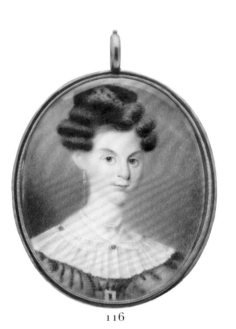

116

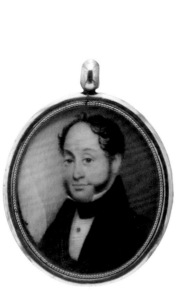

117

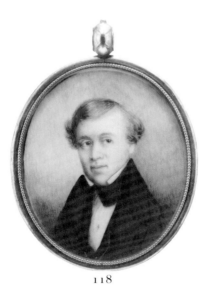

118

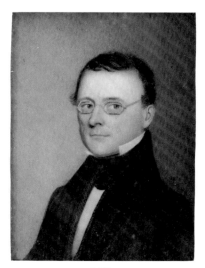

119

THEODORE LUND

(active 1836–46)

Theodore Lund lived in New York, painting miniatures there between 1836 and 1843 and exhibiting them at the National Academy of Design in 1836 and 1837, the Apollo Association in 1839, and the American Institute in 1842. Miniatures by him are extant dated as late as 1846.

Lund painted in a meticulous, linear style. The subjects of his charming, whimsical portraits wear a slight smile. Backgrounds are finely hatched.

119. *Samuel Baldwin Ludlow*

1838
Watercolor on ivory, 2¹¹/₁₆ x 1⅞ in. (6.8 x 4.9 cm)
 Signed and dated at lower right: *1838 / T LUND*
Casework: modern (not shown). Inscribed on old
 paper backing: *Samuel Baldwin Ludlow*
Ex COLL.: purchased from Edward Sheppard, New
 York

WILLIAM LYDSTON, JR.

(ca. 1813–1881)

William Lydston, Jr., was born in Massachusetts and established himself in Boston, where he listed his occupation as a portrait and miniature painter from 1835 to 1858, a fresco and sign painter in 1859–61, a musician in 1862–66, and then again a sign painter. He exhibited miniatures at the Boston Mechanics' Association in 1841; the committee recorded then that "in attempting to produce a striking effect, the artist has rendered his picture too somber." He exhibited another miniature there in 1847. His brother, Francis A. Lydston (b. 1819), worked in Boston as a miniature and fresco painter.

Lydston was probably self-taught; his works are naively executed. Pale children with oversized heads, wearing pale clothing, are set against light gray, hatched backgrounds.

120. *Child*

Watercolor on ivory, 2⅛ x 1¹¹/₁₆ in. (5.5 x 4.3 cm)
On the backing paper, two sketches in graphite of
 children's faces
Casework: hinged leather, ormolu mat (partially
 shown)

121. *Child named Mary D—*

1842
Watercolor on ivory, 2 x 1⅝ in. (5 x 4.2 cm)
Inscribed on backing card: *Painted / of / Mary
 D[illegible] 1842 / By / Wm. Lydston Jr.*
Casework: gilded copper with chiseled bezel

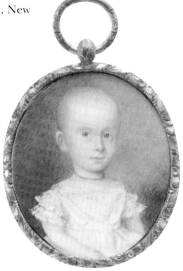

121

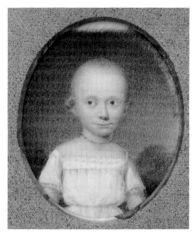

120

EDWARD GREENE MALBONE

(1777–1807)

Edward Greene Malbone, a self-taught artist who was active for less than twelve years, is regarded as America's finest miniature painter. He was born in Newport, Rhode Island, the son of a merchant, John Malbone, and his common-law wife, Patience Greene. As a boy he was encouraged by the artist Samuel King (1748/49–1819), who lent him engravings to copy. In 1794 Malbone, then seventeen, established himself as a miniature painter in nearby Providence. After two years he settled in Boston, where he renewed an earlier friendship with the painter Washington Allston (1779–1843). Next he worked for two years in Philadelphia and New York. In 1801 Malbone visited Charleston, South Carolina, there befriending CHARLES FRASER, whose work he strongly influenced.

Malbone and Allston traveled to London in the spring of 1801. They met Benjamin West (1738–1820), who greatly admired Malbone's portrait of Allston and expressed surprise at how far the miniaturist had advanced without instruction. In England Malbone studied portraits by Sir Thomas Lawrence (1769–1830) and miniatures by Samuel Shelley (1750–1808) and Richard Cosway (1742–1821). He returned to Charleston in December of 1801; then began his most prolific period, which is documented in the account book he kept (Henry Francis Dupont Winterthur Museum, Winterthur, Delaware). During the next five months he painted about three miniatures per week.

Between 1802 and 1806 Malbone worked in New York, Newport, Providence, Philadelphia, Boston, and Charleston. His output diminished, however, when he contracted tuberculosis. By March of 1806, having all but ceased painting, he returned to Newport. On his doctor's advice Malbone traveled to Jamaica in the hope that the climate would be beneficial; after a voyage of seventeen days he arrived in Port Antonio, which he described as "the most wretched and miserable hole that I ever was in" (quoted in Tolman, 1929, p. 53; see bibliography for Malbone). He began the return trip

in a weakened condition and died before reaching home. His age was twenty-nine.

Malbone's earliest miniatures, although somewhat primitive, are remarkably accomplished for a self-taught seventeen-year-old. The faces are finely stippled and crisply outlined; subjects are placed against the conventional English background of a red curtain. By 1801 Malbone had developed a technique of delicate cross-hatching, creating form by means of fine interwoven lines. His brushstroke had grown more assured, and he began to allow the luminosity of the ivory support to emerge through thin washes of transparent color. After his trip to England, Malbone's brushwork became freer and broader, with subtler transitions between the painted areas. Backgrounds grew lighter, often displaying a sky and cloud motif. He employed a larger ivory, often well over three inches high. Only about a fifth of his works are signed, usually his early ones, and in a variety of ways: *Malbone*, *E G Malbone*, *E G M*, or *E M*. Occasionally he inscribed the backing card.

122. *Nathaniel Pearce*

1795
Watercolor on ivory, 2⅜ x 2 in. (6 x 5 cm)
Signed and dated at lower right: *E M 1795*
Casework: modern

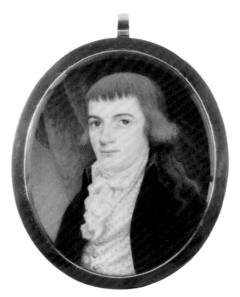

122

Colorplate 6a

Nathaniel Pearce (1770–1851) was born in Providence. He married Sally Stoddard there in 1791, and they had five children. Pearce had his miniature painted by Malbone at least twice. This was the first, and was one of Malbone's earliest miniatures. Malbone made another miniature of Pearce in 1796 (Newport Historical Society) and seems to have painted him again in 1804–05, according to his record book.

123. *George Bethune*

ca. 1800
Watercolor on ivory, 3⅛ x 2⁷⁄₁₆ in. (7.8 x 6.2 cm)
Casework: gold bezel and hanger set with pearls; on the reverse, triple bezel framing blue Bristol glass, compartment containing braided hair, and blue glass medallion with gold monogram *B*. The middle bezel is engraved: *George Bethune born April 29th 1769 / Died Sept. 20. 1859. AE 90 Yrs.* The outer bezel is engraved: *By Malbone 1800*
Reference: Ruel Pardee Tolman, *The Life and Works of Edward Greene Malbone, 1777–1807* (New York: New-York Historical Society, 1958), p. 138
Exhibited: National Gallery of Art, Washington, D.C., 1929, *Miniatures and Other Works by Edward Greene Malbone, 1777–1807*, no. 6; exh. cat. p. 10
Ex colls.: the subject's son, George Amory Bethune; his son John MacLean Bethune; his daughter, Katharine B. Adams, Boston, on long-term loan to the Museum of Fine Arts, Boston

Colorplate 6d and page 31, d

George Bethune was born in Boston to George and Mary Faneuil Bethune. He became a prominent Boston physician and in 1810 married Mary Amory; they had two sons. This miniature was made when Bethune was about thirty. Gilbert Stuart painted an oil portrait of Bethune some twenty years later (coll. Faneuil D. Weisse, New York).

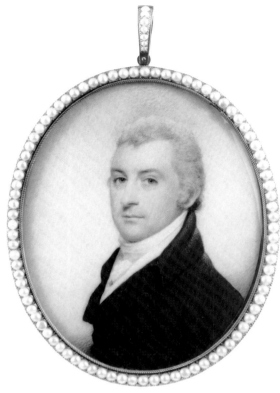

123

124. *Samuel Denman*

Watercolor on ivory, 2¹³⁄₁₆ x 2⁵⁄₁₆ in. (7.1 x 5.9 cm)
Casework: gilded copper; on the reverse, compartment containing plaited hair
Ex colls.: Mrs. J. Hampton Lynch; Mrs. J. E. Emerson (Madeline Lynch), Titusville, Pennsylvania; sale, Sotheby Parke-Bernet, New York, July 17, 1984, lot 32

Colorplate 6c

Samuel Denman (1774–1816) was born in Springfield, New Jersey, to Mathias and Phebe Baldwin Denman. Mathias Denman, a Revolutionary soldier, received a large land grant from the government in 1788. In 1801 Samuel Denman married Anna Maria Hampton. He was a merchant in Philadelphia from 1803 until his death.

Catalogue nos. 124 and 125 are companion pieces.

125. *Anna Maria Hampton*
 (Mrs. Samuel Denman)

Watercolor on ivory, 2⅝ x 2⅛ in. (6.8 x 5.5 cm)
Casework: as for cat. no. 124
Ex colls.: as for cat. no. 124, except in lot 31

Colorplate 6b

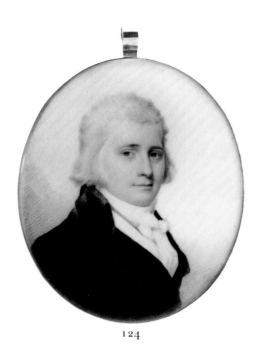

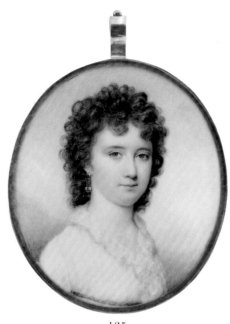

124

125

Anna Maria Hampton (1776–1818) was born in Elizabethtown, New Jersey, the daughter of Jonathan Hampton, a well-to-do Essex County landowner. She married Samuel Denman in 1801 in Philadelphia, where she lived for the rest of her life. The Denmans had one son.

EDWARD DALTON MARCHANT

(1806–1887)

Edward Dalton Marchant was born in Edgartown, Massachusetts, the son of Elisha Marchant. According to family records he received some instruction in painting from Gilbert Stuart (1755–1828). In his early oil portrait *Septima Sexta Middleton Rutledge* (Middleton Place, Charleston) the influence of Stuart is evident. Where Marchant received his training in miniature painting is not known, but in 1827–28 he was in Charleston, where his advertisement to take likenesses in oil and miniature included the confidence that he was "impelled to the exercise of his art by an insurmountable

affection for it" (Rutledge, 1949, p. 133). He exhibited portraits and miniatures regularly at the National Academy of Design between 1832 and 1852 and was elected an associate there in 1833. He maintained a studio in New York during those years but also worked in New Orleans and Nashville and in Ohio.

The author of a letter sent in 1838 to Thomas Cole (1801–1848) from Zanesville, Ohio, wrote that Marchant's "last pictures are decidedly superior to those he first executed. I regard them as works of art of a high order. . . . He has gone to Cincinnati to set up his easel where he will be liberally encouraged" (W. A. Adams; Archives of American Art, roll ALC 1). Marchant lived in Philadelphia from 1854 to 1860 and between 1850 and 1868 exhibited frequently at the Pennsylvania Academy of the Fine Arts. He painted oil portraits of many prominent persons, including Abraham Lincoln, John Quincy Adams, Henry Clay, Andrew Jackson, and John Jacob Astor. His son, Henry A. Marchant, also became a miniature painter.

A great many oil portraits by Marchant survive, but fewer than ten miniatures by him are known today. Those painted in the 1830s are

crisp and carefully delineated, with hatched backgrounds. His miniatures from the 1840s, more formulaic in conception, have regular stippling in the background and often show a red drape.

126. *Lady*

1842
Watercolor on ivory, 3¼ x 2⁹⁄₁₆ in. (8.4 x 6.5 cm)
Signed and dated on lower right edge: *E M 1842*
Casework: hinged red leather with ormolu mat
 (partially shown)

JOHN ALEXANDER MCDOUGALL

(1810/11–1894)

A miniature painter and photographer, John (also known as James) Alexander McDougall was born in Livingston, New Jersey, the son of a cabinetmaker. He studied painting at the National Academy of Design in New York, exhibiting at their annual shows between 1841 and 1852. He also exhibited in New York at the Apollo Association and the American Institute, where he often won first prize for miniatures, and at the Artists' Fund Society in Philadelphia. Although McDougall kept a studio in New York during much of the 1840s and early 1850s, he worked chiefly in Newark, New Jersey, as a miniature painter and photographer. He worked for shorter periods in New Orleans in 1839 and 1853 and also in Charleston and Saratoga Springs, New York.

In 1838 McDougall formed a partnership in Newark with George Gates Ross (1814–1856); McDougall painted the miniatures, Ross the larger oil portraits. McDougall's sitters included Edgar Allan Poe, Cornelius Vanderbilt, and Henry Clay. He had four sons, all involved in the arts: John A. McDougall, Jr. (1843–1924), a miniature and marine painter who is often confused with his father; William, a landscape painter and engraver; Harry, an editor of the *Newark Sunday Call*; and Walter, a well-known cartoonist.

In 1926 Walter published an autobiography, *This Is the Life* (New York), in which he reminisced that his father "constantly experimented with novelties in pigments, mediums, and papers." One of his experiments was painting on celluloid as a substitute for ivory. Later in his career McDougall turned to portrait photography; he thus was able to supply his customers with either a painted or a photographic miniature. McDougall remained active until about 1880, long after all the other well-known miniaturists except JOHN HENRY BROWN had given up painting altogether in the face of competition from photography. He was a good friend of the painters George Inness and Asher B. Durand and of Thomas A. Edison, "who kept an electrical shop around the corner."

McDougall painted likenesses that were technically accurate, if somewhat dry and uninspired; they were typical of works of the mid-century in their deep, rich coloring, realism, and broad stippling. It is known that he also painted very tiny miniatures for the smallest of gold lockets, which were usually engraved on the reverse with the subject's initials. His works are rarely signed.

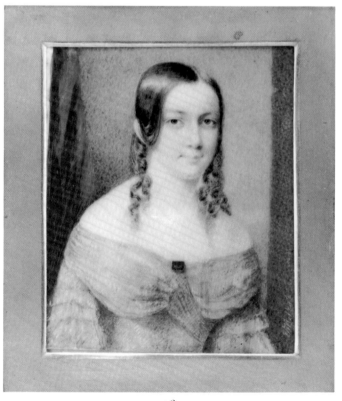

126

127. *Boy with the Initials L N L*

Watercolor on ivory, 2½ x 2 in. (6.4 x 5 cm)
Casework: gilded copper; reverse machine turned, with compartment containing braided hair and an engraved medallion inscribed: *L N L*
Ex COLL.: purchased from Edward Sheppard, New York

128. *Gentleman with the Initials J P R*

1848
Watercolor on ivory, 3 x 2⅜ in. (7.6 x 6.1 cm)
Casework: gilded copper with chased bezel and hanger; on the reverse, chased bezel framing central compartment and engraved inscription: *J P R to J C W / 1848*
Inscribed in graphite on backing card: *Mr. Panton / 109 Clinton Place / Continuation of 8th Str. / Opposite McDougal*
Ex COLLS.: with E. Grosvenor Paine, New Orleans; sale, Sotheby Parke-Bernet, New York, Jan. 29, 1986, lot 123; purchased from Edward Sheppard, New York

As there was no known miniaturist with the name Panton and the name does not correspond to the subject's engraved initials, the inscription may refer to the casemaker.

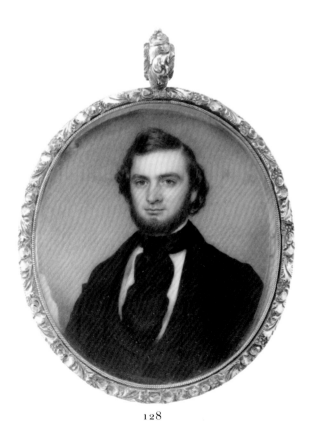

127

Attributed to John Alexander McDougall

129. *Gentleman*

Watercolor on ivory, ¹⁵⁄₁₆ x ¹¹⁄₁₆ in. (2.4 x 1.8 cm)
Inscribed on backing card: *N A J* [or *N A S*] / *Charleston*
Casework: gold with chased bezel, mounted as a brooch

McDougall probably painted this miniature during one of his winters in Charleston. The miniature is attributed to him on the basis of its precise technique and its unusually small size, which is often a characteristic of McDougall's work.

Attributed to John Alexander McDougall

130. *Gentleman*

Watercolor on ivory, ⅞ x ⅞ in. (2.5 x 2.5 cm)
Casework: gold plated with chased bezel, watch style, with engine-turned lids front and back; engraved inside lid: *My Father*
Ex COLL.: sale, Sotheby Parke-Bernet, New York, July 17, 1984, lot 81A

This miniature is also attributed to McDougall on the grounds of its style and exceptionally small size.

128

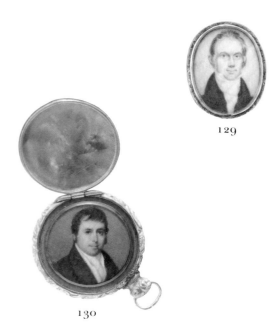

129

130

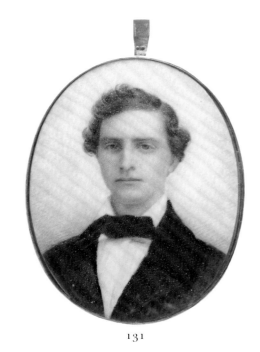

131

Attributed to John Alexander McDougall

131. *Hampton Denman*

Watercolor on ivory, 2¹³⁄₁₆ x 2³⁄₁₆ in. (7.1 x 5.6 cm)
Casework: gilded copper with burnished bezel
Ex coll.: sale, Sotheby Parke-Bernet, New York,
 July 17, 1984, lot 33

Hampton Boyle Denman was a grandson of
Samuel and Anna Maria Hampton Denman
(see cat. nos. 124 and 125). His parents, Samuel
and Susan Boyle Denman, married in Lancas-
ter, Ohio, and raised seven children in Law-
rence, Kansas.

MEDESCHINI

Nothing is known of the artist who signed his
name Medeschini along the right edge of this
ivory. His obscurity here, in England, and on
the Continent, together with his name, suggests
that he was an itinerant artist from Italy who
painted briefly in the United States. If this min-
iature is typical of his technique, his works are
naively drawn, show little modeling, and utilize
a light gray background.

132. *Naval Officer*

Watercolor on ivory, 2⅞ x 2⁵⁄₁₆ in. (7.2 x 6 cm)
Signed along right edge: *Medeschini*
Casework: papier-mâché with brass bezel and
 acorn hanger (partially shown)
Ex coll.: purchased from Edward Sheppard, New
 York

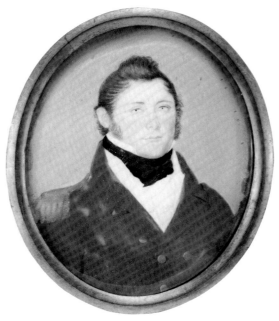

132

ANTHONY MEUCCI

(active 1818–37)

Anthony (or Antoine, Anton) Meucci and his wife, Nina Meucci (active 1818–27), also a miniature painter, arrived in the United States from Rome in 1818. They began working in New Orleans as portrait and miniature painters, and in the course of the next eight years they worked there and in Charleston, Baltimore, Havana, Salem (Massachusetts), Portland (Maine), Richmond (Virginia), and New York, taking likenesses and teaching. In the drawing and painting academy the Meuccis ran in Charleston, according to their advertisement, they taught young ladies—in fifteen lessons—how to paint on velvet and do figure, landscape, and miniature painting. In 1824 the Meuccis exhibited at the American Academy of Fine Arts a *Row of Four Miniatures*. In 1826 they returned to New Orleans, where Meucci was employed by the New Orleans Theatre to paint opera scenery and decorations. Meucci left New Orleans in 1827, stopping in Havana on his way to Cartagena, Colombia. There he painted a miniature of Simón Bolívar in 1828. He traveled widely in South America, executing miniature portraits, until 1837; there is no record of him after that date.

Miniatures painted by Anthony Meucci are distinctively linear, with a minimum of modeling. Their decorative quality, with an emphasis placed on meticulously detailed lace collars, bonnets, paisley shawls, and jewelry, is much in the tradition of self-taught folk art. The backgrounds, typical of those in Continental miniatures, are opaquely painted in pinkish gray. The works are often signed along an edge.

133. *Lady*

Watercolor on ivory, 2¾ x 2¼ in. (6.9 x 5.7 cm)
Signed along right edge: *Meucci*
Casework: gold with maker's mark; on the reverse, hinged cover over compartment containing braided hair
Ex colls.: with E. Grosvenor Paine, New Orleans; sale, Sotheby Parke-Bernet, New York, Jan. 29, 1986, lot 111

Colorplate 20c

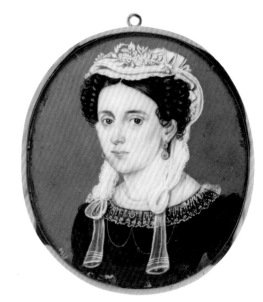

133

EDWARD MILES

(1752–1828)

Born in Yarmouth, England, Edward Miles started as an errand boy to a surgeon, who encouraged his talent for drawing. At nineteen he went to London, where he met Sir Joshua Reynolds and made miniature copies of the master's portraits. He entered the Royal Academy Schools in 1772 and exhibited miniatures there regularly between 1775 and 1797. His success was such that he was appointed miniature painter to the Duchess of York and Queen Charlotte; in 1797 he went to St. Petersburg, where he became court painter to Emperor Paul and later to Czar Alexander I.

Miles arrived in Philadelphia in 1807, aged fifty-four. He listed himself in the city directory as a miniature painter or portraitist in crayon until 1811, when he opened a drawing academy. He was a founder and drawing master of the Society of Artists of the United States, which in 1813 became the Columbian Society of Artists. Miles produced few miniatures in Philadelphia; he was far better known as a drawing teacher. One of his pupils, James Reid Lambdin (1807–1889), became a successful

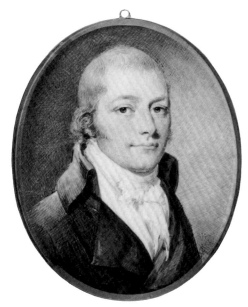

134

Miles was a fine miniaturist in the English tradition; his work, rarely signed, is often confused with that of the British miniaturist Richard Cosway (1742–1821). In Miles's miniatures the hair and flesh are softly modeled with a delicate, pale-toned stipple, while clothing and backgrounds are broadly hatched. The subjects, their features strongly delineated, appear affable and elegant.

134. *L. B. Walker*

Watercolor on ivory, 2⅞ x 2³⁄₁₆ in. (7.2 x 5.5 cm)
Casework: gilded copper; on the reverse, compartment containing plaited hair with pearl initials *L B W*
Ex coll.: sale, Sotheby Parke-Bernet, New York, Nov. 19, 1980, lot 221 (attributed to Robert Field)

Attributed to Edward Miles

135. *Gentleman*

Watercolor on ivory, 2⁷⁄₁₆ x 2 in. (6.2 x 5.2 cm)
Casework: gilded copper

On the reverse:

Boy

Watercolor on ivory, 1⁹⁄₁₆ x 1⅛ in. (4 x 2.8 cm)

portraitist and miniature painter. The only works by Miles whose exhibition in this country is documented were shown at the Louisville Museum in 1834, after his death. An erroneous record states that Miles died in Yarmouth in 1798, but it has been confirmed that his death took place in Philadelphia in 1828.

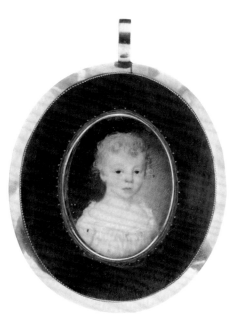

135 reverse

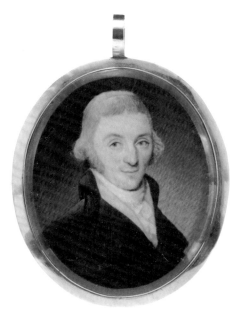

135

136

137

STUDENT AT MRS. MORRIS'S ACADEMY

The miniature watercolors shown here were painted by an unidentified student at Mrs. Morris's Academy, a school for young ladies which was in operation in Philadelphia during the years 1810–14. Few such examples of documented student work have survived. Mrs. Morris exhibited at the Pennsylvania Academy of the Fine Arts in 1828, showing *Sea View— Fishery*, after a painting by an artist named Wright, of Pimlico (London), who was said to be her father.

136. *The Tomb of Irwin*

ca. 1810
Watercolor on paper, 1¹¹⁄₁₆ x 1¹¹⁄₁₆ in. (4.3 x 4.3 cm)
Inscribed on the reverse: *The Tomb of / Irwin / erected by a Female Friend / and wept over by every friend who knew / him*
Casework: modern
REFERENCE: Frank S. Schwarz & Son, *Philadelphia Collection XI*, exh. cat. (Philadelphia, 1981), no. 58
EX COLL.: purchased from Frank S. Schwarz & Son, Philadelphia, 1981

137. *May Thy Voyage Be Prosperous*

ca. 1810
Watercolor on paper, 1⅝ x 1⅝ in. (4.1 x 4.1 cm)
Inscribed along bottom edge: *May thy voyage be prosperous*

Trade card on the reverse reads: *Mrs. Morris / Painting & Drawing / Academy / Heyde's Court, Filbert, between 8 & 9 / PHILA*
Casework: modern
REFERENCE: as for cat. no. 136
EX COLL.: as for cat. no. 136

SAMUEL FINLEY BREESE MORSE

(1791–1872)

Samuel F. B. Morse, the inventor of the telegraph and also a history and portrait painter and a miniaturist, was born in Charlestown, Massachusetts. His father, Jedidiah Morse, was a geographer and Calvinist minister. During his student years at Yale, Morse earned pocket money from fellow students by executing miniatures on ivory for five dollars apiece and profiles for one dollar. Despite strong parental disapproval of his decision to become an artist, he went to London in 1811 with his mentor, Washington Allston (1779–1843). For four years Morse studied history painting under Allston and Benjamin West and also at the Royal Academy. In 1812 he won a gold medal from the Society of Arts for a statuette of Hercules and produced two large history paintings, which were exhibited at the Royal Academy in 1813 and 1815.

When Morse returned to America in 1815

he found little that might support his ambition to be a history painter, and out of necessity he returned to portraiture. He first set up a studio in Boston; next he traveled through New Hampshire and Vermont, working as an itinerant portrait painter. A trip to Charleston in 1818 was so successful in producing commissions that he returned there each winter until 1822. That year Morse completed *The Old House of Representatives* (Corcoran Gallery, Washington, D.C.), which incorporated eighty-six portraits done from life.

In 1823 Morse settled in New York City, where he was commissioned to paint the full-length portrait *Lafayette* (in City Hall), which won him recognition as a major figure of the New York art community. He led a group of dissidents away from the moribund American Academy of Fine Arts to found, in 1826, the institution that ultimately became the National Academy of Design; he served as its president until 1845. Despite his artistic and social distinction, Morse could barely make a living.

Between the years 1825 and 1828, Morse endured the successive deaths of his wife, father, and mother. He left New York to paint in France and Italy for four years; after his return he was increasingly absorbed with perfecting the electric telegraph he had invented. By 1837 he had ceased painting altogether. He championed the advancement of the daguerreotype in this country in 1839. Morse contributed to the fund for the establishment of the Metropolitan Museum, of which he was a trustee and vice president during the last year of his life.

There are only a few known miniatures on ivory by Morse. Almost all were painted between 1808 and 1811, before he had had any formal artistic training, and are the works of a self-taught artist. Forms are expressive but simplified: expressions are somewhat wooden, hair and features are linear in treatment, clothing is painted in a stylized manner. The opaque backgrounds are shaded gray-blue. Morse's miniature *Self-portrait* in which he holds palette and brush (National Academy of Design, New York), which is undated but was probably made before his trip to London in 1811, is evidence of a remarkable growth in his skill within a few years.

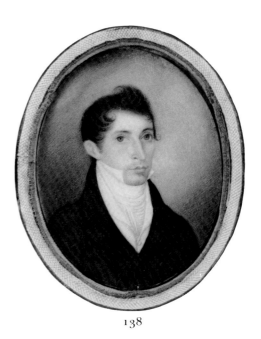

138

138. *Cyrus Mansfield*

ca. 1808
Watercolor on ivory, 2⅝ x 1¹⁵⁄₁₆ in. (6.8 x 4.9 cm)
Inscribed on backing paper: *Cy Mansfield / Saml Morse*
Casework: hinged leather
Ex colls.: sale, Sotheby Parke-Bernet, New York, June 10, 1985, lot 81; purchased from Edward Sheppard, New York

This appears to be the earliest extant ivory

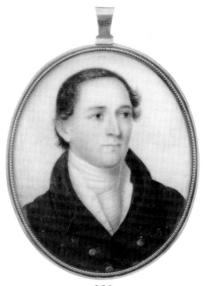

139

miniature by Morse. A Cyrus Mansfield living in Hudson, Columbia County, was listed in the New York State census for 1820. The subject may have been a fellow student of Morse's at Yale.

Attributed to Samuel F. B. Morse

139. *Gentleman*

Watercolor on ivory, 2⅜ x 2 in. (6 x 5.1 cm)
Casework: gilded copper with beaded bezel
Ex coll.: sale, Sotheby Parke-Bernet, New York, July 17, 1984, lot 90

THOMAS STORY OFFICER

(1810–1859)

Thomas Story Officer was born in Carlisle, Pennsylvania, the son of John and Mary Storey Officer. He studied under THOMAS SULLY in Philadelphia and worked there as a portrait and miniature painter from about 1834 until 1845, exhibiting frequently at the Artists' Fund Society. He also painted in Mobile, Charleston, New Orleans, and Richmond before moving to New York in 1846. He exhibited at the National Academy of Design and the American Art Union from 1846 to 1850.

At the close of the Mexican War Officer visited Mexico City, where he painted a miniature of the wife of the United States minister to Mexico. He lived in Australia for a while before moving in 1855 to San Francisco; there he opened a studio and achieved great success. He received a bronze medal at the Mechanics' Institute Fair in 1857, and in 1858 a certificate of merit for a miniature, *Professor Mapes* (location unknown), which was praised by critics for its "delicacy of handling, force of character and expression, and exquisiteness of finish" (quoted in Yarnall and Gerdts, 1986, vol. 4, p. 2623). For a while he was associated as a colorist with the photographer George B. Johnson; he submitted a "photograph in oil" to the 1858 Mechanics' Institute Fair. The writer of his obituary described Officer as "in all probability, the best portrait painter ever in California. . . . As soon as Mr. Officer began his labors in California a visible improvement was noticed among the other artists of this city" (*Alta California*, December 9, 1859). Nonetheless, Officer had died an impoverished alcoholic and was buried in a public plot.

To modern tastes Officer's early miniature portraits, painted from life, are more successful than his "fancy pieces," which are slick and overly sentimental. During the mid-nineteenth century, however, works of this kind held wide appeal.

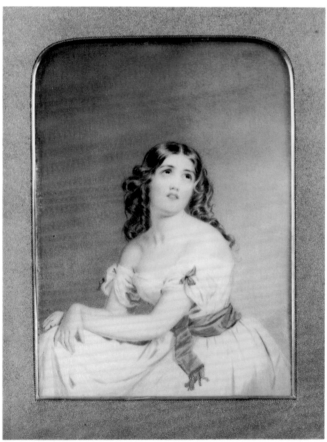

140. *Holy Eyes*

1848
Watercolor on ivory, 7⅝ x 5¼ in. (19.4 x 13.3 cm); shown reduced
Signed at right edge: *Officer 1848*. Inscribed on backing paper: *Painted by Tho. S. Officer / New York 1848 / Fancy piece / Holy Eyes*
Casework: cast metal with ormolu mat (partially shown)
EXHIBITED: American Art Union, New York, 1848, no. 163
Ex coll.: Fanny M. C. Farrell, New York, 1848

ANNA CLAYPOOLE PEALE

(1791–1878)

Anna Claypoole Peale was born in Philadelphia, the daughter of JAMES PEALE and Mary Claypoole. Her grandfather was James Claypoole (1720–ca. 1796), Pennsylvania's first portraitist. Anna was trained by her father, whom she assisted in painting miniatures when his eyesight began to fail. Her uncle, CHARLES WILLSON PEALE, took her to Washington, D.C., in 1818 to promote her already burgeoning career. "Her merit in miniature painting brings her into high estimation," he wrote, "and so many ladies and Gentlemen desire to sett to her that she frequently is obliged to raise her prices" (C. W. Peale to Rembrandt Peale, October 1, 1818, in Peale-Sellers Papers [unpublished manuscript], Letterbook 15 [American Philosophical Society, Philadelphia]). During their three-month stay, Charles Willson painted portraits for his Philadelphia Museum, while Anna executed miniature portraits of the same subjects. Among their distinguished sitters were President James Monroe (miniature unlocated), General Andrew Jackson (miniature: Yale University Art Gallery, New Haven), and Colonel Richard M. Johnson (miniature: Museum of Fine Arts, Boston). The two painters breakfasted with President Monroe and attended glittering receptions at the White House.

Anna's success in Washington helped her establish a thriving business in both Philadelphia and Baltimore. During the 1820s she shared a studio in Philadelphia with her sister Sarah Miriam Peale (1800–1885) and there trained her niece, Mary Jane Simes (1807–1872), in the art of miniature painting; she also maintained a studio at the Peale Museum in Baltimore and additionally made trips to Washington, New York, and Boston. Anna ceased painting on her marriage in 1829 to the Reverend William Staughton but resumed work soon after his early death. She continued to make portraits, fulfilling a steady stream of commissions, until her second marriage, in 1841, to General William Duncan. Thereafter she seems to have all but abandoned painting. In later life she lived in Philadelphia with her artist sisters, Sarah and

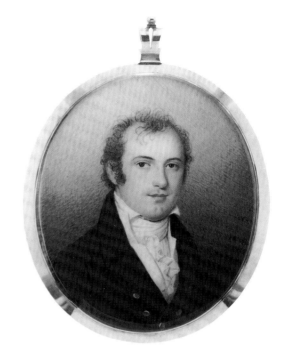

141

Margaretta Angelica Peale (1795–1882). She died there on Christmas Day at the age of eighty-seven.

The artist's miniatures were shown in annual exhibitions at the Pennsylvania Academy of the Fine Arts from 1814 until 1843; she was elected an academician there in 1824. She also exhibited at the Boston Athenaeum, the Artists' Fund Society, and Peale's Baltimore and New York museums. Although primarily a miniaturist, she also painted portraits in oil, landscapes, and still lifes.

In her work Anna Peale made considerable use of fine, intricate cross-hatching, creating a somewhat wiry effect. Lively skin tones are modulated with delicate, transparent shadows. Deeply colored, opaque backgrounds give some of the depth of oil painting. The details and textures of dress are exceptionally well rendered. Many of the subjects are represented with overly small torsos and elongated necks. The precise treatment of the artist's early miniatures gave way to a somewhat freer handling as her work matured. Although the portraits display a certain sameness, they are always sprightly and charming. The miniatures are dated and signed in very small letters, variously, *Anna C. Peale*, *Mrs. A. C. Staughton*, or *Mrs. Anna Duncan*.

141. *Gentleman with the Initials J C*

Watercolor on ivory, 2¾ x 2¼ in. (7 x 5.7 cm)
Casework: gilded copper; on the reverse,
 compartment containing plaited hair and cut
 gold initials: *J C*
Ex colls.: sale, Sotheby Parke-Bernet, New York,
 Nov. 19, 1980, lot 258; purchased from Edward
 Sheppard, New York

142. *Lady with Red Hair*

1822
Watercolor on ivory, 2⅝ x 2⅛ in. (6.7 x 5.4 cm)
Signed and dated lower left: *Anna C / Peale / 1822*
Casework: gilded copper with chased bezel and
 hanger
Ex coll.: purchased from Edward Sheppard, New
 York

Colorplate 11b

143. *Mrs. John A. Brown* (Grace Brown)

1827
Watercolor on ivory, 2⅞ x 2½ in. (7.3 x 6.2 cm)
Signed and dated at lower right: *Anna C. Peale /
1827*
Casework: modern
Ex colls.: Herbert T. Tiffany, Baltimore, 1944;
 his nephew, C. Wyatt Tiffany, Baltimore; sale,
 Sotheby Parke-Bernet, New York, July 14,
 1981, lot 274; purchased from Edward
 Sheppard, New York

Colorplate 11c

Grace Brown (1794–1880), the daughter of Dr.
George Brown and Rose Davison Brown, was
born in Baltimore. In 1824 she married John
A. Brown, a merchant banker and founder of

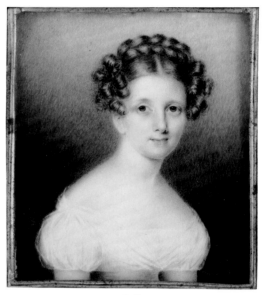

143

Brown Brothers & Company of Philadelphia.
She bore him three daughters, all of whom
died while still in their teens.

144. *George Weaver*

1833
Watercolor on ivory, 2¼ x 1⅞ in. (5.8 x 4.8 cm)
Signed and dated on backing paper: *Painted by /
Mrs A C Staughton / Philad 1833 / George Weaver*
Casework: gilded copper with chiseled bezel and
 hanger; on the reverse, chiseled bezel framing
 central compartment containing lock of hair
Ex colls.: Henry V. Weil, New York; Mrs. J.
 Amory Haskell; sale, Parke-Bernet, New York,
 Apr. 26, 1944, lot 404; sale, Sotheby Parke-
 Bernet, New York, Jan. 29, 1976, lot 213;
 purchased from Edward Sheppard, New York

145. *Mrs. Samuel Vaughan*

1838
Watercolor on ivory, 2⁵⁄₁₆ x 1¹³⁄₁₆ in. (5.9 x 4.6 cm)
Signed and dated on backing paper: *Anna C
 Staughton (Anna Peale) / Philadelphia, 1838*, and
 on back of frame: *Painted by Mrs A C Staughton /
 Philad Oct. 1838*
Casework: black lacquer with gilt metal bezel and
 acorn hanger (not shown)
Ex colls.: Emma E. Copper, Philadelphia; sale,
 Stan V. Henkels, Philadelphia, Apr. 13, 1916;
 Samuel Spragel, New York, 1941; Harry
 Fromke, New York; sale, Christie's, New York,
 Oct. 18, 1986, lot 404

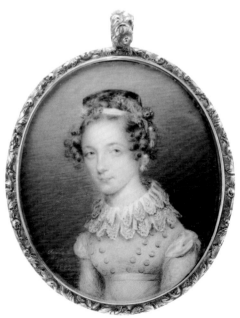

142

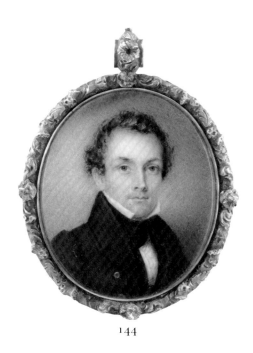

144

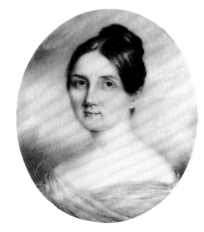

145

The subject was a member of the Copper family, probably the daughter of James Claypoole and Elizabeth Chambers Copper; she married Samuel Vaughan, the first president of the Pennsylvania Railroad. She was a relative of the artist, perhaps an aunt. A replica of this miniature belonged to Frank W. Bayley of Boston in 1926.

146. *George Washington*

Watercolor on ivory, 3 x 2⁷⁄₁₆ in. (7.7 x 6.2 cm)
Casework: modern
Ex coll.: sale, Sotheby Parke-Bernet, New York,
 Nov. 18, 1976, lot 521

Colorplate 11a

In the autumn of 1795, several members of the Peale family congregated at Philosophical Hall in Philadelphia to take George Washington's likeness. Charles Willson painted an oil portrait while sitting a little to Washington's left (New-York Historical Society); Rembrandt executed one almost frontally (National Portrait Gallery, Washington, D.C.); a miniature was taken by James from slightly to the sitter's right; and Raphaelle made a profile drawing (both, unlocated). Titian Ramsay Peale was also present. The scene inspired Gilbert Stuart's now-famous pun that Washington was being

"Pealed all around" (for a description of this gathering, see Sellers, 1952 [in bibliography for Charles Willson Peale], pp. 239–41). It is likely that the miniature shown here is a replica painted by Anna C. Peale after the miniature made by her father. Similarities of costume, pose, and expression link it to the portraits executed at that sitting, while on the basis of technique it can be assigned to Anna. At the miniature's purchase it was called a copy after Stuart, but it is unlike his portraits of Washington both in pose and in sentiment.

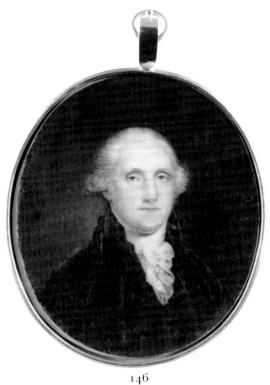

146

CHARLES WILLSON PEALE

(1741–1827)

An artist, inventor, scientist, author, and founder of a museum, Charles Willson Peale personified the pragmatic optimism of young America. He was born in Queen Anne County, Maryland; his father, a country schoolteacher, died when Peale was nine. Mrs. Peale moved her family to Annapolis, where Charles received a smattering of education, helped his seamstress mother by drafting patterns for her needlework, and copied engravings in his spare time. He was apprenticed to a saddlemaker at the age of fourteen; at twenty he was already married to Rachel Brewer (see cat. no. 147) and established in his own saddlery business.

Peale journeyed to Philadelphia, where he visited the studios of portraitists Christopher Steele (of London) and James Claypoole (1720–ca. 1796), who later became the father-in-law of Peale's brother James; he purchased a copy of Robert Dossie's *The Handmaid to the Arts* (London, 1758) and a supply of colors and returned to Annapolis, where he advertised himself as a sign painter. He persuaded John Hesselius (1728–1778) to instruct him for a while in portrait painting in exchange for a saddle and fittings.

Peale, a man of passion and energy, took an active interest in politics. By becoming one of the Sons of Liberty he angered his Tory creditors, who pressed him for repayment of his debts. In 1765 he fled to Boston and there sought out John Smibert (1688–1751), whose works he greatly admired. He also visited JOHN SINGLETON COPLEY; the powerful impression made by Copley's paintings had a lasting effect on Peale's work. Peale borrowed a portrait by Copley, probably *Henry Pelham* (1765; Museum of Fine Arts, Boston), and copied it. He returned to Annapolis with his work so much improved that his friends financed his travel to London for further study; there Benjamin West took him on as a student in 1767 and during the next two years instructed him in a variety of mediums including etching, mezzotint, and clay. Peale showed a strong penchant for miniature painting and supported himself in London by making miniature portraits.

In 1769 Peale returned to Annapolis, where he found an enthusiastic clientele for portraits in both full size and miniature; it was during this period that he produced the best work of his long and successful career, becoming one of the leading portraitists in the colonies. He probably taught himself the arts of hairwork and memorial and allegorical painting for the reverse side of a miniature. Some of his earliest works incorporate these small sepia-toned paintings; Peale may have been the first person in America to produce them.

In 1776 Peale moved his family to Philadelphia, where he painted most of the important gentlemen and ladies of the Revolutionary era. When serving as an officer of the colonial militia, Peale brought along his paint box and took miniature likenesses of most of the officers. During the winter at Valley Forge he recorded that he painted at least forty miniatures and received between $56 and $120 for each. He wrote to Benjamin West: "You will naturally conclude that the arts must languish in a country imbbroiled with Civil Wars. yet when I could disengage myself from a military life I have not wanted employment, but I have done more in miniature than in any other manner, because these are more portable and therefore could be keep out of the way of a plundering Enemy" (this and succeeding references to Peale's papers from *Selected Papers*, ed. Miller, 1983 [see bibliography for C. W. Peale]; this reference, pp. 387–88).

When the war ended Peale moved his family to a larger house and added a gallery to exhibit his likenesses of Revolutionary War heroes. He also collected wildlife specimens, preserved them, and mounted them for display in the gallery. About 1795 he opened a museum, called the Columbianum, which later became the Pennsylvania Academy of the Fine Arts. In 1801 Peale exhumed the remains of a mastodon in upstate New York, which he assembled and placed on exhibit; he recorded the event on canvas (Peale Museum, Baltimore).

Peale had trained his brother JAMES PEALE as a miniaturist, and the two so often collaborated that it is frequently difficult to distinguish their separate hands. Charles recorded in 1788 (*Selected Papers*, p. 523): "Worked . . . a little on a miniature of my Brothers painted by himself"

(MMA). Charles recognized James's superb talent for the art; his own vision was becoming less sharp, and when in 1786 they divided the business, James assumed the practice in miniatures. The division was not always strictly adhered to, however, and in 1809, still experimenting, Charles wrote to his son Rembrandt about his current work in miniature: "Grinding the colors in a weak solution of gum arabic only sufficient to hold them on the palette . . . produced an admirable effect . . . I found in laying in the backgrounds I could use opaque colors and retouch with color on color, either to lighten or to give depth of color where wanting without stippling, but with broad strokes, which give great facility to the work, with a more even surface, and not mottled as my former grounds were" (Sellers, 1952, p. 9; see bibliography for C. W. Peale). Very few miniatures by Peale from this late period are known, however.

After about 1795 Peale turned over his practice in oil portraits and silhouettes to his sons Rembrandt and RAPHAELLE PEALE. During the first two decades of the nineteenth century Peale was concerned with running the museum and his Pennsylvania farm, Belfield. He still continued to paint occasionally, however, and produced one of his greatest works, the full-length self-portrait *The Artist in His Museum*, which had been commissioned by the Peale Museum trustees (Pennsylvania Academy of the Fine Arts, Philadelphia).

Peale worked throughout his life as an inventor and a craftsman. Among his creations were a patent for a truss bridge, a fireplace that consumed its own smoke, and a portable steam bath. He made false teeth of ivory, ground lenses for spectacles and miniature cases, and improved the polygraph for copying documents. In addition to his memoirs he wrote several practical essays. Peale outlived three wives and fathered seventeen children. He and his brother James, together with their combined offspring, constituted a remarkable dynasty of artists.

Peale's subjects are portrayed as intelligent, affable, spirited citizens. Like his full-size portraits, his miniatures are charming but never entirely free of provincial naiveté. Generally painted on the tiny oval slices of ivory then popular in London, they show a lively counte-

nance with a Cupid's-bow mouth and narrow, sloping shoulders. Peale's technique first consisted of a small stipple for the face and fine vertical hatching in the background; later it became bolder and somewhat coarse, with long curving strokes used to model the face and a stubbled background. The earliest works employ delicate color and often achieve excellent characterization. Those painted after about 1780 are less expressive, often tending toward sameness. Details of dress, which at first are meticulously delineated, later receive a more summary treatment. Typical examples of Peale's mature style have dense, opaque blue-gray or green backgrounds shaded with short broad hatches; the side of the nose is outlined by a strong shadow, and wavy broad strokes delineate the powdered hair.

Peale's continual experimentation with pigments often resulted in deterioration. Many of his early works have faded significantly, and the fugitive color carmine has often disappeared entirely, leaving the miniature with a splotchy or predominantly blue appearance.

147. *Rachel Brewer Peale and Baby Eleanor*

1770
Watercolor on ivory, 2 9/16 x 2 1/16 in. (6.5 x 5.2 cm)
Casework: modern replacement for original black lacquer board, with replication of original gilt tracery surrounding bezel; original gilded metal bezel and rose-and-wheat-sheaf design hanger (partially shown)
Typed label on back: *Rachel (Brewer) / 1744–1790, wife of / Charles Willson Peale; and daughter / Eleanor (1770–1773). / Painted by Charles Willson Peale 1770 / Mrs. Sabin W. Colton / Bryn Mawr, Phila.*
RELATED WORKS: This miniature is painted after another miniature, *Rachel Brewer Peale*, ca. 1769 (MMA). That work, which is slightly smaller, does not include the baby, the subject does not wear pearls, and her fichu is tied. However, the general pose and the treatment of the face and hair in the two miniatures are identical. In 1771 Peale painted two full-size oil portraits of Rachel holding the baby Eleanor, both unlocated (Sellers, 1952 [see bibliography for C. W. Peale], nos. 643, 644). Peale's own description of those portraits reveals that they are more elaborate in composition than the miniatures. Sellers suggested that the oil portraits were inspired by Benjamin West's *Mrs. West and Son Raphael* (Cleveland Museum of Art) of ca. 1768. Peale probably saw that portrait in London; it was also

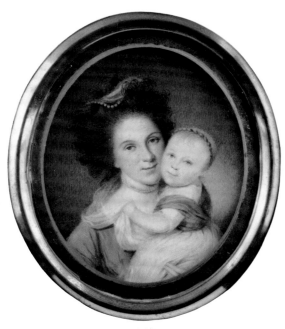

147

published as a mezzotint by Valentine Green in 1770. In composition and in sentiment this miniature too seems strongly influenced by the West portrait, although the positions of the subjects are reversed.

REFERENCES: Wehle, *American Miniatures*, p. xii, ill. pl. 3; Frederic Fairchild Sherman, "Charles Willson Peale's Portrait Miniatures," *Art in America* 19 (June 1931), p. 175, no. 31; Charles Coleman Sellers, *Portraits and Miniatures by Charles Willson Peale*, vol. 42, part 1 of *The Transactions of the American Philosophical Society* (Philadelphia, 1952), p. 163, no. 642, where this miniature is listed as unlocated

EXHIBITED: MMA, 1927, *Miniatures Painted in America*

EX COLLS.: Charles Willson and Rachel Brewer Peale's daughter Sophonisba A. Peale (1786–1859); her son, Coleman Sellers (1827–1907); his daughter, Jesse Sellers Colton (Mrs. Sabin Woolworth Colton, Jr.), Bryn Mawr, Pennsylvania; her daughter, Suzanne Colton Wilson, Corpus Christi, Texas; Tohono Chul Park, Tucson, Arizona; sale, Sotheby's, New York, May 28, 1987, lot 23

Colorplate 2

Rachel Brewer Peale (1744–1790) was the daughter of John and Eleanor Maccubbin Brewer of Anne Arundel County, Maryland. She married Charles Willson Peale in 1762 and bore him eleven children; six survived to adult-

hood. Three of their sons went on to become prominent artists, RAPHAELLE PEALE, Rembrandt Peale (1778–1860), and Rubens Peale (1784–1865). Peale described his wife in his autobiography: "This Lady belonged to the class of small women, of fair complexion, altho' her hair was of a dark brown color which hung in curling ringlets on her long beautiful white neck.—Her face [was] a perfect oval. She had sprightly dark Eyes. Her Nose [was] strait with some few angles, such as Painters are fond to imitate,—her mouth small and most pleasingly formed" (quoted in Sellers, 1947, vol. 1, p. 91; see bibliography for C. W. Peale).

Eleanor Peale (1770–1773) was born in Annapolis, the third child of Charles Willson and Rachel. A brother and sister born previously had died in infancy. Peale was eminently proud of the new baby, referring to her often in correspondence. I "have a fond Wife and Child and more coming, which my success in the Art I hope will ennable me to provide for," he wrote on July 18, 1771, to Edmund Jenings (*Selected Papers*, pp. 100–1). Margaret Bordley Peale was born the following January but died the next year of smallpox during an epidemic. Rachel persuaded Peale to paint a posthumous portrait of the baby, to which he later added the image of Rachel to create the intensely realistic, dramatic *Rachel Weeping* (1772 and 1776; the Barra Foundation, Philadelphia). Eleanor died at the age of three. Rachel never fully recovered from the birth of her eleventh child; she died of consumption in 1790.

148. *Mrs. Joseph Donaldson*
(Frances Johnston)

1776
Watercolor on ivory, 1½ x 1³⁄₁₆ in. (3.8 x 3.1 cm)
Casework: gold with burnished bezel
REFERENCE: Sellers, 1952 (as for cat. no. 147), p. 70, no. 224, ill. p. 366
EX COLLS.: the subject's son, Samuel Johnston Donaldson (1785–1865); his daughter, Frances Donaldson (1833–1909); her cousin, John Johnston Donaldson; his daughter, Miriam Shoemaker Donaldson (Mrs. James R. Manning), Great Barrington, Massachusetts; sale, Sotheby Parke-Bernet, New York, Nov. 18, 1976, lot 523

Colorplate 1a

This miniature is recorded in Peale's diary for September 3, 1776: "began a M: of Mrs Donaldson"; and for September 17: "Rd in full of Mr Donaldson on his & Ladys miniture 56 Dollars. Brocken Glass 1/6" (*Selected Papers*, pp. 194, 198).

Frances Johnston (1754–1836) was the daughter of Samuel and Deborah Ball Johnston. Her family emigrated from Dublin, Ireland, to York, Pennsylvania, about 1755. She married Joseph Donaldson in 1772, and they moved to Baltimore. About 1784 her father also left York to settle in Baltimore, where he became a prominent lawyer. The Donaldsons had five children.

Catalogue nos. 148 and 149 are companion pieces.

149. *Joseph Donaldson*

1776
Watercolor on ivory, 1⅜ x 1⅛ in. (3.4 x 2.8 cm)
Casework: gold with burnished bezel
REFERENCE: Sellers, 1952 (as for cat. no. 147), p. 70, no. 223, ill. p. 366
EX COLLS.: as for cat. no. 148

Colorplate 1b

This miniature is recorded in Peale's diary for September 6, 1776: "at Minia: began one of Mr Donaldson" (*Selected Papers*, p. 196); and see September 17 entry for cat. no. 148.

Joseph Donaldson (1750–1799) was born in Ireland and immigrated to America about 1770. He settled first in York, Pennsylvania, where he was employed by Samuel Johnston. He married Johnston's daughter Frances in 1772, moved with her to Baltimore, and established a prominent mercantile firm, Donaldson and Usher.

150. *Ennion Williams*

1776
Watercolor on ivory, 1½ x 1³⁄₁₆ in. (3.8 x 3 cm)
Casework: gold with burnished bezel; engraved on the reverse (probably at a later date): *Major Enion Williams / by / Charles Wilson Peale*
REFERENCES: Sellers, 1952 (as for cat. no. 147), p. 249, no. 984, ill. p. 367, no. 412; Hirschl & Adler Galleries, *Recent Acquisitions of American Art, 1769–1938* (New York, 1979), no. 2, ill.; Hirschl & Adler Galleries, *American Art from the Colonial and Federal Periods* (New York, 1982), p. 27

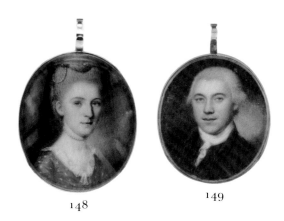

148 149

EXHIBITED: Pennsylvania Academy of the Fine Arts, Philadelphia, 1923, *Exhibition of Portraits by Charles Willson Peale, James Peale and Rembrandt Peale*, no. 305, exh. cat. p. 229; National Portrait Gallery, Washington, D.C., 1987, *American Colonial Portraits 1700–1776*, no. 103, exh. cat. p. 295, ill. p. 215
EX COLLS.: descended in the subject's family; Mrs. J. Madison Taylor, Philadelphia, until 1923; her great-great-niece, Mrs. Edward Ellwanger, Rochester, until 1977; purchased from Hirschl & Adler Galleries, New York, 1982

Colorplate 1c

Peale recorded this miniature in his diary for October 21, 1776: "began a Whole length of Major Williams"; and for October 23: "finished Mr. Williams." On the 26th he noted: "Rd. of Mr. Williams 28 Dolrs. for his Minature," and later that day, "put a Glass on Mr. Williams Min: Miss Williams having broke the first for which I expect 10 s (*Selected Papers*, pp. 201–2).

Ennion Williams (1753–1830) was the son of Daniel Williams, a signer of the Philadelphia nonimportation resolutions. In 1776 Ennion

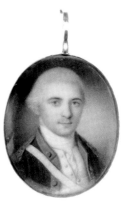

150

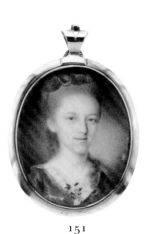

151

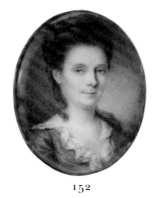

152

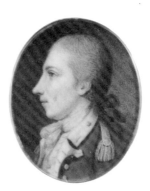

153

was commissioned a major in the first battalion of the Pennsylvania rifle regiment of the Continental army. He remained on active duty throughout the Trenton-Princeton campaign, resigning at its close in 1777. His first wife was Catherine Leonard; later, about 1802, he married Margaret Sims, a mantua maker.

151. *Lady said to be Catherine Scott Brown*

ca. 1778
Watercolor on ivory, 1½ x 1³⁄₁₆ in. (3.9 x 3 cm)
Casework: gold; fitted shagreen case (not shown)
Ex colls.: sale, Sotheby Parke-Bernet, New York, Dec. 14, 1983, lot 566; sale, Sotheby Parke-Bernet, New York, July 17, 1984, lot 35

Peale recorded in his diary a miniature of Mrs. Brown begun on October 30, 1778, and finished in November (*Selected Papers*, p. 634).

152. *Mrs. John Cox* (Esther Bowes)

ca. 1778
Watercolor on ivory, 1¾ x 1⅜ in. (4.4 x 3.5 cm)
Casework: gold with burnished bezel, mounted in a larger modern locket (not shown); engraved on the reverse, *Esther (Bowes) Cox / Born Nov 18th 1760 / Died Feb 10th 1814*
Ex coll.: purchased from Alexander Gallery, New York, 1989

Esther Bowes, the daughter of Francis and Rachel Le Chevalier Bowes of Trenton, New Jersey, married John Cox (1732–1793) in 1760. A New Jersey merchant and iron manufacturer, Colonel Cox was appointed assistant

quartermaster general of the Revolutionary army in 1778; he supplied the army with ammunition from his foundry. The Coxes entertained George Washington and Generals Lafayette and Rochambeau at Bloomsbury Court, their estate on the Delaware River near Trenton. They also maintained a home in Philadelphia. They had six daughters.

Peale recorded in his diary on April 23, 1778, when at Valley Forge (*Selected Papers*, p. 272): "Col. Cox set for the finishing his miniature" (private collection). The miniature shown here is not recorded, but was probably painted about the same time.

153. *General Richard Montgomery*

ca. 1784–86
Watercolor on ivory, 1¾ x 1⁵⁄₁₆ in. (4.4 x 3.4 cm)
Casework: modern
Inscribed on the back of an earlier modern frame: *Genl Richard Montgomery. / by C W Peale*
Related works: Peale painted a full-size portrait of Montgomery for his museum gallery about 1785–95 (Independence Hall, Philadelphia). According to Sellers, the best characterization of Montgomery is in the "delicate, interesting" miniature shown here, and the full-size portrait was perhaps copied after it (1952 [as for cat. no. 147], no. 561, pp. 144–45). If this miniature was painted from life by Charles Willson Peale as Sellers suggests, Montgomery could not have been younger than thirty-nine at the time; however, the miniature portrays a younger man. Possibly both of Peale's works were copied from an oil portrait Montgomery brought with him from Ireland that portrayed him as a

young British ensign (coll. John Ross Delafield, New York), and Peale updated his copies by giving Montgomery an American uniform. It is possible that in America no portrait was painted of Montgomery during his lifetime and that when he died, copies were made from the only surviving portrait. A stipple engraving by E. MacKenzie was made after Peale's full-size portrait and published in *The National Portrait Gallery of Distinguished Americans* (Washington, D.C., 1834–39), p. 60.

Ex colls.: descended in the artist's family; Harry Fromke, New York; sale, Christie's, New York, Oct. 18, 1986, lot 428

Colorplate 1d

Richard Montgomery (1736–1775) was born in Ireland and educated at Trinity College, Dublin. He entered the British army as an ensign, in 1757 was ordered to Halifax, Nova Scotia, served in the siege of Louisburg in 1758, and was promoted to captain in 1762. He sold his commission in 1773. Montgomery settled in New York and married Janet Livingston. He was appointed a brigadier general in the Continental army in 1775 and led a force against the British at Montreal, capturing the city. After joining forces with Benedict Arnold, he was killed in their ill-fated assault on Quebec.

This miniature, along with one of the subject's father-in-law, Robert R. Livingston, was retained in Peale's own collection.

JAMES PEALE

(1749–1831)

One of the country's finest miniature painters, James Peale was born in Chestertown, Maryland, the youngest brother of CHARLES WILLSON PEALE. He spent his early years in Annapolis, apprenticed to Charles in the saddlery business. In 1769 James became Charles's assistant in his studio, and by 1771 he had learned the techniques of watercolor and oil painting. During the Revolution James served in the Continental Army, attaining the rank of captain before he resigned in 1779. He followed Charles to Philadelphia, where the brothers worked together, painting in such close collaboration that it is often difficult to distinguish

their separate hands. In 1786 they divided their painting business: James was to concentrate on miniatures, Charles on oil portraits. They do not seem to have adhered strictly to plan, since Charles continued to paint miniatures occasionally, and James by 1788 was painting landscapes, among other things. It was James's outstanding execution of miniatures, however, that kept him constantly employed. From time to time he also painted memorial and allegorical scenes in sepia on ivory; these were set on the reverse side of the mounted miniature. Eventually his eyesight became too weak for such small-scale work, and after about 1818 he turned to painting still lifes.

Peale married Mary Claypoole, daughter of the painter James Claypoole (1720–1796). Of their seven children, at least five were artists; ANNA CLAYPOOLE PEALE, taught by her father, was also a very fine miniaturist.

Peale usually signed his miniatures *IP*, followed by the date. The style of his early portrait miniatures is much like his brother's: small in size, densely colored, employing fine linear strokes, and with a strong shadow to one side of the face. About 1794 Peale began to use a larger ivory and to achieve a softer, delicate, more luminous finish. Flesh, hair, and eyebrows are rendered with a delicate linear brushstroke. The details of costume and accessories are often brilliantly realized. After 1800 Peale devoted less attention to these particulars and concentrated on capturing the personalities of his subjects, whom he presented in a new, directly frontal pose. He adopted a simpler technique, using less background hatching and employing transparent washes of color that allow the luminous ivory to show through. His miniatures painted after 1805 are quite similar to ones by his daughter Anna, who helped him with his work until the end of his career.

154. *George Washington*

1782
Watercolor on ivory, 1½ x 1 in. (2.5 x 3.8 cm)
Casework: silver and silver gilt with Centennial
 motifs (partially shown); on the reverse, maker's
 inscription: *W. K. Vanderslice & Co. / 136 / Sutter
 St. / S.F. Cal.*

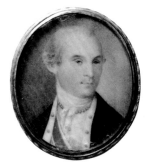

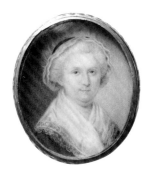

154 155

RELATED WORK: This miniature is a copy after one
 painted by Charles Willson Peale in 1777
 (MMA).
REFERENCES: *Centennial Celebration of the
 Inauguration of George Washington 1889*, exh. cat.
 (New York, 1889), no. 16, facing p. 10.; Bolton,
 1921, p. 126, no. 34
EX COLLS.: James Peale to his daughter Anna
 Claypoole Peale; her second husband, General
 William Duncan; his grandson, Joseph C.
 Duncan, San Francisco; Durant du Pont, New
 Orleans, 1892; James Duval Phelan; San
 Francisco Art Institute; sale, Butterfield's, San
 Francisco, May 20, 1986, lot 894

Catalogue nos. 154 and 155 are companion pieces.

155. *Martha Washington*

1782
Watercolor on ivory, 1½ x 1 in. (2.5 x 3.8 cm)
Casework: as for cat. no. 154
RELATED WORK: This miniature is similar to
 another by Peale owned by the Ladies'
 Association of Mount Vernon.
REFERENCES: as for cat. no. 154, except Bolton,
 no. 33
EX COLLS.: as for cat. no. 154

156. *Gentleman thought to be John Sager*

ca. 1785
Watercolor on ivory, 1 11/16 x 1¼ in. (4.4 x 3.2 cm)
Casework: gilded copper with burnished bezel
Label: on reverse, identifying the subject
EX COLL.: sale, Sotheby Parke-Bernet, New York,
 Oct. 13, 1978, lot 447

Colorplate 1e

A John Sager living in Lower Dublin Town-
ship, Philadelphia County, is listed in the Penn-
sylvania census of 1790 and 1800.

157. *Self-portrait*

1789
Watercolor on ivory, 1¾ x 1¼ in. (4.4 x 3.2 cm)
Dated at lower right: *1789*
Casework: modern
REFERENCES: Frank S. Schwarz & Son, *American
 Paintings and Watercolors*, exh. cat. (Philadelphia,
 1980), no. 17; idem, *A Gallery Collects Peales*, exh.
 cat. (Philadelphia, 1987), p. 48, no. 37
EX COLLS.: Anna Claypoole Peale, probably to her
 nephew, James Godman Peale; Mrs. Fulton
 Field Peale; probably to Washington James

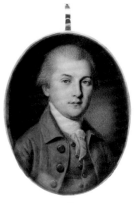

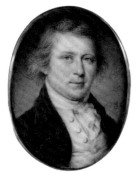

156 157

Peale; Mary G. Magary Peale; Lillian Peale
Rowan; Mary Peale Rowan, 1976; purchased
from Frank S. Schwarz & Son, Philadelphia,
1980

Colorplate 3a

Peale painted two miniature self-portraits prior
to this one: a signed and dated work of 1787
(Mead Art Gallery, Amherst, Massachusetts)
and another that Charles helped him with in
1788 (MMA). The miniature shown here is
similar to one owned by Mrs. John Eager How-
ard of Cockeysville, Maryland. Peale also
painted a self-portrait much later in his life,
around 1820 (R. W. Norton Art Gallery,
Shreveport, Louisiana).

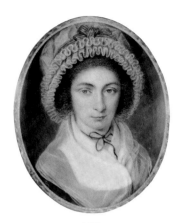

159

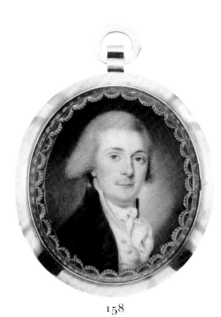

158

158. *Gentleman with the Initials E C*

1791
Watercolor on ivory, 1⅞ x 1½ in. (4.8 x 3.8 cm)
Signed and dated lower left: *I P / 1791*
Casework: gold with scalloped and bright cut
 border; on the reverse, compartment con-
 taining plaited hair and gold monogram: *E C*
Ex colls.: estate of J. Amory Haskell, New York;
 sale, Parke-Bernet, New York, Apr. 28, 1944,
 lot 399; with Arthur J. Sussel, Philadelphia,
 Mar. 1950; Harry Fromke, New York; sale,
 Christie's, New York, Oct. 18, 1986, lot 394

159. *Mrs. John McAllister*
 (Frances Wardale)

1791
Watercolor on ivory, 2 x 1½ in. (5.1 x 3.9 cm)
Signed and dated lower left: *I P / 1791*
Casework: gold with bright cut border and
 burnished bezel
On card inside case: *J. Boone Septr 6 / Philadelphia /
 J. P. fecit*
Ex colls.: descended through the family; sale,
 Sotheby Parke-Bernet, New York, Feb. 22,
 1979, lot 400; purchased from Hirschl & Adler
 Galleries, New York

Colorplate 3d

Frances Wardale (1746–1814) was born in
Yorkshire, England, and married in 1770 to
John Henry Leiber in London; they immi-
grated to Philadelphia in 1773. Leiber died
nine years later, and in 1783 Frances Wardale
married John McAllister, the leading optician
in Philadelphia. They had three children. Peale
painted a full-size portrait of Mrs. McAllister in
1812. She died in Auburn, Pennsylvania, at the
age of sixty-eight.

160. *Gentleman in a Green Coat*

1794
Watercolor on ivory, 2⅜ x 1⅞ in. (6 x 4.8 cm)
Signed and dated lower right: *I P / 1794*
Casework: modern
Ex colls.: sale, Sotheby Parke-Bernet, New York,
 Jan. 26, 1977, lot 241; purchased from Bernard
 & S. Dean Levy, New York, July 1977

Colorplate 3e

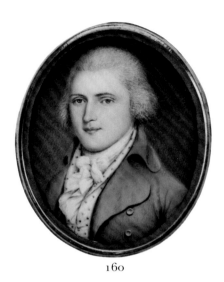

160

161. *Gentleman*

ca. 1795
Watercolor on ivory, 2¼ x 1¾ in. (5.8 x 4.6 cm)
Casework: gilded copper with chased bezel; on the
reverse, compartment containing plaited hair
Ex coll.: sale, Sotheby Parke-Bernet, New York,
Nov. 19, 1976, lot 510

162. *William Jonas Keen*

1796
Watercolor on ivory, 2¹¹⁄₁₆ x 2¹⁄₁₆ in. (6.8 x 5.2 cm)
Signed and dated lower left: *I P / 1796*
Casework: gold with bright cut border and
burnished bezel

References: Gregory B. Keen, "Descendants of
Joran Kyn-Patrick Hayes," *The Pennsylvania
Magazine of History and Biography* 5 (1881), p. 87;
idem, *The Descendants of Joran Kyn of New Sweden*
(1913), p. 147; Hirschl & Adler Galleries,
American Art from the Colonial and Federal Periods,
exh. cat. (New York, 1982), no. 42
Ex colls.: descendants of the subject; sale, Sotheby
Parke-Bernet, New York, Feb. 22, 1979, lot
397; purchased from Hirschl & Adler Galleries,
New York, Jan. 1982

Colorplate 3b

A sea captain and merchant, Keen served on
the Common Council of Philadelphia from
1805 to 1808. He married Sarah Somers, the
daughter of Colonel Richard Somers, a Revo-
lutionary War hero.

163. *Mrs. Joseph Cooper* (Mary Justice)

1797
Watercolor on ivory, 2⅞ x 2¼ in. (7.3 x 5.8 cm)
Signed and dated lower right: *I P / 1797*
Casework: gilded copper with plain bezel
References: Frank S. Schwarz & Son, *Philadelphia
Portraiture: 1740–1910*, exh. cat. (Philadelphia,
1982), no. 4; idem, *A Gallery Collects Peales*, exh.
cat. (Philadelphia, 1987), no. 38; Strickler, 1989,
p. 99, where it is stated that the miniature
Thomas Cumpston (Worcester [Massachusetts] Art
Museum) was once framed on the reverse side
of *Mrs. Joseph Cooper*

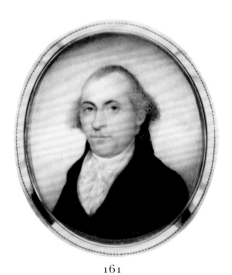

161

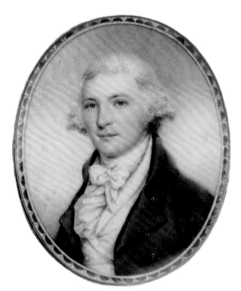

162

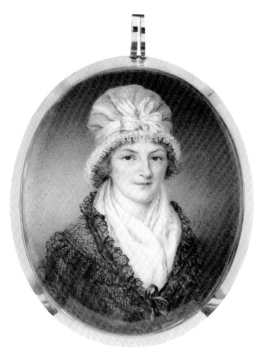

163

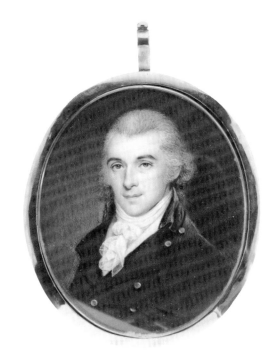

164

Ex colls.: probably Thomas Cumpston, to 1820;
his daughter, Anna Maria Cumpston Williams;
her daughter, Emily Williams Cooper; heirs of
Emily Williams Cooper; purchased from Frank
S. Schwarz & Son, Philadelphia, 1983

Mary Justice was the daughter of John and
Mary Swan Justice. She married Joseph
Cooper, a tailor from Mt. Holly, New Jersey.
In 1795 they moved to Philadelphia, where
Cooper went into the mercantile business with
his wife's brother, George Justice.

164. *Curtis Clay*

1798
Watercolor on ivory, 2¹¹⁄₁₆ x 2³⁄₁₆ in. (6.8 x 5.6 cm)
Signed and dated lower left: *I P / 1798*
Casework: gilded copper with plain bezel; on the
reverse, compartment for hair
References: Frank S. Schwarz & Son, *Philadelphia
Paintings (1795–1930)*, exh. cat. (Philadelphia,
1984), no. 6
Ex colls.: Arnold Dickler; purchased from Frank
S. Schwarz & Son, Philadelphia, 1984

Two gentlemen named Curtis Clay lived in
Philadelphia around the time this miniature
was painted. One, a merchant, imported dry
goods during the Revolution; the other, his
son, was quartermaster of the First Regiment
of Cavalry of the County and City in 1811.

165. *Gentleman said to be James Ladson*

1799
Watercolor on ivory, 2¾ x 2¼ in. (7 x 5.8 cm)
Signed and dated lower left: *I P / 1799*
Casework: gilded copper with plain bezel; on the
reverse, central compartment containing plaited
hair and gold monogram: *J L*
Ex coll.: sale, Sotheby Parke-Bernet, New York,
June 10, 1985, lot 90

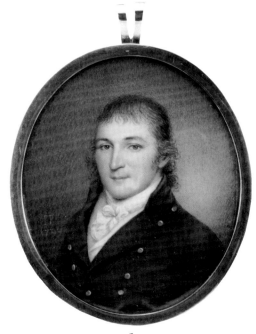

165

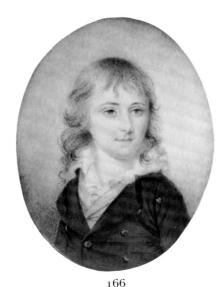

166

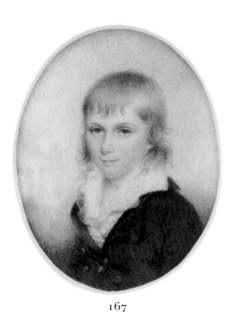

167

166. William Smallwood

ca. 1798
Watercolor on ivory, 2¾ x 2¹⁄₁₆ in. (6.9 x 5.1 cm)
Casework: modern (not shown)
Ex colls.: Elizabeth Smallwood Samson,
 Washington, D.C.; her granddaughter Rebecca

Middleton Samson Munday; sale, Parke-Bernet,
New York, Feb. 12, 1944, lot 326; Norvin H.
Green, Tuxedo Park, New York; sale, Parke-
Bernet, New York, Nov. 30, 1950, lot 245;
Harry Fromke, New York; sale, Christie's, New
York, Oct. 18, 1986, lot 390

Catalogue nos. 166 and 167 are companion pieces.

167. Pryor Smallwood

ca. 1798
Watercolor on ivory, 2¹³⁄₁₆ x 2¹⁄₁₆ in. (7.1 x 5.2 cm)
Casework: as for cat. no. 166
Ex colls.: as for cat. no. 166

William (see above) and Pryor Smallwood were
the sons of Lydia Hutchinson Smallwood and
Benjamin Smallwood (d. 1800) of Georgetown,
District of Columbia. In 1798 James Peale
painted miniatures of their parents as well (lo-
cations unknown).

168. Lady with the Initials T B

180(?)
Watercolor on ivory, 2⁷⁄₁₆ x 1¹³⁄₁₆ in. (6.2 x 4.6 cm)
Signed and dated lower right: *I P / 180[?]*; final
 digit obscured by frame
Casework: gilded copper with plain bezel; on the
 reverse, compartment containing plaited hair
 and gold monogram: *T B*
Ex colls.: sale, Sotheby Parke-Bernet, New York,
 Feb. 18, 1982, lot 582; purchased from Edward
 Sheppard, New York

Colorplate 3c

169. Henry Nicolls Kitchin

1807
Watercolor on ivory, 2¹³⁄₁₆ x 2¼ in. (7.1 x 5.8 cm)
Signed and dated lower left: *I P / 1807.* Inscribed
 on backing card: *Henry Nicolls Kitchin*
Casework: gilded copper with chased bezel and
 hanger
Ex colls.: sale, Sotheby Parke-Bernet, New York,
 June 14, 1978, lot 143; purchased from Edward
 Sheppard, New York

Kitchin was one of the country's first brain sur-
geons; he was associated with Hahnemann
Hospital in Philadelphia. At one time he owned
the Merchants' Coffee Shop in Philadelphia,
where the first draft of the Declaration of In-
dependence is believed to have been written.

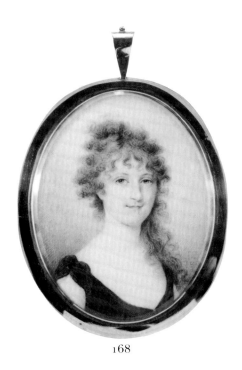

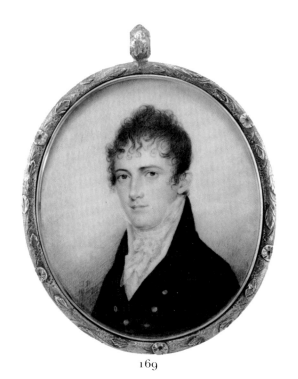

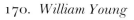
168

169

170. *William Young*

1807
Watercolor on ivory, 2¹³⁄₁₆ x 2¼ in. (7.1 x 5.8 cm)
Signed and dated lower right: *I P / 1807*
Casework: gold; on the reverse, central compart-
 ment containing plaited hair and gold mono-
 gram: *W Y*. Red leather case (not shown)
Label on case: *This miniature likeness / of William
 Young was / painted in 1807 / by James Peale and
 presented / by Mr. Young to his daughter, / Mrs.
 Margaretta M. Hamilton. / Bequeathed by T. Fenton
 Hamilton / to his aunt / Elisa Y. McAllister / 1837.*
RELATED WORK: Peale painted another version of
 this miniature in 1806 (location unknown).
EX COLLS.: descended in the subject's family; HARRY
 Fromke, New York; sale, Christie's, New York,
 Oct. 18, 1986, lot 395

William Young (1755–1829) was born in Ir-
vine, Ayrshire, Scotland. After arriving in this
country he established a paper mill in Wilming-
ton, Delaware, and later became a newspaper
publisher in Philadelphia. In 1802 he moved to
Rockland, Delaware; he died in Wilmington at
the age of sixty-six. Young and his first wife,
Agnes McLaws Young, had five children, one
of whom was Elisa Melville, who married John
McAllister, Jr., the son of John and Frances
McAllister (see cat. no. 159).

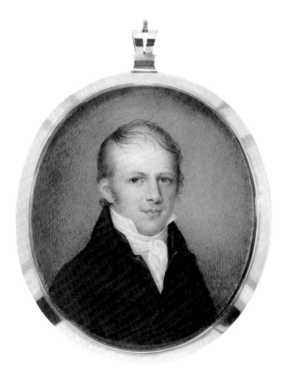

170

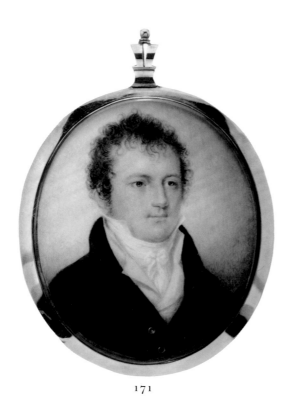

171

This miniature has descended together with a framed note written by the sitter: *This Miniature of myself I present to Sarah / Kirby during her Natural life and no / longer at her decease I do give It to Anna L. Ross / to her—her Heirs and [illegible] forever / 5th Mo 25th 1812 Beulah Elmy Twining*

EX COLLS.: descended in the subject's family; sale, Sotheby Parke-Bernet, New York, Nov. 19, 1980, lot 237; purchased from Edward Sheppard, New York

Beulah Elmy Twining (ca. 1767–1826) was the youngest daughter of David and Elizabeth Twining, Quakers who lived in Bucks County, Pennsylvania. She married Dr. Torbert, who was not a Quaker, "out of meeting," for which she was expelled from Wrightstown Meeting. Later she was divorced and subsequently readmitted to meeting, and in time she became women's clerk at Makefield. Beulah managed her father's estate and was his principal heir.

Edward Hicks (1780–1849), an adopted son of the Twinings, made several paintings of their farm in Bucks County. In each he portrayed Beulah, his favorite adopted sister, standing in the doorway of the stone farmhouse.

171. *Anthony Wayne Robinson*

1811
Watercolor on ivory, 2¹³⁄₁₆ x 2¼ in. (7.1 x 5.7 cm)
Signed and dated lower right: *I P / 1811*
Casework: gilded copper with plain bezel; on the reverse, compartment containing plaited hair and gold monogram: *A W R*
Jeweler's trade card in case: *A. Williams / Smith Jeweller & Hair Worker / No 8 South Second Street / Philadelphia*

Colorplate page 31, e

Anthony Wayne Robinson was probably the son of Mary Phillips Robinson and Anthony Robinson (1771–1851), who was a clerk of the district court in Richmond and discount clerk in the Bank of Virginia. His miniature, painted by RAPHAELLE PEALE (Valentine Museum, Richmond), reveals a strong family resemblance to the subject of this miniature.

172. *Beulah Elmy Twining* (Mrs. Torbert)

1811
Watercolor on ivory, 2¾ x 2¼ in. (7 x 5.7 cm)
Signed and dated lower right: *I P / 1811*
Casework: gilded copper with plain bezel; on the reverse, central compartment containing lock of hair

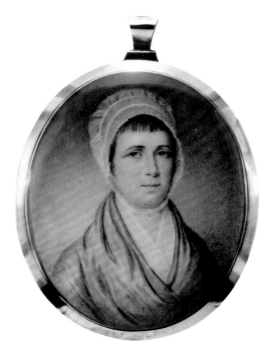

172

RAPHAELLE PEALE

(1774–1825)

Raphaelle Peale, the eldest son of Rachel Brewer and CHARLES WILLSON PEALE, was born in Annapolis and raised in Philadelphia. He inherited his father's artistic talent and scientific inventiveness, but not his determination or self-control. Raphaelle apprenticed in his father's studio, where his uncle, JAMES PEALE, instructed him in the making of miniatures. He assisted his father in the establishment of a natural history museum, traveling to Mexico and South America to collect specimens and preserving animals with an arsenic compound, a technique developed by his father. About 1794 Raphaelle and his brother Rembrandt Peale (1778–1860) took over their father's portrait business. They spent 1796–97 in Charleston and Baltimore, where they exhibited their copies of Charles Willson's portraits of American patriots and advertised their availability to take likenesses in miniature and in oil. From the start, it seems, Raphaelle painted the miniatures and Rembrandt the full-size works, since few portraits in oil by Raphaelle are known, and there are no documented miniatures by Rembrandt.

In 1797 Raphaelle returned to Philadelphia, where he married the ill-tempered Martha (Patty) McGlathery and embarked on scientific experiments, patenting a preservative for ships' timbers, a plan for heating houses, and a method of purifying seawater. With a wife to support, however, he soon turned back to portraiture and over the next six years painted miniatures in Philadelphia and Baltimore. His advertisements were eye-catching, announcing: "NO LIKENESS, NO PAY"; "ASTONISHING LIKENESSES"; and offering his services to paint portraits "from the corpse" under the heading "Still Life" (*Poulson's American Daily Advertiser*, October 10, 1801; *Philadelphia Gazette*, September 11, 1800; see Sellers, 1959 [in bibliography for Raphaelle Peale]). His financial situation worsening, Raphaelle toured the South in 1803, taking with him a physiognotrace. With this newly invented device he could rapidly make small silhouette profiles on paper; he sold thousands, charging twenty-five cents for

a set of four. But the novelty of the products soon wore off, and his success faded. He continued to travel frequently, seeking commissions to paint miniatures or cut profiles in Baltimore, Norfolk, Portsmouth, Richmond, Annapolis, Savannah, and Charleston.

From the beginning, Raphaelle Peale had painted more than portraits: at the 1795 exhibition at the Columbianum (America's first art academy, started in Philadelphia by his father), he had shown, in addition to portraits, five still lifes and three trompe l'oeil paintings. He exhibited annually during the years 1811–25 at the Pennsylvania Academy of the Fine Arts and at the Boston Athenaeum in 1827–28. Upcoming exhibitions spurred him to work more energetically. He usually painted still lifes for exhibition.

Sometime around 1805 Peale started drinking heavily, and his health began to decline; he contracted severe gout, which affected his stomach and made his hands swell. The condition may have been prompted by arsenic poisoning from the preservatives he had used at the museum. He abandoned miniatures for the still lifes for which he is better known. They were easier to execute when his hands were swollen, and required less of the human company he had begun to shun. Charles Willson wrote myriad remonstrances to his son regarding his squandered ability, style of living, poor domestic situation, and lack of discipline. Peale's final years were spent in poverty; his last employment was writing sentimental poetry for a baker to insert in cakes. He died in Philadelphia at the age of fifty-one.

Raphaelle Peale's miniatures reveal the strong influence of JAMES PEALE, yet are decidedly original. Despite some similarity among them, the portraits project the individual characters of their subjects, often to the point of being unflattering. In the earliest works, painted 1798–99, the subject appears small and a bit stiff against a solid background of dark blue-gray. By 1800 Peale's technique had dramatically improved, and his best, most typical work was executed over the next five years. In these miniatures the faces are painted in very pale skin tones and modeled with blue hatches. The backgrounds are light, often blue and white striated to suggest sky, and occasion-

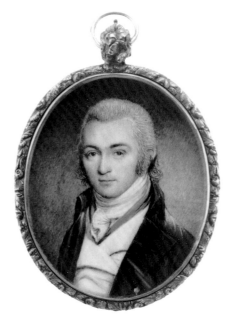

173

ally incorporating an unusual combination of lavender, pale yellow, and pink. Peale's subjects were usually gentlemen; identically posed with faces turned slightly to the left, they have round, sloping shoulders and wear blue coats with brass buttons, of which often only the top one is buttoned. The hair is always distinctive, either a woolly wig, or wiry, or sometimes with serpentine strands covering the forehead. Late works are summarily handled, showing little modeling or attention to detail. Most miniatures by Raphaelle Peale are signed next to the subject's shoulder: *R P*.

173. *Gentleman said to be James Paul*

Watercolor on ivory, 2⅜ x 1⅞ in. (6.1 x 4.8 cm)
Signed and dated lower left: *R P 99*
Casework: gilded copper with chased bezel and hanger
Enclosed trade card (part missing): *smith Jeweller & Hair . . . / Has Removed / 89 South Second Street / . . . Philadel* [probably James Black; see cat. no. 175]
Ex colls.: the subject's daughter, Mrs. Soule; her husband, Professor Soule, Lyons, France; his wife, Mrs. Soule; Mr. Ferry, New York; his daughter, M.H. Ferry, San Diego, 1937; sale, Sotheby Parke-Bernet, New York, May 31, 1979, lot 401; purchased from Edward Sheppard, New York

James Paul (1770–1839), a Philadelphian and a Quaker, was a prominent merchant who

imported goods from China and India. He was dismissed from meeting for joining the Pennsylvania militia during the "Whiskey Insurrection" of 1794. In 1797 he married Elizabeth Rodman in Philadelphia; they had twelve children.

174. *Gentleman with the Initials J G L*

Watercolor on ivory, 2⅞ x 2⁵⁄₁₆ in. (7.3 x 5.9 cm)
Signed lower left: *R P*
Casework: gilded copper with plain bezel; on the reverse, compartment containing plaited hair and gold monogram: *J G L*

Colorplate 7c

175. *Gentleman with the Initials T L L*

Watercolor on ivory, 2⅝ x 2¹⁄₁₆ in. (6.7 x 5.3 cm)
Casework: gilded copper with plain bezel, case converted to a brooch; on the reverse, compartment containing plaited hair and gold monogram: *T L L*
Enclosed trade card: *James Black / Gold Smith Jeweller & Hair Worker / No 89 South Second / Phila.* [James Black was listed as a goldsmith in the city directories from 1795 to 1822.]
Ex coll.: sale, Sotheby Parke-Bernet, New York, June 10, 1985, lot 89A

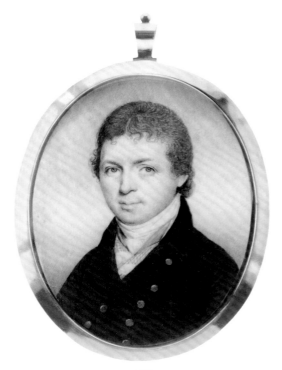

174

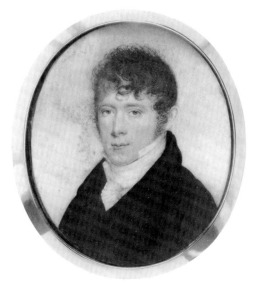

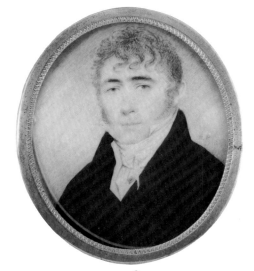

175

176

176. *P. F. Ronbeau*

1821
Watercolor on ivory, 2⁷⁄₁₆ x 2¹⁄₁₆ in. (6.2 x 5.2 cm)
Signed and dated lower right: *R P / 1821*
Casework: gilded metal with stamped bezel; on the
 reverse, a calligraphic decoration with a central
 ivory bearing the initials *P F R*
Inscription on backing paper: *P. F. Ronbeau / to his
 friend / H. Peters / 12 January 1821 / Stamford*
Ex coll.: G. H. Peters, Stamford

HENRY PELHAM

(1749–1806)

Henry Pelham was born in Boston to Peter Pelham (1697–1751) and his third wife, Mary Singleton Copley, the previously widowed mother of JOHN SINGLETON COPLEY. Peter Pelham, a portraitist, mezzotint engraver, and schoolmaster, died when Henry was only two, but he had earlier instructed Henry's half-brother Copley, who in turn trained young Pelham. Pelham attended the Boston Latin School and assisted in Copley's studio, where he also copied portraits. He is best known today as the subject of Copley's portrait *Boy with a Squirrel*, painted about 1758 (Museum of Fine Arts, Boston). The par-

ticularly close relationship between the two is well documented in the *Letters and Papers of John Singleton Copley and Henry Pelham* compiled by the Massachusetts Historical Society (see bibliography for Pelham). By about 1770 Pelham was painting portraits in oil that were accomplished enough to be mistaken for the work of Copley and was producing in other mediums as well. His engraving *The Bloody Massacre* (1770) was plagiarized by Paul Revere, whose less skilled copy of the image enjoyed very wide popularity.

Pelham learned from Copley the art of making miniatures, in both oil on copper and watercolor on ivory, during the late 1760s. All of Copley's miniatures were painted during that decade, and all of Pelham's are from the next; thus, Copley seems to have turned the miniature business over to Pelham around 1772. In that year Pelham was commissioned to paint a posthumous miniature of the Reverend Edward Holyoke, who had been president of Harvard College (private collection, Boston); he copied an oil portrait done from life by Copley in 1759–61 (Harvard University, Cambridge). Copley wrote to his mother in 1775 regarding Pelham, "His process in Miniature is I believe very right, only Mr. Humphreys tells me he uses no Shugar Candy in his colours; that he tints them at first exceeding faint, and

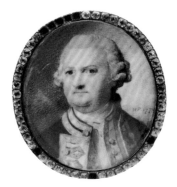

177

so brings on their effect by degrees" (June 25, 1775; *Letters and Papers*, p. 331).

The American political climate created mounting apprehension for Pelham. In 1775, on the way to Philadelphia on horseback, he was attacked by a mob for being one of "a damn'd pack of Torys." After the siege of Boston Pelham complained that it had "entirely stopp'd all my business, and annialated all my Property, the fruits of 4 or 5 years Labor. I find it impossible to collect any Monies that are due to me . . . " (Pelham to Copley, May 16, 1775; *Letters and Papers*, p. 321). He left Boston in August 1776, joining Copley in London.

In London Pelham exhibited at the Royal Academy, showing *The Finding of Moses* in 1777 and miniatures in 1778. He produced a large number of miniatures in 1779. Soon thereafter he went to Ireland as estate agent to Lord Lansdowne, exhibiting at the Society of Arts in Dublin in 1780. Pelham lived the rest of his life in Ireland; he was overseeing the erection of a tower he had engineered on the River Kenmare when he drowned in a boating accident.

Pelham is little known because his works are rare. Fewer than a dozen extant miniatures were painted in this country; they all date from the years 1773–75. His miniatures are of fine quality and are often thought to be the work of Copley. In pose and presentation and in the rendering of fabric, bold modeling, and sharp light-dark contrasts, they reveal Copley's strong influence. Pelham's subjects are portrayed with more sensitivity than Copley's, however; frequently the sitter's personality is very vividly communicated. Unlike Copley's delicate stip-

ple, Pelham's characteristic brushwork is a vigorous, assured cross-hatching that realistically models the flesh, with a lively combination of stipple and hatch for the hair. Backgrounds are dark and broadly hatched.

177. *Gentleman*

1779
Watercolor on ivory, 1⅝ x 1⅜ in. (4.2 x 3.5 cm)
Signed and dated lower right: *H P 1779*
Casework: silver, the bezel ornamented with paste jewels
Ex coll.: purchased from Edward Sheppard, New York

This miniature was probably painted in London shortly before Pelham's departure for Ireland.

GENNARINO PERSICO

(ca. 1800–ca. 1859)

Gennarino (or Gennaro) Persico and his brother E. Luigi Persico (1791–1860) came from Naples, Italy, to Baltimore in 1817. They advertised together as "Pupils of the Roman Academy, and lately arrived from Italy; . . . will draw Miniatures, full Portraits, &c. in the neatest manner, and with striking likeness, no likeness no pay." E. Luigi became known in this country as a sculptor, while Gennarino remained a portrait and miniature painter. In 1819 or 1820 Gennarino left Baltimore for Lancaster, Pennsylvania, and later went on to Reading, where he met his future bride, Elizabeth McKnight Kennedy. He settled in Philadelphia in 1822. He painted miniatures and gave drawing lessons there until 1833, exhibiting at the Pennsylvania Academy of the Fine Arts in the years 1822–27 and again in 1831, when he showed several miniatures of the Madonna and various drawings in crayon and chalk. Next Persico moved to Richmond, Virginia, and opened an academy for young ladies, which he continued to operate after his wife's death in 1842. After the school failed he went back to Naples for a few years but returned to this country probably in 1849; in that

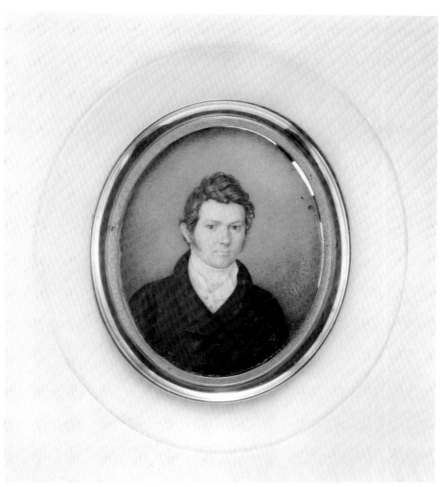

178

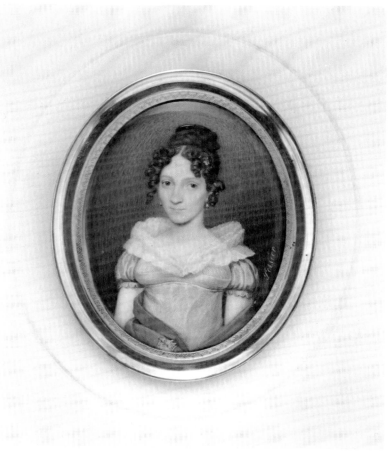

179

year he showed drawings and paintings at the Maryland Historical Society in Baltimore. He exhibited again in 1851 at the Philadelphia Art Union. Persico was back in Richmond and actively painting from 1852 to about 1859, the year he may have died at sea.

The miniatures by Persico known today were all painted in the 1820s and 1830s. They share characteristics of style with works by other Continental artists painting in this country: lively coloring, a distinctly linear treatment, meticulous detail, and an opaque blue background. Persico usually signed his miniatures along the right edge of the ivory.

178. *Dr. Richard Wilmot Hall*

Watercolor on ivory, 2 11/16 x 2 1/8 in. (6.8 x 5.3 cm)
Signed at right: *Persico*
Casework: marble with ormolu liner and hanger. The frame, unusual in its material, appears to be original and may have been made by the artist or his brother E. Luigi, who often worked in marble.
Ex COLL.: purchased from Edward Sheppard, New York

Richard W. Hall (1785–1847), for many years a professor of obstetrics at the University of Maryland, married Eliza J. Taylor in 1815.

Catalogue nos. 178 and 179 are companion pieces.

179. *Eliza Taylor Hall*

Watercolor on ivory, 2 11/16 x 2 1/8 in. (6.8 x 5.3 cm)
Signed at right: *Persico*
Casework: as for cat. no. 178. Inscribed on card backing frame: *Eliza Taylor Hall / wife of / Dr. Richard W. Hall*
Ex COLL.: purchased from Edward Sheppard, New York

Colorplate 20d

PHILIPPE ABRAHAM PETICOLAS

(1760–1841)

A miniaturist and teacher of drawing and music, Philippe A. Peticolas was born in Meziers, France. He left school at an early age to enlist in the army of the king of Bavaria. In

1790 Peticolas went to Santo Domingo as part of an attempt to suppress a slave insurrection; he left the island after the birth of his son Augustus and in 1791 moved his family to Philadelphia. There he advertised his willingness to give lessons in miniature painting and drawing "such as osteology, myology, anatomy, flowers, landscapes, figures." During the next few years he also traveled about and took likenesses in Lancaster, Pennsylvania, New York City, and Alexandria and Winchester, Virginia. In 1796 he made several miniature copies after Gilbert Stuart's *George Washington*, the Vaughan type. He was in Baltimore in 1798 and 1799.

Peticolas moved to Richmond in 1804; there he opened an academy for young ladies, offering instruction in miniature painting, music, and French, while his wife taught artificial flower making and sewing. In 1805 he arranged for his son Edward to take painting lessons from THOMAS SULLY and in return gave Mrs. Sully music lessons. Peticolas remained in business in Richmond for the next fifteen years. His sons were musicians and artists: Augustus taught music at the academy and Theodore (b. 1797) and Edward (1793–ca. 1853) were also miniature painters. Peticolas spent his

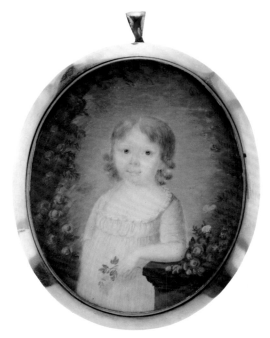

180

last years at the home of a son, probably Edward, in Petersburg, Virginia.

Peticolas's technique, although provincial, reveals his Continental training. He employed either a smooth gray opaque background or a blue, delicately hatched one, occasionally including elaborate detail. His brushwork is linear, and details are carefully articulated. Faces are somewhat primitively rendered, showing large, round eyes and a prominent crease next to a slightly misshapen mouth. Modeling is achieved by means of strong dark hatches which have a peculiar splotchy effect.

180. *Little Girl*

1797
Watercolor on ivory, 2¹¹⁄₁₆ x 2³⁄₁₆ in. (6.9 x 5.5 cm)
Signed and dated lower left: *P A Peticolas fecit / 1797*
Casework: gold-plated locket, also mounted as a brooch; on the reverse, brightwork framing compartment containing hair of two colors, plaited.
Inscription on trade card backing ivory: *John Pittman / Goldsmith, jeweller & Watch maker / Alexandria*
Ex COLLS.: sale, Sotheby Parke-Bernet, New York, July 14, 1981, lot 289; purchased from Edward Sheppard, New York

Colorplate 5b

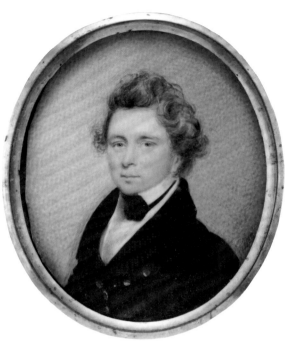

181

rose-and-thistle hanger (partially shown)
Ex COLLS.: sale, Sotheby Parke-Bernet, New York, Nov. 19, 1980, lot 245; purchased from Edward Sheppard, New York

CROWELL POTTER

(active ca. 1825–30)

Little is known about this artist. He was active in New York City, where he painted miniatures of John J. Brower and Cornelius Leverich Brower (coll. W. L. Brower, New York). Both are signed *Potter* along the right edge and are similar in approach to the miniature shown here. Strongly modeled faces are placed against shaded, broadly stippled blue-green backgrounds.

181. *Gentleman*

Watercolor on ivory, 3⅛ x 2½ in. (8 x 6.5 cm)
Signed lower right: *Potter*
Casework: papier-mâché frame, brass bezel and

JOHN RAMAGE

(ca. 1748–1802)

John Ramage, a miniature painter and goldsmith, was born in Ireland; he entered the Dublin Society Schools in 1763. Ramage was married at least three times, and many details of his personal life remain obscure. Shortly after his first marriage he left his wife, the former Elizabeth Kiddell (d. 1784), in London and about 1772 settled in Halifax, Nova Scotia. By 1775 he had moved to Boston and was established as a miniature painter and practicing goldsmith. Ramage enlisted in a Loyalist regiment that Irish merchants had formed to fight

for the British against the colonists; in 1776 he went with his regiment to Halifax.[1]

The following year, having left the regiment, Ramage moved to British-occupied New York in search of portrait commissions. He quickly became the city's leading miniature painter and retained that distinction for over fifteen years. Ramage "was in reality the only artist in New York . . . [and painted] all the military heroes or beaux of the garrison and all the belles of the place" (Dunlap, 1834, vol. 1, p. 226). His more prominent sitters included George Washington, George Clinton, and members of the Van Rensselaer, Ludlow, Van Cortlandt, and Pintard families. His male sitters are portrayed rather as Dunlap described Ramage: "a handsome man of the middle size, with an intelligent countenance and lively eye. He dressed fashionably and according to the time, beauishly. A scarlet coat with mother-of-pearl buttons . . . a white silk waistcoat embroidered with coloured flowers" (p. 227). However, by 1784 Ramage's position was declining because of fast living, and his later life was filled with misfortune. He narrowly escaped debtor's prison by fleeing to Montreal, leaving his wife and children behind. Family correspondence reveals that his last years were marked by ill health, impoverishment, and time in jail.

The miniatures Ramage painted in Ireland were quite small, the heads often touching the top of the ivory; their drawing was less than accurate. They were mounted in plain burnished bezel cases. Those painted after his arrival in North America are of consistently high quality. Though never signed, Ramage's miniatures are recognizable because of their distinctive style. His palette of rich colors and his brushwork, which is linear but delicate and smooth, create the effect of an enamel. Forms are built up by a series of fine hatches. The sitters, who wear whimsical half-smiles, appear both elegant and gentle. Their features are sharply delineated, the textures and details of their dress meticulously rendered. Faces are turned slightly to the left, with a highlight against the cheek and shoulder. Backgrounds are greenish brown or occasionally deep blue with a suggestion of landscape. Ramage also produced allegorical and memorial scenes in miniature. He made his own extremely fine gold cases, fluted, scalloped, and chased in decorative patterns.

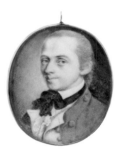

182

182. *Officer in a Red Coat*

Watercolor on ivory, 1¼ x 1 1/16 in. (3.2 x 3.5 cm)
Casework: gold with burnished bezel
Ex coll.: purchased from Edward Sheppard, New York

This miniature and catalogue no. 183 were probably painted in Ireland.

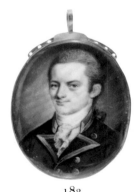

183

183. *Officer in a Blue Coat*

Watercolor on ivory, 1 7/16 x 1¼ in. (3.8 x 3.1 cm)
Casework: gold with burnished bezel, mounted to be worn as a bracelet or locket
Ex coll.: purchased from E. Grosvenor Paine, New Orleans

1. In 1776 Ramage bigamously married his second wife, Maria Victoria Ball of Boston; he left her after seven days and they were later divorced. According to Ramage's biographer (Morgan, 1930), his third wife, a Mrs. Taylor of Halifax, may in fact have been his first wife, who had caught up with him. Lastly, in 1787 he married Catherine Collins, the daughter of a New York merchant. He had children by his first and last wives.

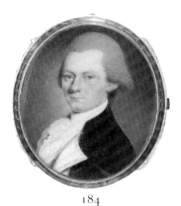

184

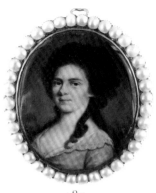

185

184. *William Few*

Watercolor on ivory, 1¹¹⁄₁₆ x 1⁷⁄₁₆ in. (4.3 x 3.7 cm)
Casework: gold with red enameled surround; case
 mounted with slide clasps to be worn on a
 bracelet
RELATED WORK: an oil painting after this miniature,
 executed in 1861 by Carl L. Brandt (1831–
 1905), also descended in the family.
EXHIBITED: National Portrait Gallery, Washington,
 D.C., 1989, *First Federal Congress*, exh. cat. pp.
 256–58
EX COLLS.: the subject's grandson, William Few
 Chrystie, Hastings-on-Hudson, New York; in
 1892 to his son, William Few Chrystie, Hastings-
 on-Hudson; sale, Parke-Bernet, New York, Jan.
 13, 1949, lot 297; Harry Fromke, New York;
 sale, Christie's, New York, Oct. 18, 1986, lot 421

Colorplate 4a

A statesman, soldier, and banker, William Few
(1748–1828) was born near Baltimore. The
family moved to Orange County, North Caro-
lina, and later to St. Paul's Parish, Georgia. Few
served as a lieutenant colonel in the Georgia
militia during the Revolution. Later he began
to practice law. He was twice a member of the
General Assembly of Georgia and in 1787 rep-
resented Georgia at the Constitutional Conven-
tion in Philadelphia. He was a senator from
Georgia in the first United States Senate, serv-
ing for four terms altogether. In 1799 Few
moved to New York City. Elected to the New
York State Assembly, he later became a federal
judge. He was a director of Manhattan Bank
and later president of City Bank. He died in
Fishkill, New York.

This portrait was probably made in 1787,

the year that the miniature of Mrs. Few was
painted and also the year Few was in Philadel-
phia. According to family legend, Mrs. Few at-
tended a ball wearing the miniature on her
wrist and lost it during the evening. The por-
trait was found and returned to her by George
Washington, who added a felicitous note.

Catalogue nos. 184, 185, and 186 are companion pieces.

185. *Catherine Few*

1787
Watercolor on ivory, 1⁹⁄₁₆ x 1¼ in. (3.8 x 3.1 cm)
Casework: gold, with half-pearl surround added at
 a later date; on the reverse, compartment
 containing plaited hair and gold initial *F;*
 inscribed: *Catherine Few aged 23 years, 1787*
EXHIBITED: as for cat. no. 184, except pp. 258–61
EX COLLS.: as for cat. no. 184, except Parke-Bernet
 sale, lot 298, and Christie's sale, lot 423

Colorplate 4c

This miniature was painted in 1787, at the high
point of Ramage's career. Catherine Nicholson
(1764–1854), the daughter of James and
Frances Witter Nicholson, married William
Few. *Common Sense* author Thomas Paine, who
had known Kitty Nicholson as a schoolgirl in
Bordentown, New Jersey, congratulated Mrs.
Few on her marriage, writing from London: "I
request my fair correspondent to present me
to her partner, and to say, for me, that he has
obtained one of the highest Prizes on the
wheel" (Moncure Daniel Conway, *The Writings
of Thomas Paine* [reprint, New York, 1969], vol.
3, p. 433). The Fews had three daughters.

186. *Thomas Witter*

Watercolor on ivory, 1¹¹⁄₁₆ x 1³⁄₈ in. (4.3 x 3.5 cm)
Casework: gold with red enameled surround; case
 mounted with slide clasps to be worn on a
 bracelet. Inscribed on reverse: *Thomas Witter /
 born 25th October 1713 / obit 20th October 1786*
RELATED WORK: an oil portrait after this miniature,
 attributed to Carl L. Brandt (1831–1905), also
 descended in the family
EX COLLS.: as for cat. no. 184, except Parke-Bernet
 sale, lot 299, and Christie's sale, lot 422

Colorplate 4b

Thomas Witter (1713–1786), the son of Mat-
thew and Frances Tucker Witter, was a native
of Bermuda. His first wife, Mary Lewis, pre-
deceased him. Their daughter Frances Witter
and her husband, James Nicholson, were the
parents of Catherine Nicholson Few (see cat.
no. 185), Thomas Witter's granddaughter.
Thomas Witter's second wife was Catherine
Van Zandt of New York.

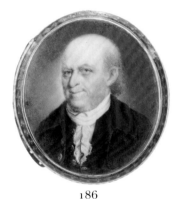

186

Since this miniature and the one of William
Few (cat. no. 184) are identically mounted, they
were probably commissioned at the same time.
If they were painted in 1787, the date of Cath-
erine's miniature, this miniature must have
been made posthumously by copying an earlier
portrait of Witter.

187

Attributed to John Ramage

187. *Garrit Van Horne*

Watercolor on ivory, 1³⁄₁₆ x ¹⁵⁄₁₆ in. (3 x 2.4 cm)
Casework: gold with beaded and burnished bezel;
 on the reverse, engraved: *Garrit Van Horne /
 Married to / Ann Margaret Clarkson / 16 Nov 1784*
EX COLL.: purchased from Alexander Gallery, New
 York, 1989

Garrit Van Horne (d. 1825) was married in
New York to Ann Margaret Clarkson, sister of
Matthew Clarkson (1758–1825), the Revolu-
tionary War general. The Van Hornes had
three daughters.

ARCHIBALD ROBERTSON

(1765–1835)

Archibald Robertson, eldest brother of the
miniature painters Alexander and Andrew,
was born near Aberdeen, Scotland, the son of
an architect. He attended King's College in
Aberdeen and in 1782 went to Edinburgh to
study painting. In 1786 he journeyed to Lon-
don, where he was taught the art of miniature
painting by Charles Shirreff (b. ca. 1750) and
is also said to have studied at the Royal Acad-
emy and in the studios of Sir Joshua Reynolds
and Benjamin West. He returned to Aberdeen
and established himself as a miniaturist, be-
coming so successful that he was dubbed "the
Reynolds of Scotland."

Robertson was invited to open a school of
drawing in New York; he arrived in 1791 and
liked it so much that he stayed for the rest of
his life. He and his brother Alexander founded

the Columbian Academy of Painting, offering instruction "drawing Heads, Figures, Historical Subjects, Landscapes, Flowers, Patterns, etc. in Water Colors, India Ink, Chalks etc." and also advertising their ability "to paint Portraits, Miniatures, Devices, Hair Work for Lockets" (*The Evening Register* [New York], April 30, 1794). The brothers ran the school together for almost ten years; in 1802 Alexander left to open his own drawing academy, and Archibald renamed the original school the Academy of Painting.

In 1800 Archibald wrote "A Treatise on Miniature Painting" for his brother Andrew, who was studying the art in London. (It was later published in *Letters and Papers of Andrew Robertson, A. M.* [Robertson, ed., 1895].) The treatise emphasized that "the fewer colors you use the better—the greater simplicity the better." Archibald also wrote the first comprehensive drawing manual in America, *Elements of the Graphic Arts*, which was published in New York in 1803. In 1808 Andrew Robertson wrote his own "Treatise on Miniature Painting" and sent it to Archibald in New York. It became an extremely influential work that was studied widely in this country and in England by aspiring miniaturists. (Both treatises are discussed in this book's introductory essays.)

After about 1810, Archibald concentrated mainly on painting topographical landscapes, making architectural plans for public buildings, and teaching, continuing to give instruction at his academy until 1821. His sketches and the tools and portable paintbox he used for painting miniatures are in the collection of the Rosenbach Library, Philadelphia.

Most of the known miniatures by Robertson were painted before 1805. His best works are the small ones done early in his career. They are similar in style to portraits by JOHN RAMAGE, who was then New York's leading miniaturist. Robertson frequently portrayed his subjects with elongated heads and angular features. He carried out the modeling by means of short hatchings and cross-hatchings. "In working shades of any kind I always use straight strokes unless something very extraordinary demands a curved or waved line—such as in hair." Clothing was more broadly executed. "As to linen . . . if the ivory is of too yellow a tint, you must tinge in the shades . . . a wash of blue . . . to alter the yellow tone, then a pale tint of thin white and brighter touches of white . . . put on with clean spirited strokes . . . execute with ease, boldness, and certainty. . . . [For] a gentleman's coat, you can float any plain simple tint, the color being rubbed down with very weak gum water, and sugar candy, which makes the tint lie smoother and adhere more to the ivory" (Robertson, ed., pp. 31, 29).

Robertson's early miniatures are sprightly characterizations using lively, pure color. Later works, which are larger, are not as carefully modeled and in general are more mechanically painted. Occasionally Robertson signed his works *A R*, a signature which has often caused confusion because of its similarity to Andrew's.

188

188. *William Loughton Smith*

Watercolor on ivory, 2³⁄₁₆ x 1¹³⁄₁₆ in. (5.6 x 4.6 cm)
Casework: gilded copper with burnished bezel and bright cut border
EX COLL.: purchased from Edward Sheppard, New York

William Loughton Smith (ca. 1758–1812) was born in Charleston, South Carolina, and educated in Switzerland and England. Elected to the first Congress, he became a leading Federalist and authored many pamphlets, several of which attack Thomas Jefferson. After 1803 he returned to Charleston, where he was a planter

189

and a lawyer. He was married twice: to Charlotte Izard, who died in 1792, and in 1805 to Charlotte Wragg (both of Charleston).

Two other portraits of Smith exist, which seem, from the style of dress and the apparent age of the sitter, to have been painted about the same time as this miniature. One, a miniature in oil on wood, was made by John Trumbull (1756–1843) in 1792 (Yale University Art Gallery, New Haven); the other is a full-size portrait painted by Gilbert Stuart about 1795 (Carolina Art Association, Charleston).

Colorplate 7a

189. *Gentleman*

Watercolor on ivory, 2⅛ x 1¾ in. (5.5 x 4.4 cm)
Casework: gilded copper with plain bezel; on the
 reverse, compartment with plaited hair
Ex COLL.: purchased from E. Grosvenor Paine,
 New Orleans

WALTER ROBERTSON

(ca. 1750–1802)

Born in Dublin the son of a goldsmith, Walter Robertson is often referred to as "the Irish Robertson" to distinguish him from the brothers Alexander and ARCHIBALD ROBERTSON, to whom he was not related. Robertson studied at

the Dublin Society Schools and about 1768 established himself as a miniaturist; he exhibited miniatures at the Society of Artists in Dublin in the years 1769–75 and 1777 and is said to have been regarded as a leading miniaturist there. He left for London about 1784 but apparently had little success, for in 1792 he returned to Dublin and declared bankruptcy.

Robertson became friendly with Gilbert Stuart (1755–1828), who had been in Dublin for several years and was preparing to return to America. In 1793 they made the voyage together to New York; there Robertson began making miniature copies of Stuart's portraits. The following year they went to Philadelphia, where Robertson lodged with ROBERT FIELD and an engraver named John James Barralet (1747–1815). Robertson painted a miniature of George Washington in his Continental uniform (probably from life), Field engraved it in stipple, and Barralet added embellishments (Hart, 1904, illustration facing p. 118). The miniature was recorded as lost; there is a replica in the collection of the R. W. Norton Museum, Shreveport, Louisiana. An exceedingly popular image, it was thereafter engraved by other artists as well. Robertson made several later miniature likenesses of Washington and at least two miniatures of Martha Washington. His copies after Stuart's paintings included the portraits *Bishop William White* (private collection) and *Abigail Willing Peters* (MMA). "With [Robertson's] coloring, and Stuart's characteristic likenesses, he was at the pinnacle of fame for a time" (Dunlap, 1918, p. 98).

It has often been recorded that Robertson left the United States toward the end of 1795, but he is listed in New York directories for 1795 and 1796 as "limner and miniaturist." A number of his miniatures done from life are of prominent New Yorkers such as Augustus Vallette Van Horne (MMA) and Peter Schuyler Livingston (Museum of the City of New York). So many of his subjects were from Charleston that it seems very likely he also painted in that city. An oil portrait by Robertson of Sarah McClean Bolton of Savannah (St. Louis Art Museum) is inscribed on the back: *Walter Robertson of New York 1796.* Apparently, then, Robertson considered himself a resident of New York and was still in this country in 1796. It is

not known when he left for India, but he died there in Futtehpur in 1802.

Robertson's miniatures, conceived in the English tradition, employ an elegant, formulaic pose. Those painted in the United States were all made within three years of each other and vary little in style and technique; faces, too, often tend toward sameness. Portions of the surface that appear to be smooth are actually rendered as a network of very fine hatching and cross-hatching. Features frequently seen in Robertson's miniatures are round blue eyes, a solemn expression, powdered hair tied back in a queue against a light brown hatched background; also a high-collared blue waistcoat with brass buttons, a gold vest, and a soft white jabot. Robertson's white highlights in the hair and on the collar are in the style of ROBERT FIELD but are more subtly executed. His technique was well described by Wehle: "Typical of Robertson's workmanship are the elegant artificiality of starched frills and powdered hair, the fine cross-hatching of translucent backgrounds, and the astonishingly skilful modeling of the heads by means of very fine long brush lines following the facial contours and usually blue in the depressions, notably the eye sockets" (*American Miniatures*, p. 32).

190

190. *Matthew Clarkson*

Watercolor on ivory, 2¹⁄₁₆ x 1¾ in. (5.2 x 4.5 cm)
Signed lower left, probably at a later date: *G S*
Casework: modern

This miniature is similar to one owned by Bernard H. Cone and incorrectly identified by him as a portrait of Elisha Kent Kane; see Cone, 1940 (in bibliography for Robertson), p. 13. A later identification of the subject as Matthew Clarkson was made at the Frick Art Reference Library, New York, by John Marshall Philips. About 1794 Gilbert Stuart painted an oil portrait of Matthew Clarkson in military uniform (MMA). While the dress and hairstyle are dissimilar, in pose and facial expression Robertson's miniature closely resembles the portrait by Stuart, of which it appears to be a copy. There is no comparable inscription on other copies by Robertson; probably the initials *G S* were added later.

Matthew Clarkson, a soldier and philanthropist from New York City, was the son of David and Elizabeth French Clarkson. During the Revolution Clarkson participated as a volunteer in the battle of Long Island, was aide-de-camp to Benedict Arnold at Fort Edward, where he was wounded, and performed with conspicuous bravery in the battle of Saratoga. He also served as aide-de-camp to General Benjamin Lincoln, who was secretary of war under the Confederation Congress. His later service was as brigadier general and then major general of the New York State militia. He was married in 1785 to Mary Rutherfurd and in 1792 to Sarah Cornell.

NATHANIEL ROGERS

(1787–1844)

One of New York City's leading miniaturists of the early nineteenth century, Nathaniel Rogers was born in Bridgehampton, Long Island. His father, John T. Rogers, was a farmer; his mother, Caroline Matilda Brown, was the daughter of a local minister. At about sixteen Rogers was apprenticed to a shipbuilder in

Hudson, New York. Later, while recovering from a knee injury, he began copying prints and miniatures. Soon Rogers was taking likenesses on paper and ivory in Connecticut, where he may have met ANSON DICKINSON. About 1806 he went to New York and there received some instruction from the miniaturists P. Howell (active 1806–7) and Uriah Brown (active 1808).

In 1811 JOSEPH WOOD, whose partnership with John Wesley Jarvis (1780–1840) had just dissolved, took Rogers on as an apprentice. Rogers progressed rapidly and in a short time was painting the secondary areas of miniatures, principally the clothing and backgrounds. Within the year he opened his own studio; when Wood moved to Philadelphia two years later, Rogers quickly attained prominence in New York. By that time he undoubtedly knew Dickinson, who from 1812 to 1820 worked in a studio near Rogers on Broadway. Extremely productive and in constant demand, Rogers painted "most of the fashionables of his day" (Cummings, 1865, p. 185). In 1818 he was married to Caroline Matilda Denison, daughter of Captain Samuel Denison of Sag Harbor. His life threatened by tuberculosis in 1825, Rogers

remained at home in Long Island much of the time thereafter but retained a studio in New York until 1839. Between 1817 and 1831 he exhibited at the annual shows of the American Academy of Fine Arts and the National Academy of Design (of which he was a founding member). In 1839 he retired and built an imposing home, Hampton House, in Bridgehampton.

Rogers's early attempts on paper, done from about 1805 to 1815, are similar and often parallel to the work of Dickinson. As a result of his association with Wood his drawing and modeling became more skillful, losing their labored quality. Unlike Wood, Rogers employed a palette of clear, lively color. His work of around 1815 was already delicate and sophisticated. The subjects of his highly individualized portraits are presented in a direct and appealing manner. Rogers used an oval format until about 1825, when he began to favor a rectangular one. He painted faces with a delicate stipple, often modeling the shadows in tones of red and emphasizing the eyes. When representing women he tended to make the heads disproportionately large and the bodies small. Details of dress are sharply defined with gum arabic.

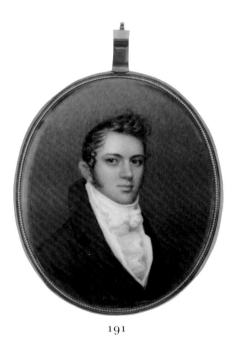

191

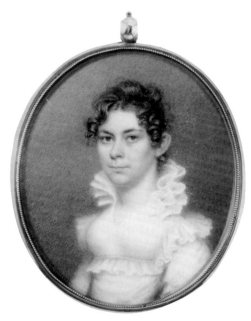

192

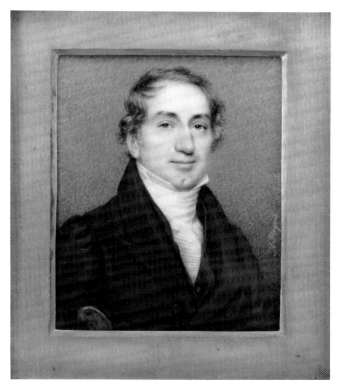

193

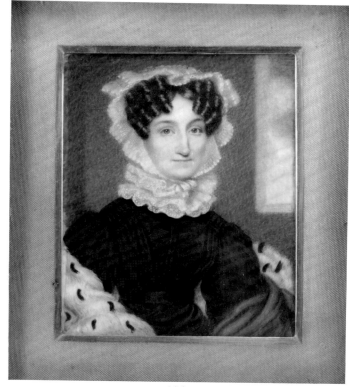

194

191. *Gentleman with a Pleated Stock*

Watercolor on ivory, 2½ x 2 in. (6.4 x 5.2 cm)
Casework: gilded copper with wire bezel; on the
 reverse, central compartment containing plaited
 hair
Ex coll.: sale, Sotheby Parke-Bernet, Feb. 17,
 1982, lot 571

192. *Matilda Few*

Watercolor on ivory, 2¾ x 2⁵⁄₁₆ in. (7.1 x 5.8 cm)
Casework: gold with wire bezel; on the reverse,
 hair compartment and engraved inscription:
 Matilda Few / aged 21 years. With fitted red
 leather case (not shown)
Ex colls.: the subject's nephew, William Few
 Chrystie, Hastings-on-Hudson, New York; his
 son, William Few Chrystie, Hastings-on-
 Hudson; sale, Parke-Bernet, New York, Jan. 13,
 1949, lot 297; Harry Fromke, New York; sale,
 Christie's, New York, Oct. 18, 1986, lot 421

Matilda Few was the daughter of William Few
and Catherine Nicholson Few (see cat. nos.
184, 185). She married John C. Tillotson.

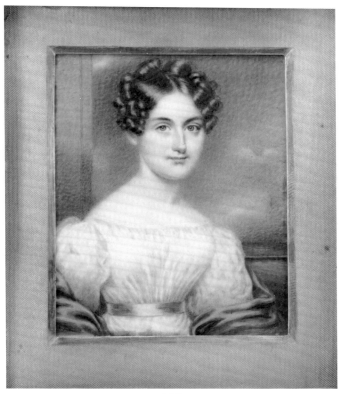

195

193. *Gentleman*

Watercolor on ivory, 2 15/16 x 2 5/16 in. (7.4 x 5.8 cm)
Signed along right edge: *N Rogers N York*
Casework: hinged green leather with ormolu mat
 and green velvet lining (partially shown)
Ex colls.: sale, Sotheby Parke-Bernet, New York,
 June 10, 1985, lot 88; purchased from Edward
 Sheppard, New York

Colorplate 15b

Catalogue nos. 193, 194, and 195 are companion pieces.

194. *Lady Wearing a Bonnet*

Watercolor on ivory, 3 x 2⅜ in. (7.6 x 6 cm)
Casework: as for cat. no. 193
Ex colls.: as for cat. no. 193

Colorplate 15a

195. *Young Lady*

Watercolor on ivory, 3 x 2⅜ in. (7.6 x 6 cm)
Casework: as for cat. no. 193
Ex colls.: as for cat. no. 193

Colorplate 15c

196. *Little Girl*

Watercolor on ivory, 2¾ x 2 3/16 in. (6.9 x 5.5 cm)
Casework: hinged green leather with ormolu mat
 and green velvet lining (partially shown)

197. *Gentleman with Red Hair*

Watercolor on ivory, 2 13/16 x 2 5/16 in. (7.2 x 5.9 cm)
Casework: gilded copper with wire bezel; on the

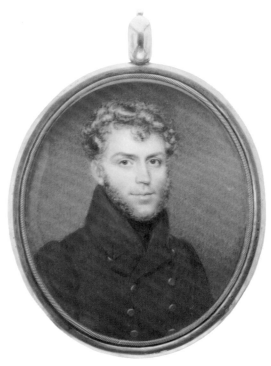

197

reverse, similar bezel framing hair compartment
Ex coll.: purchased from Edward Sheppard, New
 York

198. *John Ludlow Morton*

Watercolor on ivory, 2 15/16 x 2 3/16 in. (7.5 x 5.5 cm)
Casework: modern (not shown)
Label: *John Ludlow Morton / (1792–1871) / by
 Nathaniel Rogers*
RELATED WORK: This miniature is a replica of one
 signed and dated *N. Rogers, 1829* and mounted

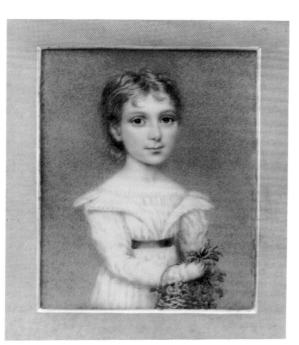

196

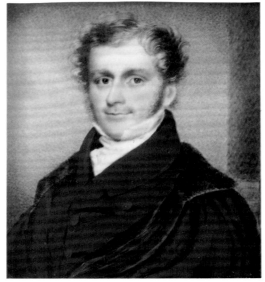

198

199

200

in Morton's book containing sketches by fellow members of the National Academy of Design (New-York Historical Society).
EX COLLS.: descended through the subject's family; purchased from Edward Sheppard, New York

John Ludlow Morton was born in New York, the eldest son of General Jacob Morton and Catharine Ludlow Morton. A painter of historical scenes, landscapes, and portraits, Morton exhibited regularly at the National Academy of Design for eighteen years. He was elected an associate in 1828, a full member in 1832, and secretary and corresponding secretary for the years 1826–44. He married his cousin, Maria Ludlow, in 1823. Morton divided his time between New York City and his farm near New Windsor, New York. His brothers Edmund and Henry Jackson Morton were also artists.

199. *Gentleman*

Watercolor on ivory, 2⅞ x 2¼ in. (7.3 x 5.7 cm)
Casework: brown leather with ormolu mat (partially shown); lid missing

200. *Gentleman of the Grinnell Family*

Watercolor on ivory, 2¹¹⁄₁₆ x 2⅛ in. (6.8 x 5.4 cm)
Casework: gilded copper with wire bezel; on the reverse, similar bezel framing hair compartment; with fitted brown leather case (not shown)

201. *Gentleman with New York City Street Plan*

Watercolor on ivory, 3⁵⁄₁₆ x 2⅝ in. (8.4 x 6.6 cm)
Casework: modern
EX COLL.: sale, Sotheby Parke-Bernet, New York, Sept. 15, 1979, lot 683

The subject holds a street plan of part of lower Manhattan; clearly visible on it are the names of Broadway, Chambers, Reade, and Duane streets and the date 1813. The sitter may have been an architect, a surveyor, or a city planner.

201

202

203

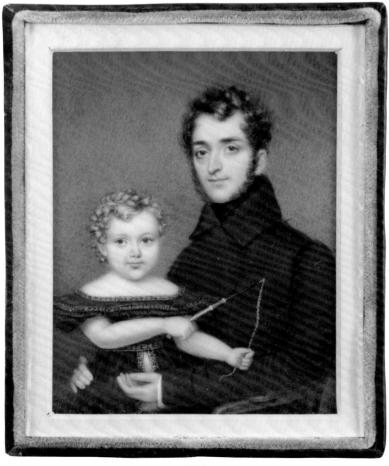

204

202. *Young Gentleman of the Jackson Family*

Watercolor on ivory, 2¹³⁄₁₆ x 2⅜ in. (7.2 x 6 cm)
Casework: gilded copper with chased bezel and
　　hanger; on the reverse, chased bezel framing
　　compartment containing plaited hair; with fitted
　　red leather case (not shown)
Ex coll.: sale, Sotheby Parke-Bernet, New York,
　　July 17, 1984, lot 28

Catalogue nos. 202 and 203 are companion pieces.

203. *Gentleman of the Jackson Family*

Watercolor on ivory, 2¹¹⁄₁₆ x 2⅛ in. (6.8 x 5.5 cm)
Casework: as for cat. no. 202
Ex coll.: as for cat. no. 202, except lot 29

**204. *Ferdinand Sands and Eldest Son
　　Joseph Sands***

Watercolor on ivory, 3⅞ x 2⅞ in. (9.8 x 7.3 cm)
Inscribed on a paper backing: *Ferdinand Sands Esq.
　　/ son of Joseph Sands—1 / born in New York city / May
　　26 / 1806 / Died in New York Dec 7 1839 / m. Susan
　　Bard of Hyde / Park & left issue / five Sons*
Casework: modern
Label on back: *The picture of Ferdinand Sands and
　　eldest son Joseph Sands*

Colorplate 16c

MOSES B. RUSSELL

(1810–1884)

Born in Woodstock, New Hampshire, Moses B.
Russell was active for over fifty years, from
1833 until 1884, as a portrait and miniature
painter and later as a daguerreotypist. Except
for the years 1854–61, when he was working
in New York and Philadelphia, his life was
spent in Boston. Between 1834 and 1856 Rus-
sell exhibited at the Boston Athenaeum, the
(Boston) Harding Gallery, the Boston Art As-
sociation, the Boston Mechanics' Association,
and the American Institute of the City of New
York. His entries were primarily miniatures,
occasionally portraits in oil. In 1841 he received
a silver medal for five miniatures shown at the
Boston Mechanics' Association. The judges
wrote that "these, although entered under one
name, appear to be the work of different

hands, and quite unequal in point of execution.
Several of them possessed much merit, and
were undoubtedly the best miniatures in the
Exhibition" (Yarnall and Gerdts, 1986, vol. 4,
p. 3086). In 1839 Russell had married the min-
iaturist Clarissa Peters (see MRS. MOSES B. RUS-
SELL) of Andover. Since Clarissa did not exhibit
on her own until 1842, the paintings Russell
exhibited in 1841 may have been a joint effort.
After his wife's death in 1854, Russell spent
some time in Italy. He survived his wife by
thirty years.

Russell's work of the early 1830s is quite
primitive. By 1834 it had improved markedly,
and paintings he executed over the following
ten years, such as the ones shown here, are in
his best style. The subjects of his portraits are
solemn in demeanor and project forceful per-
sonalities. They are predominantly male; their
dark hair and whiskers and black coats and
stocks make for a severe appearance. Back-
grounds are often of pearl gray strikingly com-
bined with subtle hues of pink. Later in
Russell's career, dark backgrounds and em-
phatic shadows demonstrate the adverse im-
pact of photography on his work.

205. *Gentleman*

1834
Watercolor on ivory, 2⅝ x 2¹⁄₁₆ in. (6.6 x 5.3 cm)
Signed and dated along left edge: *M. B. Russell
　　Pinxt / 1834*
Casework: gilded copper with wire bezel; on the
　　reverse, central compartment containing hair of
　　two shades, plaited
Reference: Bolton, 1921, p. 139
Exhibited: C. W. Lyon, New York, *Privately Owned
　　Early American Paintings with a Collection of
　　Miniatures*, 1941, no. 36; exh. cat., p. 50
Ex colls.: Joseph Stewart, Washington, D.C.; with
　　C. W. Lyon, New York, until 1941; Norvin H.
　　Green, Tuxedo Park, New York; sale, Parke-
　　Bernet, New York, Nov. 29, 1950, lot 238; sale,
　　Parke-Bernet, New York, Oct. 14, 1955, lot 219;
　　sale, Sotheby Parke-Bernet, New York, July 14,
　　1981, lot 272

Colorplate 22b

206. *Gentleman*

Watercolor on ivory, 2⅝ x 2¹⁄₁₆ in. (6.8 x 5.2 cm)
Signed along right edge (probably a later addition):
　　M. B. Russell pinx

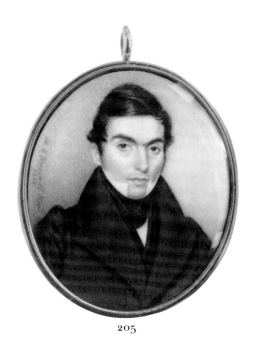

205

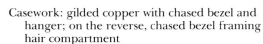

Casework: gilded copper with chased bezel and
hanger; on the reverse, chased bezel framing
hair compartment
Ex coll.: sale, Sotheby Parke-Bernet, New York,
Nov. 19, 1980, lot 232

207. *Gentleman said to be Edward Brinley of Boston*

Watercolor on ivory, 3 x 2¼ in. (7.6 x 5.8 cm)
Casework: hinged leather case with arch-shaped
ormolu mat (partially shown)
Framemaker's label on inside back of frame: *Made
at / Smith's / No 2, Milk St. / Opposite Old South /
Boston*
Ex coll.: purchased from Ronald Bourgeault,
Hampton, New Hampshire

Edward Brinley married Matilda Ann Bartlett
in Roxbury, Massachusetts, in 1835. From 1846
to 1850 Brinley was listed in the Boston direc-
tories as a druggist, with a shop at 3, South Side
of Faneuil Hall, and a home in Roxbury.

208. *Gentleman*

Watercolor on ivory, 2¾ x 2⅛ in. (6.9 x 5.4 cm)
Casework: gilded copper with wire bezel and
chased hanger; fitted red leather case (not
shown)

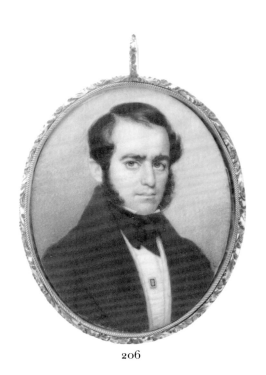

206

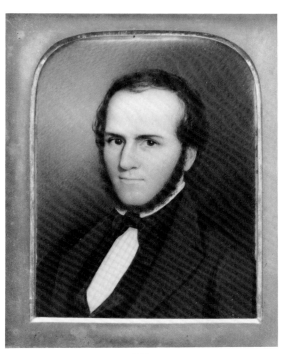

207

Framemaker's label: *Made at / Smith's / No 2, Milk St. / Opposite Old South / Boston*
Label on back of case: *by / Moses B. / Russell / (Boston)*
Ex COLL.: purchased from E. Grosvenor Paine, New Orleans

Attributed to Moses B. Russell

209. *Lady with an Open Book, probably Miss Ross*

Watercolor on ivory, 4¹³⁄₁₆ x 3¾ in. (12.2 x 9.4 cm); shown reduced
Inscribed in the painting on a page of the book: *Miss Ross / Rockport*
Casework: modern
Ex COLL.: purchased from Edward Sheppard, New York, 1988

Catalogue nos. 209 and 210 are companion pieces.

Attributed to Moses B. Russell

210. *Lady with a Closed Book*

Watercolor on ivory, 5 x 3¹⁵⁄₁₆ in. (12.8 x 10 cm); shown reduced
Casework: modern
Ex COLL.: as for cat. no. 209

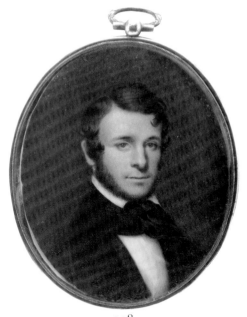

208

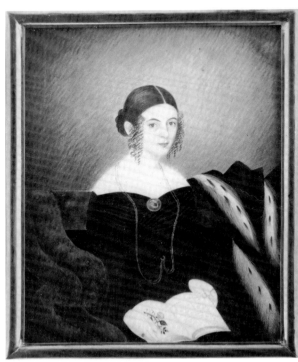

209

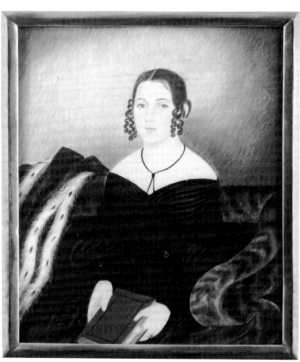

210

Miniatures nos. 209 and 210 resemble works by MRS. MOSES B. RUSSELL and it is entirely possible that she and her husband collaborated on them. The paintings are attributed to Moses B. Russell, however, on the basis of coloration, the subjects' expressions, and the painterly rather than linear treatment of the eyebrows. The backgrounds too, in both color and hatching, more closely resemble those in other paintings by Moses Russell than those by Clarissa.

These may be the miniatures entitled *Two Sisters* that Moses B. Russell exhibited at the Boston Art Association in 1842. Possibly the subjects are Ann and Elizabeth Ross, who lived at 39 Sumner Street in Boston during the 1830s.

Attributed to Moses B. Russell

211. *Lady in a Blue Dress*

Watercolor on ivory, 3¹⁄₁₆ x 2⁵⁄₁₆ in. (7.8 x 5.8 cm)
Inscribed on reverse of backing paper (apparently a later addition): *Painted by M. B. Russell 1846*
Casework: hinged red leather with ormolu mat, stamped on back: *I PRICE* [possibly Joseph H. Price, listed in the Boston directories 1830–54, who may have made the case and/or mat]; not shown
Ex COLL.: purchased from E. Grosvenor Paine, New Orleans

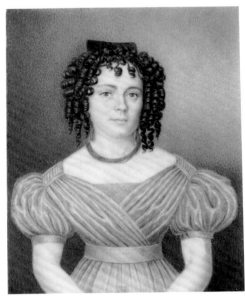

211

MRS. MOSES B. RUSSELL (CLARISSA PETERS)

(1809–1854)

Clarissa Peters was born in Andover, Massachusetts, the daughter of John and Elizabeth Davis Peters. Her younger sister, SARAH PETERS GROZELIER, was also a miniaturist. Clarissa was active as a miniature painter in Boston and its environs between 1836 and 1854. In 1839 she married the portraitist MOSES B. RUSSELL in Salem, Massachusetts. They lived in Boston at 21 School Street and were listed jointly in the city directory through 1849; then Clarissa is listed separately for four years as "miniature painter." She exhibited at the Boston Athenaeum, the Boston Art Association, and the Boston Mechanics' Association between 1841 and 1850. Her works were on one occasion judged "highly finished though somewhat defective in drawing" (see Yarnall and Gerdts, 1986, vol. 4, p. 3087). The Russells' son, Albert Cuyp Russell (1838–1917), was apprenticed to his uncle, Leopold Grozelier (1830–1865), and later became an engraver and illustrator.

Miniatures by Clarissa and Moses B. Russell seem to overlap in style and are often mistaken for one another. One suspects that the two painters worked in concert—a practice that was not uncommon—and that Clarissa had a hand in many works signed by or attributed to Moses. To add to the confusion, Clarissa's miniatures have often been attributed to the portraitist Joseph Whiting Stock (1815–1855). Mrs. Russell was a highly productive and accomplished miniaturist who has been unduly neglected because of misattribution. Her paintings, despite certain similarities to her husband's work, are quite distinctive: charming, somewhat naive likenesses of their subjects, who are almost always women and children. Her most common compositions show a single baby seated in an interior or present the posthumous portrait of a child, his head surrounded by clouds. Sitters are represented with large round eyes, the irises broadly outlined, and brushed-up eyebrows (each hair delineated); a dark line separates the lips. Details of dress and interior furnishings are very decorative, incorporating a variety of patterns. Flow-

ers or vines are often introduced at the edges of the composition. Pale skin tones contrast with the deep shades of fabrics, against striated backgrounds which are unique combinations of some or all of the colors brown, pink, green, light blue, and white. The miniatures, usually rectangular, are often framed in daguerreotype cases. They are rarely signed.

212. *The Starbird Children*

1841
Watercolor on ivory, 5 1/16 x 4 1/16 in. (12.8 x 10.4 cm); shown reduced
Inscribed on backing paper: *Henry E. Starbird AE 10 yrs / Caroline M. Starbird AE 8 yrs / Louis D Starbird AE 5 yrs. / Painted Sept 1841—Mrs. Russell.* Written below, in another hand: *Boston / M. B. Russell*
Casework: ormolu mat, modern frame (not shown)
Ex colls.: descended in the Starbird family; with Philip N. Grime, Saco, Maine, 1983; purchased from Edward Sheppard, New York

Colorplate 25

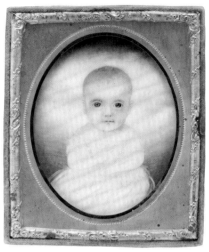

213

The subjects of this portrait are the children of Nathaniel W. and Mary Horn Starbird, who were married in Charlestown, Massachusetts, on December 2, 1829. They lived in Malden, and Nathaniel had a tailoring business in Boston. In 1863 Louis and Henry went into business with their father as N. W. Starbird & Sons. Henry left the business in 1870 and died in Boston in 1884. Louis remained with the business until his death in 1926, long after his father's demise in 1888. Nothing is known of their sister Caroline.

This is one of Mrs. Moses B. Russell's earliest known miniatures; it may be the *Group of Children* that she exhibited at the Boston Art Association in 1842. Moses Russell painted a miniature of Nathaniel Starbird in 1833 (coll. Philip N. Grime, Saco, Maine).

213. *Baby*

Watercolor on ivory, 1 15/16 x 1 1/2 in. (5 x 3.8 cm)
Casework: hinged thermoplastic daguerreotype case lined in purple velvet, with stamped metal mat (partially shown)

Colorplate 32a

214. *Child*

Watercolor on ivory, 2 1/2 x 2 1/16 in. (6.5 x 5.3 cm)
Casework: hinged brown leather lined in red velvet, with stamped metal mat (partially shown)

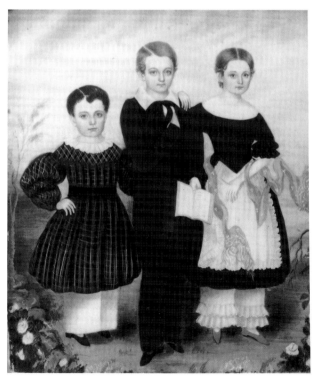

212

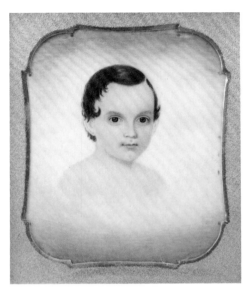

214

The painted clouds that surround the child's head indicate that this is a memorial portrait made posthumously.

GEORGE LETHBRIDGE SAUNDERS

(1807–1863)

Published information regarding George Lethbridge Saunders is often incorrect, since he has frequently (and as recently as 1965) been confused with George Sanders (1774–1846), a miniature painter from Kingshorn, Scotland. Saunders was born in Bristol, England. He exhibited at the Royal Academy and the Free Society of British Artists in the years 1829–39 and 1851–53. He lived in this country during the 1840s, making two brief trips to London within that period. Saunders worked in New York, Philadelphia, Boston, Baltimore, Richmond, Savannah, Columbia, and Charleston. Between 1840 and 1843 he exhibited at the Apollo Association in New York and at the Artists' Fund Society in Philadelphia. He was acquainted with the artists THOMAS SULLY and CHARLES FRASER. He painted portraits of many people from prominent families, including the John

Ridgelys and Charles S. Gilmor of Baltimore, the Thomas Dwights of Boston, and the Benjamin Chew Wilcockses of Philadelphia. Saunders returned to England around 1851 and died in Bristol.

Saunders was solely a miniaturist. His relatively large works, either oval or rectangular in format, usually carry along an edge the incised signature *G L Saunders*. He used rich, pure colors mixed with gum, which gives the surface a varnished appearance. In some of his portraits the skin has a slightly yellow cast. Saunders generally used a smooth, broad wash in painting the face and costume, setting them against a background tightly textured by stippling and hatching. He meticulously represented the details of lace, trimmings, jewelry, and background. His miniatures look like small oil portraits; they are sometimes overly sentimental, as is typical of the period.

215. *Jubal Anderson Early*

Watercolor on ivory, 3¹⁵⁄₁₆ x 3 in. (10 x 7.6 cm)
Signature incised along the left edge: *G L Saunders*
Casework: modern
Ex coll.: purchased from Edward Sheppard, New York

A soldier and a lawyer, Jubal Early (1816–1894) was born in Franklin County, Virginia. He graduated from West Point, then in 1838 began the study of law, which he practiced sporadically throughout his life. In 1847–48 Early served in the Mexican War as major of the First Virginia Regiment. He entered the Confederate army as brigadier general in 1861, rising to the rank of lieutenant general.

216. *Mrs. Israel Thorndike* (Sarah Dana)

1843
Watercolor on ivory, 3¹¹⁄₁₆ x 2¹⁵⁄₁₆ in. (9.3 x 7.4 cm)
Signed along right edge: *Saunders*
Inscribed on backing paper: *Mrs. Israel Thorndike / by Saunders / 1843*
Casework: modern (not shown)
Ex coll.: sale, Sotheby Parke-Bernet, New York, Nov. 19, 1980, lot 215

Colorplate 27

Sarah Dana was born in Ipswich, Massachusetts, the daughter of the Reverend Joseph Dana. She married Israel Thorndike, whose fa-

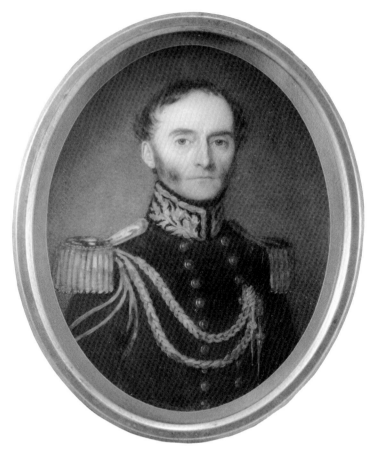

215

ther, Israel Thorndike of Boston (1755–1832), was a merchant in the China and India trade and a patriot during the Revolution. On the table in the background of this painting lies the *Book of Common Prayer.*

EDWARD SAVAGE

(1761–1817)

Best known for his portraits of George Washington, Edward Savage was born in Princeton, Massachusetts, the son of Seth and Lydia Craige Savage. He is said to have begun as a goldsmith. By 1784 he was in Boston, painting portraits in oil. Savage was probably a self-taught artist. It is known that he made copies after works by JOHN SINGLETON COPLEY, whose influence is particularly apparent in his early work. In 1789 Savage was commissioned to

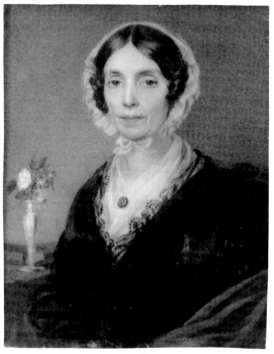

216

paint a portrait of George Washington for Harvard College. About 1791 he executed miniatures of himself and his betrothed, Sarah Seaver (both, Worcester Art Museum). The Savage self-portrait is indebted to Copley's self-portrait of 1769 (cat. no. 41) in both pose and style of dress. The charming portrait of Sarah Seaver, which Wehle calls "delectably quaint" (*American Miniatures*, p. 27), depicts her in an elaborate interior setting. Savage went to London in 1791; there he learned the art of engraving and perhaps studied briefly with Benjamin West. While in London he published prints of George Washington, General Henry Knox, and Benjamin Franklin.

In 1794 Savage returned to Boston and was married. He moved to Philadelphia in the summer of 1795; in 1796 he opened the Columbian Gallery in Charleston and exhibited his most famous oil painting, *The Washington Family* (National Gallery, Washington, D.C.). In his gallery Savage also showed his own collection of "ancient and modern" paintings and prints. He moved the gallery to New York City in 1802 and in 1810 moved it again to Boston, renaming it the New York Museum. It was absorbed by the New England Museum in 1825. Savage spent his last years at his farm in Princeton, Massachusetts.

Miniatures by Savage were all painted between approximately 1785 and 1791. With the exception of his self-portrait, they are quite primitive and lack modeling. A Savage miniature typically depicts a male sitter and shows a slightly elongated torso with waistcoat, embroidered vest, white stock, and powdered hair, hatched in a decorative staccato pattern against a blue-green background. The housing is likely to be a simple burnished bezel locket.

Attributed to Edward Savage

217. *George Johnston*

Watercolor on ivory, 1⅞ x 1⁵⁄₁₆ in. (4.8 x 3.4 cm)
Casework: gold with burnished bezel, mounted as a locket and a brooch; with fitted red leather case (not shown)
Ex colls.: the subject's granddaughter, Mrs. Thomas B. Gresham, Baltimore; her husband, Thomas B. Gresham, Baltimore; purchased from E. Grosvenor Paine, New Orleans

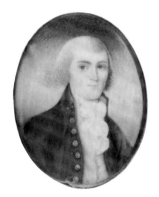

217

George Johnston was born in 1764 in Princess Anne County, Maryland, the son of Samuel Johnston. He married Peggy Wilson in 1793 and moved to Baltimore.

This miniature, attributed to Savage at the time of its purchase, is very close in style to two other miniatures in private collections also attributed to Savage. It differs considerably, however, from the documented miniatures in Worcester. Savage's miniatures are quite uneven in quality, varying from somewhat primitive productions to rather academic work.

WILLIAM HARRISON SCARBOROUGH

(1812–1871)

Born in Dover, Tennessee, William Harrison Scarborough was educated in both medicine and art. He began studying painting around 1830 with the portraitist John C. Grimes (1804–1837) in nearby Nashville, then went to Cincinnati, where he received instruction from Horace Harding (ca. 1794–ca. 1857) at the Littleton Museum. After working as a portraitist in oil for a few years in Tennessee, Scarborough moved to Alabama and then in 1836 to Charleston, South Carolina. There he met John Miller, a planter and lawyer, who invited the artist home to take likenesses of his entire family, including a daughter, Miranda Eliza Miller, whom Scarborough married two years

later. For the next six years Scarborough worked as an itinerant portraitist, producing full-size and miniature portraits throughout Georgia and the Carolinas. In 1843 he moved his family to Columbia, South Carolina, where he was constantly employed painting portraits in oil until his death. Many prominent personages sat for Scarborough, including three governors of the state. In 1857 he spent a year traveling and studying in Europe, and while there he became good friends with the American sculptor Hiram Powers (1805–1873).

Much material has descended in Scarborough's family, including his highly detailed account books from the years 1841–65, and pen-and-ink sketches preparatory to his miniatures (coll. Miller family, Sumter, South Carolina). In 1937 the Carolina Art Association held an exhibition of Scarborough's works, showing fifty of his portraits and miniatures. Only a handful of his miniatures are known today. They were executed early in his career; failing eyesight forced him to give up painting miniatures later in life. Scarborough used the same three-quarter pose for many of these, often placing the subject low on the ivory. In portraying men he achieved lively characterization, but to women subjects he gave doleful expressions and a limp appearance.

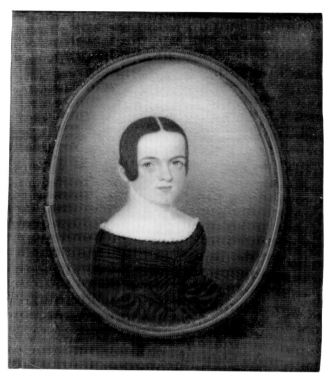

219

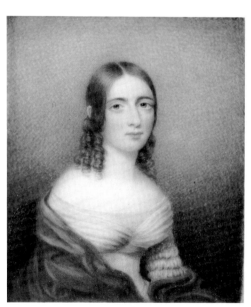

218

218. *Lady*

Watercolor on ivory, 3 1/16 x 2 1/2 in. (7.7 x 6.5 cm)
Casework: gilded bronze with floral decoration (not shown)
Ex colls.: with E. Grosvenor Paine, New Orleans; sale, Sotheby Parke-Bernet, New York, Jan. 29, 1986, lot 140

219. *Girl*

Watercolor on ivory, 2 7/8 x 2 1/4 in. (7.3 x 5.7 cm)
Casework: hinged red leather with green velvet mat (partially shown)
Ex colls.: as for cat. no. 218

WILLIAM P. SHEYS

(active 1813–21)

William P. Sheys was active as a portraitist in New York City. He listed himself in the city directory in 1813 and 1814 as a miniature painter and in 1820 as a portrait and miniature painter. According to Dunlap, Sheys was a pupil of John Wesley Jarvis (1780–1840) of un-

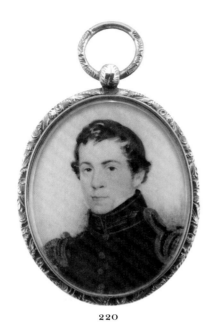

220

common talent, but had "sunk to vicious courses, and died a common sailor in a foreign land" (1834; vol. 2, Appendix, p. 470).

220. *Naval Officer*

1821
Watercolor on ivory, 2¹⁄₁₆ x 1⅝ in. (5.2 x 4.2 cm)
Signed lower right: *Shey*. Backing paper inscribed:
 Painted—1821—[illegible signature]
Casework: gilded copper with chased bezel and
 hanger; on the reverse, repoussé decoration
 with wire bezel framing hair compartment
Ex colls.: with E. Grosvenor Paine, New Orleans;
 sale, Sotheby Parke-Bernet, New York, Jan. 29,
 1986, lot 178

HENRY COLTON SHUMWAY

(1807–1884)

Henry Colton Shumway was born on the Fourth of July, 1807, in Middletown, Connecticut. At twenty-one he went to New York, where he took life drawing classes at the National Academy of Design and probably studied miniature painting with THOMAS SEIR CUMMINGS. By 1831 he had established himself as a miniature painter. Shumway exhibited at the academy from 1829 through 1861 and was

elected an academician in 1832. He also exhibited at the Apollo Association and the Artists' Fund Society in New York, the Boston Athenaeum, and the Pennsylvania Academy of the Fine Arts. He received a gold palette in 1844 for the best miniatures at the New York Fair exhibit. Except for visits to Washington, D.C., and New Orleans and summers in Connecticut, Shumway spent his entire career in New York. Dunlap placed him "in the foremost rank of the miniature painters of New-York" (1834; vol. 2, p. 451). His prominent subjects included Daniel Webster, Henry Clay, Cyrus W. Field, Colonel Wadsworth and Governor Jonathan Trumbull of Connecticut, and fellow artists Henry Peters Gray and James Frothingham. Shumway had charged $10 for his first works; he was receiving up to $300 per miniature at the height of his career.

Active in the Seventh Regiment of the New York State militia, Shumway served as a colonel during the Civil War. After 1860, when the market for miniatures had been largely taken over by photography, he worked principally at coloring daguerreotypes.

Most of Shumway's known miniatures are large (approximately five by four inches) and rectangular in format. Usually they are incised *Shumway* along an edge or at an angle on the lower right. In his early portraits the flesh areas are painted with a wash, backgrounds are very delicately stippled, and the color is subtle and harmonious. Later works, which reveal the adverse influence of photography, are often heavily and mechanically stippled throughout, harsh in color, and highly finished with excessive gum.

221. *Frances Ann Osborne*
 (Mrs. Samuel Russell)

Watercolor on ivory, 3⁷⁄₁₆ x 2⁹⁄₁₆ in. (8.7 x 6.6 cm)
Casework: carved gilt wood (not shown)
Inscription in ink on back of frame: *Frances Ann
 Osborne / wife of / Samuel Russell / of Middletown
 Connecticut / U.S. of America. / [pain]ted C[olton]
 Shumway*
Ex colls.: with E. Grosvenor Paine, New Orleans;
 sale, Sotheby Parke-Bernet, New York, Jan. 29,
 1986, lot 147

Frances Ann Osborne was the daughter of Mary and David Osborne. In 1825 she married

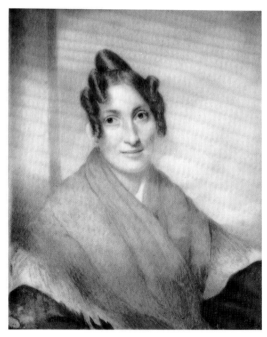

221

Samuel Russell (1789–1862), a manufacturer of elastic webbing in Middletown, Connecticut, and in Canton, China. Russell was a president of Middlesex County Bank and a founder of Wesleyan University.

JAMES PASSMORE SMITH

(1803–1888)

Born in Philadelphia, James Passmore Smith established himself there as a miniature painter in 1824 and by 1829 was also teaching drawing and painting. He may have been instructed by THOMAS SULLY, the leading Philadelphia portraitist and later a close friend of Smith's. He was also well acquainted with the artists John Neagle (1796–1865), JOHN HENRY BROWN, and Jacob Eicholtz (1776–1842). In 1835 Eicholtz made an oil portrait of Smith engaged in painting a miniature (National Gallery, Washington, D.C.). Smith, whose entire career took place in Philadelphia, exhibited occasionally between 1834 and 1850 at the Pennsylvania Academy of the Fine Arts. His entries were usually min-

iature copies of portraits or "fancy" or ideal pieces after other artists. When his vision grew less sharp he abandoned miniature painting, but he continued to teach pen-and-ink drawing until his death.

Fewer than fifteen of Smith's miniatures have been located; all were painted in the 1830s and 1840s. His works are unsigned, but often his trade card is mounted inside the case. Although Smith was regarded as a prominent Philadelphia miniaturist, most of his miniatures were copies after paintings by well-known artists rather than portraits from life. Smith's skillfully executed miniatures give an effect of spontaneity and achieve strong characterization. The flesh is rendered by delicate stippling. The background is often a bold sky-and-cloud design.

222. *Gentleman with the Initials E W*

1829
Watercolor on ivory, 2½ x 2 1/16 in. (6.4 x 5.3 cm)
Casework: gilded copper with chased bezel and hanger; on the reverse, chased bezel framing hair compartment, and engraved initials: *E W*
Trade card (inside case): *James P. Smith / Miniature Painter / and / Teacher of Drawing and Painting / No 282 Chestnut St. / Philadelphia.* Added in graphite: *1829*
Ex COLLS.: with E. Grosvenor Paine, New Orleans; sale, Sotheby Parke-Bernet, New York, Jan. 29, 1986, lot 104

Colorplate 21a

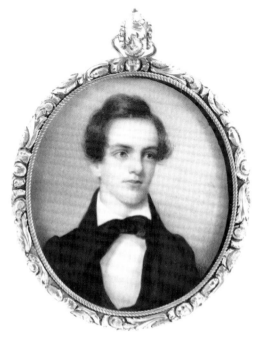

222

RICHARD MORRELL STAIGG

(1817–1881)

Born in Leeds, England, Richard Morrell Staigg worked as an architect's assistant before coming to the United States in 1831. His family settled in Newport, Rhode Island, and Staigg became an ornamental and sign painter. His artistic talent was soon noticed by JANE STUART, who taught him the rudiments of miniature painting. He was also encouraged by Washington Allston (1779–1843), whose miniature he painted in 1841 (MMA). Staigg was naturally attracted to the work of the celebrated Newport miniaturist EDWARD GREENE MALBONE, who had died three decades earlier. He carefully copied *The Hours* (Providence Athenaeum) and other works of the master. Soon after he estab-

lished himself as a miniaturist, Staigg was in demand by a distinguished clientele; engravings were made after his miniatures of Daniel Webster and Edward Everett. He exhibited regularly at the Boston Athenaeum and in New York at the National Academy of Design, where he was elected a member in 1861. Sometime around 1860 he turned from making miniatures to painting full-size oil portraits, landscapes, and genre scenes.

Staigg lived in Boston during 1841–52, in New York City in 1853–64, and again in Boston from 1865 to 1881. He spent summers in Newport, visited Baltimore in 1845, and took two extended trips to Europe, in 1867–69 and 1872–74, exhibiting at the Paris Salon and at the Royal Academy in London. He died in Newport.

Staigg's earliest works, which show an in-

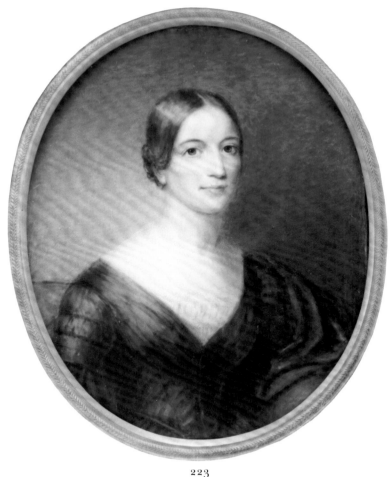

223

debtedness to Malbone, are characterized by delicate brushwork with fine cross-hatching, pale colors, and light backgrounds. Later he developed a distinctive technique, using broad, sweeping strokes to define flesh areas and costumes and setting the figure against a mottled background. Staigg's mature palette is a medley of luminous pastel hues for the flesh and rich, deep tones in the clothing and background. He achieved highlights in the hair by rubbing areas of the painted surface with a stick, exposing the glossy, light-colored ivory. His miniatures have the richness of small oil paintings. Unlike many late miniaturists, Staigg did not devitalize his style in an attempt to imitate photography.

Miniatures from the late 1830s to the mid-forties are rectangular and are signed on the backing paper; later works are larger and oval in shape, with the signature and date incised along the painting's right edge.

223. *Miss Ann King*

Watercolor on ivory, 4⅞₁₆ x 3½ in. (11.3 x 9 cm)
Signature incised along right edge: *Staigg*
Casework: gilt wood with ormolu liner (partially shown)
Label on back of frame: *Miss Ann King / Newport, R. I. / Born 1800 / by Staigg*
Ex colls.: sale, Sotheby Parke-Bernet, New York, Nov. 29, 1980, lot 22; sale, Sotheby Parke-Bernet, New York, July 14, 1981, lot 266

Attributed to Richard Morrell Staigg

224. *Gentleman said to be Jeremiah Van Rensselaer*

Watercolor on ivory, 3¾ x 2¾ in. (9.5 x 7 cm)
Casework: modern
Label (added later): identifying the artist as Thomas Sully
Exhibited: Museum of the City of New York, 1939–40 (lent by Bernard H. Cone)
Ex colls.: Bernard H. Cone, New York; Harry Fromke, New York; sale, Christie's, New York, Oct. 18, 1986, lot 380

This miniature has been attributed to THOMAS SULLY and also to Andrew Robertson. In certain technical respects it is much closer to the work of Staigg, however, than to either of those artists. Staigg's highly distinctive glowing pastel coloring of the flesh is apparent here; there are similar long highlights on the nose and flicker-

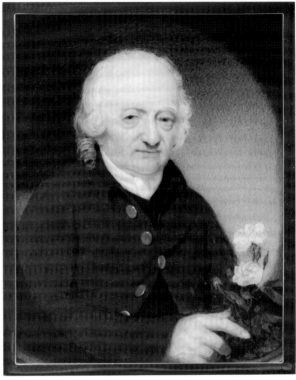

224

ing highlights on the buttons. The treatment of the clothing with a broad wash and the miniature's varnishlike finish overall are characteristic of Staigg. However, the brushwork is tighter than is typical for Staigg, probably because this portrait, whose subject lived in an earlier time, was copied from an oil painting.

Jeremiah Van Rensselaer (1738–1810) was born in New York, graduated from Princeton College in 1758, and settled in Albany. He took an active part in the Revolution, was a member of the Albany Committee of Safety, and served as lieutenant governor of New York for several years. He was elected president of the Bank of Albany in 1799.

GEORGE W. STEVENS

(ca. 1820–1891)

George W. Stevens was actively painting miniatures in Boston from about 1840 to 1850. He listed himself in the city directories as a miniature painter from 1840 until 1843; thereafter he became an upholsterer and a furniture maker. Stevens exhibited miniatures at the Boston Mechanics' Association in 1841, 1844, and 1850. The two miniatures he showed at the 1844 exhibition were judged "smoothly finished, and delicately colored. The cool tints of the face are pretty well managed, but faulty in drawing" (see Yarnall and Gerdts, 1986, vol. 5, p. 3386).

225. *Boy*

1845
Watercolor on ivory, 2½ x 2 in. (6.3 x 5 cm)
On trade card used as backing: *George W. Stevens / July 1845 / Boston*
Casework: gilded copper with chased bezel and hanger; on the reverse, chased bezel framing hair compartment

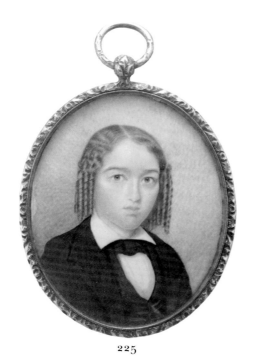

225

LOUISA CATHERINE STROBEL

(1803–1883)

Louisa Catherine Strobel was born in Liverpool, England, to American parents from Charleston, South Carolina. After returning to this country in 1812, the family moved in 1815 to Bordeaux, France, where Louisa's father, Daniel Strobel, was the American consul. In Bordeaux Louisa studied the art of miniature painting. The family returned to the United States in 1830 and lived successively in New York, Washington, D.C., and New Hampshire, where Louisa met William Martin, a Presbyterian minister, whom she married in 1840. She apparently abandoned miniature painting after her marriage. The couple lived in Massachusetts, Albany, and, after 1852, New York City. They had one son.

Louisa practiced as an amateur miniaturist only, painting numerous likenesses of her family and close friends. Some of the early portraits she painted in Bordeaux (in private collections) are academic in style, displaying realistic modeling, robust color, and strong characterization. The more primitive miniatures she painted in this country show little modeling or expression, instead emphasizing pattern to create a highly decorative effect. The use of opaque slate-colored backgrounds reveals the artist's French training. She occasionally signed her name in full but more often initialed her works along an edge: *L C S*.

226. *Gentleman*

Watercolor on ivory, 2¾ x 2 in. (7 x 5.1 cm)
Signed along right edge: *Louisa. C. Strobel*
Casework: modern
Ex coll.: sale, Sotheby Parke-Bernet, New York, July 17, 1984, lot 70

Catalogue nos. 226 and 227 are companion pieces.

227. *Lady*

Watercolor on ivory, 2¾ x 1¹⁵⁄₁₆ in. (7 x 4.8 cm)
Signed along right edge: *Louisa. C. Strobel*
Casework: modern
Ex coll.: as for cat. no. 226

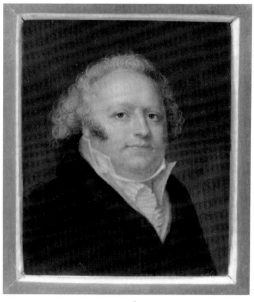

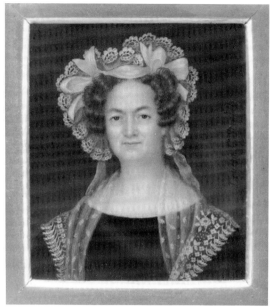

226

227

JANE STUART

(1812–1888)

The youngest child of Gilbert Stuart (1755–1828), Jane Stuart was born in Boston sixteen years before her father's death. She worked in her father's studio, grinding paints and filling in backgrounds, but received little training in art. Once, when asked why he did not teach his daughter to draw, Stuart is said to have replied, "When they want to know if a puppy is of the true Newfoundland breed, they throw him into the river; if true, he will swim without being taught" (Dunlap, 1834, vol. 2, p. 445). Jane later remarked that her father had kept her too busy working when he should have been giving her instruction.

After Stuart's death Jane became the sole support of her mother and sisters. She opened a studio in Boston and there turned out dozens of copies of her father's famous paintings, particularly those of George Washington. Both full-size and miniature, the copies were skillful enough for contemporary dealers to pass them off as originals. Jane made copies after works

by other prominent artists as well, and a few "fancy" pictures and portraits from life. She exhibited regularly at the Boston Athenaeum from 1827 through 1870 and occasionally at the National Academy of Design and the American Academy in New York, where she lived from 1840 to 1842. In the 1850s her studio in Boston burned, destroying much of her own work and almost the entire collection of her father's correspondence and memorabilia. She moved her studio to her family's home in Newport, continuing there to make replicas and paint posthumous portraits from daguerreotypes. Jane, who bore a striking resemblance to her father, also inherited his droll wit and fascinating personality; these helped her win a prominent social position in Newport, where she died at the age of seventy-six.

The only extant miniatures known to be by Jane Stuart are of George Washington after a Gilbert Stuart portrait of 1796 (Athenaeum III, type 3 series). They are carefully executed but, like most copies, lack spontaneity. The oval miniatures are inscribed with the monogram *I S*; backgrounds are opaque gray.

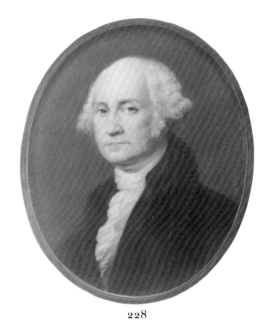

228

228. *George Washington*

Watercolor on ivory, 2⅞ x 2³⁄₁₆ in. (7.3 x 5.6 cm)
Signed lower right with monogram: *I S*
Casework: plain brass bezel
RELATED WORK: The Metropolitan Museum owns a
 replica of this miniature which is attributed to
 Jane Stuart. It is also signed with the monogram
 I S.
REFERENCES: Eisen, 1932, vol. 2, describes and
 illustrates the miniature (pp. 501, 699), calling it
 the work of an unknown artist. Frederic
 Fairchild Sherman, in "The Attribution of
 Unsigned American Miniatures," *Art in America*
 28 (July 1940), pp. 124–25, terms the painting
 "a practically flawless work technically, the
 coloring pure but subdued and the stippling so
 fine as to be almost invisible to the naked eye";
 on the basis of the initials he tentatively
 attributes it to John Stevenson, a miniaturist
 who painted in Charleston from 1773 to 1780.
EX COLLS.: with art market, Lucerne, Switzerland,
 1910; Guy M. Walker, New York, 1932; sale,
 Parke-Bernet, New York, Mar. 19, 1959, lot
 554; sale, Sotheby Parke-Bernet, New York,
 June 2, 1983, lot 215A

J. V. STURGEON

(active 1833–36)

J. V. Sturgeon exhibited once, in 1833, at the
American Academy of Fine Arts in New York.
His group of miniatures received high praise
from a contemporary critic: "We cannot for-
bear expressing our admiration of some min-
iatures of exquisite beauty and finish, just
shown to us, executed by Capt. J. W. Sturgeon.
. . . He has only been in the city long enough
to complete a few specimens. . . . It will be dif-
ficult for ladies especially, in depicting whom
the artist is peculiarly felicitous, to withstand
the temptation to have their charms perpetu-
ated by his 'beauty-breathing pencil' " (*Morning
Courier* [New York], February 20, 1833). Little
else is known of Sturgeon except that in 1835
and 1836 he advertised in Charleston to paint
miniatures on ivory. At least two of his works
contain elaborate landscape backgrounds.

229. *Lady said to be Mrs. Sarah Talbot*

Watercolor on ivory, 2⁷⁄₁₆ x 2 in. (6.1 x 5 cm)
Casework: gold, with hinged lid (not shown),
 engine-turned front and back, engraved on lid:
 L Talbot [perhaps the sitter's husband]
EX COLLS.: with E. Grosvenor Paine, New Orleans;
 sale, Sotheby Parke-Bernet, New York, Jan. 29,
 1986, lot 214

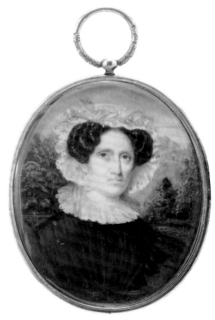

229

Nothing is known about the subject of this miniature. A Sally Talbot living in Fabius, Onondaga County, New York, is recorded in the census for 1830.

LAWRENCE SULLY

(1769–1804)

Lawrence Sully was born in Kilkenny, Ireland, to Matthew and Sarah Chester Sully, who were actors. The family moved to Horncastle, England, and later journeyed to America, settling for a while in Richmond, Virginia. Sully advertised as a "Miniature Painter (and Student of the Royal Academy, London). . . . Specimens of his art to be seen at Messrs. William & George Richardson's" (*The Virginia Gazette* [Richmond], September 26, 1792). The Richardsons, who were silversmiths, probably made the artist's miniature cases. Another advertisement announced that Sully's miniatures were "warranted never to fade" and offered his services for "all kinds of Mourning, Fancy and hair devices executed in the neatest manner" (*The Examiner* [Richmond], December 6, 1799).

In 1793 Sully was married to Sarah Annis of Annapolis. He continued to practice his profession in Richmond and also worked in Norfolk and Petersburg, Virginia, and Philadelphia. In 1795 he painted the finest of his known miniatures, a portrait of Patrick Henry (Mead Art Museum, Amherst, Massachusetts).

In 1799 Sully's brother THOMAS SULLY came to live with him and receive instruction in the painting of miniatures and memorial scenes. In 1801 Lawrence advertised a plan to open a drawing school in Richmond but soon thereafter took his household to Norfolk. Meanwhile Thomas quickly surpassed his older brother in artistic ability and, it seems, became the main support of Lawrence's family. Lawrence, increasingly in financial straits, returned to Richmond in 1803, seeking commissions. In 1804 Thomas was called to Richmond, where one story has it that Lawrence had been killed in a fight with some sailors. Thomas married his brother's widow in 1806.

Lawrence Sully's miniatures rarely rise above the level of the primitive. The treatment is linear, with little facial modeling and stiff, somewhat awkward body forms. Pale skin tones and light-colored backgrounds make for a blond tonality overall. Sully discreetly blended his signature into the hatching next to the subject's shoulder.

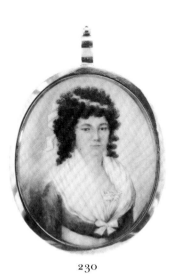

230

230. *Lady with the Initials P M*

Watercolor on ivory, 1⅞ x 1⁷⁄₁₆ in. (4.8 x 3.7 cm)
Casework: gilded copper; on the reverse, compartment containing ivory medallion with initials *P M* drawn in chopped hair and hair pigment
EX COLLS.: sale, Sotheby Parke-Bernet, New York, Dec. 16, 1982, lot 279; purchased from Edward Sheppard, New York

Colorplate page 31, b

231. *Edward C. Cunningham*

Watercolor on ivory, 2⁷⁄₁₆ x 2 in. (6.3 x 5.1 cm)
Signed center left: *Sully*
Casework: rose gold with burnished bezel; engraved on the reverse: *Edward C. Cunningham / 1750. / Katharine B. Craddock*
EXHIBITED: Randolph-Macon Art Gallery, Lynchburg, Virginia, 1954, *Eighteenth- and Nineteenth-Century American Paintings from Lynchburg*
EX COLLS.: Mrs. C. G. Craddock, Lynchburg, Virginia; with E. Grosvenor Paine, New Orleans; sale, Sotheby Parke-Bernet, New York, Jan. 29, 1986, lot 176

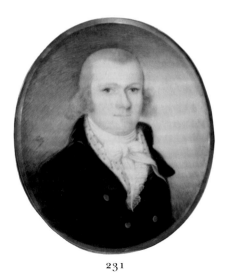

231

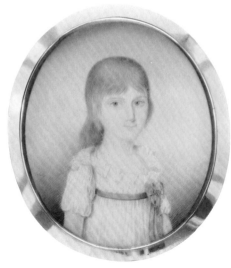

232

The date *1750* engraved on the case is probably an error.

232. *Miss Annis*

Watercolor on ivory, 2⁷⁄₁₆ x 1¹⁵⁄₁₆ in. (6.3 x 5 cm)
Signed lower left: *Sully*
Casework: gilded copper; fitted red leather case (not shown)
Label: *Signed miniature / of little Miss Annis / the artist's niece / by Lawrence Sully / oldest brother of / Thomas Sully / his teacher / gold frame*
Ex colls.: Harry Fromke, New York; sale, Christie's, New York, Oct. 18, 1986, lot 387

Colorplate 5a

Miss Annis was actually the younger sister of Lawrence Sully's wife, Sarah.

THOMAS SULLY

(1783–1872)

Thomas Sully was born in Horncastle, England; his parents were actors, and his older brother was LAWRENCE SULLY. In 1792 the family immigrated to Richmond, Virginia, and two years later settled in Charleston, South Carolina. Sully's school chum CHARLES FRASER introduced him to the art of miniature painting; his next instruction was from his brother-in-law

Jean Belzons (active 1794–1812), a French miniature painter, with whom he served an apprenticeship until the two men got into a fist fight. In September of 1799 Sully went to Richmond to study miniature painting with his brother, Lawrence, and in 1801 moved with him to Norfolk. In 1803 Sully began a record book in which he carefully documented his output of portraits and miniatures during his entire career (Historical Society of Pennsylvania, Philadelphia).

In 1801 Sully produced one of his first miniatures, of his father, Matthew Sully, which shows the strong influence of his brother; a few months later he painted the miniature *George Ott*, which is already markedly superior to Lawrence's work (for both miniatures, see Fabian, 1983 [in bibliography for T. Sully], p. 42). He described himself on the back as *T Sully, Miniature and Fancy Painter*.

In 1802 Thomas set out on his own to Petersburg, Virginia. When he received word of Lawrence's death, he returned to Richmond and assumed the responsibility for supporting his brother's family. In June 1806 he married Lawrence's widow, and the family moved successively to New York, Hartford, and Boston, where he met Gilbert Stuart, who gave him advice and informal instruction. Sully's friend Benjamin Chew Wilcocks persuaded Sully to move to Philadelphia, which remained his residence for the rest of his life. For a while he

shared a house and studio with BENJAMIN TROTT, who looked after Sully's family when he went to England in 1809 to resume his training.

Benjamin West advised Sully to study anatomy; Sir Thomas Lawrence became his friend and mentor. In England Sully evolved the brilliant, stylish approach that characterizes his mature work. On his return to Philadelphia in 1810 he quickly became the city's leading portraitist; by the 1830s he had come to be regarded as the finest portraitist in the country. Primarily a painter of full-size portraits, he also produced historical paintings, landscapes, "fancy" pictures, and occasionally miniatures. In 1842 he was offered the presidency of the Pennsylvania Academy of the Fine Arts, which he declined. His *Hints to Young Painters and the Process of Portrait Painting* was published posthumously in 1872.

Of the approximately sixty miniatures Sully produced, more than two-thirds were painted prior to 1806. These early miniatures show fine attention to detail, and the memorial scenes are superbly and elegantly rendered. Study in England transformed Sully's characteristic portraits to flattering, dashing, romantic likenesses, often bordering on sentimentality. His later miniatures are uneven in quality and vary from spontaneous sketches showing vigorous brushwork to tightly controlled works with a smooth, polished appearance.

233. *Alfred Sully*

ca. 1839
Watercolor on ivory, 2¾ x 2¾ in. (7 x 7 cm)
Casework: carved, gilded wood (partially shown)
RELATED WORK: This miniature is a copy after a full-size portrait painted in oil on wood panel which was made for Mrs. Sully in 1839 (private collection).
REFERENCE: Edward Biddle and Mantle Fielding, *The Life and Works of Thomas Sully (1783–1872)* (Philadelphia: Wickersham Press, 1921), no. 2063, p. 331
EXHIBITED: Pennsylvania Academy of the Fine Arts, Philadelphia, 1922, *Memorial Exhibition of Portraits by Thomas Sully*, no. 91, exh. cat. p. 60; Corcoran and Grand Central Art Galleries, New York, 1925–26, *Commemorative Exhibition of the National Academy of Design, 1825–1925*, no. 526, p. 17; Hirschl & Adler Galleries, New York, 1970, *Forty Masterworks of American Art*, no. 14b, exh. cat. p. 24
EX COLLS.: the subject's son, Dr. Albert Walter

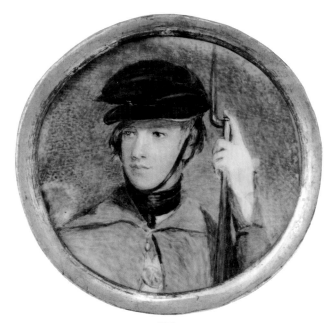

233

Sully, Brooklyn, New York; his wife, Mrs. Albert Walter Sully; purchased from Hirschl & Adler Galleries, New York, 1970

Colorplate 23a

Alfred Sully (1820–1879), the artist's son, enrolled at West Point in 1837 and graduated in 1841. He had a long and distinguished military career, serving in the Seminole, Mexican, Indian, and Civil wars. In 1863 he was made a brigadier general and commanded several expeditions against the Indians in the Northwest. He died at Fort Vancouver, Washington. An amateur watercolorist, he documented places and incidents related to his military service.

234. *Lady*

ca. 1843
Watercolor on ivory, 3¹⁄₁₆ x 2⁹⁄₁₆ in. (7.9 x 6.5 cm)
Casework: modern
Mounted on the reverse: a ticket to the Eighth Annual Exhibition of the Artists' Fund Society, Philadelphia, for April 3, 1843, made out to *Thos Sully Esq*
EX COLL.: purchased from Hirschl & Adler Galleries, New York

Of the portraits exhibited by Sully at the Artists' Fund Society in 1843, none is described as a miniature. Moreover, this painting appears to be unfinished—the head is tightly delineated,

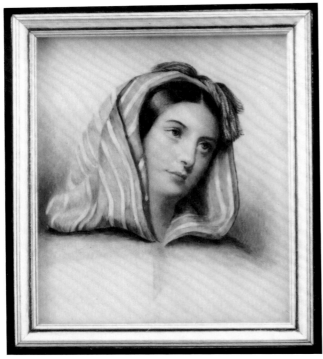

234

the rest of the figure only broadly outlined—and it is unlikely that Sully would have exhibited an unfinished miniature. Perhaps the ticket was used as a backing to the ivory. This miniature may be the one listed in Biddle and Fielding (see cat. no. 233) as "*Ruth,* Thomas Sully's conception of the Biblical character" (no. 2060), a description that fits no other known work.

Attributed to Thomas Sully

235. *Hannah P. Moore*

Watercolor on ivory, 1 15/16 x 1 5/8 in. (4.9 x 4 cm)
Casework: gilded copper with chased bezel and
 hanger; on the reverse, chased bezel framing
 compartment containing plaited hair
On paper backing inside case: *Hannah Moore /
 Grandmother Dillard's / Great Aunt*; on second
 paper backing: *Hannah P. Moore died / April 18
 1848. / Aged 36 years*
Ex COLLS.: descended in the Dillard family;
 purchased from Edward Sheppard, New York

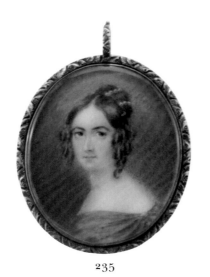

235

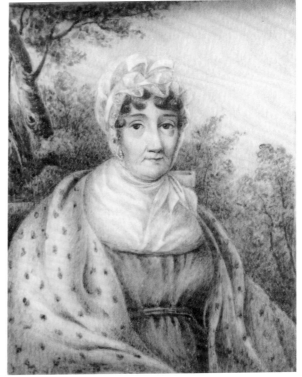

236

ANNE TEAKES

(active 1812–27)

Nothing is known about the life of Anne Teakes. The miniature of Mrs. Teakes, although decorative and colorful, is not the work of a professional miniaturist. The face is schematically modeled, and the summarily fashioned costume gives little sense of form. The painting of the background is somewhat more accomplished.

236. *Mrs. Teakes*

1812, 1827
Watercolor on ivory, 4 x 3 in. (10.2 x 7.5 cm)
Inscribed on palette card: *Mrs. Teakes the original face / taken in 1812 / the rest drawn in 1827 / by Anne Teakes*
Casework: hinged red leather with ormolu mat (not shown)
Ex colls.: with E. Grosvenor Paine, New Orleans; sale, Sotheby Parke-Bernet, New York, Jan. 29, 1986, lot 189

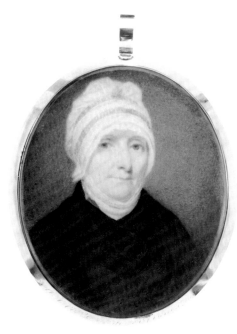

237

WILLIAM JOHN THOMSON

(1771–1845)

William John Thomson (or Thompson) was born in Savannah, Georgia, the son of a Scotch-American loyalist. As a child he was taken to London, where he learned to paint portraits and miniatures. He began exhibiting at the Royal Academy in 1795 and entered the Schools there in 1808. Thomson moved to his ancestral home in Edinburgh four years later and became a prominent figure in the artistic life of Scotland, holding a variety of official positions. He exhibited portraits, miniatures, landscapes, and genre paintings; in 1829 he was elected an academician of the Royal Scottish Academy. He died in Edinburgh.

Thomson worked in a solemn, realistic, somewhat simplified style, devoid of the affectation that often characterized the work of his Scottish contemporaries. His subjects face slightly to the right; their features are emphatically delineated, the left eye appearing overly large. A pink tonality suffuses the paintings, reddish-brown shading models the forms, and brown hatching often makes up the background. Thomson usually signed his works on the backing paper, also noting the date and the city.

237. *Lady said to be Mrs. George Smith*

1817
Watercolor on ivory, 2¹¹/₁₆ x 2¹/₁₆ in. (6.8 x 5.3 cm)
Inscribed on backing paper: *Painted by W J Thomson / Sept 1817 / Edinbu.*
Casework: gilded copper, with worn, illegible inscription on lower rim of case; on the reverse, engine-turned foil under opalescent glass and sheaf-of-wheat hair design with seed pearls
Ex coll.: sale, Sotheby Parke-Bernet, New York, July 17, 1984, lot 67/2

238. *Young Lady said to be Miss Smith*

1822
Watercolor on ivory, 2½ x 2 in. (6.4 x 5.2 cm)
Inscribed on backing paper: *Painted by W. Thomson / July 1822 / Edin.*
Casework: gilded copper
Ex coll.: sale, Sotheby Parke-Bernet, New York, July 17, 1984, lot 67/2

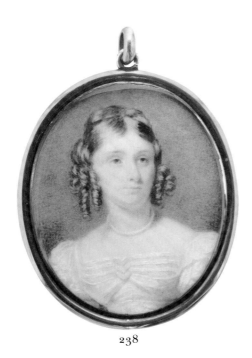

238

The subject is the daughter of Mrs. George Smith (see cat. no. 237).

239. *Gentleman*

Watercolor on ivory, 2⅜ x 1⅞ in. (6.1 x 4.8 cm)
Casework: gilded copper; on the reverse, central
 compartment containing plaited hair, with blue
 opalescent glass border
Ex coll.: purchased from Edward Sheppard, New
 York

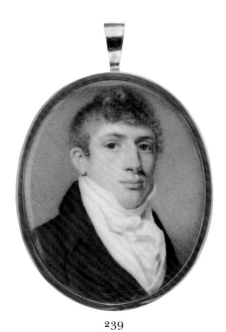

239

ELKANAH TISDALE

(1771–after 1834)

Elkanah Tisdale was born in Lebanon, Connecticut, where he probably had some training as a carriage painter in his father's wagon shop. He went to New York about 1794 and worked there as an engraver until 1798, when he began listing himself in the city directories as a miniature painter. That year he met BENJAMIN TROTT. Fleeing an epidemic of yellow fever, the two journeyed to Albany and there shared a studio. Tisdale soon returned and for some years divided his time between New York and Hartford, Connecticut. He listed himself as a miniature painter in the New York directories from 1809 to 1812. He worked in Boston in the years 1813–18.

Several of Tisdale's early paintings, including *The Battle of Lexington* and *The Triumph of Christianity*, were engraved by Cornelius Tiebout (1773–1832) of New York. Tisdale designed and engraved illustrations for the poet John Trumbull's *McFingal* (New York, 1795 edition). He was a founder of the Hartford Graphic and Bank Note Engraving Company, for which he designed vignettes.

An engraver and designer of modest ability, Tisdale was far better known for his works as a miniaturist. Wrote H. W. French in 1879: "Tisdale's finest work by far was in miniature portrait painting on ivory. . . . a portrait of Gen. Knox,—fully display[s] the touch of a master. The flesh-tints of the cheek, the fire in the eye, the waves of white hair, the life in the face of the florid old man, are remarkably fine" (H. W. French, *Art and Artists in Connecticut* [republished by Kennedy Graphics: New York, 1970], p. 38).

The few miniatures by Tisdale that are known reveal the influence of Trott. Tisdale's early oval miniature portraits, like Trott's, display a highly skilled use of the glowing ivory surface to create luminous skin tones and give life to the background. The complex crosshatching that models the face and the broad, dark cross-hatching in the background are also similar to Trott's. Early miniatures by Tisdale portray handsome people arranged in an elegant three-quarter pose. Later he adopted a

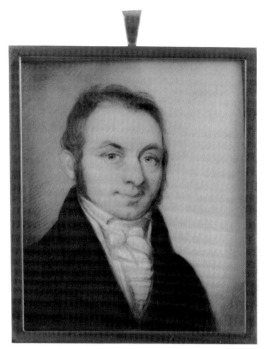

240

rectangular format and his technique became more exacting and precise, probably because of his work in engraving. In some miniatures there is a single source of strong light that creates dramatic contrasts.

240. *James Fowle Baldwin*

1817
Watercolor on ivory, 2¹⁵⁄₁₆ x 2⁵⁄₁₆ in. (7.5 x 5.9 cm)
Inscribed on backing paper: *James F. Baldwin Born / April 29 1782 / By E. Tisdale / Boston Decr 1817 / married July / 1818*
Casework: modern

First a Boston merchant and then an engineer, James Fowle Baldwin (1782–1862) helped direct the construction of a dry dock at the Charlestown navy yard. He was commissioned to make a survey for a railroad from Boston to Albany and later engineered the construction of the railroad between Boston and Lowell. During the years 1837–48 Baldwin devised and implemented a plan that ensured Boston's water supply. He was a Massachusetts state senator and was water commissioner of Suffolk County.

BENJAMIN TROTT

(ca. 1770–1843)

Benjamin Trott, one of this country's foremost miniature painters, was born in Boston. Where he was instructed is not known; according to his friend William Dunlap, Trott arrived in New York in 1793 having already "attained a great portion of skill" (all Dunlap quotations for Trott: 1834, vol. 1, pp. 414, 415, 430).

Trott attracted the attention of Gilbert Stuart (1755–1828), who had recently returned from Dublin in the company of WALTER ROBERTSON. A few months later Stuart left New York for Philadelphia, accompanied by Trott. When Stuart painted his first portrait of Washington, Trott made a miniature copy after it (unlocated) which was engraved at least five times. Stuart called Trott the best and closest of his imitators; Trott made many copies after the master. Dunlap observed that Stuart "assisted [Trott] by advice, and recommended him. Trott's blunt and caustic manner was probably to Stuart's taste."

Trott's irrational jealousy and his eccentric nature have been well documented. When Robertson and ROBERT FIELD were also in Philadelphia, wrote Dunlap, "Field and Robertson both annoyed Trott. Of Robertson [Trott claimed that] his excellence depended upon the secret he possessed—the chemical composition with which he mixed and used his colours; of Field, that his work was too much like engraving."

In 1797 Trott returned to New York, then retreated to Albany because of a yellow fever epidemic, moved back to New York in 1799, and by 1804 was in Philadelphia again. The following year he packed up the tools of his trade and traveled on horseback through western Pennsylvania, Kentucky, and Ohio, a journey that proved financially successful. He returned to Philadelphia once more in 1806, listing himself in the city directory there every year but one until 1820. Dunlap recorded that in 1806 he himself "became somewhat intimate with Trott and pleased with the pungency of his remarks and amused by the eccentricity of his manners. At this time his reputation was at its height . . . by his distillations and filterings

he produced some of the cleanest pigments that I ever used; and he bestowed upon me specimens of all the necessary colours for miniature." Trott was less generous when he met EDWARD GREENE MALBONE, who proposed that they exchange examples of their work; "the fame of the young painter annoyed Trott," wrote Dunlap, and he refused. In 1809 Trott shared a house and studio with THOMAS SULLY.

Trott became a member of the Society of Artists and contributed to their exhibitions at the Pennsylvania Academy of the Fine Arts from 1811 to 1814. In 1812 a critic signing himself *G. M.* praised Trott's miniatures for possessing "all the force and effort of the best oil painting . . . and the . . . likeness, dignity of character, expression and harmony of coloring . . . approach nearer to the exquisite productions of Stuart, than those of any other artist in America" (*Portfolio*, July 1812; quoted in Bolton, 1944 [see bibliography for Trott], p. 267).

In 1819 Trott traveled south to Norfolk and Charleston. On his return to Philadelphia he married precipitously and imprudently. In 1823 he settled in Newark, New Jersey, where he obtained a divorce and lived in relative obscurity until about 1829. As the vogue shifted from light-colored, translucent miniatures toward opaquely painted ones, Trott's work had fallen out of favor. He moved to New York, avoiding Philadelphia, where he felt he had lost his public. In 1833 he was in Boston. Trott moved to Baltimore in 1839, writing to a friend, A. Woolcot: "I am at present busy painting in miniature how long it may last I can't tell so far I have been frustrated in giving sattisfaction to the few I have painted who are of the *right kind*. I have had many difficulties to encounter besides ill health and the want of money" (January 2, 1839; correspondence in Gratz Collection, Historical Society of Pennsylvania). He died in Washington, D.C.

Trott's early copies in miniature after Stuart, such as the portrait *Joseph Anthony Jr.* (Yale University Art Gallery, New Haven), reveal his initial indebtedness to his rival, Robertson, as well: backgrounds are dark and densely hatched on the diagonal, and the treatment is labored. As his own style began to develop, the background hatching diminished and the heads of his subjects became large and angular.

Trott's work is often criticized for its unevenness, but the miniatures from the period about 1800–1825 are generally finely executed and consistent in style. His technique had rapidly matured into an assured, dashing, fluid brushwork applied in natural, clear colors. Backgrounds with a sky motif were created by floating on thin washes of white and blue and leaving large areas of the pure ivory unpainted. Hatching was confined to the areas on either side of the shoulders. Trott posed his sitters elegantly and usually similarly, with body turned to the left and an almost full face making arresting eye contact with the viewer. Subjects have elongated necks and wear coats with extremely high collars. The coats are rendered with broad washes; the jabots are painted with bold, rapid strokes that heighten the portraits' immediacy. Traces of the preparatory drawing can often be seen. Shadows are articulated in blue around the eyes, nose, and mouth. Men, their hair frequently brushed forward in the *coup de vent* style, at times appear disheveled— even rakish.

For likenesses of women, Trott continued to employ on occasion a dark, hatched background. His late works were undistinguished because of changes in fashion and the effects of his diminished circumstances. Trott rarely signed his miniatures.

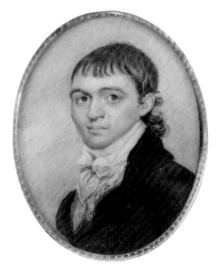

241

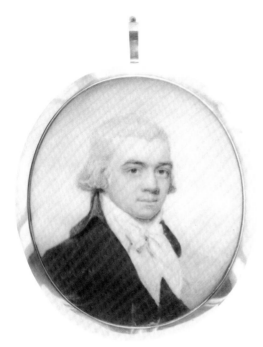

242

REFERENCE: Theodore Bolton and Ruel P. Tolman, "A Catalogue of Miniatures by or Attributed to Benjamin Trott," *Art Quarterly* 7 (Autumn 1944), p. 279, no. 9
EX COLLS.: Russell W. Thorpe, New York, 1944; with C. W. Lyon, New York; Norvin H. Green, Tuxedo Park, New York; sale, Parke-Bernet, New York, Nov. 30, 1950, lot 228, as *Portrait of a Gentleman*; Harry Fromke, New York; sale, Christie's, New York, Oct. 18, 1986, lot 391

Colorplate 8c

When this miniature was sold in 1950 its subject was listed as unknown, but in 1944 Russell W. Thorpe, a previous owner, had identified the sitter as Alexander Henry Durdin and had presented a photograph of the miniature to the Frick Art Reference Library in New York. Nonetheless, the portrait was sold again in 1986 as unidentified.

241. *Gentleman*

Watercolor on ivory, 2⁹⁄₁₆ x 1⅞ in. (6.4 x 4.8 cm)
Casework: gilded copper burnished bezel with brightwork fillet; fitted red leather case (not shown)
EX COLL.: sale, C. G. Sloan & Co., Inc., Washington, D.C., Sept. 23, 1979, lot 2139, as attributed to Charles Fraser

The subject's head is treated as an angular form; the background is nearly covered with diagonal hatches. This is one of Trott's earliest known works.

242. *Gentleman*

Watercolor on ivory, 2¹¹⁄₁₆ x 2³⁄₁₆ in. (6.8 x 5.6 cm)
Casework: gilded copper with plain bezel; fitted red leather case (not shown)

This miniature typifies Trott's painting style during his years in Philadelphia prior to 1800. The subject is placed low on the ivory and closer to the picture plane than in later works. The background is hatched without any suggestion of sky, but Trott is beginning to use the light ivory surface for a background.

243. *Alexander Henry Durdin*

Watercolor on ivory, 3 x 2⅜ in. (7.6 x 6.1 cm)
Casework: gold double-sided locket with burnished bezel; on the reverse, plaited hair

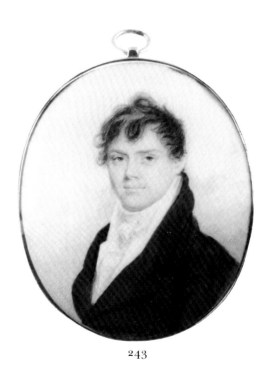

243

244. *Benjamin Chew Wilcocks*

Watercolor on ivory, 3½ x 2¹¹⁄₁₆ in. (8.9 x 6.8 cm)
Casework: modern (not shown)
Label on back of frame: identifying previous owners, exhibitions, and references
RELATED WORKS: Trott painted at least three miniatures of Benjamin Chew Wilcocks shortly

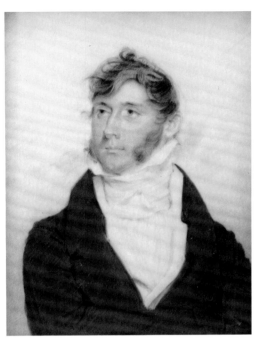

244

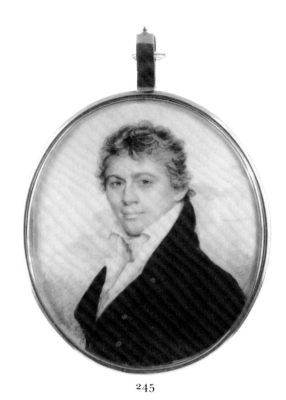

245

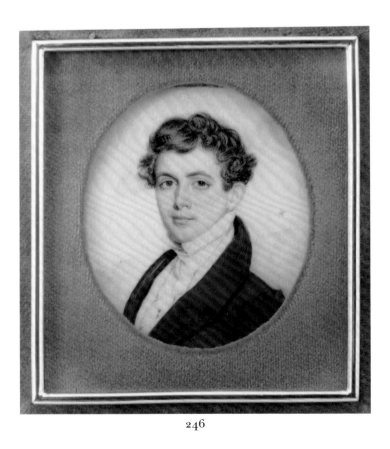

246

before 1812, including this miniature, a similar one at the Winterthur Museum (Winterthur, Delaware), and another variation in the Metropolitan Museum. All three descended to Wilcocks's granddaughter, Mrs. Campbell Madeira, and her niece, Mrs. B. B. Reath, before being dispersed to different owners. One of them was exhibited in 1812 in Philadelphia at the Pennsylvania Academy.

REFERENCES: Bernard H. Cone, "Benjamin Trott—Yankee Miniature Painter," *American Collector* 9 (October 1940), p. 9, ill. p. 8; Bolton and Tolman (as for cat. no. 243), p. 284, no. 40

EXHIBITED: Pennsylvania Academy of the Fine Arts, Philadelphia, 1926, as by Malbone; MMA, 1927; New-York Historical Society, 1934

EX COLLS.: the subject's granddaughter, Mrs. Campbell Madeira, Philadelphia; her niece, Mrs. B. B. Reath, Merion, Pennsylvania; Edmund Bury, Philadelphia, 1932; Erskine Hewitt; sale, Parke-Bernet, New York, Oct. 18, 1938, lot 1036; estate of Norvin H. Green, Tuxedo Park, New York; sale, Parke-Bernet, New York, Oct. 14, 1955, lot 241; Harry Fromke, New York; sale, Christie's, New York, Oct. 18, 1986, lot 379

Colorplate 8d

Benjamin Chew Wilcocks (1776–1845) was the grandson of Benjamin Chew, the chief justice of Pennsylvania and a friend of George Washington. Wilcocks, a Philadelphia merchant, married Sally Waln, whose miniature was also painted by Trott (R. W. Norton Museum, Shreveport, Louisiana). He was a patron of the arts and a friend of THOMAS SULLY; he later named his son Thomas Sully Wilcocks. At Wilcocks's suggestion, Sully settled in Philadelphia in 1809 and shared a house with Trott for two years. During those years Trott painted the three miniatures of Wilcocks.

245. *George Wood*

Watercolor on ivory, 2⅞ x 2⅜ in. (7.3 x 6 cm)
Inscribed on the backing paper: *George Wood / Born 29th day / of 11 mo 1753*
Casework: modern
EX COLLS.: Harry Fromke, New York; sale, Christie's, New York, Oct. 18, 1986, lot 411

The miniature was painted about 1815. The birth date inscribed on the backing paper must be incorrect, since in his portrait Wood appears to be a young man in his twenties.

246. *Charles Wagner*

Watercolor on ivory, 2¹³⁄₁₆ x 2³⁄₁₆ in. (7.1 x 5.5 cm)
Casework: modern
Label: identifying the subject
REFERENCE: Bolton and Tolman (as for cat no. 243), p. 283, no. 36
EX COLLS.: Harry Fromke, New York; sale, Christie's, New York, Oct. 18, 1986, lot 410

Charles Wagner was a lawyer from Philadelphia and a diplomat during Andrew Jackson's presidency. He married a Miss Stokes.

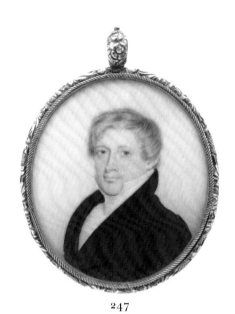

247

247. *Gentleman said to be George Harrison*

Watercolor on ivory, 2³⁄₁₆ x 1¹³⁄₁₆ in. (5.6 x 4.6 cm)
Casework: gilded copper with cast bezel and hanger; on the reverse, cast bezel framing compartment containing a lock of hair
EX COLLS.: with E. Grosvenor Paine, New Orleans; sale, Sotheby Parke-Bernet, New York, Jan. 29, 1986, lot 178; purchased from Edward Sheppard, New York

This miniature was attributed to ANNE HALL at the time of its purchase in 1986, but it is much closer, in pose and in technique, to the late work of Trott.

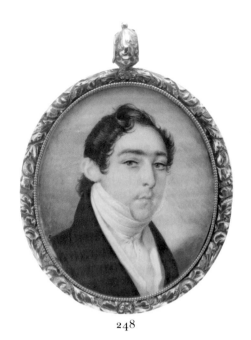

248

Attributed to Benjamin Trott

248. *Gentleman*

Watercolor on ivory, 2⁵⁄₁₆ x 1⁷⁄₈ in. (5.9 x 4.8 cm)
Inscribed on backing paper in graphite: *Benjamin Trott*
Casework: gilded copper with chased bezel and hanger; on the reverse, chased bezel framing compartment for hair; fitted red leather case (not shown)
Ex coll.: purchased from Edward Sheppard, New York

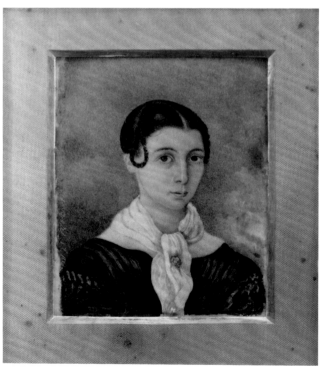

249

LEOPOLD PAUL UNGER

(1812–1859)

Leopold Paul Unger was born in Königsberg, East Prussia. He came to the United States in 1838, stopping first in Brazil. In 1839 he moved to Allentown, Pennsylvania, where he married Mary Hart. Unger established a portrait- and miniature-painting business in Allentown, but also traveled about taking likenesses in Pennsylvania and Virginia and is known to have painted in New Orleans. He may have worked briefly in New York City.

Unger's miniatures, painted in a hard, linear style, show some affinities to folk art. The subjects' heads are distinctively shaped ovals with pointed chins, large, round, outlined eyes, small, oddly shaped mouths, and tiny ears. The backgrounds are usually opaque gray, although some are mottled and lighter in color. Only a few are signed or carry backing-paper inscriptions.

249. *Charlotte Allard*

1840
Watercolor on ivory, 2¾ x 2¼ in. (7.1 x 5.8 cm)
Signed and dated along left edge: *Unger 1840* [perhaps added later]; inscribed on backing card: *Charlotte Allard / Nw Orleans / 1840*
Casework: hinged leather with ormolu mat (partially shown)

The 1840 census for Louisiana lists a Celina Allard living in New Orleans, but no Charlotte Allard.

Attributed to Leopold Paul Unger

250. *Lady with a Letter*

Watercolor on ivory, 2¾ x 2¼ in. (7 x 5.7 cm)
Casework: chased gold bezel in hinged, velvet-lined tortoiseshell case (partially shown)
Ex coll.: purchased from Marguerite Riordan, Stonington, Connecticut

Colorplate 26c

ARAMENTA DIANTHE VAIL

(active 1837–63)

Aramenta Vail lived in Newark, New Jersey, during 1837–38 and in New York City from 1839 to 1863. She exhibited miniatures at the National Academy of Design in 1838, 1841, and 1847, the Apollo Association in 1839, the American Institute in 1845, and the Brooklyn Art Association in 1863. She listed herself in the city directories as "miniature painter" until 1858; thereafter she is listed until 1863 as a "seller of fancy goods."

The miniature shown here is the only known example of Aramenta Vail's work. Some elements of the painting suggest self-instruction (the proportions of the figure, the drawing of the hands and balustrade); but the child's face and the dog are rendered with psychological acumen and considerable skill. The subject's eyes establish mesmerizing contact with the viewer. Flesh and clothing are painted with a smooth wash, while parts of the background are broadly hatched. The artist displays a pleasing sense of composition and an ability to render meticulous details of lace and jewelry.

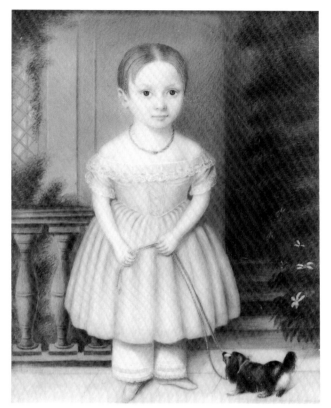

251

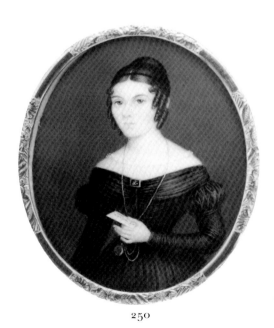

250

251. *Rebecca Fanshaw*

1843
Watercolor on ivory, 4¼ x 3⅛ in. (10.7 x 8 cm); shown reduced
Inscribed on backing paper: *A D Vail / Artist / 449 Broadway / 1843*
Casework: modern (not shown)
Label on back of frame: *One primitive painting / on ivory of / Rebecca Fanshaw, age 4 / artist: A. D. Vail / 449 Broadway / New York City / dated: 1843*
Ex COLLS.: descended in the subject's family; sale, Sotheby Parke-Bernet, New York, June 30, 1984, lot 178; purchased from Edward Sheppard, New York

Colorplate 31

Rebecca Fanshaw was probably the daughter of Charles Fanshaw, the only Fanshaw listed in the New York census at that time.

JAMES VAN DYCK

(active 1825–43)

A portrait painter in oil, pastel, and miniature, James Van Dyck may have been the son of James and Sophia and grandson of Jacobus Van Dyck, who was born in New York in 1792. The earliest known works by Van Dyck are pastel portraits on paper of Mr. and Mrs. Robert Chambers that were executed in 1825 (coll. A. Chambers Oliphant). Close to the same time, he made pastels of the Beekman family. Van Dyck painted miniature copies after works by his friend HENRY INMAN, who probably taught him the art of miniature painting. Van Dyck listed himself as a miniature painter in the New York directories intermittently between 1834 and 1844. He exhibited miniatures at the American Academy of Fine Arts in 1835 and at the National Academy of Design in 1838, where he also showed an oil portrait of Aaron Burr in 1843. He may be the Captain James C. Van Dyck who died in 1843 in New Brunswick, New Jersey, while he was waiting for a coach to Princeton.[1]

The few known miniature portraits by Van Dyck reveal certain idiosyncrasies. Frequently one eyelid droops, and the eyes do not seem to be looking in the same direction. In some cases the nose appears to be painted from the side, although the face is seen almost frontally. Disproportionately small bodies are held proudly erect. Cravats are rendered formulaically; backgrounds are broadly stippled and often dark brown. The artist usually signed his miniatures along the right edge: *Vandyck pinxt.*

1. Much of the information about this obscure artist's life was supplied by Professor William C. Watterson of Bowdoin College, Brunswick, Maine.

252. *Aaron Burr*

1834
Signed and dated along right edge: *I.V. 34*
Watercolor on ivory, 2 5/16 x 1 13/16 in. (5.9 x 4.6 cm)
Casework: gilded copper with chased bezel and hanger; on the reverse, chased bezel framing hair compartment
EX COLLS.: Mrs. J. Owens, New Jersey, 1979; sale, Sotheby Parke-Bernet, New York, Dec. 5, 1979, lot 684

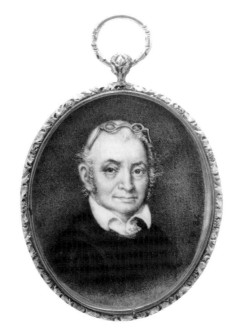

252

Aaron Burr (1756–1836), the politician and statesman, was born in Newark, New Jersey. He served as a United States senator from New York between 1791 and 1797 and was vice president of the United States from 1801 to 1805. In 1804 Burr killed Alexander Hamilton in a duel. He was tried for treason in 1807; the charge was conspiring in a scheme to seize Texas and Mexico, with the intention of becoming president of a newly formed republic in the Southwest. However, he was acquitted. Shunned by society, Burr spent his last years practicing law in New York. At the age of seventy-eight he married an heiress, Madame Eliza Bowen Jumel, but his reckless spending of her fortune caused their separation. He died in Port Richmond, Staten Island.

Van Dyck made several versions of his portrait of Aaron Burr: an original oil on canvas painted in 1834, a cabinet-size oil on panel, and at least two miniatures on ivory. He exhibited the original at the National Academy of Design in 1843, offering it for sale. The portrait was painted the year of Burr's short-lived marriage to Madame Jumel; perhaps it was never paid for because of their separation and for that reason remained in the artist's possession.

Attributed to James Van Dyck

253. *Gentleman*

Watercolor on ivory, 2⅜ x 2 in. (6.1 x 5 cm)
Casework: gilded copper with chased bezel and
 hanger; on the reverse, chased bezel framing
 compartment containing a lock of hair
Ex COLL.: sale, Sotheby Parke-Bernet, New York,
 July 17, 1984, lot 66

Although unsigned, this miniature appears, on
the basis of the unique treatment of the eyes
and nose, to be an early work by James Van
Dyck. Instead of his typical brown stippled
background the artist has set the figure against
a charming river scene. Pink and red tones are
emphasized in the hair, stickpin, trees, and
clouds.

Attributed to James Van Dyck

254. *Gentleman*

Watercolor on ivory, 2⅜ x 1⅞ in. (6 x 4.7 cm)
Casework: gilded copper with chased bezel

254

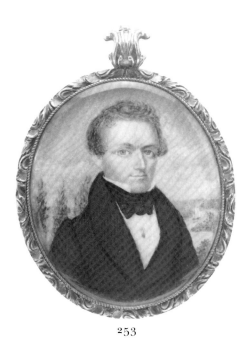

253

WILLIAM VERSTILLE

(1757–1803)

William Verstille was born in Boston, where his
father was a merchant; the family moved to
Wethersfield, Connecticut, in 1761. Verstille
early on developed an interest in art, and later,
when he played an active part in the American
Revolution, he found time to paint miniatures
of a number of the officers. In 1780 he married
Eliza Sheldon and moved to East Windsor,
Connecticut, where five of their six children
were born. Apparently Verstille could not find
enough work in Connecticut in the 1780s. He
worked in Philadelphia during 1782–83 and in
New York City in 1784 and 1787–90; for the
latter period he kept an account book record-
ing the commissions not only for miniatures
but also for hairwork, mourning pieces, and
many different forms of jewelry (see "Accounts
of William Verstille" in bibliography for Ver-
stille, pp. 25–31).

During his years in New York Verstille
clearly took notice of the work of JOHN RAMAGE,
then the city's leading miniaturist. Verstille's
miniatures from that time are so like Ramage's
in size, coloring, pose of subject, and format
that they are often mistaken for each other.

Additionally, many of the distinctive gold cases housing Verstille's miniatures are very close to the ones Ramage made for his own works (although not quite as finely crafted as Ramage's), making it tempting to conclude that Verstille apprenticed under Ramage—or at the very least copied some of Ramage's pieces which he borrowed or owned.

Verstille was able to work closer to home in the 1790s; he traveled through Connecticut and southern Massachusetts, painting miniatures. Many of them are in Hartford in the collection of the Wadsworth Athenaeum. At least once he was asked to rework a miniature by another artist, since a Dr. Bentley wrote in his diary: "My miniature was by [John] Hazlitt, now celebrated in London. The dress was changed by Verstille from Connecticut" ("Accounts of William Verstille," p. 23). In 1802 Verstille was in Salem, Massachusetts, advertising that he would soon be leaving town. While in Salem he painted a number of portraits of sea captains, setting each against a charming seascape background that often included a ship, a lighthouse, and perhaps a rowboat. A number of his works from throughout his career are in the collections of the Peabody Museum and the Essex Institute in Salem. Verstille died in Boston.

Verstille's miniatures do not in fact merit confusion with Ramage's, since they are quite distinctive. His brushwork has a sketchy quality, with thin, wavering lines. Modeling, which is minimal, is effected by a blue or gray hatch. Verstille tends to portray his subjects with large, piercing, dark eyes, thin brows set too close to the eyes, a long, somewhat crooked nose, thin, slightly mispositioned lips that occasionally curl at the corners, and bristly hair. The backgrounds are frequently blue or gray, thickly painted and shaded with long, vertical, gray hatches; on later examples they are often light, shaded with blue. Details of costume are charmingly decorative but are not rendered with the precision of Ramage. The signature *Verstille* is often placed beside the subject's shoulder, half hidden by shading.

 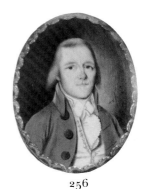

255 256

255. *Frederick Kuhl*

Watercolor on ivory, 1⅝ x 1¼ in. (4.1 x 3.1 cm)
Casework: vermeil (gilded silver), mounted as a brooch and locket (partially shown)
Inscribed in graphite on tag: *Frederick Kuhl (elder) / brother Thomas Kuhl*
Ex COLL.: purchased from Edward Sheppard, New York

256. *Gentleman*

Watercolor on ivory, 1⅝ x 1³⁄₁₆ in. (4.1 x 3.1 cm)
Signed lower right: *W V. pinxt.*
Casework: gold scalloped fillet with brightwork, mounted as a brooch
Ex COLL.: purchased from Edward Sheppard, New York

257. *Lieutenant Colonel Elias Parker*

Watercolor on ivory, 1⅜ x 1³⁄₁₆ in. (3.6 x 3 cm)
Casework: gold with burnished bezel, with slide mounts for a bracelet converted to a brooch (not shown); on the reverse, engraved: *Elias Parker / Lieutenant Colonel / in the / Revolutionary Army / died Dec. 8th. 1798. / aged 39 years*
Ex COLLS.: with C. W. Lyon, Inc., New York; sale, Parke-Bernet, New York, Jan. 13, 1949, lot 231, as attributed to Ramage; Harry Fromke, New York; sale, Christie's, Oct. 18, 1986, lot 377; purchased from Edward Sheppard, New York

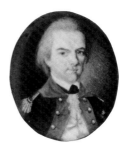

257

258. *Elderly Gentleman*

Watercolor on ivory, 2¼ x 1¹³⁄₁₆ in. (5.8 x 4.6 cm)
Signed lower left: *Verstille*
Casework: gold
Ex COLL.: with E. Grosvenor Paine, New Orleans,
 Sept. 1981; purchased from Edward Sheppard,
 New York

Colorplate 7d

259. *Mrs. Anstis Stone*

ca. 1802
Watercolor on ivory, 1⅞ x 1⁹⁄₁₆ in. (4.8 x 4 cm)
Signed lower right: *Verstille*
Casework: gold with burnished bezel, mounted as a
 locket and a brooch, with fitted red leather case
 (not shown)
Label: *Mrs. Anstis / Stone / Salem, Mass. / c. 1802 / by
 Wm. Verstile*
Ex COLL.: purchased from Edward Sheppard, New
 York

260. *Mrs. Joseph White* (Elizabeth Stone)

Watercolor on ivory, 2³⁄₁₆ x 1¹¹⁄₁₆ in. (5.6 x 4.2 cm)
Signed lower right: *Verstille*
Casework: gold with chased bezel; on the reverse,
 compartment containing hair of three colors,
 plaited; with fitted red leather case (not shown)
Label: *Mrs. Joseph / White (Eliz- / abeth Stone) / Salem,
 Mass. / by William / Verstile*
Ex COLL.: purchased from Edward Sheppard, New
 York

Colorplate 7e

The subjects of catalogue nos. 259 and 260 are
probably sisters-in-law.

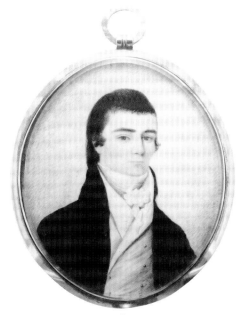

261

261. *T. Matthew Pratt*

ca. 1790
Watercolor on ivory, 2⁹⁄₁₆ x 2¹⁄₁₆ in. (6.5 x 5.2 cm)
Casework: gold plated with plain bezel; on the
 reverse, plain bezel framing compartment
 containing ivory oval with the initials *T M P*
 drawn in chopped hair and hair pigment
Label: *William Verstille / c. 1790 / sitter—Matthew
 Pratt / of Braintree County / Mass.*
Ex COLLS.: with E. Grosvenor Paine, New Orleans;
 purchased from Edward Sheppard, New York

T. Matthew Pratt (1766–1819) was born in
Braintree County, Massachusetts. He was mar-
ried to Mary Niles in 1784, to Elizabeth Brown
in 1803, and to Mrs. Polly Burrage in 1818.

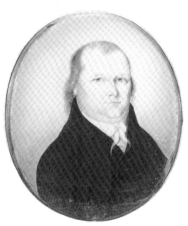

258

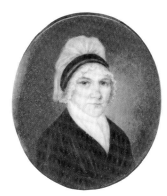

259

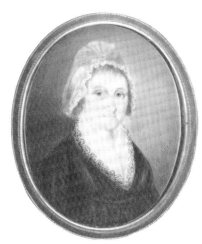

260

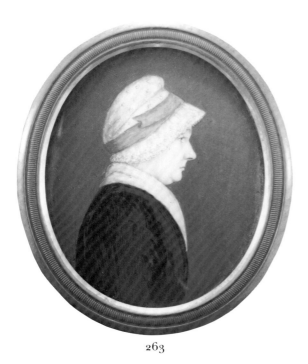

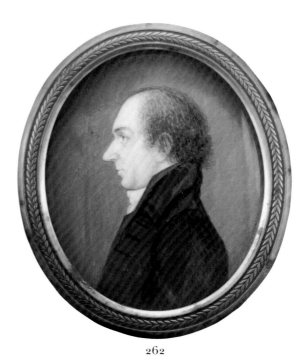

263

262

SAMUEL WALLIN

(active 1820–58)

Samuel Wallin (or sometimes, Walling), who worked in New York City, was chiefly an engraver and illustrator. He exhibited three drawings at the National Academy of Design in 1845. Most of his illustrations were portraits made by wood engraving; he engraved illustrations for *The Parthenon* (1851) and drew all the heads in the *Illustrated American Biography*, vol. 2, by A. D. Jones (New York: J. Milton Emerson & Co., 1854). Many of his portraits were based on daguerreotypes. His son, Samuel Wallin, Jr., was also an engraver in New York.

No documented miniatures by this artist are known. The attribution of these works to Wallin rests primarily on the inscription and on the fact that he was a portraitist.

Attributed to Samuel Wallin

262. *David Howe*

Watercolor on ivory, 2^{13}⁄₁₆ x 2¼ in. (7.2 x 5.8 cm)
Inscribed in graphite on back of frame: *Walling*
Casework: black lacquered pressed board with

gilded metal bezel with leaf design and acorn-and-leaf hanger (partially shown)
Inscribed on paper backing of frame: *David Howe / of / Castine / Maine / 1759–1828*

David Howe (1759–1828), a Boston silversmith, moved in 1795 to Castine, Maine. He served as postmaster and as a United States marshal, and for many years he held a commission in the militia. He married Margaret Summer in 1780; after her death in 1807, he married Sarah Whitney.

Catalogue nos. 262 and 263 are companion pieces.

Attributed to Samuel Wallin

263. *Sally Whitney Howe*

Watercolor on ivory, 2^{13}⁄₁₆ x 2¼ in. (7.2 x 5.8 cm)
Casework: black lacquered pressed board with fluted, gilded metal bezel and rosebud-and-thistle hanger (partially shown)
Inscribed on paper backing of frame: *Sally Whitney / Howe / Wife of David Howe / of / Castine—Maine / 1776–1857*

Sarah Whitney (1776–1857), the daughter of Samuel and Abigail Whitney, married David Howe and with him had four children.

WILLIAM WARNER, JR.

(ca. 1813–1848)

Little is known about William Warner, Jr. He was born in Philadelphia and may have learned the arts of miniature painting and engraving from Bass Otis (1784–1861), who worked in Philadelphia as a portraitist from 1812 to 1845. Warner exhibited a miniature after a work by Otis at the Artists' Fund Society in 1836; he continued to exhibit there and at the Pennsylvania Academy of the Fine Arts until 1848 and at the Apollo Association in 1838–39, showing landscapes, miniatures, portraits, and, a critic wrote, "very beautiful fancy portraits." Warner was also a mezzotint engraver; although he made few plates, the larger ones, according to contemporary sources, were of high quality.

264. *Gentleman*

1836
Watercolor on ivory, 2½ x 2 in. (6.4 x 5.2 cm)
Inscribed on backing paper: *W Warner Jr /
 Philadelphia / 1836*
Casework: gilded copper with chased bezel and
 hanger; on the reverse, chased bezel framing
 hair compartment

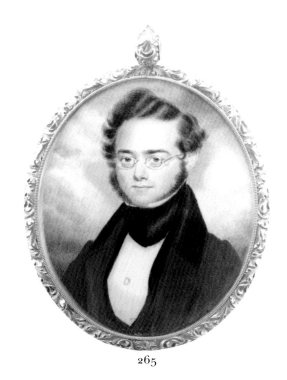

265

WILLIAM A. WATKINS

(active ca. 1825–67)

William A. Watkins was born in England and came to this country with his family about 1825. He settled in Steubenville, Ohio, where, it is said, he was unexcelled in miniature painting. He traveled seeking commissions, and was painting in nearby Pittsburgh in 1834. In 1840 Watkins moved to Cincinnati, where he is listed sporadically in the city directories between 1840 and 1867, with his occupation described as, variously, clerk, miniature painter, distillery worker, and medicine salesman.

265. *L. P. Church*

1834
Watercolor on ivory, 2¹³⁄₁₆ x 2¼ in. (7.2 x 5.7 cm)
Inscribed on backing paper: *Executed by W. A.
 Watkins / Pittsburgh / Feby 1834 / for / L. P. Church
 who at / that time enjoyed / verry good health*
Casework: gilded copper with chased bezel and
 hanger; on the reverse, compartment
 containing braided hair; engraved inside:
 Providence [perhaps Providence, Kentucky] *1833
 / Manufactured by Wm H Hopkins*
Ex COLLS.: with E. Grosvenor Paine, New Orleans;

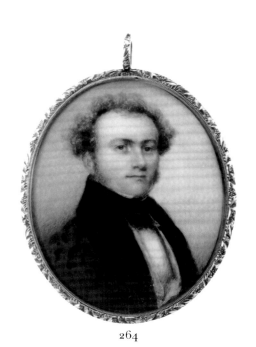

264

sale, Sotheby Parke-Bernet, New York, Jan. 29, 1986, lot 126

Colorplate 22c

An unusually brilliant blue sky fills the background. Whimsical and a little naive in presentation, the portrait is nonetheless skillfully painted.

ALFRED S. WAUGH

(ca. 1810–1856)

An itinerant sculptor, portrait and miniature painter, profile maker, writer, and lecturer, Alfred Waugh was a native of ·Ireland. He studied sculpture in Dublin in 1827 and toured the Continent before coming to the United States. He was working in Baltimore in 1833, Raleigh in 1838, various parts of Alabama in 1842, and Pensacola in 1843. He painted a miniature of John C. Calhoun in Mobile in 1844. Waugh joined forces with a young artist, John B. Tisdale (ca. 1822–ca. 1885), in making colored profile portraits; the two took a studio in New Orleans for five months but were barely able to cover their expenses. They traveled north to St. Louis, hoping to join John Charles Fremont's expedition to the Rocky Mountains as recording artists, but their petition was not accepted. Next they traveled through Missouri, taking profiles and painting miniatures in Jefferson City, Independence, and Lexington. When Tisdale joined the Missouri Mounted Volunteers in 1846, Waugh went to Santa Fe and then to Boonville, Missouri, for a year before settling permanently in St. Louis in 1848. He spent his time sculpting, lecturing, and writing articles about art. His autobiography, *Travels in Search of the Elephant: The Wanderings of Alfred S. Waugh, Artist in Louisiana, Missouri, and Santa Fe, in 1845–1846*, of which only the first part survives, was published almost one hundred years after his death (edited by John F. McDermott [St. Louis: Missouri Historical Society, 1951]).

Waugh's known works portray gentlemen, each posed slightly left of center against a gray

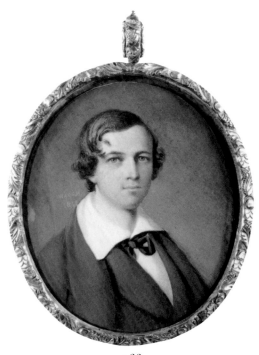

266

stippled background, and are signed and dated on the left, above the subject's shoulder.

266. *Gentleman said to be William Wallace Wiley Wood*

1841
Watercolor on ivory, 2¾ x 2³⁄₁₆ in. (7 x 5.6 cm)
Signed and dated left: *Waugh. / 1841*
Casework: gilded copper with chased bezel and hanger; on the reverse, chased bezel framing compartment containing a lock of hair
Ex colls.: sale, Adam A. Weschler & Son, Washington, D.C., Oct. 30, 1970; with E. Grosvenor Paine, New Orleans; sale, Sotheby Parke-Bernet, New York, Jan. 29, 1986, lot 180

CARL WEINEDEL

(1795–1845)

All that is known of the life of the miniaturist Carl Weinedel has been gleaned from advertisements, notices of exhibitions, and city directories. At age twenty-four he advertised his craft in Leesburg, Virginia, offering to paint families at their city or country homes. He was working in Alexandria, Fredericksburg, and

Richmond, Virginia, during the 1820s and in Augusta, Georgia, and Columbia, South Carolina, between 1829 and 1832; he traveled north by way of Richmond in 1833, arriving in New York City the following year. There he was fully employed carrying out commissions to paint miniatures. He exhibited annually from 1834 to 1844 at the National Academy of Design and was elected an associate in 1839.

Weinedel's works are distinctive by virtue of their extreme realism. The faces are strongly lit; soft modeling, carried out in a broad stipple using gray pigment, skillfully reveals their contours. The hair is painted with a wash that has been incised with a needle to create highlights and define details. The miniatures are strongly composed, with boldly contrasting light and dark areas. The backgrounds are hatched in blue or green, becoming lighter on the right side. Works are usually signed along the left edge with the artist's last name and the date.

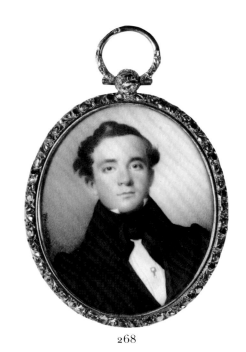

268

267. *Mrs. E. Hunt*

1829
Watercolor on ivory, 2⁵⁄₁₆ x 1¹³⁄₁₆ in. (5.9 x 4.6 cm)
Signed and dated along left edge: *Weinedel 1829*
Inscribed on backing paper: *Mrs. E. Hunt / painted at Augusta / 1829 / by Carl Weinedel*
Casework: gilded copper with chased bezel and hanger gilded in three hues of gold; on the

reverse, hair compartment with similar bezel
Ex coll.: sale, Sotheby Parke-Bernet, New York, Dec. 4, 1979, lot 681A

268. *Gentleman*

1836
Watercolor on ivory, 2⁵⁄₁₆ x 1¹³⁄₁₆ in. (6 x 4.7 cm)
Signed and dated along left edge: *Weinedel.1836.*

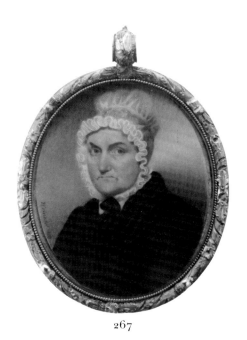

267

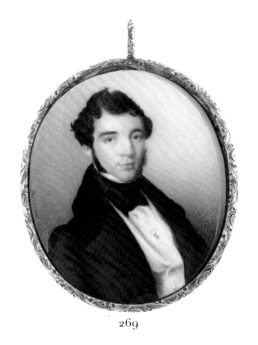

269

Inscribed on backing paper: *Carl Weinedel /
Miniature Painter / No 200 Broadway / N Y*
Casework: gilded copper with chased bezel and
hanger; the reverse machine turned, with
chased bezel framing compartment containing
plaited hair
Ex colls.: sale, Sotheby Parke-Bernet, New York,
Nov. 19, 1980, lot 244; purchased from Edward
Sheppard, New York

269. *Gentleman*

1837
Watercolor on ivory, 2½ x 2 in. (6.4 x 5.1 cm)
Signed and dated along left edge: *Weinedel. 1837.*
Casework: gilded copper with chased bezel and
hanger; on the reverse, chased bezel framing
central hair compartment
Ex colls.: with E. Grosvenor Paine, New Orleans;
sale, Sotheby Parke-Bernet, New York, Jan. 29,
1986, lot 175

JAMES A. WHITEHORNE

(1803–1888)

Born in Wallingford, Vermont, James White-
horne moved to New York City about 1826
and there received informal instruction from
John Trumbull (1756–1843) and SAMUEL F. B.
MORSE. He also studied under Alexander Rob-
ertson (1772–1841), who with his brother AR-
CHIBALD ROBERTSON directed the Columbian
Academy and who probably taught him the art
of miniature painting. Whitehorne was a stu-
dent at the National Academy of Design, win-
ning a silver medal there in 1827; he exhibited
over 180 portraits at the academy during the
fifty-five years that followed, as many as seven-
teen at one time. He was elected a member in
1829 and served as recording secretary in the
years 1838–44. Whitehorne's long professional
career was spent in New York except for the
years 1843–46, when he worked in Washing-
ton, D.C. During a period of financial difficulty
he was assisted by his friends and fellow aca-
demicians THOMAS SEIR CUMMINGS, Morse, and
John Gadsby Chapman (1808–1889).

Whitehorne painted oil portraits of many of
his fellow artists, including HENRY COLTON
SHUMWAY, John Ludlow Morton (1792–1871),

and James Edward Freeman (1808–1884). He
also executed a large posthumous portrait of
Silas Wright, previously governor of New
York, which hangs in City Hall. A well-known
mezzotint engraving published about 1846,
Henry Clay Addressing the Senate, was engraved
from a design of his making. Whitehorne ex-
hibited extensively and was a prominent figure
in the artistic community. Wrote Dunlap, "The
moral conduct of this gentleman, and his ami-
able manners, ensure him the esteem of all who
know him" (1834, vol. 2, p. 434). Nevertheless,
his name is little known today.

Few known miniatures by Whitehorne have
survived, a surprising fact in light of their high
level of accomplishment. The faces in these
portraits are softly modeled with a delicate stip-
ple, while the overall surface is worked with a
varying hatch-and-stipple that creates a deco-
rative pattern. Characteristically broken brush-
strokes, particularly in the hair, give a soft,
somewhat fuzzy effect. Strongly posed subjects
make direct, engaging eye contact with the
viewer, much in the style of portraits by HENRY
INMAN. Backgrounds are hatched blue-green or
green-brown.

270. *Nancy Kellogg*

1838
Watercolor on ivory, 3¹⁄₁₆ x 2⁹⁄₁₆ in. (7.8 x 6.5 cm)
Inscribed on backing paper: *J. Whitehorne Pxt /
1838*
Casework: hinged maroon leather with ormolu
mat (partially shown)
Label on back of case: *Nancy Kellogg / b. 21 Nov
1798. / d. 2 March 1877.* [The dates given are
incorrect, since they would put the sitter, an
apparently young woman, in her fortieth year.]
Ex colls.: sale, Sotheby Parke-Bernet, New York,
Nov. 19, 1980, lot 219/2; purchased from
Edward Sheppard, New York

Nancy Kellogg was born in 1808, the daughter
of Frederick and Esther Guthrie Kellogg of
Hartford, New York. She married Jotham
Gaylord of New Hartford, Connecticut.

Catalogue nos. 270 and 271 are companion pieces.

271. *Mary Kellogg*

Probably 1838 (see cat. no. 270)
Watercolor on ivory, 3¹⁄₁₆ x 2½ in. (7.7 x 6.4 cm)
Casework: as for cat. no. 270

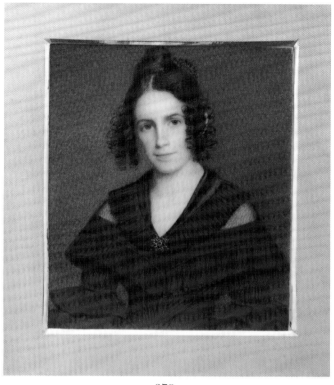

270

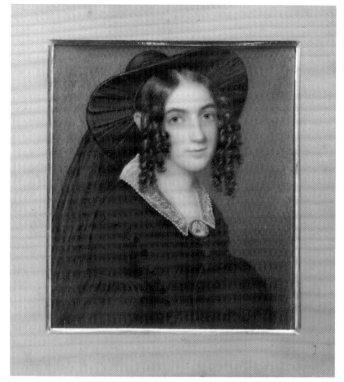

271

Label on back of case: *Mary Kellogg / b. 12 Nov.
 1789 / d. 26 June 1872.* [The dates given are
 incorrect, since they would put the sitter in her
 forty-ninth year.]
Ex COLLS.: as for cat. no. 270

Colorplate 26b

Mary Kellogg, the sister of Nancy Kellogg (see
cat. no. 270), married Ammi Nichols (1806–
1854) and lived in Washington Mills, New
York. They had seven children.

Attributed to James A. Whitehorne

272. *Gentleman*

Watercolor on ivory, 3⅜ x 2½ in. (8.5 x 6.4 cm)
Casework: gilded bronze with metal back and
 gilded mat (partially shown). Inside the frame
 behind the ivory, a daguerreotype of a young
 man, from a later period, inscribed in graphite:
 Yours "Everly" / J. Eberle West., and on the
 reverse: *Randall / Fisher's Block / Opp. Russell
 House / Detroit.*

The distinctive pose, brushwork, and highlight-
ing that characterize the miniatures of the Kel-
logg sisters are evident in this painting as well.

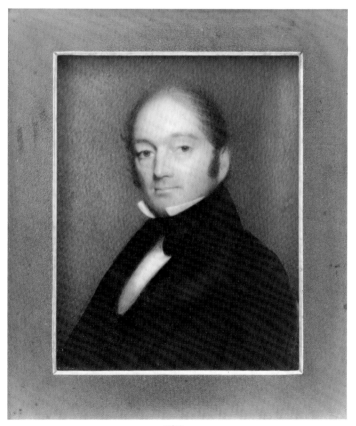

272

HENRY WILLIAMS

(1787–1830)

An engraver, pastelist, profile cutter, modeler in wax, portrait and miniature painter, Henry Williams was born in Boston and lived there all his life. At the age of nineteen he had already become an enterprising artist. He advertised that he could "take correct Profile Likenesses with his new machine; which takes 16 different sizes down to a quarter of an inch . . . elegantly framed with enameled glasses . . . Miniatures and Portraits executed upon Ivory; Portraits in Oil and Crayons; profiles painted upon glass." Furthermore, he would give "Constant attention from 7 o'clock in the morning, until 9 in the evening" (*Columbian Centinel* [Boston], November 12, 1806). During the years 1807–15 Williams was in partnership with WILLIAM M. S. DOYLE; many works exist that are signed jointly.

In 1814 Williams published a treatise, *Elements of Drawing* (Boston), consisting of an essay and twenty-six copperplate engraved examples, both figures and portraits. Many of his portraits were copied in engravings by John Rubens Smith. In a later advertisement for his portraits and miniatures Williams announced that he "continues to paint from the dead in his peculiar manner by Masks" (*The New England Palladium*, 1824; quoted in Wehle, *American Miniatures*, p. 112). His works were exhibited at

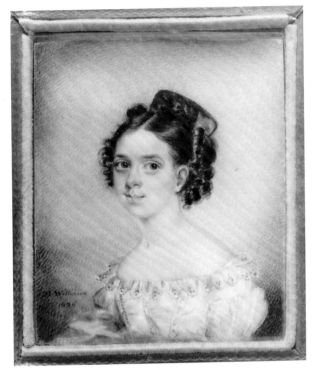

274

the Boston Athenaeum from 1828 to 1831. Dunlap reported that "Williams painted both in oil and miniature at this period in Boston. He was likewise a professor of electricity; and in addition modelled in wax" (1834, vol. 2, p. 263).

Williams was most active painting miniatures in the years between 1808 and 1826; many signed and dated works from that period are known. The quality of his work is inconsistent. Miniatures painted in his best style are delicate, assured, and accurate, but others appear somewhat hesitant. During the time he painted together with Doyle their products were very similar, and they are often confused. Characteristically, Williams's color is restrained. Faces are fully modeled, with rounded forms and contours and with a slight pouchiness under the eyes and around the mouth. Eyes are frequently large and round. The tips of noses are strongly highlighted. Williams had difficulty drawing ears correctly. He rendered clothing with suggestive strokes rather than in detail. Most works show strong value contrasts. In the background, the pale ivory surface often shows

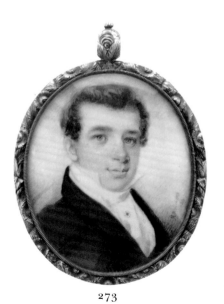

273

through the light hatching on one side of the figure, while dark, broad cross-hatching shades the other side.

273. *Gentleman of the Weaks Family*

1824
Watercolor on ivory, 2⅛ x 1¾ in. (5.5 x 4.4 cm)
Signed and dated along right edge: *H. Williams / 1824*
Casework: gilded copper with chased bezel and hanger; on the reverse, chased bezel framing compartment containing lock of hair
EX COLL.: purchased from Edward Sheppard, New York

This miniature was purchased with catalogue no. 274; for its identification, see below.

274. *Lady of the Weaks Family*

1826
Watercolor on ivory, 3⅜ x 2⅝ in. (8.5 x 6.8 cm)
Signed and dated lower left: *H. Williams / 1826.*
Inscribed on paper backing: *Williams 1826*
Casework: hinged red leather
Typed label accompanying this work: *Williams miniatures came from the Weaks / family of Boston— and are, to the best of / anyone's knowledge—brother and sister.*
EX COLL.: as for cat. no. 273

Colorplate 21c

JOSEPH WOOD

(1778–1830)

A painter of miniatures and cabinet-sized portraits and an engraver, Joseph Wood was born in Clarkstown, New York, the son of a farmer. Obsessed by the idea of becoming an artist, he ran away to New York City at the age of fifteen. Eventually he became apprenticed to a silversmith; in his spare time he copied miniatures that had been left in the shop for framing. In 1800 he married Margaret Haring of Tappan, New York, and the following year established himself as a portrait and miniature painter. In 1803 Wood went into partnership with John Wesley Jarvis in what quickly became a highly lucrative business; they painted silhouettes on glass and cut profiles in paper with the aid of a physiognotrace, at times taking in one hundred dollars a day. Reaping those rewards apparently led to high living, spawning rumors about Wood's licentious behavior.

Wood met EDWARD GREENE MALBONE in 1802 or 1803, shortly after Wood and Jarvis became partners; Malbone visited their studio and later instructed them both in various aspects of miniature painting. Malbone became a close friend of Wood, continuing to offer advice and assistance, as is evident from his visible influence on Wood's work. The Jarvis-Wood partnership broke up in 1809, and in 1811 Wood took on NATHANIEL ROGERS as an apprentice. Wood left New York for Philadelphia in 1813, where he exhibited regularly at the Pennsylvania Academy of the Fine Arts. In 1818 he moved to Baltimore and worked both there and in Washington, D.C., perhaps also traveling through the South. During his last years, which were spent in Washington, his patronage declined; for a while he was reduced to making drawings for patent applications. He died in poverty. His notoriously dissolute life was the basis for a temperance tract published in Washington in 1834. Wood had three children with his first wife and one son with his second wife, Abigail Camp Wood.

In Wood's earliest known miniatures, which are all framed in similar gold cases, the background is an opaque dark gray and the signature and date are very finely incised. *James Stuart* (see below) is an extremely realistic likeness, linear in treatment and meticulous in execution. The painting is one of Wood's finest early portraits.

Subsequently Wood's miniatures show the strong influence of Malbone and are often mistaken for his work. The technique is similar to Malbone's, although Wood's brushwork is slightly grainier and the paint is applied in something closer to a wash technique. In Wood's mature work the backgrounds, like Malbone's, are light and shaded by dark hatches or painted to resemble sky. However, Wood's portraits are more sharply defined than Malbone's, showing stronger contrasts and deeper shadows, with dark outlines around the eyes. Gum arabic is used liberally, and at times the works are even varnished. The hair is brilliantly and airily rendered, often in

the *coup de vent* style popular at the time. Heads are usually smaller than those by Malbone, and the subject is often placed off center or low on the ivory. Like Malbone's, Wood's subjects are self-assured; their presentations, however, are more varied and offer fuller characterizations.

Later works by Wood, although skillful, are not as forceful as those of his best period; the drawing is more hesitant, the brushwork is broader, and the backgrounds are somewhat darker.

275. *James Stuart*

1805
Watercolor on ivory, 2⅞ x 2⁵⁄₁₆ in. (7.2 x 5.9 cm)
Signed and dated lower right: *Jos. Wood Pinx. / 1805.*
Casework: gold plated with plain bezel; on the reverse, compartment containing plaited hair; fitted red leather case (not shown); label inside case: *James Stuart– / Grandma Bogart's / Grandfather—father / of William Stuart who / married Frances Harriman*
REFERENCES: George C. Groce, Jr., and J. T. Chase Willet, "Joseph Wood: A Brief Account of His Life and the First Catalogue of His Work," *Art Quarterly* 3 (Spring 1940), pp. 149–61, esp. p. 151 and ill. p. 155, fig. 2, and Supp., pp. 393–400, cat. no. 68

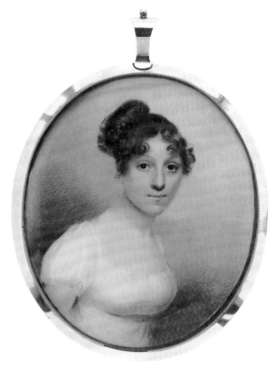

276

EXHIBITED: Museum of the City of New York, 1935, lent by E. Wilton Lyon
EX COLLS.: E. Wilton Lyon, Elizabeth, New Jersey; sale, Christie's, Jan. 22, 1983, lot 439 (as *Portrait of a Gentleman*); purchased from Edward Sheppard, New York

Colorplate 8a

James Stuart was a member of the Order of the Cincinnati and of the St. Andrew's Society of Philadelphia. This miniature may have been painted after an oil portrait.

276. *M. Muir*

Watercolor on ivory, 2¹⁵⁄₁₆ x 2⅜ in. (7.4 x 6 cm)
Casework: gold plated with plain bezel; on the reverse, hair compartment
EX COLL.: sale, Sotheby Parke-Bernet, New York, July 17, 1984, lot 30

Colorplate 8b

When this miniature was purchased, the subject was said to be Margaret or Mary Muir, a member of the Jackson family. In 1808 a Mary Muir married a George Wilson in New York; perhaps she was the lady portrayed here.

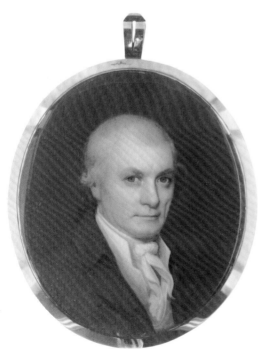

275

MINIATURES BY UNIDENTIFIED ARTISTS

277

277. *Young Boy*

Watercolor on ivory, 1½ x 1⅛ in. (3.8 x 2.8 cm)
Casework: gilded copper with burnished bezel

278. *Gentleman with the Initials A M*

Watercolor on paper, 2¼ x 2¼ in. (5.7 x 5.7 cm)
Casework: gilded copper; on the reverse, hairwork design with a star motif and initials *A M* made with hair of several colors
Ex colls.: sale, Parke-Bernet, New York, Oct. 31, 1952, lot 97; sale, Sotheby Parke-Bernet, New York, Nov. 19, 1980, lot 250

When this miniature was purchased it was attributed to Charles B. J. Saint-Mémin (1770–1852), a French-born artist who spent many years in the United States. However, a leading authority on Saint-Mémin, Ellen Miles of the National Portrait Gallery, has pointed out the absence in his oeuvre of any known works of this type. Saint-Mémin's known portraits were either large chalk drawings, small round black-and-white engravings, or watercolors on paper measuring about seven by five inches. According to Dr. Miles, this small portrait is far more precise than works by Saint-Mémin. It was probably painted by a French artist.

279. *Memorial*

Watercolor on ivory, 1¾ x 1¾ (4.4 x 4.4 cm)
Casework: gilded copper, hinged double-sided locket with eglomise mat; on the reverse, design in cut hair and hair pigment on ivory, depicting a weeping willow tree and a tomb bearing the inscription: *Reste Précieux*
Inscribed on backing paper: *Whom having not seen I love*

The miniature shows a seated woman holding a tablet inscribed: *Pen / sez / a / moi* [Think of me].

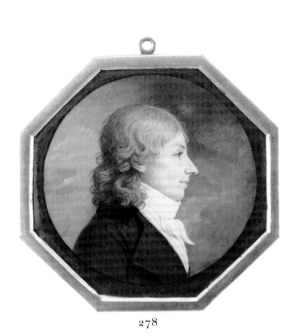

278

279

280

281

281. *Gentleman*

Watercolor on ivory, 2 1/16 x 1 11/16 in. (5.2 x 4.3 cm)
Signed and dated lower left (apparently added
 later): *J Wood / Pinx / 1812*
Casework: gilded copper with chased bezel and
 hanger; the reverse machine turned, with hair
 compartment

The signature on this miniature is unlike those
on documented miniatures by JOSEPH WOOD,
and the painting technique and pose of the
sitter are not characteristic of his style. The
work may be by an English miniaturist.

282

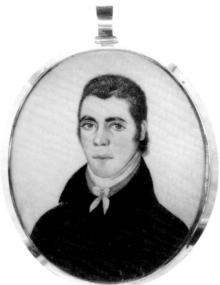

283

280. *Hope*

Watercolor on ivory, 1 7/8 x 1 7/8 in. (4.7 x 4.7 cm)
Casework: gilded copper; on the reverse,
 opalescent glass over pressed foil surmounted
 by pearl, hair, and gold wire design, with a
 central medallion of blue glass surrounded by
 seed pearls and pearls forming the letter *H*
EX COLLS.: Dr. J. Smith, Connecticut; purchased
 from Edward Sheppard, New York

This allegorical scene combines the idealized
figure of a woman, an anchor symbolizing
hope, and a ship in the background; it probably
refers to the anticipated return of a loved one
on a sea voyage.

282. *Gentleman*

Watercolor on ivory, 2½ x 1¹⁵⁄₁₆ in. (6.4 x 4.8 cm)
Casework: modern (not shown)

This painting may be by an English miniaturist.

283. *William Cross*

1800
Watercolor on ivory, 2½ x 2¹⁄₁₆ in. (6.4 x 5.2 cm)
Casework: gilded copper with plain bezel; on the
 reverse, white opalescent glass over machine-
 turned foil; red leather case (not shown)
Inscribed on satin lining of case back: *W. Cross /
 W m. to E. Stevens* [?] *Feby the 4 1804*; inscribed
 on satin lining of case lid: *May the 2 1800 / this
 was taken / Wm Cross died Feby / the 19, 1819
 aged 37*

284. *Gentleman said to be Benjamin Chew*

1807
Watercolor on ivory, 3 x 2½ in. (7.6 x 6.4 cm)
Signed and dated lower right: *H W / 1807*
Casework: black lacquer with brass bezel and
 ormolu hanger (partially shown)
Inscribed on back of frame: *Mr. Chew of Phila. /
 Williams / Boston / signed & dated / 1807*

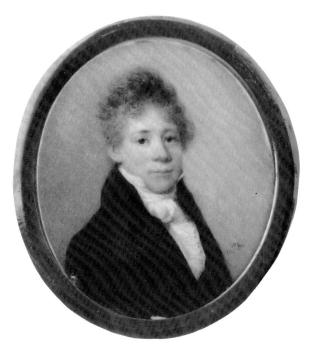

284

Benjamin Chew (1722–1810) was elected a
chief justice of Pennsylvania in 1774 and was
also for many years a speaker of the house of
delegates for the three lower counties of Dela-
ware. Since the gentleman in this miniature was
portrayed as a young man in 1807, he cannot
possibly be the same person. However, he may
have been a member of the Chew family.

 Although the initials and inscription suggest
that this miniature was painted by HENRY WIL-
LIAMS, the work is not in his style. Very likely
its maker was the English artist Horace Hone
(1754/6–1825), since in technique the minia-
ture closely resembles his work. Hone signed
his miniatures with an *H* and the date, an in-
scription exactly like the one here but without
the *W*, which was probably added to this min-
iature at a later date.

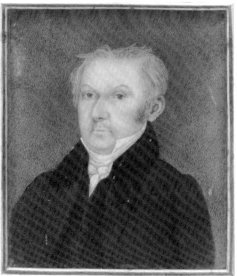

285

285. *Stern Gentleman*

Watercolor on ivory, 2¹³⁄₁₆ x 2¼ in. (7.1 x 5.7 cm)
Casework: modern

286. *Lady in a White Dress*

Watercolor on ivory, 2⁵⁄₁₆ x 1¹³⁄₁₆ in. (5.9 x 4.6 cm)
Casework: modern
Ex coll.: purchased from Edward Sheppard, New
 York

This work is similar in style to miniatures by
EDWARD GREENE MALBONE and JOSEPH WOOD,
but is not of the same quality. It was probably
painted by one of Malbone's followers.

287. *Gentleman*

Watercolor on ivory, 3⅜ x 2⁷⁄₁₆ in. (8.6 x 6.2 cm)
Casework: modern
Ex coll.: sale, Sotheby Parke-Bernet, July 17,
 1984, lot 83A

288. *George Washington*

Watercolor on ivory, 3⅛ x 2½ in. (7.9 x 6.4 cm)
Casework: modern
Ex coll.: purchased from Edward Sheppard, New
 York

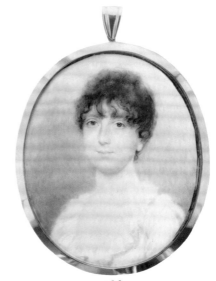

286

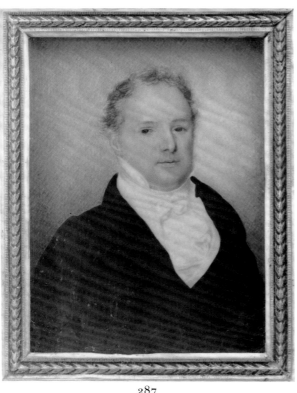

287

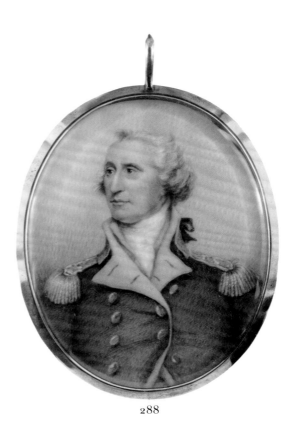

288

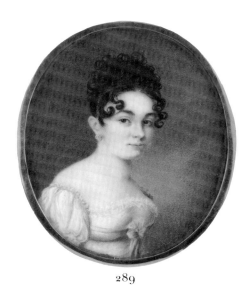

289

289. *Lady in a White Dress*

Watercolor on ivory, 2½ x 2⅛ in. (6.4 x 5.4 cm)
Casework: gold, with hinged lid
Ex COLL.: purchased from Edward Sheppard, New
York

290. *Gentleman*

Watercolor on ivory, 2½ x 2¹⁄₁₆ in. (6.4 x 5.2 cm)
Casework: gilded copper with chased bezel and
 hanger; on the reverse, chased bezel framing
 compartment containing a piece of black fabric

291. *Lady said to be Maria Ludlow*

Watercolor on ivory, 2¹⁵⁄₁₆ x 2³⁄₁₆ (7.5 x 5.6 cm)
Casework: carved, gilded wood (partially shown)

Maria Ludlow (1772–1848) was born in New
York to Thomas and Mary W. Ludlow. She
married her second cousin, Gulian Ludlow, in
1792; they had nine children.

290

291

292

293

294

295

292. *Gentleman of the Dillard Family of Philadelphia*

Watercolor on ivory, 2⁵⁄₁₆ x 1⅞ in. (5.9 x 4.7 cm)
Casework: gilded copper with chased bezel and
 hanger
Ex coll.: purchased from Edward Sheppard, New
 York

The subject of this portrait may be the Dr. Thomas Dillard who was listed in the Philadelphia directories in the 1830s, approximately the same time that the miniature was executed.

Catalogue nos. 292 and 293 are companion pieces.

293. *Lady of the Dillard Family of Philadelphia*

Watercolor on ivory, 2⁷⁄₁₆ x 1¹⁵⁄₁₆ in. (6.2 x 4.9 cm)
Casework: as for cat. no. 292
Ex coll.: as for cat. no. 292

294. *Gentleman*

Watercolor on ivory, 2⅛ x 1¹³⁄₁₆ in. (5.4 x 4.6 cm)
Casework: gilded copper with chased bezel and
 hanger

The ivory has a horizontal crack near the top.

Catalogue nos. 294 and 295 are companion pieces.

295. *Lady in a Mob Cap*

Watercolor on ivory, 2⅛ x 1¹³⁄₁₆ in. (5.4 x 4.6 cm)
Casework: as for cat. no. 294

296. *Lady*

Watercolor on ivory, 2½ x 2 in. (6.4 x 5.1 cm)
Casework: gilded copper with chased bezel of
 three-color metal; on the reverse, similar bezel
 framing compartment containing finely woven
 hair; fitted leather case (not shown)
Ex colls.: sale, Sotheby Parke-Bernet, New York,
 Nov. 18, 1976, lot 530; purchased from E.
 Grosvenor Paine, New Orleans

297. *Lady*

Oil on wood, 2½ x 1⅞ in. (6.4 x 4.7 cm)
Casework: modern

296

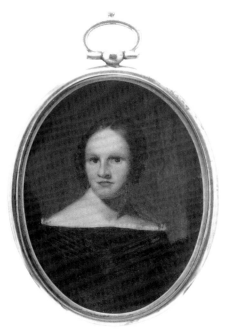

297

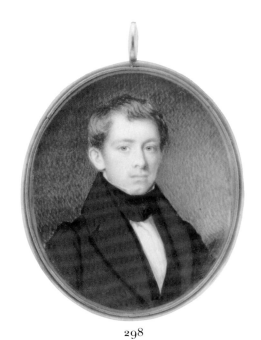

298

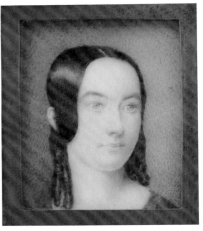

300

298. *Gentleman with Pale Skin*

Watercolor on ivory, 2⅝ x 2⅛ in. (6.7 x 5.4 cm)
Casework: gilded copper with wire bezel; on the
 reverse, compartment containing a blond curl
 and a brown curl
Inscribed on backing paper: *Laura's hair / &
 Edward's hair / when 19 months / old.* Filler behind
 backing paper from a Boston newspaper

299. *Lady in a Green Dress*

Watercolor on ivory, 5 x 3¹¹⁄₁₆ in. (12.6 x 9.4 cm);
 shown reduced
Casework: hinged red leather with ormolu liner
 stamped: *I Price* (not shown)
Ex coll.: purchased from Edward Sheppard, New
 York

300. *Lady with Ringlets*

Watercolor on ivory, 2¹⁄₁₆ x 1¹¹⁄₁₆ in. (5.2 x 4.3 cm)
Casework: hinged brown leather with ormolu mat
 (partially shown); backing card cut from an
 exhibition invitation

301. *Child with a Black Dog*

Watercolor on ivory, 5⁵⁄₁₆ x 4⁵⁄₁₆ in. (13.5 x 11 cm);
 shown reduced
Casework: wood, with painted wood-grain (not
 shown)
Ex coll.: sale, Sotheby Parke-Bernet, July 17,
 1984, lot 95

302. *Baby*

Watercolor on ivory, 4⁵⁄₁₆ x 3 in. (11 x 7.6 cm)
Casework: gilt wood (not shown)

299

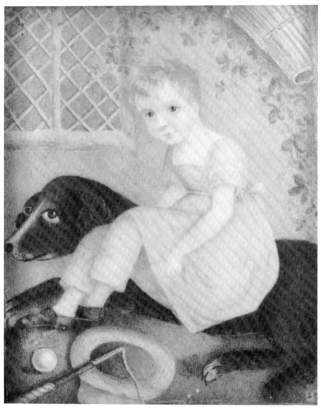

301

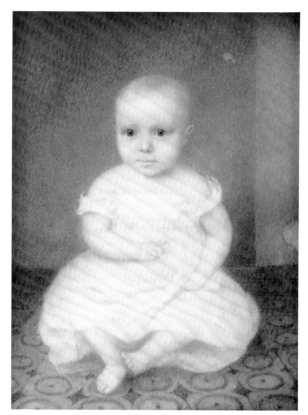

302

This miniature, with its somewhat naive image of a child seated on a Brussels-style carpet, closely resembles a number of full-size paintings of about 1840–50 by Joseph Whiting Stock (1815–1855). However, there are no documented miniatures of this type by Stock with which it might be compared.

303. *Captain John Lovejoy*

Watercolor on ivory, 2⁹⁄₁₆ x 2⅛ in. (6.5 x 5.4 cm)
Casework: gilded copper with wire bezel; on the reverse, hair compartment
Label on back of case: *Capt. John Lovejoy / b. Wilton, N.H. Dec 16 1789 / m. Lavina Blanchard May 30, 1813 / d. Lynn Mass. Sept 12 1876*

This miniature shows certain similarities to works by the little-known portrait and miniature painter Nathan Negus (1801–1825) of Petersham, Massachusetts. The off-center positioning of the subject, prominent stipple, and bright green background are characteristic of Negus's work.

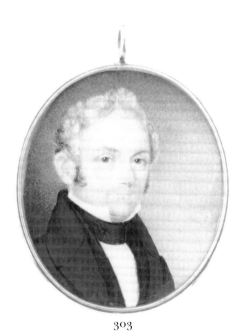

303

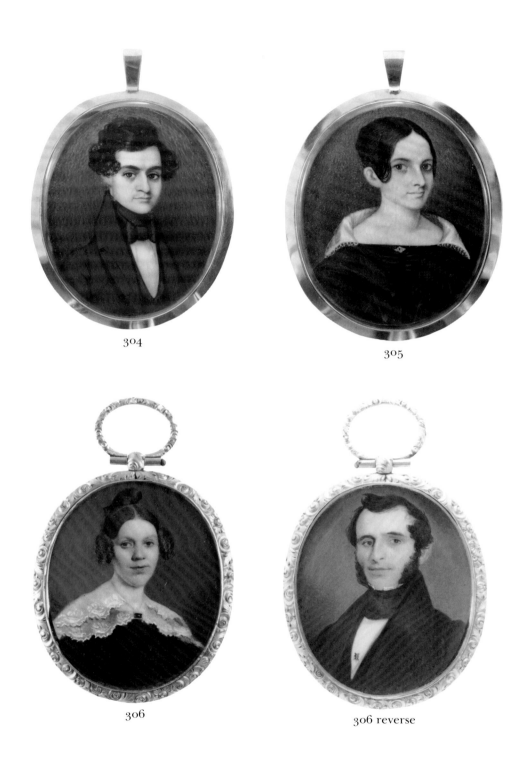

304

305

306

306 reverse

304. *Gentleman*

Watercolor on ivory, 2⁵⁄₁₆ x 1¹³⁄₁₆ in. (5.9 x 4.6 cm)
Casework: gilded copper with plain bezel
Ex coll.: sale, Sotheby Parke-Bernet, New York,
 July 17, 1984, lot 81A

Catalogue nos. 304 and 305 are companion pieces.

305. *Lady*

Watercolor on ivory, 2³⁄₈ x 1⁷⁄₈ in. (6 x 4.7 cm)
Casework: as for cat. no. 304
Ex coll.: as for cat. no. 304

306. *Lady*

Watercolor on ivory, 2¼ x 1⁷⁄₈ in. (5.7 x 4.7 cm)

On the reverse:

Gentleman

Watercolor on ivory, 2¼ x 1¾ in. (5.7 x 4.4 cm)
Casework: gilded copper, double-sided, with
 chased bezel and hanger
Ex coll.: sale, Sotheby Parke-Bernet, Nov. 18,
 1976, lot 517

307. *Baby with Blue Flowers*

Watercolor on ivory, 3 x 2³⁄₈ in. (7.6 x 6 cm)
Casework: gilded copper with chased bezel
Related work: This miniature is very similar to
 one in Florida; see Susan Colgan, "Muriel and
 Herbert Tannenbaum: Collectors of Miniature
 Portrait Paintings," *Art and Antiques* 6 (January/
 February 1983), p. 74.
Ex coll.: purchased from Edward Sheppard, New
 York

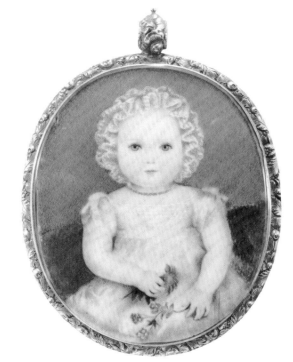

307

308. *Gentleman with Red Hair*

Watercolor on ivory, 3³⁄₁₆ x 2½ in. (8.1 x 6.4 cm)
Casework: hinged brown leather with ormolu mat
 (partially shown)
Ex coll.: purchased from Ronald Bourgeault,
 Massachusetts

This miniature may be by Chester Harding
(1792–1866). Most of his works are full-size oil
paintings on canvas, but his few known minia-
tures are similar to this portrait in pose and in
the pervasive red tonality.

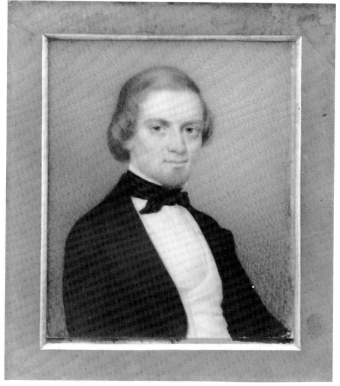

308

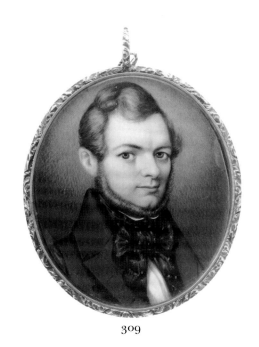

309

309. *Gentleman with Red Hair and Beard*

Watercolor on ivory, 2½ x 2 in. (6.4 x 5.1 cm)
Casework: gilded copper with chased bezel and
 hanger
Ex COLL.: purchased from Ronald Bourgeault,
 Massachusetts

310. *George Washington after the Battle of Trenton*

Watercolor on ivory, 4½ x 3⁷⁄₁₆ in. (11.4 x 8.7 cm);
 shown reduced
Signed center right: *I T*
Casework: veneered wood (not shown)
Written on the back of the frame, in graphite: *Gen
 Geo Washington / after the Battle of / Trenton I T*

This miniature is probably a nineteenth-century copy after a miniature by John Trumbull (1756–1843). A description of a miniature by Trumbull formerly owned by Miss Markham of Dorrancetown, Pennsylvania, and now unlocated (see Eisen, 1932, p. 473) matches this work. Between 1785 and 1796 Trumbull produced numerous portraits of Washington— full-size paintings, miniatures, and pen-and-ink sketches. Most of his miniatures are painted in oil on mahogany panel. In the pose and in the rendering of the uniform, this miniature most closely resembles the full-length portrait by Trumbull in the Yale University Art Gallery, New Haven; however, in that painting Washington is shown without a hat.

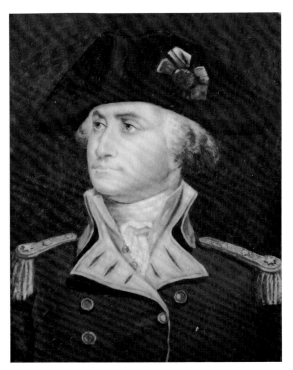

310

311. *Lydia Ethel F. Painter*

Watercolor on ivory, 3⅝ x 2⅝ in. (9.3 x 6.7 cm)
Signed lower left: *D & E*
Casework: gold encrusted with diamonds on the
 bezel and hanger; on the reverse, maker's mark:
 Tiffany / & / Co.; also engraved on the reverse, a
 poem by Lydia Ethel F. Painter

The only other known works inscribed *D & E*
are in the collection of the Lynn Historical So-
ciety, Lynn, Massachusetts. They are not as
finely painted as this miniature and appear to
be based on photographic images. No known
miniaturist has the initials inscribed. In the
opinion of Lewis Rabbage, the leading author-
ity on revival-period miniatures, it is very likely
that the miniature was produced in a commer-
cial studio.

Lydia Painter (1842–1909) was born in
Cleveland. She married Elihu J. Farmer and
after his death married John Vickers Painter, a
prominent Cleveland banker and socialite. She
was active in Cleveland in literary, musical, and
artistic activities. Lydia Painter was also a lead-
ing figure in the women's suffrage movement.
She published many novels and poems, usually
under the pen name G.E.X.

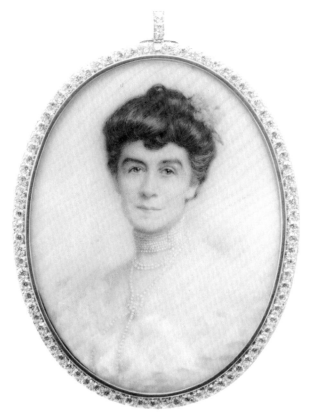

311

Selected Bibliography

GENERAL

*Works especially useful for the general study
of portrait miniatures are marked with an asterisk.*

Archives of American Art. Smithsonian Institution, Washington, D.C., and New York City.

Arnold, John Nelson. *Art and Artists in Rhode Island.* Providence: Rhode Island Citizens' Historical Association, 1905.

Art Gallery of Nova Scotia. *Robert Field: 1769–1819.* Halifax, Nova Scotia, 1978.

Bardo, Pamela Pierrepont. *English and Continental Portrait Miniatures: The Latter-Schlesinger Collection.* New Orleans: New Orleans Museum of Art, 1978.

Barker, Virgil. *American Painting: History and Interpretation.* New York: Macmillan, 1950.

Barter, Judith. "American paintings, pastels, and watercolors in the Mead Art Museum, Amherst College, Amherst, Massachusetts." *Antiques* 122 (November 1982), pp. 1040–51.

Bayley, Frank William. *Little Known Early American Portrait Painters.* Boston: The Copley Gallery, 1915–17.

Belknap, Henry W. *Artists and Craftsmen of Essex County, Massachusetts.* Salem, Mass.: The Essex Institute, 1927.

Bénézit, E. *Dictionnaire critique et documentaire des peintres, sculpteurs, dessinateurs et graveurs.* 10 vols. Paris: Librairie Gründ, 1976.

Bilodeau, Francis W., and Tobias, Mrs. Thomas J., comp. and ed. *Art in South Carolina 1670–1970.* Charleston, S.C.: South Carolina Tricentennial Commission, 1970.

*Bolton, Theodore. *Early American Portrait Painters in Miniature.* New York: Frederic Fairchild Sherman, 1921.

————. *Early American Portrait Draughtsmen in Crayons.* New York: Frederic Fairchild Sherman, 1923.

Bolton-Smith, Robin. *Portrait Miniatures from Private Collections.* Washington, D.C.: National Collection of Fine Arts, Smithsonian Institution, 1976.

*————. "Fraser's Place in the Evolution of Miniature Portraits." In *Charles Fraser of Charleston,* edited by Martha R. Severens and Charles L.

Wyrick, Jr. Charleston, S.C.: Gibbes Art Gallery, 1983, pp. 39–56.

————. *Portrait Miniatures in the National Museum of American Art.* Chicago: University of Chicago Press, 1984.

Brooklyn Museum. *Five Centuries of Miniature Painting.* Brooklyn, 1936.

Burroughs, Alan. *Limners and Likenesses: Three Centuries of American Painting.* Cambridge, Mass.: Harvard University Press, 1936.

Carolina Art Association. *Exhibition of Miniatures from Charleston and Its Vicinity, Painted Before the Year 1860.* Charleston, S.C., 1935.

————. *An Exhibition of Miniatures Owned in South Carolina and Miniatures of South Carolinians Owned Elsewhere, Painted before the Year 1860.* Charleston, S.C., 1936.

Carpenter, Ralph E., Jr. *The Arts and Crafts of Newport Rhode Island, 1640–1820.* Newport, R.I.: The Preservation Society of Newport County, 1954.

Carson, Marian Stadtler. "Early American Water Color Painting." *Antiques* 59 (January 1951), pp. 54–56.

Centennial Celebration of the Inauguration of George Washington. Catalogue of the loan exhibition of historical portraits and relics. New York, 1889.

Clark, Edna Maria. *Ohio Art and Artists.* Richmond, Va.: Garrett and Massie, 1932.

Clement, Clara Erskine, and Hutton, Laurence. *Artists of the Nineteenth Century and Their Works.* 5th ed., rev. Boston: Houghton, Mifflin and Company, 1889.

Cleveland Museum of Art. *Portrait Miniatures: The Edward B. Greene Collection.* Cleveland, 1951.

Cline, Isaac Monroe. "Art and Artists in New Orleans During the Last Century." Reprint from the *Biennial Report,* Louisiana State Museum, New Orleans, 1922.

Coad, Oral Sumner. *William Dunlap: A Study of his Life and Works and of his Place in Contemporary Culture.* New York: The Dunlap Society, 1917.

Colding, Torben Holck. *Aspects of Miniature Painting: Its Origins and Development.* Copenhagen: Ejnar Munksgaard, 1953.

Colwill, Stiles Tuttle. "A Chronicle of Artists in Joshua Johnson's Baltimore." In *Joshua Johnson: Freeman and Early American Portrait Painter*. Exh. cat. Abby Aldrich Rockefeller Folk Art Center and Maryland Historical Society, 1987, pp. 69–98.

Cowdrey, Mary Bartlett. *American Academy of Fine Arts and American Art-Union: Introduction 1816–1852*. New York: New-York Historical Society, 1953.

———, ed. *National Academy of Design Exhibition Record, 1826–1860*. New York: New-York Historical Society, 1943.

The Crayon: A Journal Devoted to the Graphic Arts, and the Literature Related to Them. Reprint ed. 4 vols. New York: AMS Press, 1970.

Cummings, Thomas S. *Historic Annals of the National Academy of Design . . . from 1825 to the Present Time*. Philadelphia: George W. Childs, 1865.

Day, Charles William. *The Art of Miniature Painting*. London: Winsor and Newton [1878].

Day, Lewis F. *The Course of Art and Workmanship: Enamelling*. London: B. T. Batsford, 1907.

Dunbar, Philip H. "Portrait Miniatures on Ivory, 1750–1850, From the Collection of the Connecticut Historical Society." *Connecticut Historical Society Bulletin* 29 (October 1964), pp. 97–121.

*Dunlap, William. *History of the Rise and Progress of the Arts of Design in the United States*. 2 vols. New York: George P. Scott and Co., 1834.

*———. *A History of the Rise and Progress of the Arts of Design in the United States*. Edited, with additions by Frank W. Bayley and Charles E. Goodspeed. 3 vols. Boston: C. E. Goodspeed, 1918.

*———. *Diary of William Dunlap, 1766–1839: The Memoirs of a Dramatist, Theatrical Manager, Painter, Critic, Novelist, and Historian*. 3 vols. New York: New-York Historical Society, 1931.

Ehrich Galleries. *Exhibition of Miniatures by Early American Artists and of American Subjects*. New York, 1931.

Eisen, Gustavus A. *Portraits of Washington*. 3 vols. New York: Robert Hamilton & Associates, 1932.

Encyclopedia of New Orleans Artists 1718–1918. New Orleans: The Historic New Orleans Collection, 1987.

Fales, Martha Gandy. "Federal Bostonians and their London jeweler, Stephen Twycross." *Antiques* 131 (March 1987), pp. 642–49.

Falk, Peter Hastings, ed. *Who Was Who in American Art*. Madison, Conn.: Sound View Press, 1985.

Fielding, Mantle. *Dictionary of American Painters, Sculptors and Engravers with an Addendum*. New York: James F. Carr, 1965.

Flexner, James Thomas. *American Painting, The Light of Distant Skies, 1760–1835*. New York: Harcourt, Brace and Company, 1954.

———. *America's Old Masters*. 2d ed., rev. Garden City, N.Y.: Doubleday & Company, 1980.

Foskett, Daphne. *A Dictionary of British Miniature Painters*. 2 vols. New York: Praeger, 1972.

———. *Miniatures, Dictionary and Guide*. Woodbridge, Suffolk (England): Antique Collectors' Club, 1987.

Foster, J. J. *A Dictionary of Painters of Miniatures (1525–1850)*. 1926; reprint ed. New York: Burt Franklin, 1968.

French, H. W. *Art and Artists in Connecticut*. Boston: Lee and Shepard; New York: Charles T. Dillingham, 1879.

Gardner, Albert Ten Eyck, and Feld, Stuart P. *American Paintings: A Catalogue of the Collection of The Metropolitan Museum of Art. I: Painters born by 1815*. New York: Metropolitan Museum of Art, 1965.

Gerdts, William H. *Women Artists of America, 1707–1964*. Newark, N.J.: Newark Museum, 1965.

Goodyear, Frank H., Jr. *American Paintings in the Rhode Island Historical Society*. Providence: Rhode Island Historical Society, 1974.

*Groce, George C., and Wallace, David H. *The New-York Historical Society's Dictionary of Artists in America, 1564–1860*. New Haven and London: Yale University Press, 1957.

Groft, Tammis Kane. *The Folk Spirit of Albany*. Albany: Albany Institute of History & Art, 1978.

Hart, Charles Henry. *Catalogue of the Engraved Portraits of Washington*. New York: The Grolier Club, 1904.

———. *Historical Descriptive and Critical Catalogue of the Works of American Artists in the Collection of Herbert L. Pratt*. New York, 1917.

Henkels, Stan V. *The Albert Rosenthal Collection of Miniatures and Small Oil Portraits*. Philadelphia, 1920.

Hickl-Szabo, H. *Portrait Miniatures in the Royal Ontario Museum*. Toronto: Royal Ontario Museum, 1981.

Hughes, Edan Milton. *Artists in California 1786–1940*. San Francisco: Hughes Publishing Company, 1986.

Huntington, Collis Potter. *A Catalogue of Miniatures in the Collection of Collis P. Huntington*. New York: A. M. Huntington, 1897.

Johnson, Allen, ed. *Dictionary of American Biography*. 11 vols. New York: Charles Scribner's Sons, 1958.

Kelby, William. *Notes on American Artists, 1754–1820, copied from Advertisements Appearing in the Newspapers of the Day*. New York: New-York Historical Society, 1922.

Kent, Henry Watson, and Levy, Florence N. *The Hudson-Fulton Celebration: Catalogue of an Exhibition of American Paintings, Furniture, Silver and other Objects of Art*, vol. 2. New York: Metropolitan Museum of Art, 1909.

LaFollette, Suzanne. *Art in America From Colonial Times to the Present Day*. New York: W. W. Norton, 1929.

Lipman, Jean, and Winchester, Alice. *Primitive Painters in America, 1750–1950: An Anthology*. New York: Dodd Mead and Company, 1950.

London, Hannah R. *Miniatures and Silhouettes of Early American Jews.* Rutland, Vt.: Charles E. Tuttle Company, 1970.

Long, Basil. *British Miniaturists, 1520–1860.* London: Saifer, 1966.

Marlor, Clark S. *A History of the Brooklyn Art Association with an Index of Exhibitions.* New York: James F. Carr, 1970.

Maryland Historical Society. *Four Generations of Commissions: The Peale Collection of the Maryland Historical Society.* Baltimore, 1975.

McKechnie, Sue. *British Silhouette Artists and their Work, 1760–1860.* London: Sotheby Parke-Bernet, 1978.

Metropolitan Museum of Art. *American Paintings & Historical Prints from the Middendorf Collection.* New York, 1967.

———. *Catalogue of an Exhibition of Miniatures Painted in America 1720–1850.* New York, 1927.

Miles, Ellen, ed. *Portrait Painting in America: The Nineteenth Century.* New York: Main Street/Universe Books, 1977.

Morgan, John Hill. *Early American Painters.* New York: New-York Historical Society, 1921.

———. *Gilbert Stuart and His Pupils.* New York: New-York Historical Society, 1939.

Morgan, John Hill, and Fielding, Mantle. *The Life Portraits of Washington and Their Replicas.* Philadelphia, 1931.

*Murdoch, John, et al. *The English Miniature.* New Haven and London: Yale University Press, 1981.

Murrell, V. James. "Notes on the Techniques of Portrait Miniatures." In *English and Continental Portrait Miniatures: The Latter-Schlesinger Collection,* by Pamela Pierrepont Bardo. New Orleans: New Orleans Museum of Art, 1978.

Museum of Early Southern Decorative Arts, Winston-Salem, N.C. Index of Early Southern Artists and Artisans.

Museum of Fine Arts, Boston. *New England Miniatures: 1750–1850.* Boston, 1957.

Museum of Modern Art. *American Folk Art: The Art of the Common Man in America 1750–1900.* New York, 1932.

National Collection of Fine Arts, Smithsonian Institution. *Preliminary Catalogue Listing of Miniatures.* Washington, D.C., 1965.

———. *Portrait Miniatures from Private Collections.* Washington, D.C., 1977.

National Museum of American Art, Smithsonian Institution, Washington, D.C. Inventory of American Paintings Executed before 1914. Database.

Naylor, Maria, ed. *The National Academy of Design Exhibition Record 1861–1900.* 2 vols. New York: Kennedy Galleries, 1973.

New-York Historical Society. *National Academy of Design Exhibition Record 1826–1860.* 2 vols. New York, 1943.

———. *Catalogue of American Portraits in the New-York Historical Society.* 2 vols. New Haven and London: Yale University Press, 1974.

R. W. Norton Art Gallery. *Portrait Miniatures in Early American History: 1750–1840.* Shreveport, La., 1976.

Parker, Barbara Neville, ed. *New England Miniatures 1750 to 1850.* Boston: Museum of Fine Arts, 1957.

Pennsylvania Academy of the Fine Arts, Philadelphia, Pennsylvania. Check List: Paintings, Sculptures, Miniatures from the Permanent Collection. Philadelphia, 1969.

Perkins, Robert F., and Gavin, William J., III, eds. *The Boston Athenaeum Art Exhibition Index 1827–1874.* Boston: Library of the Boston Athenaeum, 1980.

Philadelphia Museum of Art. *Philadelphia: Three Centuries of American Art: Bicentennial Exhibition.* Philadelphia, 1976.

———. *Portraits by Early American Artists of the Seventeenth, Eighteenth, and Nineteenth Centuries, Collected by Thomas B. Clarke.* Philadelphia, 1928.

Pike, Martha V., and Armstrong, Janice Gray. *A Time to Mourn: Expressions of Grief in Nineteenth Century America.* Stony Brook, N.Y.: Museums at Stony Brook, 1980.

Pleasants, J. Hall. *Two Hundred and Fifty Years of Painting in Maryland.* Baltimore: Baltimore Museum of Art, 1945.

Prime, Alfred Coxe. *The Arts and Crafts in Philadelphia, Maryland and South Carolina 1786–1800, Series Two, Gleanings from Newspapers.* Topsfield, Mass.: Walpole Society, 1932.

Reaves, Wendy Wick, ed. *American Portrait Prints: Proceedings of the Tenth Annual American Print Conference.* Charlottesville, Va.: University Press of Virginia, 1984.

Redgrave, Samuel. *Dictionary of Artists of the English School.* London: Longmans, Green and Co., 1874.

Reynolds, Graham. *The Starr Collection of Miniatures in the William Rockhill Nelson Gallery.* Kansas City: Nelson Gallery–Atkins Museum, 1971.

*———. *English Portrait Miniatures.* Rev. ed. Cambridge: Cambridge University Press, 1988.

Richardson, E. P. *Painting in America: The story of 450 years.* New York: Thomas Y. Crowell Company, 1956.

Rinhart, Floyd and Marion. *American Miniature Case Art.* South Brunswick, N.J., and New York: A. S. Barnes and Company; London: Thomas Yoseloff, 1969.

Robertson, Emily, ed. *Letters and Papers of Andrew Robertson, A. M.* London: Eyre and Spottiswoode, 1895.

Rubinstein, Charlotte Streifer. *American Women Artists from Early Indian Times to the Present.* New York: Avon, 1982.

Rutledge, Anna Wells. *Artists in the Life of Charleston.* Philadelphia: American Philosophical Society, 1949.

———. *Cumulative Record of Exhibition Catalogues, The Pennsylvania Academy of the Fine Arts, 1807–*

1870, The Society of Artists, 1800–1814, The Artists' Fund Society, 1835–1845. Philadelphia: The American Philosophical Society, 1955.

Sadik, Marvin S. Colonial and Federal Portraits at Bowdoin College. Brunswick, Me.: Bowdoin College Museum of Art, 1966.

Saunders, Richard H., and Miles, Ellen G. American Colonial Portraits: 1770–1776. Washington, D.C.: National Portrait Gallery, Smithsonian Institution, 1987.

Sawitzky, William. Catalogue Descriptive and Critical of the Paintings and Miniatures in the Historical Society of Pennsylvania. Philadelphia: Historical Society of Pennsylvania, 1942.

*Schidlof, Leo R. La Miniature en Europe, aux 16e, 17e, 18e, et 19e siècles. Graz, Austria: Akademische Druck- und Verlagsanstalt, 1964.

Schorsch, Anita. "Mourning Art: A Neoclassical Reflection in America." American Art Journal 8 (May 1976), pp. 4–15.

Sellers, Charles Coleman. Benjamin Franklin in Portraiture. New Haven and London: Yale University Press, 1962.

*Severens, Martha R. The Miniature Portrait Collection of the Carolina Art Association. Charleston, S.C.: Gibbes Art Gallery, 1984.

Shepard, Lewis A., and Paley, David. American Art at Amherst: A Summary Catalogue of the Collection at the Mead Art Gallery, Amherst College. Middletown, Conn.: Wesleyan University Press, 1978.

Sherman, Frederic Fairchild. Early American Portraiture. New York, 1930 (privately printed).

———. Early American Painting. New York and London: The Century Co., 1932.

Soria, Regina. Dictionary of Nineteenth-Century American Artists in Italy 1760–1914. East Brunswick, N.J.: Associated University Presses, 1982.

Spassky, Natalie. American Paintings in the Metropolitan Museum of Art. Volume II, A Catalogue of Works by Artists Born between 1816 and 1845. New York: Metropolitan Museum of Art, 1985.

Stauffer, David McNeely. American Engravers upon Copper and Steel. New York: Grolier Club, 1907.

Stebbins, Theodore E., Jr., and Gorokhoff, Galina. A Checklist of American Paintings at Yale University. New Haven: Yale University Art Gallery, 1982.

*Strickler, Susan E. American Portrait Miniatures, The Worcester Art Museum Collection. Worcester, Mass.: Worcester Art Museum, 1989.

Swan, Mabel Munson. The Athenaeum Gallery, 1827–1873: The Boston Athenaeum as an Early Patron of Art. Boston: Boston Athenaeum, 1940.

Thieme, Ulrich, and Becker, Felix, eds. Allgemeines Lexikon der Bildenden Künstler von der Antike bis zur Gegenwart. 37 vols. Leipzig, 1907–50.

*Tuckerman, Henry T. Book of the Artists. American Artist Life, Comprising Biographical and Critical Sketches of American Artists: Preceded by an Historical Account of the Rise and Progress of Art in America. New York: G. P. Putnam & Son, 1867.

Tufts, Eleanor. American Women Artists 1830–1930. Exh. cat. Washington, D.C.: National Museum of Women in the Arts, 1987.

Universal Exposition. Official Catalogue of Exhibitors, Universal Exposition, St. Louis, U.S.A., 1904, Department B: Art. St. Louis, 1904.

Valentine Museum. Richmond Portraits in an Exhibition of Makers of Richmond, 1737–1860. Richmond, Va, 1949.

Virginia Museum of Fine Arts. An Exhibition of Virginia Miniatures. Richmond, Va., 1941.

*Wehle, Harry B. American Miniatures, 1730–1850. Garden City, N.Y.: Doubleday, Page & Company, 1927.

———. Catalogue of an Exhibition of Miniatures Painted in America, 1720–1850. New York: Metropolitan Museum of Art, 1927.

Wharton, Anne Hollingsworth. Heirlooms in Miniatures. Philadelphia and London: J. B. Lippincott, 1898.

Whitebook, Jeannette Stern. "Some Philadelphia miniatures." Antiques 82 (October 1962), pp. 390–94.

Whittock, N. The Miniature Painter's Manual Containing Progressive Lessons on the Art . . . London: Sherwood, Gilbert, and Piper, 1844.

Williamson, George Charles. The Miniature Collector: A Guide for the Amateur Collector of Portrait Miniatures. New York: Dodd, Mead, 1921.

———. Portrait Miniatures from the Time of Holbein 1531 to that of Sir William Ross 1860. London: George Bell and Sons, 1897.

Williamson, George C., and Buckman, Percy. The Art of the Miniature Painter. London: Chapman and Hall, 1926.

Wilmerding, John. American Art. Harmondsworth, Middlesex (England): Penguin Books, 1976.

Wright, R. Lewis. Artists in Virginia Before 1900: An Annotated Checklist. Charlottesville, Va.: University Press of Virginia, 1983.

Yarnall, James L., and Gerdts, William H., comps. The National Museum of American Art's Index to American Art Exhibition Catalogues From the Beginning through the 1876 Centennial Year. 6 vols. Boston: G. K. Hall, 1986.

INDIVIDUAL MINIATURISTS

Works that also appear in the General Bibliography are cited here in shortened form.

AGATE, ALFRED

Manthorne, Kathie. "Alfred Thomas Agate." In Barbara Novak et al. *Next to Nature: Landscape Paintings from the National Academy of Design.* New York: Harper & Row, 1980, pp. 98–104.

Nostrand, Jeanne van. *The First Hundred Years of Painting in California 1775–1875.* San Francisco: John Howell, 1980, p. 81.

BAKER, GEORGE A.

French, 1879, pp. 109–10.

Tuckerman, 1867, pp. 489–90.

BIRCH, THOMAS

Creer, Doris Jean. "Thomas Birch: A Study of the Condition of Painting and the Artist's Position in Federal America." M.A. thesis, University of Delaware, 1958.

Gerdts, William H. "Thomas Birch: America's First Marine Artist." *Antiques* 89 (April 1966), pp. 528–34.

BIRCH, WILLIAM

Birch, William. "The Life of William Russell Birch, Enamel Painter, Written by Himself." Unpublished manuscript, 51 pages. Birch Papers, Historical Society of Pennsylvania, Philadelphia.

Brockway, Jean Lambert. "William Birch: His American Enamel Portraits." *Antiques* 24 (September 1933), pp. 94–96.

Ross, Marvin Chauncey. "William Birch, Enamel Miniaturist." *American Collector* 9 (July 1940), pp. 5, 20.

BOUDON, DAVID

Richards, Nancy E. "A Most Perfect Resemblance at Moderate Prices: The Miniatures of David Boudon." *Winterthur Portfolio* 9 (1974), pp. 77–101.

BRIDPORT, HUGH

Craven, Wayne. "Hugh Bridport, Philadelphia miniaturist, engraver, and lithographer." *Antiques* 89 (April 1966), pp. 548–52.

Philadelphia Museum of Art, 1976, pp. 285–86.

BROADBENT, SAMUEL, JR.

Warren, William Lamson. "Doctor Samuel Broadbent (1759–1828) Itinerant Limner." *The Connecticut Historical Society Bulletin* 38 (October 1973), pp. 97–128.

BROWN, JOHN HENRY

Clement and Hutton, 1889, vol. 1, p. 100.

"Miniature by John Henry Brown, 1848." *Antiques* 44 (November 1943), pp. 210, 212.

Wharton, 1898, pp. 214–24.

CARLIN, JOHN

Carlin, John. Credit Books, 1832–1856. Manuscript Collection, New-York Historical Society.

Deaf Mutes' Journal (April 30, 1891).

Gardner and Feld, vol. 1, pp. 267–69.

CATLIN, GEORGE

Catlin, George. *Letters and Notes on the North American Indians.* Edited by Michael MacDonald Mooney. New York: Clarkson N. Potter, 1975.

McCracken, Harold. *George Catlin and the Old Frontier.* New York: Dial Press, 1959.

Thomas, W. Stephen. "George Catlin, Portrait Painter." *Antiques* 54 (August 1948), pp. 96–100.

CHODOWIECKI, DANIEL NIKOLAUS

Bauer, Jens-Heiner. *Daniel Nikolaus Chodowiecki: Das druckgraphische Werk. Die Sammlung Wilhelm Burggraf zu Dohna-Schlobitten.* Hannover: Verlag Galerie J. H. Bauer, 1982.

CLARK, ALVAN

Clark, Alvan. "Autobiography of Alvan Clark." *New-England Historical and Genealogical Register* 43 (January 1889), pp. 52–58.

COLLAS, LOUIS ANTOINE

Severens, 1984, pp. 22–24, 25, colorplate III.

Simmons, Linda Crocker. "The Emerging Nation, 1790 to 1830." *Painting in the South: 1564–1980.* Exh. cat. Richmond: Virginia Museum, 1983, p. 53.

COPLEY, JOHN SINGLETON

Massachusetts Historical Society. *Letters & Papers of John Singleton Copley and Henry Pelham, 1739–1776.* Collections, vol. 71. Cambridge, 1914.

Prown, Jules David. *John Singleton Copley in America 1738–1774.* Cambridge, Mass.: Harvard University Press, 1966.

Saunders and Miles, 1987.

Sherman, Frederic Fairchild. "John Singleton Copley as a Portrait Miniaturist." *Art in America* 18 (June 1930), pp. 207–14.

CUMMINGS, THOMAS SEIR

Allen, Josephine L. "A Mother's Pearls." *The Metropolitan Museum of Art Bulletin* 15 (April 1957), pp. 205–7.

Cummings, T. S. "Practical Directions for Miniature Painting." In Dunlap, 1834, vol. 2, pp. 10–14.

Hartshorne, Whitney. "Thomas Seir Cummings—Miniaturist." *America in Britain.* New York, pp. 5–8.

DICKINSON, ANSON

Dearborn, Mona Leithiser. *Anson Dickinson: The Celebrated Miniature Painter, 1779–1852.* Hartford: Connecticut Historical Society, 1983.

Kidder, Mary Helen, ed. *List of Miniatures Painted by Anson Dickinson 1803–1851*. Hartford: Connecticut Historical Society, 1937.

DICKINSON, DANIEL

Dunlap, 1834, vol. 2, p. 333.
French, 1879, p. 56.

DODGE, JOHN WOOD

Elliot, Anne O. "A Master of Miniatures." *Southern Woman's Magazine* (January 1917), pp. 20–23, 28.
John Wood Dodge Papers lent by Mr. and Mrs Leonard Mee, Santa Rosa, CA, microfilm roll #960. Includes correspondence, account book, clippings, and photographs. Archives of American Art, Smithsonian Institution, Washington, D.C.

DOYLE, WILLIAM M. S.

Kern, Arthur B., and Kern, Sybil B. "The Pastel Portraits of William M. S. Doyle." *The Clarion* 13 (Fall 1988), pp. 41–47.

DUNKERLEY, JOSEPH

Parker, Barbara N. "New England Miniatures." In Miles, 1977, pp. 50–51.
Sherman, 1932, p. 179.

DUPLESSIS, JOSEPH

Sellers, Charles Coleman. *Benjamin Franklin in Portraiture*. New Haven and London: Yale University Press, 1962, pp. 246–75.

ELOUIS, JEAN PIERRE HENRI

Dunlap, 1918, vol. 3, pp. 298–99.
Wehle, 1927, pp. 32, 82, plate XIII.

FIELD, ROBERT

Paikowsky, Sandra R. *Robert Field*. Exh. cat. Halifax, Nova Scotia: Art Gallery of Nova Scotia, 1978.
Piers, Harry. *Robert Field, Portrait Painter in Oils, Miniature and Water-Colours and Engraver*. New York: Frederic Fairchild Sherman, 1917.

FRASER, CHARLES

Carolina Art Association. *A Short Sketch of Charles Fraser and a List of Miniatures and Other Works*. Exh. cat. Charleston, S.C.: Gibbes Art Gallery, 1934.
Fraser Gallery. *Catalogue of Miniature Portraits, Landscapes, and Other Pieces, Executed by Charles Fraser and Exhibited in the Fraser Gallery*. Exh. cat. Charleston, S.C.: James and Williams, 1857.
Severens, Martha R., and Wyrick, Charles L., Jr., eds. *Charles Fraser of Charleston: Essays on the Man, His Art and His Times*. Charleston, S.C.: Carolina Art Association and Gibbes Art Gallery, 1983.
Smith, Alice R. Huger, and Smith, D. E. Huger. *Charles Fraser*. New York: Frederic Fairchild Sherman, 1924.

FULLER, AUGUSTUS

Dods, Agnes M. "Connecticut Valley Painters." *Antiques* 46 (October 1944), pp. 207–9.
Robinson, Frederick B. "A Primitive Portraitist." *Art in America* 39 (April 1951), pp. 50–52.

FULTON, ROBERT

Fulton, Eleanore J. "Robert J. Fulton as an Artist." *Papers Read Before the Lancaster County Historical Society* 42 (1938), pp. 49–96.
Morgan, John S. *Robert Fulton*. New York: Mason/Charter, 1977.
Philip, Cynthia Owen. *Robert Fulton: A Biography*. New York: Franklin Watts, 1985.

GOODRIDGE, ELIZA

Dresser, Louisa. "Portraits owned by the American Antiquarian Society." *Antiques* 96 (November 1969), p. 726.
Strickler, 1989, pp. 62–64.

GOODRIDGE, SARAH

Dods, Agnes M. "Sarah Goodridge." *Antiques* 51 (May 1947), pp. 328–29.
Rubinstein, 1982, pp. 45–46.
Strickler, 1989, pp. 65–66.
Tufts, 1987, no. 28.

GOULD, WALTER

Clement and Hutton, 1889, vol. 1, p. 307.

GROZELIER, SARAH

Swan, 1940, p. 184.

HALL, ANNE

Dunlap, 1918, vol. 3, pp. 160–62.
Tufts, 1987, no. 29.

HARVEY, GEORGE

Shelley, Donald A. "George Harvey, English Painter of Atmospheric Landscapes in America." *American Collector* 17 (April 1948), pp. 10–13.
Stebbins, Theodore E., Jr. *American Master Drawings and Watercolors*. New York: Harper & Row, 1976, pp. 143–44.

HAZLITT, JOHN

Moyne, Ernest J. "John Hazlitt, Miniaturist and Portrait Painter in America, 1783–1787." *Winterthur Portfolio* 6 (1970), pp. 33–40.

HENRI, PIERRE

Sherman, Frederic Fairchild. "Pierre Henri's American Miniatures." *Art in America* 28 (April 1940), pp. 78–81.

INGHAM, CHARLES CROMWELL

Cummings, 1865, p. 353.
Dunlap, 1834, vol. 2, pp. 271–74.
Gardner, Albert Ten Eyck. "Ingham in Manhattan." *The Metropolitan Museum of Art Bulletin* 10 (May 1952), pp. 245–53.

INMAN, HENRY

Bolton, Theodore. "Henry Inman, An Account of His Life and Work." *Art Quarterly* 3 (Autumn 1940), pp. 353–75, supplement to vol. 3, pp. 401–18.

Dunlap, 1834, vol. 2, pp. 11–12, 348–50.

Gerdts, William H., and Rebora, Carrie. *The Art of Henry Inman*. Washington, D.C.: The National Portrait Gallery, Smithsonian Institution, 1987.

JARVIS, CHARLES WESLEY

Dickson, Harold E. *John Wesley Jarvis*. New York: New-York Historical Society, 1949.

LAZARUS, JACOB

Sherman, Frederic Fairchild. "Unrecorded Early American Portrait Miniaturists and Miniatures." *Antiques* 23 (January 1933), p. 13.

Spassky, 1985, vol. 2, pp. 154–55.

LEUTZE, EMANUEL

Groseclose, Barbara S. *Emanuel Leutze, 1816–1868: Freedom Is the Only King*. Washington, D.C.: National Collection of Fine Arts, Smithsonian Institution, 1975.

LEWIS, WILLIAM

Sherman, Frederic Fairchild. "Newly Discovered American Miniaturists." *Antiques* 8 (August 1925), p. 97.

MALBONE, EDWARD GREENE

Brockway, Jean Lambert. "Malbone, American Miniature Painter." *American Magazine of Art* 20 (April 1929), pp. 185–91.

National Gallery of Art. *Catalogue of an Exhibition of Miniatures and Other Works by Edward Greene Malbone 1777–1807*. Exh. cat. Washington, D.C., 1929.

Sadik, 1966, pp. 123–30.

Tolman, Ruel P. "Newly Discovered Miniatures by Edward Greene Malbone." *Antiques* 16 (November 1929), pp. 373–80.

———. *The Life and Works of Edward Greene Malbone, 1777–1807*. New York: New-York Historical Society, 1958.

MARCHANT, EDWARD D.

Heckscher Museum. *Catalogue of the Collection, Paintings and Sculpture*. Huntington, N.Y., 1979, pp. 49–50.

MCDOUGALL, JOHN A.

Gerdts, William H. *Painting and Sculpture in New Jersey*. Princeton, N.J.: D. Van Nostrand Company, 1964, pp. 46–47.

———. "People and Places of New Jersey." *Museum* (Newark) 15 (Spring–Summer 1963), pp. 28–29.

MEUCCI, ANTON

New-York Historical Society, 1974, vol. 2, p. 804.

MILES, EDWARD

Foskett, 1987, pp. 299–300.

MORSE, SAMUEL F. B.

Lipton, Leah. "William Dunlap, Samuel F. B. Morse, John Wesley Jarvis, and Chester Harding: Their Careers as Itinerant Portrait Painters." *American Art Journal* 13 (Summer 1981), pp. 36–40.

Prime, Samuel Irenaeus. *The Life of Samuel F. B. Morse, LL.D*. New York: D. Appleton and Company, 1875.

Staiti, Paul J. "Samuel F. B. Morse's Search for a Personal Style." *Winterthur Portfolio* 16 (Winter 1981), pp. 253–81.

Wehle, Harry B. *Samuel F. B. Morse: American Painter*. Exh. cat. New York: Metropolitan Museum of Art, 1932.

OFFICER, THOMAS STORY

Nostrand, Jeanne van. *The First Hundred Years of Painting in California, 1775–1875*. San Francisco: John Howell, 1980, pp. 48, 114–15.

PEALE, ANNA CLAYPOOLE

Hirshorn, Anne Sue. "Legacy of Ivory: Anna Claypoole Peale's Portrait Miniatures." *Bulletin of the Detroit Institute of Arts* 64, no. 4 (1989), pp. 16–27.

Philadelphia Museum of Art, 1976, pp. 254–55, 281.

Rubinstein, 1982, p. 49.

PEALE, CHARLES WILLSON

Miller, Lillian B., ed. *The Collected Papers of Charles Willson Peale and His Family*. Millwood, N.Y.: Kraus Microform for the National Portrait Gallery, Smithsonian Institution, 1980.

———. *The Selected Papers of Charles Willson Peale and His Family*, vol. 1. New Haven and London: Yale University Press, 1983.

Richardson, Edgar P.; Hindle, Brooke; and Miller, Lillian B. *Charles Willson Peale and His World*. New York: Harry N. Abrams, 1983.

Sellers, Charles Coleman. *Charles Willson Peale*. 2 vols. Philadelphia: American Philosophical Society, 1947.

———. *Portraits and Miniatures by Charles Willson Peale*. vol. 42, part I of *The Transactions of the American Philosophical Society*. Philadelphia, 1952.

PEALE, JAMES

Brockway, Jean Lambert. "The Miniatures of James Peale." *Antiques* 22 (October 1932), pp. 130–34.

Elam, Charles H. *The Peale Family: Three Generations of American Artists*. Exh. cat. Detroit: Detroit Institute of Arts, 1967.

Maryland Historical Society. *Four Generations of Commissions: The Peale Collection of the Maryland Historical Society*. Exh. cat. Baltimore, 1973.

Sherman, Frederic Fairchild. "James Peale's Portrait

Miniatures." *Art in America* 19 (August 1931), pp. 208–21.

PEALE, RAPHAELLE

Bury, Edmund. "Raphaelle Peale (1774–1825), Miniature Painter." *American Collector* 17 (August 1948), pp. 6–9.
Cikovsky, Nicolai, Jr. *Raphaelle Peale Still Lifes.* Exh. cat. Washington, D.C.: National Gallery of Art, 1988.
Philadelphia Museum of Art, 1976, pp. 255–56.
Sellers, Charles Coleman. *Raphaelle Peale.* Exh. cat. Milwaukee: Milwaukee Art Center, 1959.

PELHAM, HENRY

Burroughs, Alan. "A Pelham portrait?" *Antiques* 71 (April 1957), pp. 358–59.
Massachusetts Historical Society. *Letters and Papers of John Singleton Copley and Henry Pelham, 1739–1776.* Collections, vol. 71. Cambridge, Mass., 1914.
Saunders and Miles, 1987, pp. 215, 307–8.
Slade, Denison Rogers. "Henry Pelham, the Half-Brother of John Singleton Copley." *Publications of the Colonial Society of Massachusetts* 5, Transactions, 1897, 1898. Boston, 1902, pp. 193–211.

PERSICO, GENNARINO

Philadelphia Museum of Art, 1976, pp. 251–52.

PETICOLAS, PHILIPPE ABRAHAM

Virginia Museum. *Painting in the South: 1564–1980.* Richmond, Va., 1983, pp. 47, 53, 64, 198.

ROBERTSON, ARCHIBALD

Goddard, Mrs. J. Warren. *Archibald Robertson, The Founder of the First School of Art in America.* New York: New York Genealogical and Biographical Society, 1920.
Kennedy Galleries. "A. & A. Robertson, Limners." *American Drawings, Pastels and Watercolors.* Exh. cat. New York, 1967, pp. 13–27.
Robertson, 1895.
Stillwell, John E. "Archibald Robertson, Miniaturist, 1765–1835." *New-York Historical Society Quarterly Bulletin* 13 (April 1929), pp. 1–33.

ROBERTSON, WALTER

Cone, Bernard H. "The American Miniatures of Walter Robertson." *American Collector* 9 (April 1940), pp. 6–7, 14–20.
Strickland, Walter G. *A Dictionary of Irish Artists.* Dublin and London: Maunsel & Company, 1913, vol. 2, pp. 287–89.

ROGERS, NATHANIEL

Dunlap, 1834, vol. 2, pp. 251–53.
Sherman, Frederic Fairchild. "Nathaniel Rogers and His Miniatures." *Art in America* 23 (October 1935), pp. 158–62.

RUSSELL, MOSES B.

Swan, 1940, pp. 189–90.

RUSSELL, MRS. MOSES B.

Tufts, 1987, no. 30.

SAUNDERS, GEORGE LETHBRIDGE

Allen, Josephine L. "Some Notes on Miniatures." *The Metropolitan Museum of Art Bulletin* 13 (April 1955), pp. 244–46.

SAVAGE, EDWARD

Dresser, Louisa. "Edward Savage, 1761–1817." *Art in America* 40 (Autumn 1952), pp. 157–212.
Hart, Charles Henry. *Edward Savage, Painter and Engraver.* Boston: Massachusetts Historical Society, 1905.
Strickler, 1989, pp. 17, 19, 24, 52, 104–7.

SCARBOROUGH, WILLIAM HARRISON

Hennig, Helen Kohn. *William Harrison Scarborough; Portraitist and Miniaturist: "A Parade of the Living Past."* Columbia, S.C.: R. L. Bryan Company, 1937.
———. "William Harrison Scarborough, Portrait Painter and Miniaturist." *Art in America* 22 (October 1934), pp. 125–34.

SHUMWAY, HENRY COLTON

French, 1879, pp. 73–74.
Sherman, Frederic Fairchild. "Henry Colton Shumway—American Miniaturist." *Art in America* 31 (July 1943), p. 155.

SMITH, JAMES P.

Beal, Rebecca J. *Jacob Eichholtz 1776–1842: Portrait Painter of Pennsylvania.* Philadelphia: Historical Society of Pennsylvania, 1969, pp. 223–24.

STAIGG, RICHARD MORRELL

Decatur, Stephen. "Richard Morrell Staigg." *American Collector* 9 (August 1940), pp. 8–9.
Tuckerman, 1867, pp. 445–47.

STROBEL, LOUISA C.

Severens, 1984, pp. 110–14.

STUART, JANE

Morgan, John Hill. *Gilbert Stuart and His Pupils.* New York: New-York Historical Society, 1939, pp. 49–51.
Powel, Mary E. "Miss Jane Stuart 1812–1888." *Bulletin of the Newport Historical Society*, no. 31 (January 1920), pp. 1–16.
Rubinstein, 1982, pp. 43–45.

SULLY, LAWRENCE

Dunlap, 1918, vol. 2, pp. 236–45.
Valentine Museum, 1949, pp. 232–33.

SULLY, THOMAS

Biddle, Edward, and Fielding, Mantle. *The Life and Works of Thomas Sully (1783–1872).* Philadelphia: Wickersham Press, 1921.
Bronson, Steven E. "Thomas Sully: Style and Development in Masterworks of Portraiture 1783–

1839." Ph.D. dissertation, University of Delaware, 1986.

Fabian, Monroe H. *Mr. Sully, Portrait Painter: The Works of Thomas Sully (1783–1872).* Exh. cat. Washington, D.C.: National Portrait Gallery, 1983.

THOMSON, WILLIAM JOHN

Foskett, 1972, vol. 1, p. 548, plate 368.

TISDALE, ELKANAH

French, 1879, pp. 37–38.

TROTT, BENJAMIN

Bolton, Theodore. "Benjamin Trott, An Account of His Life and Work." *Art Quarterly* 7 (Autumn 1944), pp. 257–77.

Cone, Bernard H. "Benjamin Trott—Yankee Miniature Painter." *American Collector* 9 (October 1940), pp. 8, 9, 14.

Philadelphia Museum of Art, 1976, pp. 177, 234.

Sherman, Frederic Fairchild. "Benjamin Trott, An Early American Miniaturist." *Art in America* 29 (July 1941), pp. 151–55.

VERSTILLE, WILLIAM

"Accounts of William Verstille." *Connecticut Historical Society Bulletin* 25 (January 1960), pp. 22–31.

Lipman, Jean. "William Verstille's Connecticut Miniatures." *Art in America* 29 (October 1941), p. 229.

WALLIN, SAMUEL

Hamilton, Sinclair. *Early American Book Illustrators and Wood Engravers, 1670–1870.* 2 vols. Princeton, N.J.: Princeton University, 1958–68.

WATKINS, WILLIAM

Clark, 1932, pp. 102–3, 499.

WAUGH, ALFRED

Encyclopedia of New Orleans Artists 1718–1918, 1987, p. 404.

Samuels, Peggy and Harold. *The Illustrated Biographical Encyclopedia of Artists of the American West.* New York, 1976.

WEINEDEL, CARL

Dunlap, 1918, vol. 3, p. 341.

Wright, 1983, p. 175.

WILLIAMS, HENRY

Strickler, 1989, pp. 115–16.

WOOD, JOSEPH

Groce, George C., Jr., and Willet, J. T. Chase. "Joseph Wood: A Brief Account of His Life and the First Catalogue of His Work." *Art Quarterly* 3 (Spring 1940), pp. 149–61, supplement to vol. 3, pp. 393–400.

Paulding, James K. "Sketch of the Life of Mr. Joseph Wood." *Port Folio* 5 (January 1811), pp. 64–68.

Index

Nichols, Ammi, 231
Nichols, Mary Kellogg, *see* Kellogg, Mary
Nicholson, Frances Witter, 183, 184
Nicholson, James, 183, 184
Nuttall, Thomas, 78

O

Officer, John, 158
Officer, Mary Storey, 158
OFFICER, THOMAS STORY, 158; portrait miniatures by:
 Holy Eyes, 158; cat. no. 140; *Professor Mapes*, 158
Oldham, Amelia C. Wameling, 81
Oldham, Edward (captain), 81
Oldham, Edward S., 81; portrait miniature said to be of
 (Barratt), 81; cat. no. 9
Osborne, David, 202
Osborne, Frances Ann (Mrs. Samuel Russell), 202–3;
 portrait miniature of (Shumway), 202–3; cat. no. 221
Osborne, Mary, 202
Osborne, Peter, 135
Otis, Anna Huntington, 142; portrait miniature of
 (Inman), 142; cat. no. 111; colorplate 13a; metal case
 for, *31*
Otis, Bass, 227
Otis, Joseph, 142

P

Paine, Thomas, 183
Painter, John Vickers, 247
Painter, Lydia Ethel F., 247; portrait miniature of
 (unidentified artist), 247; cat. no. 311
Panama-Pacific Exposition, San Diego (1915), 138
Panton, Mr., 152
Parker, Elias, portrait miniature of (Verstille), 224; cat.
 no. 257
Parker, Francis, 146
Parker, Mrs. Francis, *see* Dixon, Louisa W.
Parthenon, The, engravings for (Wallin), 226
Paul (emperor of Russia), 154
Paul, James, 176; portrait miniature said to be of
 (Raphaelle Peale), 176; cat. no. 173
PEALE, ANNA CLAYPOOLE, 22, 159, 167; portrait
 miniatures by: *Gentleman with the Initials J C*, 160; cat.
 no. 141; *George Washington* (after J. Peale), 161; cat.
 no. 146; colorplate 11a; *George Weaver*, 160; cat. no.
 144; *Lady with Red Hair*, 160; cat. no. 142; colorplate
 11b; *Mrs. John A. Brown*, 160; cat. no. 143; colorplate
 11c; *Mrs. Samuel Vaughan*, 160–61; cat. no. 145
PEALE, CHARLES WILLSON, 13, 162–63; art academy
 founded by, 162, 175; art education of, 162; artistic
 reputation of, 17, 162; artistic style of, 17, 163; as
 author, 116, 162, 163; autobiography of, 164; birth
 of, 162; bracelet mounts ordered by Martha
 Washington from, *32*; childhood of, 162; children
 of, 22, 163, 164, 175; collaborations with James
 Peale, 162–63, 167, 169; correspondence: to
 Edmund Jenings, 164; to Raphaelle Peale, 175; to
 Rembrandt Peale, 159, 163; to Benjamin West, 162;
 cover glasses for miniatures made by, 33; diary of,
 33, 165, 166; dynasty of artists founded by, 22, 163,
 164; influenced by: John Singleton Copley, 162;
 Benjamin West, 163; influence on Robert Fulton,
 122; as inventor and scientist, 162, 163; in London,
 162, 163; marriage of, 162, 164; museum founded

by, 162, 163, 175; partnership with James Peale, 17,
 163, 167; political interests of, 162; portrait business
 of, turned over to sons, 163; portrait miniatures by:
 Ennion Williams, 165–66; cat. no. 150; colorplate 1c;
 General Henry Knox, detail of, *18*; *General Richard
 Montgomery*, 166–67; cat. no. 153; colorplate 1d;
 Joseph Donaldson, 165; cat. no. 149; colorplate 1b;
 Lady said to be Catherine Scott Brown, 166; cat. no. 151;
 Mrs. John Cox, 166; cat. no. 152; *Mrs. Joseph
 Donaldson*, 164–65; cat. no. 148; colorplate 1a; *Rachel
 Brewer Peale*, 163; *Rachel Brewer Peale and Baby
 Eleanor*, 163–64; cat. no. 147; colorplate 2; portraits
 by, 159, 161, 162, 163, 166–67; *Rachel Weeping*, 164;
 as saddlemaker, 162, 167; self-portrait by: *Artist in
 His Museum, The*, 163; support for Anna Claypoole
 Peale, 159; as teacher, 17, 122; technique of, for
 miniature painting, 163; illustrated, *18*; work of,
 copied by James Peale, 168
Peale, Eleanor, 164; portrait miniature of (C. W. Peale),
 163–64; cat. no. 147; colorplate 2
PEALE, JAMES, 13, 159, 162, 167; artistic reputation of,
 17, 167; artistic style of, 21–22, 167; collaborations
 with Charles Willson Peale, 162–63, 167, 169; in the
 Continental Army, 167; dynasty of artists founded
 by, 163; influence: on Robert Fulton, 122, 123; on
 Raphaelle Peale, 22, 175; partnership with Charles
 Willson Peale, 17, 163, 167; portrait miniatures by:
 Anthony Wayne Robinson, 174; cat. no. 171; metal case
 for, *31*; *Beulah Elmy Twining*, 174; cat. no. 172; *Curtis
 Clay*, 171; cat. no. 164; *Gentleman*, 170; cat. no. 161;
 Gentleman in a Green Coat, 169; cat. no. 160;
 colorplate 3e; *Gentleman said to be James Ladson*, 171;
 cat. no. 165; *Gentleman thought to be John Sager*, 168;
 cat. no. 156; *Gentleman with the Initials
 E C*, 169; cat. no. 158; *George Washington* (after C. W.
 Peale), 167–68; cat. no. 154; *Henry Nicolls Kitchin*,
 172; cat. no. 169; *Lady with the Initials T B*, 172; cat.
 no. 168; colorplate 3c; *Martha Washington*, 168; cat.
 no. 155; *Mrs. John McAllister*, 169; cat. no. 159;
 colorplate 3d; *Mrs. Joseph Cooper*, 170–71; cat. no.
 163; *Pryor Smallwood*, 172; cat. no. 167; *Self-portrait*,
 168–69; cat. no. 157; colorplate 3a; *William Jonas
 Keen*, 170; cat. no. 162; colorplate 3b; *William
 Smallwood*, 172; cat. no. 166; *William Young*, 173; cat.
 no. 170; as saddlemaker, 167; self-portraits by, 168–
 69; as teacher, 17, 122, 167, 175; work of, copied by
 Anna Claypoole Peale, 161; cat. no. 146; colorplate 11a
Peale, Margaret Bordley, 164
Peale, Margaretta Angelica, 159
Peale, Martha (Patty) McGlathery, 175
Peale, Mary Claypoole, 159, 167
Peale, Rachel Brewer, 162, 164, 175; portrait miniature
 of (C. W. Peale), 163–64; cat. no. 147; colorplate 2
PEALE, RAPHAELLE, 22, 23, 161, 163, 164, 174, 175–76;
 portrait miniatures by: *Gentleman said to be James
 Paul*, 176; cat. no. 173; *Gentleman with the Initials
 J G L*, 176; cat. no. 174; colorplate 7c; *Gentleman with
 the Initials T L L*, 176; cat. no. 175; *P. F. Ronbeau*,
 177; cat. no. 176
Peale, Rembrandt, 25, 80, 159, 161, 163, 164, 175
Peale, Rubens, 164
Peale, Sarah Miriam, 159
Peale, Titian Ramsay, 161
Peale's Baltimore Museum, 98, 159
Peale's New York Museum, 116, 159
Peale's Philadelphia Museum, 159, 162, 163, 175
Pearce, Nathaniel, 149; portrait miniatures of
 (Malbone), 148–49; cat. no. 122; colorplate 6a

Russell, Albert Cuyp, 196
RUSSELL, MRS. MOSES B. (Clarissa Peters), 24, 127, 193, 196–97; portrait miniatures by: *Baby*, 197; cat. no. 213; colorplate 32a; *Child*, 197–98; cat. no. 214; *Group of Children*, 197; *Starbird Children, The*, 197; cat. no. 212; colorplate 25
Russell, Mrs. Samuel, *see* Osborne, Frances Ann
RUSSELL, MOSES B., 24, 193, 196, 197; portrait miniatures attributed to: *Lady in a Blue Dress*, 196; cat. no. 211; *Lady with a Closed Book*, 195–96; cat. no. 210; *Lady with an Open Book, probably Miss Ross*, 195, 196; cat. no. 209; portrait miniatures by: *Gentleman* (2⅝ x 2¹/₁₆ in.; undated), 193–94; cat. no. 206; *Gentleman* (2⅝ x 2¹/₁₆ in.; 1834), 193; cat. no. 205; colorplate 22b; *Gentleman* (2¾ x 2⅛ in.), 194–95; cat. no. 208; *Gentleman said to be Edward Brinley of Boston*, 194; cat. no. 207; *Two Sisters*, 196
Russell, Samuel, 203

S

Sage, Hetty, 17
Sager, John, 168; portrait miniature thought to be of (J. Peale), 168; cat. no. 156; colorplate 1e
Saint-Mémin, Charles B. J., 235
Salem Gazette, 133
Salon, Paris, 96, 97, 98, 117, 204
Sanders, George, 198
Sands, Ferdinand, portrait miniature of (Rogers), 193; cat. no. 204; colorplate 16c
Sands, Joseph, portrait miniature of (Rogers), 193; cat. no. 204; colorplate 16c
SAUNDERS, GEORGE LETHBRIDGE, 24, 198; portrait miniatures by: *Jubal Anderson Early*, 198; cat. no. 215; *Mrs. Israel Thorndike*, 198–99; cat. no. 216; colorplate 27
SAVAGE, EDWARD, 199–200; painting by: *Washington Family, The*, 200; portrait miniature attributed to: *George Johnston*, 200; cat. no. 217
Savage, Lydia Craige, 199
Savage, Sarah Seaver, 200
Savage, Seth, 199
Scarborough, Miranda Eliza Miller, 200
SCARBOROUGH, WILLIAM HARRISON, 200–201; portrait miniatures by: *Girl*, 201; cat. no. 219; *Lady*, 201; cat. no. 218
Scott, Daniel, 131
Scratchside Family, The (Carlin), 90
Shakespeare, William, 13, 95
Shelley, Samuel, 22, 148
SHEYS, WILLIAM P., 201–2; portrait miniature by: *Naval Officer*, 202; cat. no. 220
Shirreff, Charles, 184
SHUMWAY, HENRY COLTON, 202, 230; portrait miniature by: *Frances Ann Osborne*, 202–3; cat. no. 221
Sigourney, Lydia H., 77
Simes, Mary Jane, 22, 159
Sketch Club, New York City, 139
Smallwood, Benjamin, 172
Smallwood, Lydia Hutchinson, 172
Smallwood, Pryor, 172; portrait miniature of (J. Peale), 172; cat. no. 167
Smallwood, William, 172; portrait miniature of (J. Peale), 172; cat. no. 166
Smart, John, 17, 20, 22
Smibert, John, 16, 98, 162
Smith, Charlotte Izard, 186

Smith, Charlotte Wragg, 186
SMITH, JAMES PASSMORE, 203; portrait miniature by: *Gentleman with the Initials E W*, 203; cat. no. 222; colorplate 21a
Smith, John Rubens, 90, 100, 127, 144, 232
Smith, William Loughton, 185–86; portrait miniature of (Archibald Robertson), 185–86; cat. no. 188; colorplate 7a
Snow, Horatio G., 97
Snow, Mary Elizabeth, 97; portrait miniature of (Clark), 97; cat. no. 39
Snow, Nathaniel, 97
Society of Artists, Dublin, 186
Society of Artists, London, 82, 98, 122
Society of Artists, Philadelphia (later Columbian Society of Artists), 20, 81, 154, 216
Society of Arts, Dublin, 178
Society of Arts, London, 156
Somers, Richard, 170
South Carolina Institute, Charleston, 106
Spicer, Henry, 82
Splendeurs et misères des courtisanes (Balzac), 13
STAIGG, RICHARD MORRELL, 24, 204–5; portrait miniature attributed to: *Gentleman said to be Jeremiah Van Rensselaer*, 205; cat. no. 224; portrait miniature by: *Miss Ann King*, 205; cat. no. 223
Stallings, Joseph, 93; portrait miniature of (Catlin), 93; cat. no. 32; colorplate 14b
Stanton, Lucy M., 26
Starbird, Caroline, 197; portrait miniature of (Mrs. Russell), 197; cat. no. 212; colorplate 25
Starbird, Henry, 197; portrait miniature of (Mrs. Russell), 197; cat. no. 212; colorplate 25
Starbird, Louis, 197; portrait miniature of (Mrs. Russell), 197; cat. no. 212; colorplate 25
Starbird, Mary Horn, 197
Starbird, Nathaniel W., 197
Staughton, Mrs. William, *see* PEALE, ANNA CLAYPOOLE
Staughton, William, 159
Steele, Christopher, 162
Sterne, Laurence, 95
STEVENS, GEORGE W., 206; portrait miniature by: *Boy*, 206; cat. no. 225
Stevenson, John, 208
stipple: definition of, 29; illustration of, *18, 19*
Stock, Joseph Whiting, 196, 243
Stone, Elizabeth, *see* White, Mrs. Joseph
Stone, Ephraim, 123
Stone, Mrs. Anstis, 225; portrait miniature of (Verstille), 225; cat. no. 259
Strobel, Daniel, 206
STROBEL, LOUISA CATHERINE, 206; portrait miniatures by: *Gentleman*, 206; cat. no. 226; *Lady*, 206; cat. no. 227
Stuart, Gilbert, 20, 131, 161; advice given to Thomas Sully by, 210; artistic style of, 21; compared to Benjamin Trott, 216; daughter of, 24, 207; in Dublin, 21, 215; friendships of, 186, 215; influence of, 21; on Charles Fraser, 120; on Sarah Goodridge, 125; on Edward Dalton Marchant, 150; on Benjamin Trott, 22; in London, 21; portrait miniature by, 125; portrait miniatures of: (S. Goodridge), 125; (A. Dickinson), 103; portraits by, 83, 149, 186, 187; *Joseph Anthony Jr.*, 216; portraits of George Washington by, 24, 83, 117, 180, 207, 215; as teacher, 24, 125, 150; work of, copied by: John James Barralet, 117; William Russell Birch, 83; Robert Field, 117; Sarah Goodridge, 125; Philippe Peticolas, 180; Walter Robertson, 117, 186; Jane

V

Vail, Aramenta Dianthe, 221; portrait miniature by: *Rebecca Fanshaw*, 221; cat. no. 251; colorplate 31
Vallée, Jean François de, 21
Van Cortlandt family, 182
Vanderbilt, Cornelius, 85, 151; portrait of (attr. to W. R. Birch), 85; cat. no. 18
Vanderlyn, John, 80
Van Dyck, Anthony, painting by: *Cornelius van der Geest*, 22
Van Dyck, Jacobus, 222
Van Dyck, James, 222; portrait miniatures attributed to: *Gentleman* (2⅜ x 1⅞ in.), 223; cat. no. 254; *Gentleman* (2⅜ x 2 in.), 223; cat. no. 253; portrait miniature by: *Aaron Burr*, 222; cat. no. 252
Van Dyck, James (father), 222
Van Dyck, Sophia, 222
Van Horne, Ann Margaret Clarkson, 184
Van Horne, Augustus Valette, 186
Van Horne, Garrit, 184; portrait miniature of (attr. to Ramage), 184; cat. no. 187
Van Rensselaer, Jeremiah, 205; portrait miniature of (attr. to Staigg), 205; cat. no. 224
Van Rensselaer, Stephen, 103
Van Rensselaer family, 182
Vaughan, Mrs. Samuel, 161; portrait miniature of (A. C. Peale), 160–61; cat. no. 145
Vaughan, Samuel, 161
Veillard, Louis, 116
Verdi, Giuseppe, 13
Verstille, Eliza Sheldon, 223
Verstille, William, 17, 223–24; portrait miniatures by: *Elderly Gentleman*, 225; cat. no. 258; colorplate 7d; *Frederick Kuhl*, 224; cat. no. 255; *Gentleman*, 224; cat. no. 256; *Lieutenant Colonel Elias Parker*, 224; cat. no. 257; *Mrs. Anstis Stone*, 225; cat. no. 259; *Mrs. Joseph White*, 225; cat. no. 260; colorplate 7e; *T. Matthew Pratt*, 225; cat. no. 261
Views of Philadelphia, engravings (T. Birch and W. R. Birch), 83
Vincent, François André, 97
Virginia Gazette (Richmond), 209

W

Wadsworth, Colonel, 202
Wagner, Charles, 219; portrait miniature of (Trott), 219; cat. no. 246
Walker, L. B., portrait miniature of (Miles), 155; cat. no. 134
Wallin, Samuel, 226; portrait miniatures attributed to: *David Howe*, 226; cat. no. 262; *Sally Whitney Howe*, 226; cat. no. 263
Wallin, Samuel, Jr., 226
Ward, Abby Maria Hall, 129–30
Ward, Anne Catherine, 129; portrait miniature of (Hall), 129–30; cat. no. 94
Ward, Eliza Hall, 128; portrait miniature of (Hall), 129; cat. no. 93
Ward, Henry, 129
Ward, Henry Hall, 129
Ward, John, 129; portrait miniature of (Hall), 129–30; cat. no. 94
Ward, William Greene, 129, 130
Wardale, Frances, *see* McAllister, Frances Wardale

Warner, William, Jr., 227; portrait miniature by: *Gentleman*, 227; cat. no. 264
wash: definition of, 29; illustration of, *19*
Washington, George, 81, 83, 166, 183, 219; portrait miniatures of: (H. I. Brown), 87; (Elouis), 116, 117; (A. C. Peale), 161; cat. no. 146; colorplate 11a; (J. Peale), 161; (J. Peale, after C. W. Peale), 167–68; cat. no. 154; (Peticolas, after G. Stuart), 180; (Ramage), 182; (W. Robertson), 186; (J. Stuart, after G. Stuart), 207, 208; cat. no. 228; (unidentified artist), 238; cat. no. 288; (unidentified artist, after John Trumbull), 246; cat. no. 310; portraits of: (Barralet, after G. Stuart), 117; (W. R. Birch, after G. Stuart), 83; (Field, after G. Stuart), 117; (C. W. Peale), 161; (Raphaelle Peale), 161; (Rembrandt Peale), 161; (W. Robertson, after G. Stuart), 117; (Savage), 199, 200; (G. Stuart), 24, 83, 117, 180, 207, 215; (J. Stuart, after G. Stuart), 24, 207; (Trott, after G. Stuart), 215; (Trumbull), 246
Washington, Martha, 32, 116; portrait miniatures of: (Elouis), 116, 117; (attr. to Elouis), 117; cat. no. 75; (J. Peale), 168; cat. no. 155; (W. Robertson), 186
Watkins, William A., 227; portrait miniature by: *L. P. Church*, 227–28; cat. no. 265; colorplate 22c
Waugh, Alfred S., 228; portrait miniature by: *Gentleman said to be William Wallace Wiley Wood*, 228; cat. no. 266
Wayne, Anthony, 116
Weaver, George, portrait miniature of (A. C. Peale), 160; cat. no. 144
Webster, Daniel, 85, 126, 137; portrait miniatures of: (W. R. Birch, after Longacre), 85; cat. no. 17; (Hite), 137; cat. no. 103 (Shumway), 202; (Staigg), 204; portraits of: (S. Goodridge), 126
Webster-Ashburton Treaty, 137
Weed, Thurlow, 90
Wehle, Harry, 25, 80, 117, 187
Weinedel, Carl, 228–29; portrait miniatures by: *Gentleman* (2⁵⁄₁₆ x 1¹³⁄₁₆ in.), 229–30; cat. no. 268; *Gentleman* (2½ x 2 in.), 230; cat. no. 269; *Mrs. E. Hunt*, 229; cat. no. 267
Wells, James N., 110
Wentworth, John, 118
West, Benjamin: advice given to Thomas Sully by, 211; Copley encouraged by, 98; correspondence from Charles Willson Peale, 162; engravings after (W. R. Birch), 82; influence on Charles Willson Peale, 163; in London, 17, 122, 148, 156, 162; meeting with Malbone, 148; miniature by (self-portrait), 16; portrait by: *Mrs. West and Son Raphael*, 163–64; as teacher, 122, 156, 162, 184, 200
Weyler, Jean-Baptiste, 95
Whistler, James McNeill, 25
White, Mrs. Joseph, 225; portrait miniature of (Verstille), 225; cat. no. 260; colorplate 7e
Whitehorne, James A., 230; portrait miniature attributed to: *Gentleman*, 231; cat. no. 272; portrait miniatures by: *Mary Kellogg*, 230–31; cat. no. 271; colorplate 26b; *Nancy Kellogg*, 230; cat. no. 270
Whitney, Abigail, 226
Whitney, Samuel, 226
Whittemore, William J., 26
Wilcocks, Benjamin Chew, 210, 219; portrait miniatures of (Trott), 217, 219; cat. no. 244; colorplate 8d
Wilcocks, Benjamin Chew, family, 198
Wilcocks, Sally Waln, 219
Wilcocks, Thomas Sully, 219

Wilkes, Charles, 75
Wilkin, Charles, 86
Williams, Catherine Leonard, 166
Williams, Daniel, 165
Williams, Ennion, 165–66; portrait miniature of (C. W. Peale), 165–66; cat. no. 150; colorplate 1c
WILLIAMS, HENRY, 24, 114, 232–33, 237; portrait miniatures by: *Gentleman of the Weaks Family*, 233; cat. no. 273; *Lady of the Weaks Family*, 233; cat. no. 274; colorplate 21c
Williams, Margaret Sims, 166
Willing, Anne McCall, 83
Willing, Thomas, 83
Wilson, George, 234
Wiltsie, Hendrick Martenson, 111
Wiltsie family, 111
Wirt, William, 103
Witter, Catherine Van Zandt, 184
Witter, Frances Tucker, 184
Witter, Mary Lewis, 184
Witter, Matthew, 184
Witter, Thomas, 184; portrait miniature of (Ramage), 184; cat. no. 186; colorplate 4b

Wood, Abigail Camp, 233
Wood, George, 219; portrait miniature of (Trott), 219; cat. no. 245
WOOD, JOSEPH, 13, 22, 23, 188, 233–34, 236, 238; portrait miniatures by: *James Stuart*, 233, 234; cat. no. 275; colorplate 8a; *M. Muir*, 234; cat. no. 276; colorplate 8b
Wood, Margaret Haring, 233
Woolcot, A., 216
Wordsworth, William, 141
Wright, Silas, 230

Y

York, Duchess of, 154
Young, Agnes McLaws, 173
Young, William, 173; portrait miniature of (J. Peale), 173; cat. no. 170

Z

Zincke, Christian Frederick, 15